500 Great
Comic Book Action Heroes

Mike Conroy

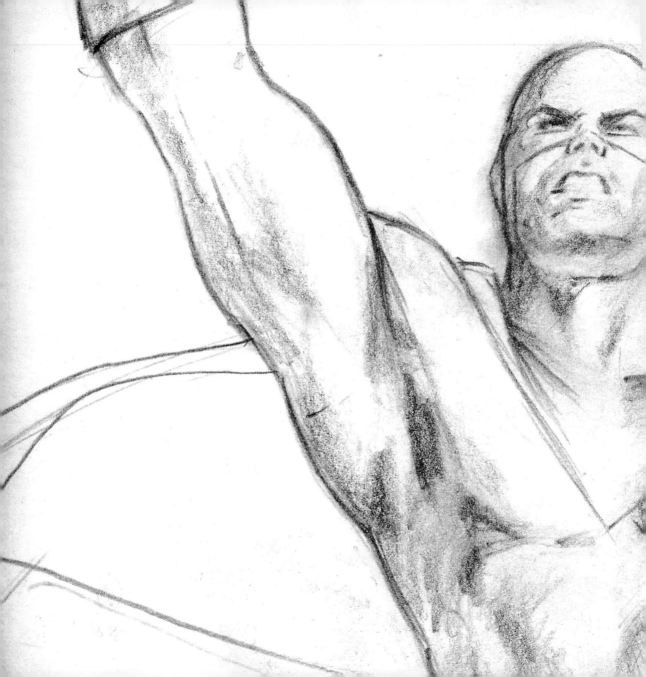

500 Great
Comicbook Action Heroes
Mike Conroy

COLLINS & BROWN

Reprinted in 2004 by Collins & Brown
An imprint of Chrysalis Books Group plc
The Chrysalis Building,
Bramley Road, London, W10 6SP
United Kingdom
An imprint of Chrysalis Books Group

ISBN 1 84411 004 4

Credits
Commissioning editors: Will Steeds, Chris Stone
Project management: Mike Evans
Front cover illustration: Ungara
Designed by Grade Design Consultants, London
Colour reproduction: Berkeley Square
Printed and bound by Times Offset (M) Sdn Bhd, Malaysia

Acknowledgements
Many thanks to David Bishop, Paul Gravett, Tony Hitchman,
Peter Normanton, Tim Pilcher and David Roach for their
contributions to this volume and to Frank Mottler for his
help with the illustrations. Special thanks to Will Eisner for
his Foreword. Final thanks to Dez Skinn, not only for his
contributions but also for being there with advice and for
the burning of the midnight oil to provide the visuals.

Contents

Foreword

As Joseph Campbell, the eminent author of classic works on mythology acknowledged, the myth of the hero is firmly lodged in popular culture where it provides a society with a kind of spiritual nourishment.

Perhaps the most significant contribution of heroes into the popular literature of the 20th century was made by the form of graphic narrative known as comics.

Beginning at the turn of the century, comics imbedded itself in the print mass media and provided us with stereotypical heroes that reflected our common yearnings. They served our secret aggressions and empowered our imaginings. Comic book heroes, once implanted in popular lore, were adopted in the language of our dreams and its secret struggle with the dangerous business of living.

The comic book heroes I know of, including ones I created, were devised out of a cultural environment of the time and a perception of audience acceptance. They came out of the visceral response to a felt need and the creators' instinctive contact with wish-fulfillment for their readers.

When this reader-contact was unerring, creators succeeded in producing popular mythical heroes. Western society acquired the invincible Superman, who served it when that society was threatened by an invincible enemy. Batman arose when Dick Tracy was no longer able to cope with big crime. Spider-Man joined the cast of heroes when we were no longer naive about the perfection of our superheroes; and the Spirit came along when there had to be a case made for heroism that was not the sole province of supermutant men and women.

500 Great Comic Book Action Heroes as a singular collection is an important guide to the product of the continuing birthrate of heroes—good and bad. It is a valuable testimony to the comic medium's custodianship of these heroes.

I applaud the editors of this work.

Right: The Building [Kitchen Sink Press, 1987]. An atmospheric Will Eisner page.

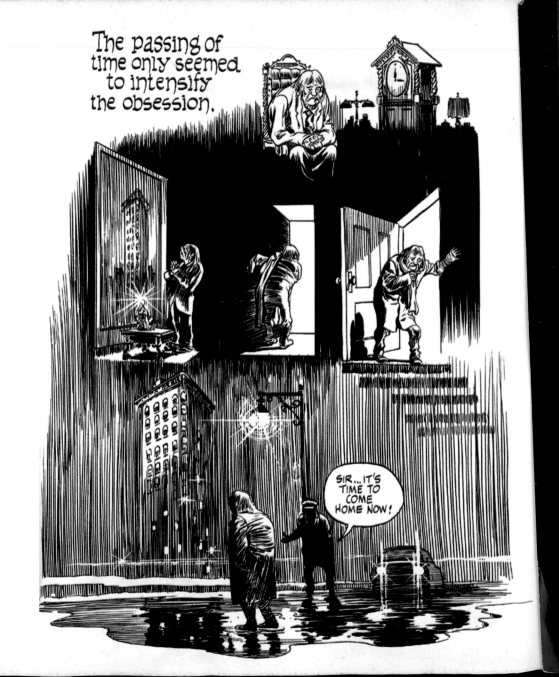

Despite the name, coined via roots in the "funnies" strip-cartoon pages of American newspapers, like the strips themselves "comics" have more often than not dealt with subjects far from humorous. As with the mass appeal of the movies, the popularity of comics proved that words and pictures speak louder than words—and no more so than in that modern-day version of the age-old craft of mythmaking, the comic book action hero.

A 20th-Century Phenomenon

Beginning in 1912 with What Happened to Mary?, the then-nascent film industry encouraged audiences to return week after week with action and adventure serials, rather than the standard comedy fare that dominated the silent cinema.

As the popularity of these cliff-hangers—as they became known—grew, U.S. newspapers began to take notice and introduce their own adventure serials as well as the humor strips they had run since the turn of the century.

America is said to have given the world only three unique art forms: jazz, Hollywood movies, and comics, but that third category is a broad generalization that fails to acknowledge the work of the early British pioneers. Amending it to adventure comics or, better yet, superheroes, gives a much better indication of the U.S. contribution to the world of sequential art. It is in that specific area that American creators altered the way the world perceives comics.

The move away from humor to adventure began with such newspaper strips as *Wash Tubbs* [launched in 1924], the aviation-based *Tailspin Tommy* and *Tim Tyler's Luck* [both begun in 1928], and *Buck Rogers in the 25th Century,* which premiered in 1929 on the same day that Edgar Rice Burroughs' *Tarzan* made his very first comics appearance.

The Lord of the Jungle's strip was initially illustrated by Harold (Hal) Foster, an advertising artist whose work on that strip, and on his own *Prince Valiant* [1938], was to revolutionize the way stories were drawn for comics. It was a manifestation of the influence Burroughs and his peers were to have on the nascent U.S. comics industry's development.

This was to become particularly evident when—in the early 1930s—the huge increase in popularity of the dime novels brought with it a different, stranger type of hero. The likes of The Shadow, Doc Savage, and The Spider were to serve as the inspiration for the countless costumed heroes that were spawned during

Right: Tarzan's long-term artist was Burne Hogarth.

THE PIRATES WERE AMAZED WHEN TARZAN ADVANCED, HELD UP TO SOME BLACK ONE AND "BE CAREFUL"

"WHY DO YOU OFFER YOURSELF TIED FOR CAPTURE?" BLACK MUEL DEMANDED.

"SO I CAN BE SURE OF GOING WITH YOU. TARZAN ANSWERED. "I INTEND TO RESCUE THE OTHER CAPTIVES."

"WHAT A JOKE!" THE PIRATE LAUGHED. "I COULD KILL YOU NOW."

"BUT YOU WILL NOT," TARZAN DECLARED. "ALREADY YOU ARE CALCULATING HOW MUCH I WILL BRING AS A SLAVE."

"TRUE," MUEL SNARLED, "SULTAN KANDULLA WILL PAY WELL FOR YOU AND YOUR KIN. BE SURE YOU WON'T ESCAPE."

HE GAVE THE COMMAND TO MARCH, THEN CALLED OUT "NOTE, PADRAK, KEEP YOUR PISTOL ON THIS TARZAN EVERY INSTANT."

AS TARZAN FELL IN BESIDE TIBEELA, SHE SMILED. "I KNOW WHY YOU HAVE COME WITH US---- BECAUSE YOU LOVE ME."

"NO, IT IS BECAUSE YOU SAVED MY LIFE. I WANT TO PAY MY DEBT," HE SAID. BUT TIBEELA DID NOT BELIEVE HIM.

WHEN THEY REACHED THE BEACH THE PIRATES TOOK THEIR TREASURE FROM THE SHIP AND BURIED IT.

SOON THE VESSEL SAILED FROM THE COVE OUT UPON THE SWELL OF THE SEA.

NEXT WEEK
THE SULTAN'S COURT

"EVEN YOU TARZAN, ARE HELPLESS NOW," TIBEELA MOANED. "PERHAPS---PERHAPS NOT," TARZAN SAID.

the 1940s—the era many refer to as the Golden Age of Comics. In much the same way, *Fantastic Adventures*, *Weird Tales*, *Thrilling Wonder Stories,* and other such anthologies were also an influence on format and content.

The Ghost Who Walks

As the pulps gained in popularity, newspapers were introducing more action strips that would shape the future comic book industry. Among them were Chester Gould's *Dick Tracy* [1931] and, in 1933, *Brick Bradford*, Milton Caniff's *Dickie Dare,* and *White Boy*. A year later came three by Alex Raymond—*Flash Gordon*, *Jungle Jim,* and the Dashiell Hammett cocreation *Secret Agent X-9*, plus Lee Falk's *Mandrake the Magician*, Caniff's *Terry and the Pirates, Don Winslow,* and *Red Barry, Undercover Man*.

Don Dixon and Zane Grey's *King of the Royal Mounted* followed in 1935, but it was Falk's *The Phantom* in 1936 that was to have the greatest impact on comics that followed. Acknowledged as the first costumed superhero, "The Ghost Who Walks" was a harbinger of things to come.

In 1934, publishers took to repackaging newspaper strips in a format more closely resembling the American comic book as we know it today. They realized that, by folding the comics supplement in half twice and adding a cover, they could sell a 32- or even 64-page version of what they had given away for free.

While mainly humor, the #1 of *Famous Funnies,* the first comic book, also featured Tailspin Tommy, Hairbreadth Harry, with Buck

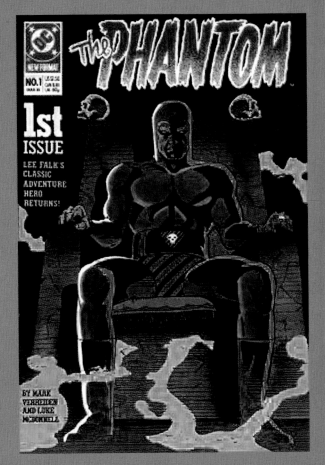

The Phantom #1 [DC Comics, 1988].

Rogers added in #3. Dan Dunn—a blatant Dick Tracy imitation—soon followed, plus more and more original strips.

National Allied Publications published *New Fun Comics* in 1935. The first successful non-reprint anthology, the black-and-white tabloid

focussed on serial adventure stories with such strips as Sandra of the Secret Service and 2033/Science Police. *New Fun Comics* #6 is a comics milestone. It introduced Dr. Occult, a supernatural prototype of the industry's earliest superhero, in a strip signed by Leger and Reuths, pen names of Jerry Siegel and Joe Shuster, a couple of youngsters who would be far better known as the creators of Superman.

As the demand for action, science fiction, and fantasy grew, so did the call for the nascent comic book industry to create heroes of its own. In 1935, National Allied launched its second title, publicizing it not only with phrases like "never printed before anywhere" but also with an increased emphasis on adventure, announcing the first issue to be "chock full of laughter and thrills, comic characters of every hue, knights and Vikings of ancient days, adventuring heroes, detectives, aviator daredevils of today and hero supermen of the days to come!"

Then came *The Comics Magazine*. Published by Comic Magazine Company, it contained only originals. Its publishers were National Allied's ex-editor and business manager who utilized many of the creators who worked on its titles. Among them were Siegel and Shuster who brought Dr. Occult with them, changing his name to Dr. Mystic. They also gave him superpowers and, in the process, created the world's first comic book superhero.

With #3 *The Comics Magazine* became *The Comic Magazine Funny Pages* and then—with #6—*Funny Pages*. That issue introduced The Clock, the first masked comic book hero.

Appearing at the same time as the initial *Funny Pages* were two companion titles—*Funny Picture Stories* and *Detective Picture Stories*, the first comic book anthology devoted to a single theme. A second themed series, the aptly titled *Western Picture Stories*, followed in 1937.

Batman and Superman

National Allied launched its third title, *Detective Comics* in 1937. The first successful comic book that was based on a single theme to the stories, it was published by a new enterprise called Detective Comics, Inc., better known today as DC Comics. Keeping Siegel and Shuster's Slam Bradley company in *Detective* were more than half-a-dozen other private eyes, among them a second Siegel and Shuster creation, Spy.

Contemporaneously with the launch of *Detective*, a new player came on the scene. Previously a packager for other comics companies, Harry "A" Chesler—the "A" being an affectation he considered gave him class—published *Star Comics* and *Star Ranger* through Ultem Publications. Both were large-sized comics featuring original material.

Where *Star Comics* was a mix of adventure and humor, *Star Ranger* was the first western series, an honor it shares with Comics Magazine Company's *Western Picture Stories*.

National Allied next developed *Action Comics*, which premiered in mid-1938. Its cover feature was a rejected newspaper strip, Siegel and Shuster's *Superman*. With most

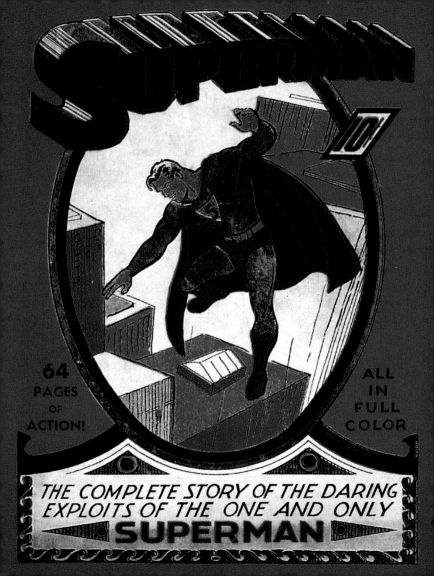

comics of the time doing about 200,000 an issue, sales of the first three issues of *Action* were not great, but with the fourth they started to rocket toward the half a million mark.

With the threat of a major war with Nazi Germany growing ever stronger, people were hungry for even greater heroes in much the same way the ancient Greeks had mythologized the gods of Mount Olympus.

Superman filled that need, and the readers were demanding more. A phenomenon had been born but, initially, the other publishers continued as if nothing had happened.

Centaur Publishing made a major push that put it at the top of the comics publishing league, in terms of number of titles. Across the course of four months it launched *Amazing Mystery Funnies*, *Little Giant Comics*, *Little Giant Detective Funnies*, and a reprint, *Little Giant Movie Funnies*. It also retitled *Star Ranger* as *Cowboy Comics* and then—after just two issues —*Star Ranger Funnies*, as well as canceling *Detective Picture Stories* to make way for *Keen Detective Funnies*.

Like most other early comic book publishers, Centaur's output was created and packaged for it by outside studios. Competing alongside Chesler's sweatshop were studios run by Bill Everett—later to create the Sub-Mariner for Marvel—and future Spirit creator Will Eisner. All three outfits provided material to Centaur. Their contributors included many talents who were to go on to much greater things. Among

them were Eisner, Everett, Charles Biro, Carlos Burgos, Fred Guardineer, Paul Gustavson, Tarpe Mills, one of only a handful of female comics creators at the time, and Jack Cole.

Pulp magazine publisher Fiction House moved in to the burgeoning market with *Jumbo Comics*. Packaged by a studio run by S. M. Iger, it introduced Sheena, Queen of the Jungle to American readers.

National followed this by assigning M. C. "Max" Gaines to spearhead a new imprint. Guided by "the midwife of American comic books," All-American debuted with *All-American Comics*, initially yet another newspaper humor strip reprint.

Then, in *Detective Comics* #27, National introduced the Batman, a new, darker kind of superhero created by Bob Kane with input from Bill Finger. And, simultaneously, a new publisher on the scene premiered its version of National's top-selling hero.

Headed by former Detective Comics accountant Victor Fox, Fox Features hired the Eisner-Iger studio to produce a "superman" for it. The result was Wonder Man, who only ever appeared in the first issue of *Wonder Comics*. He was dropped from the title— renamed *Wonderworld Comics* with #3—after National had sued for copyright infringement.

This was followed by the first ripple of superheroes in the wake of Superman's initial appearance. National with the Sandman, Centaur with the Fantom of the Fair and the Masked Marvel, and Fox with the Flame.

Then, National launched its quarterly *Superman* comic. The first original comic book

Left: Superman #1 [National Periodical Publications, 1939].

15

character to get his own title, Superman was also the first to have an entire comic book devoted to him. Initially the stories were effectively reprints from *Action Comics,* but the series saw the superhero floodgates open.

By the end of the year, Fox had introduced the *Blue Beetle*, the second costumed hero to graduate to his own title—and the Green Mask, while Centaur introduced Amazing Man and Quality Comics debuted Doll Man, its first superhero, as well as launching *Smash Comics.*

Harvey Comics premiered its *Speed Comics* and *Champion Comics* adventure anthologies. MLJ Comics—later to become Archie Comics—joined in with two anthologies of its own: *Blue Ribbon Comics* and *Top-Notch Comics*, which marked the first appearance of the Wizard as well as of Jack Cole's Manhunters. Better Comics debuted with *Best Comics*. Published in an oversized sideways format, it introduced the Mask but sank after four issues. *Silver Streak Comics*—Lev Gleason's maiden title—featured not only superheroes but, in the Claw, the first supervillain originated for comics to star in his own stories.

Marvel's genesis

Also leaping on to the bandwagon was pulp magazine publisher Martin Goodman. Encouraged by Funnies Inc. sales manager Frank Torpey, he agreed to let the comic book packaging studio produce a line of titles for him. Under the guidance of former Centaur Publications editor Lloyd Jacquet, the studio—

which included original Amazing Man artist Bill Everett—originated a number of superheroes that were to be the foundation of what would eventually become America's number one comic book publisher.

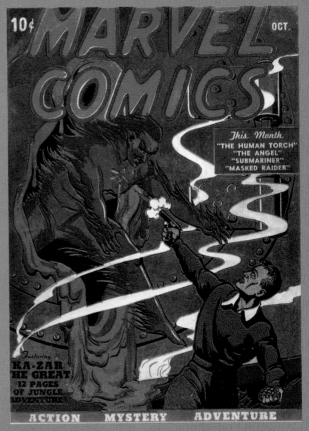

Above: Marvel Mystery Comics #1 [Timely Comics, 1939].
Right: Batman #1 [National Periodical Publications, 1940].

Contents

Foreword

As Joseph Campbell, the eminent author of classic works on mythology acknowledged, the myth of the hero is firmly lodged in popular culture where it provides a society with a kind of spiritual nourishment.

Perhaps the most significant contribution of heroes into the popular literature of the 20th century was made by the form of graphic narrative known as comics.

Beginning at the turn of the century, comics imbedded itself in the print mass media and provided us with stereotypical heroes that reflected our common yearnings. They served our secret aggressions and empowered our imaginings. Comic book heroes, once implanted in popular lore, were adopted in the language of our dreams and its secret struggle with the dangerous business of living.

The comic book heroes I know of, including ones I created, were devised out of a cultural environment of the time and a perception of audience acceptance. They came out of the visceral response to a felt need and the creators' instinctive contact with wish-fulfillment for their readers.

When this reader-contact was unerring, creators succeeded in producing popular mythical heroes. Western society acquired the invincible Superman, who served it when that society was threatened by an invincible enemy. Batman arose when Dick Tracy was no longer able to cope with big crime. Spider-Man joined the cast of heroes when we were no longer naive about the perfection of our superheroes; and the Spirit came along when there had to be a case made for heroism that was not the sole province of supermutant men and women.

500 Great Comic Book Action Heroes as a singular collection is an important guide to the product of the continuing birthrate of heroes—good and bad. It is a valuable testimony to the comic medium's custodianship of these heroes.

I applaud the editors of this work.

Right: The Building [Kitchen Sink Press, 1987]. An atmospheric Will Eisner page.

WILL EISNER

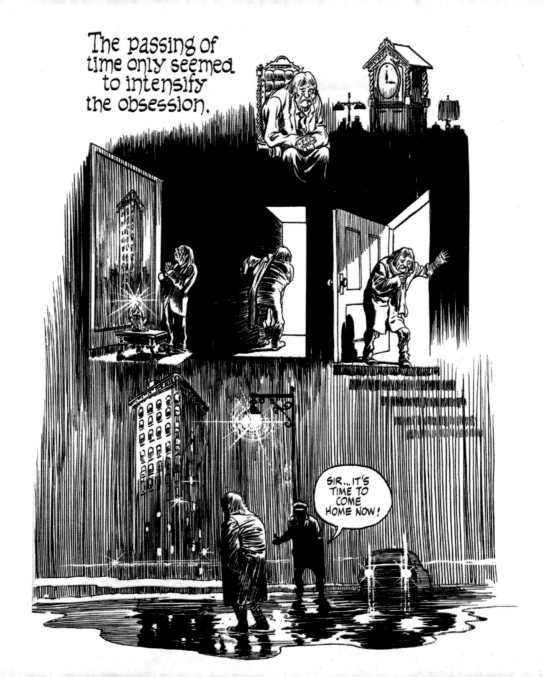

Introduction
History

A 20th-Century Phenomenon

Beginning in 1912 with What Happened to Mary?, the then-nascent film industry encouraged audiences to return week after week with action and adventure serials, rather than the standard comedy fare that dominated the silent cinema.

As the popularity of these cliff-hangers—as they became known—grew, U.S. newspapers began to take notice and introduce their own adventure serials as well as the humor strips they had run since the turn of the century.

America is said to have given the world only three unique art forms: jazz, Hollywood movies, and comics, but that third category is a broad generalization that fails to acknowledge the work of the early British pioneers. Amending it to adventure comics or, better yet, superheroes, gives a much better indication of the U.S. contribution to the world of sequential art. It is in that specific area that American creators altered the way the world perceives comics.

The move away from humor to adventure began with such newspaper strips as *Wash Tubbs* [launched in 1924], the aviation-based *Tailspin Tommy* and *Tim Tyler's Luck* [both begun in 1928], and *Buck Rogers in the 25th Century,* which premiered in 1929 on the same day that Edgar Rice Burroughs' *Tarzan* made his very first comics appearance.

The Lord of the Jungle's strip was initially illustrated by Harold (Hal) Foster, an advertising artist whose work on that strip, and on his own *Prince Valiant* [1938], was to revolutionize the way stories were drawn for comics. It was a manifestation of the influence Burroughs and his peers were to have on the nascent U.S. comics industry's development.

This was to become particularly evident when—in the early 1930s—the huge increase in popularity of the dime novels brought with it a different, stranger type of hero. The likes of The Shadow, Doc Savage, and The Spider were to serve as the inspiration for the countless costumed heroes that were spawned during

Right: Tarzan's long-term artist was Burne Hogarth.

Despite the name, coined via roots in the "funnies" strip-cartoon pages of American newspapers, like the strips themselves "comics" have more often than not dealt with subjects far from humorous. As with the mass appeal of the movies, the popularity of comics proved that words and pictures speak louder than words—and no more so than in that modern-day version of the age-old craft of mythmaking, the comic book action hero.

THE PIRATES WERE AMAZED WHEN TARZAN ADVANCED, HIS HANDS UP TO SHOW THEY WERE EMPTY. "BE CAREFUL."

"WHY DO YOU OFFER YOURSELF THUS FOR CAPTURE?" BLACK MICHAEL DEMANDED.

"SO I CAN BE SURE OF GOING WITH YOU," TARZAN ANSWERED. "I INTEND TO RESCUE THE OTHER CAPTIVES."

"WHAT A JOKE!" THE PIRATE LAUGHED. "I COULD KILL YOU NOW."

"BUT YOU WILL NOT," TARZAN DECLARED. "ALREADY YOU ARE CALCULATING HOW MUCH I WILL BRING AS A SLAVE."

"TRUE," MICHAEL SNARLED. "SULTAN KANDILLA WILL PAY WELL FOR YOU. AND YOU CAN BE SURE YOU WON'T ESCAPE."

HE GAVE THE COMMAND TO MARCH, THEN CALLED OUT, "YOU, PADRAIC, KEEP YOUR PISTOL ON THIS TARZAN EVERY INSTANT."

AS TARZAN FELL IN BESIDE TIBEELA, SHE SMILED. "I KNOW WHY YOU HAVE COME WITH US---- BECAUSE YOU LOVE ME?"

"NO, IT IS BECAUSE YOU SAVED MY LIFE. I WANT TO PAY MY DEBT," HE SAID. BUT TIBEELA DID NOT BELIEVE HIM.

WHEN THEY REACHED THE BEACH THE PIRATES TOOK THEIR TREASURE FROM THE SHIP AND BURNED IT.

SOON THE VESSEL SAILED FROM THE COVE OUT UPON THE SWELL OF THE SEA.

NEXT WEEK THE SULTAN'S COURT

"EVEN YOU, TARZAN, ARE HELPLESS NOW," TIBEELA MOANED. "PERHAPS---PERHAPS NOT," TARZAN SAID.

the 1940s—the era many refer to as the Golden Age of Comics. In much the same way, *Fantastic Adventures*, *Weird Tales*, *Thrilling Wonder Stories*, and other such anthologies were also an influence on format and content.

The Ghost Who Walks

As the pulps gained in popularity, newspapers were introducing more action strips that would shape the future comic book industry. Among them were Chester Gould's *Dick Tracy* [1931] and, in 1933, *Brick Bradford*, Milton Caniff's *Dickie Dare*, and *White Boy*. A year later came three by Alex Raymond—*Flash Gordon*, *Jungle Jim*, and the Dashiell Hammett cocreation *Secret Agent X-9*, plus Lee Falk's *Mandrake the Magician*, Caniff's *Terry and the Pirates*, *Don Winslow*, and *Red Barry, Undercover Man*.

Don Dixon and Zane Grey's *King of the Royal Mounted* followed in 1935, but it was Falk's *The Phantom* in 1936 that was to have the greatest impact on comics that followed. Acknowledged as the first costumed superhero, "The Ghost Who Walks" was a harbinger of things to come.

In 1934, publishers took to repackaging newspaper strips in a format more closely resembling the American comic book as we know it today. They realized that, by folding the comics supplement in half twice and adding a cover, they could sell a 32- or even 64-page version of what they had given away for free.

While mainly humor, the #1 of *Famous Funnies,* the first comic book, also featured Tailspin Tommy, Hairbreadth Harry, with Buck

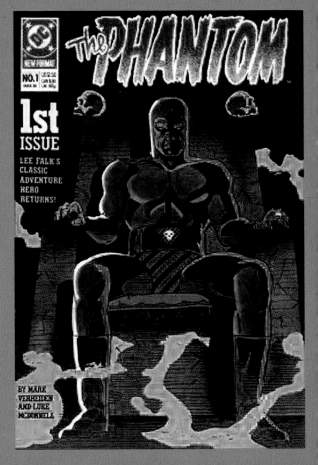

The Phantom #1 [DC Comics, 1988].

Rogers added in #3. Dan Dunn—a blatant Dick Tracy imitation—soon followed, plus more and more original strips.

National Allied Publications published *New Fun Comics* in 1935. The first successful non-reprint anthology, the black-and-white tabloid

focussed on serial adventure stories with such strips as Sandra of the Secret Service and 2033/Science Police. *New Fun Comics* #6 is a comics milestone. It introduced Dr. Occult, a supernatural prototype of the industry's earliest superhero, in a strip signed by Leger and Reuths, pen names of Jerry Siegel and Joe Shuster, a couple of youngsters who would be far better known as the creators of Superman.

As the demand for action, science fiction, and fantasy grew, so did the call for the nascent comic book industry to create heroes of its own. In 1935, National Allied launched its second title, publicizing it not only with phrases like "never printed before anywhere" but also with an increased emphasis on adventure, announcing the first issue to be "chock full of laughter and thrills, comic characters of every hue, knights and Vikings of ancient days, adventuring heroes, detectives, aviator daredevils of today and hero supermen of the days to come!"

Then came *The Comics Magazine*. Published by Comic Magazine Company, it contained only originals. Its publishers were National Allied's ex-editor and business manager who utilized many of the creators who worked on its titles. Among them were Siegel and Shuster who brought Dr. Occult with them, changing his name to Dr. Mystic. They also gave him superpowers and, in the process, created the world's first comic book superhero.

With #3 *The Comics Magazine* became *The Comic Magazine Funny Pages* and then—with #6—*Funny Pages*. That issue introduced The Clock, the first masked comic book hero.

Appearing at the same time as the initial *Funny Pages* were two companion titles—*Funny Picture Stories* and *Detective Picture Stories*, the first comic book anthology devoted to a single theme. A second themed series, the aptly titled *Western Picture Stories*, followed in 1937.

Batman and Superman

National Allied launched its third title, *Detective Comics* in 1937. The first successful comic book that was based on a single theme to the stories, it was published by a new enterprise called Detective Comics, Inc., better known today as DC Comics. Keeping Siegel and Shuster's Slam Bradley company in *Detective* were more than half-a-dozen other private eyes, among them a second Siegel and Shuster creation, Spy.

Contemporaneously with the launch of *Detective*, a new player came on the scene. Previously a packager for other comics companies, Harry "A" Chesler—the "A" being an affectation he considered gave him class— published *Star Comics* and *Star Ranger* through Ultem Publications. Both were large-sized comics featuring original material.

Where *Star Comics* was a mix of adventure and humor, *Star Ranger* was the first western series, an honor it shares with Comics Magazine Company's *Western Picture Stories*.

National Allied next developed *Action Comics*, which premiered in mid-1938. Its cover feature was a rejected newspaper strip, Siegel and Shuster's *Superman*. With most

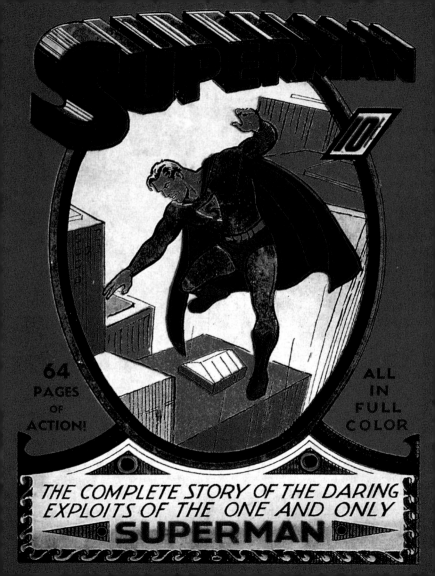

comics of the time doing about 200,000 an issue, sales of the first three issues of *Action* were not great, but with the fourth they started to rocket toward the half a million mark.

With the threat of a major war with Nazi Germany growing ever stronger, people were hungry for even greater heroes in much the same way the ancient Greeks had mythologized the gods of Mount Olympus.

Superman filled that need, and the readers were demanding more. A phenomenon had been born but, initially, the other publishers continued as if nothing had happened.

Centaur Publishing made a major push that put it at the top of the comics publishing league, in terms of number of titles. Across the course of four months it launched *Amazing Mystery Funnies*, *Little Giant Comics*, *Little Giant Detective Funnies*, and a reprint, *Little Giant Movie Funnies*. It also retitled *Star Ranger* as *Cowboy Comics* and then—after just two issues —*Star Ranger Funnies*, as well as canceling *Detective Picture Stories* to make way for *Keen Detective Funnies*.

Like most other early comic book publishers, Centaur's output was created and packaged for it by outside studios. Competing alongside Chesler's sweatshop were studios run by Bill Everett—later to create the Sub-Mariner for Marvel—and future Spirit creator Will Eisner. All three outfits provided material to Centaur. Their contributors included many talents who were to go on to much greater things. Among

them were Eisner, Everett, Charles Biro, Carlos Burgos, Fred Guardineer, Paul Gustavson, Tarpe Mills, one of only a handful of female comics creators at the time, and Jack Cole.

Pulp magazine publisher Fiction House moved in to the burgeoning market with *Jumbo Comics*. Packaged by a studio run by S. M. Iger, it introduced Sheena, Queen of the Jungle to American readers.

National followed this by assigning M. C. "Max" Gaines to spearhead a new imprint. Guided by "the midwife of American comic books," All-American debuted with *All-American Comics*, initially yet another newspaper humor strip reprint.

Then, in *Detective Comics #27*, National introduced the Batman, a new, darker kind of superhero created by Bob Kane with input from Bill Finger. And, simultaneously, a new publisher on the scene premiered its version of National's top-selling hero.

Headed by former Detective Comics accountant Victor Fox, Fox Features hired the Eisner-Iger studio to produce a "superman" for it. The result was Wonder Man, who only ever appeared in the first issue of *Wonder Comics*. He was dropped from the title— renamed *Wonderworld Comics* with #3—after National had sued for copyright infringement.

This was followed by the first ripple of superheroes in the wake of Superman's initial appearance. National with the Sandman, Centaur with the Fantom of the Fair and the Masked Marvel, and Fox with the Flame.

Then, National launched its quarterly *Superman* comic. The first original comic book

Left: Superman #1 [National Periodical Publications, 1939].

character to get his own title, Superman was also the first to have an entire comic book devoted to him. Initially the stories were effectively reprints from *Action Comics,* but the series saw the superhero floodgates open.

By the end of the year, Fox had introduced the *Blue Beetle*, the second costumed hero to graduate to his own title—and the Green Mask, while Centaur introduced Amazing Man and Quality Comics debuted Doll Man, its first superhero, as well as launching *Smash Comics*.

Harvey Comics premiered its *Speed Comics* and *Champion Comics* adventure anthologies. MLJ Comics—later to become Archie Comics—joined in with two anthologies of its own: *Blue Ribbon Comics* and *Top-Notch Comics*, which marked the first appearance of the Wizard as well as of Jack Cole's Manhunters. Better Comics debuted with *Best Comics*. Published in an oversized sideways format, it introduced the Mask but sank after four issues. *Silver Streak Comics*—Lev Gleason's maiden title—featured not only superheroes but, in the Claw, the first supervillain originated for comics to star in his own stories.

Marvel's genesis

Also leaping on to the bandwagon was pulp magazine publisher Martin Goodman. Encouraged by Funnies Inc. sales manager Frank Torpey, he agreed to let the comic book packaging studio produce a line of titles for him. Under the guidance of former Centaur Publications editor Lloyd Jacquet, the studio—

which included original Amazing Man artist Bill Everett—originated a number of superheroes that were to be the foundation of what would eventually become America's number one comic book publisher.

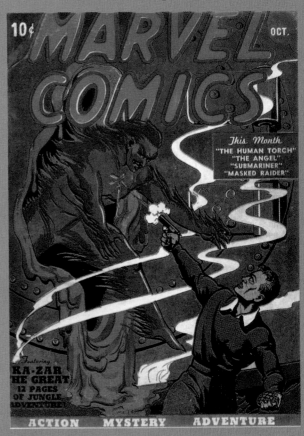

Above: Marvel Mystery Comics #1 [Timely Comics, 1939].
Right: Batman #1 [National Periodical Publications, 1940].

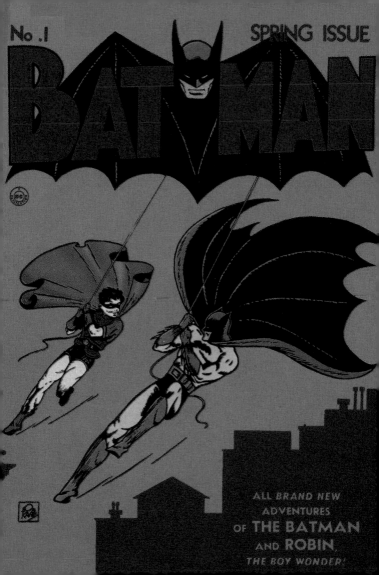

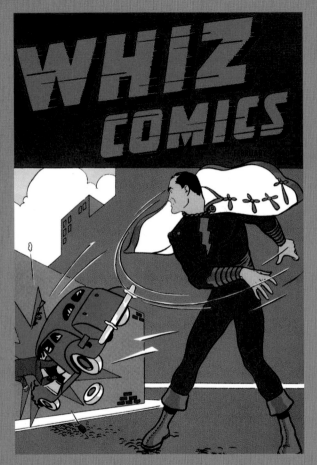

Whiz Comics #1 [Fawcett Publications, 1940].

These heroes—which included Sub-Mariner, which Everett had created for *Motion Picture Funnies Weekly*—made their debut in #1 of Timely's *Marvel Comics*. The complete lineup was the Human Torch, Ka-Zar the Great, Jungle Terror, the Angel, and the Masked Raider.

That 1939 ripple of superpowered heroes turned into a tidal wave in 1940. Inspired by the success of Superman and Batman, DC introduced the Flash, Hawkman, the Spectre, and Hourman. It also debuted Green Lantern and the Atom and launched *All-Star Comics*. Intended to be a showcase for all DC's heroes, with #3 the title introduced the Justice Society of America—the archetypal superhero team.

But it was newcomer Fawcett Comics that was to provide the blockbuster hit of the year. Created by artist C. C. Beck and editor/writer Bill Parker, Captain Marvel debuted in *Whiz Comics* #1 along with other such heroes as Spy Smasher, Golden Arrow, Ibis the Invincible, and, having no connection with the later star of Britain's *Eagle*, Dan Dare. Within months, Marvel was so successful Fawcett published *Special Edition*, a one-time collection of his earliest adventures. First appearing as Captain Thunder in Fawcett's own *Flash Comics* #1, the hero dubbed the world's mightiest mortal was viewed as nothing more than a Superman knockoff by DC.

Although it would be almost 14 years before DC could force Fawcett to withdraw Captain Marvel, the Superman publisher had better luck with Fawcett's second superhero, introduced by Fawcett in *Master Comics* #1. Again claiming infringement of its Superman copyright, DC had Master Man axed after only six issues, by which time Fawcett had launched *Nickel Comics*, which premiered with the appearance of Bulletman.

Fawcett also added *Wow Comics*, which introduced a number of minor-league

superheroes, among them Siegel and Shuster's Mr. Scarlet and Atom Blake—Boy Wizard. The title also featured Diamond Jack who, along with Mark Swift and the Time Retarder and Lee Granger, Jungle King, debuted in *Slam Bang Comics.* Launched at the same time as *Master Comics*, the series was retitled *Western Comics.*

Timely was also moving fast. *Daring Mystery Comics*—launched with Joe Simon's Fiery Mask as well as Monako, Prince of Magic and John Steele, Soldier of Fortune—was followed by *Mystic* and by *Red Raven Comics,* which ushered in the eponymous character and Comet Pierce and Mercury, two characters drawn by Jack Kirby, before being retitled *The Human Torch* with #2.

America's first patriotic hero, the Shield, debuted in MLJ's *Pep Comics* #1, an issue that also featured first appearances by Cole's Comet and by the Press Guardian—known as the Falcon from #2 on. Also from MLJ came the self-explanatory *Shield-Wizard Comics* as well as *Zip Comics*, in which Steel Sterling was first introduced to readers.

Better Publications returned with *Thrilling Comics, Exciting Comics,* and *Startling Comics,* which, between them, swelled the burgeoning superhero ranks with an array of costumed characters. *Prize Comics* was the first title to come from Prize Publications. It, too, brought with it a bunch of heroes, while another pulp magazine publisher jumping on the comic book bandwagon, Ace Magazines, debuted with *Sure-Fire Comics* and *Super Mystery Comics*, which introduced even more as did newcomer Novelty Comics' *Target Comics* and *Blue Bolt Comics.*

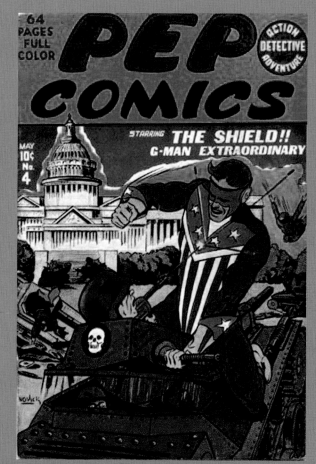

Pep Comics #4 [MLJ Magazines, 1940].

Tem—later Holyoke—Publishing's first entries in the superhero field came via the launch of *Crash Comics.* An Eastern Color subsidiary, Columbia Comics Group introduced another batch in the first issue of *Big Shot Comics* and followed up with *Heroic*

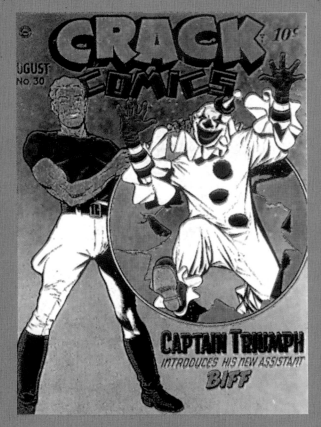

Crack Comics #30 [Quality Comics, 1943].

Comics, which added to the growing horde of costumed crime fighters.

Centaur—which had been publishing superhero stories almost since the first appearance of Superman—now began to make them the focus of its line.

Amazing Adventure Funnies became *Fantoman,* while *Masked Marvel* and *The Arrow* were launched as starring vehicles for the characters from *Keen Detective Funnies* and *Funny Pages.* In addition, two superhero anthology titles were premiered, *Wham Comics* and *Super Spy Comics,* a reprint. Like many other Centaur titles, both were short-lived, lasting only two issues.

Fox Features followed Centaur's example, giving the *Green Mask,* the *Flame,* and *Samson* their own titles. It also published an anthology that featured Blue Beetle alongside the Flame and Samson. *Big-3* was canceled after seven issues and *Science Comics,* one of the first SF titles with a hero lineup, after eight. A third superhero anthology, *Weird Comics,* fared a little better, running for 20 issues until 1942.

Following-up *Doll Man,* Quality launched *Crack Comics* and *National Comics.* Utilizing the talents of Eisner, Lou Fine, and Bob Powell, among others, the titles premiered a roster featuring the Black Condor, Uncle Sam, and Wonder Boy—the latter no relation to Better Publications' hero who debuted in *Blue Bolt* #1.

Another pulp magazine publisher, Street and Smith followed Goodman's Timely into comic books bringing Doc Savage and the Shadow with it into their own titles. Two pulp icons, and the inspiration for many of the superheroes that followed them, both of which characters had been around since the 1930s. Despite the Man of Bronze's enormous success in the pulp novels, *Doc Savage Comics* was canceled in 1943 after 20 issues. *Shadow Comics*—with some of the early issues written by The Shadow's original creator, Walter Gibson—fared much better, running to 101

issues before its final cancellation in 1949.

Street and Smith also tried another couple of its pulp heroes. *Bill Barnes Comics*, with its title amended to *Bill Barnes, America's Air Ace Comics* with #2, lasted 12 issues until 1943. Relaunched in 1944 simply as *Air Ace Comics*, it lasted a further 20 issues until 1947. *Super Magic Comics*—which became *Super Magician Comics* with #2—featured Blackstone the Magician and introduced Rex King. It too was canceled in 1947, after 56 issues.

Harvey launched *The Green Hornet* starring the eponymous pulplike radio hero, while Ralston-Purina offered a comic book featuring its western radio star as a premium to the radio audience. Along with Hawley Publications' *Red Ryder Comics*, its *Tom Mix Comics* is the first title devoted to a single "cowboy" character.

Enter the Spirit

Westerns were just one of the genres that were starting to attract the attention of comic book publishers who were also beginning to dabble in science fiction, war, and funny animal titles.

Dell launched *War Comics*, the first comic book dedicated entirely to war stories, while Fiction House's *Planet Comics* and *Jungle Comics* were the first S.F. and jungle adventure titles. Steering clear of superheroes, Fiction House also produced *Fight Comics*, an adventure anthology that included biographies of famous boxers, and the aviation-based *Wings*. Hillman's *Miracle*

Comics and *Rocket Comics* were another two anthologies, but they didn't see the year out.

One of the most important comics characters to appear in 1940 first appeared in a Sunday newspaper strip. Created by Will Eisner who imbued it with atmospheric movie-style pacing and design, The *Spirit* is recognized as a milestone in the medium. It ran as a strip for 12 years, making the transfer to comic books in 1942 when Quality began reprinting *The Spirit* commencing in 1942's Police Comics #11.

In 1941, DC began to increase the appearances of its top draws. Green Lantern

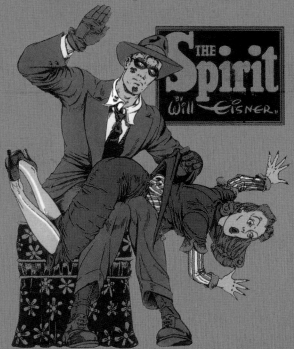

The groundbreaking Eisner character The Spirit.

was given his own title while continuing to feature in *All American Comics* and the Flash gained *All Flash Comics* to complement his regular title. With the J.S.A. proving a success in *All-Star Comics*, *Leading Comics* was launched as home for the Seven Soldiers of Victory, a second home for such minor players as Green Arrow and the Star Spangled Kid.

Despite the enormous popularity of *Action Comics*, *Batman*, *Detective Comics,* and *Superman* and the success of the Man of Steel's daily strip—running in 230 newspapers—the public's appetite for Superman and Batman was voracious. In response, DC took the next logical step and brought the two of them together in *World's Best Comics*, changing its title to *World's Finest Comics* with #2.

DC also introduced two new heroes: Starman and, more significantly, Wonder Woman. The first character aimed specifically at the female audience made her debut at the end of 1941 in *All-Star Comics* #8, leaping into *Sensation Comics* when it was launched early in 1942.

Fawcett was also expanding, promoting not only Captain Marvel to his own title but also Bulletman, Spy Smasher, and Minuteman—introduced only months earlier in *Master Comics*. All four heroes were also featured in *America's Greatest Comics*, an anthology that ran eight issues until 1943. *Captain Marvel Comics* went on to become one the most successful in American comic book history.

The first juvenile version of an adult superhero was introduced in 1941. Captain Marvel Jr. debuted in *Whiz Comics* #25, predating Superboy by four years.

Timely also gave the Sub-Mariner his own title shortly before premiering the best-known of the patriotic superheroes in the first issue of *Captain America Comics*. Simon and Kirby's Captain America also joined Sub-Mariner and the Human Torch in *All-Winners,* while his sidekick Bucky linked up with the Torch's young pal Toro and a kid gang in *Young Allies.* As a venue for even more new heroes, Timely launched *U.S.A. Comics*, which premiered by introducing Major Liberty.

Quality gave Doll Man his own quarterly title while introducing two significant creations via the launch of two new comics. Cole's stretchable sleuth Plastic Man debuted in *Police Comics* #1 as did Gustavson's Human Bomb, 711, the Firebrand by Reed Crandall, and Phantom Lady, while the war-themed *Military Comics* marked the first appearance of the Blackhawks—an international team of aviators created by Eisner—Miss America and the Death Patrol by Cole. Another pilot, the Skyman, gained his own Columbia title, as did the Face, while Catman got the same treatment over at Holyoke.

The Shield, the Eagle, Uncle Sam, Minute Man, Captain America, Miss America, and the deluge of flag-wearing superheroes that followed them were not the only signs of increased patriotic fervor. With war looming ever closer, Gleason premiered *Daredevil Comics*—which starred a hero who first appeared in *Silver Streak* #6 [1940]—and Ace

Right: Captain America Comics #1 [Timely Comics, 1941].

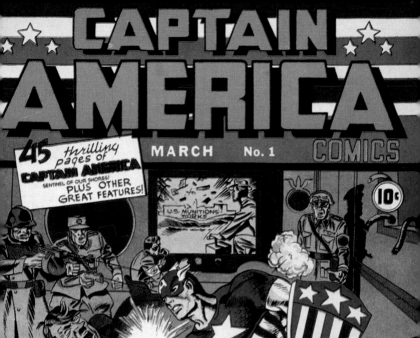

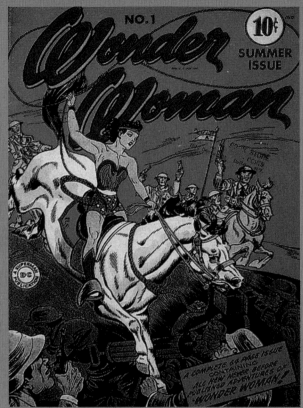

Wonder Woman #1 [National Periodical Publications, 1942].

launched *Our Flag* and *Banner Comics,* which introduced Captain Victory, the Unknown Soldier, and Captain Courageous. It also debuted *Four Favourites* in order to showcase Vulcan, Lash Lightning (formerly Sure-Fire's character Flash Lightning), Magno the Magnetic Man and the Raven. *Victory Comics* and the aptly titled *Air Fighter Comics* were

Hillman's entries. Fiction House produced *Rangers Comics,* while Chesler premiered four titles for his own line. *Yankee Comics*, *Dynamic Comics*, *Scoop Comics,* and *Punch Comics* had a whole troop of heroes including the patriotic Yankee Doodle Jones and Major Victory,

In addition, MLJ launched *Jackpot Comics* to showcase the Black Hood, Mr. Justice, Steel Sterling, and Sgt. Boyle, but by the end of 1941, the company was leading another trend. As they became the focus of its output, comics starring teenagers would lead the company to change its name to Archie Publications.

From real life to Wonder Woman

Other trends were also becoming apparent. Dell—which had already published the first war-related propaganda comic book in *U.S.A. Is Ready*—increased its funny animal line. Parents Magazine Institute released *True Comics*, followed up with *Real Comics,* and then aimed its third factual/biographical series squarely at the female audience by titling it *Calling All Girls*. Better added *Real Life Comics,* while Gilberton Publications launched *Classics Illustrated*. Adapting 169 famous works of literature beginning with Alexander Dumas's *The Three Musketeers*, the series ran until 1971, many of the titles being reprinted several times.

By 1942, the comic book was firmly established as part of American culture and the boom still showed no sign of abating.

Just months after moving her into *Sensation Comics*, National also gave Wonder Woman her own comic then featured her in a third title, *Comic Cavalcade*, alongside the Flash and Green Lantern. At around the same time, Simon and Kirby created *Boy Commandos* for the Batman publisher. Although *Boy Commandos* is credited as the first kid-gang comic book, Timely published *Tough Kid Squad*—its only nonhumor comic book launch of 1942—some months earlier. It lasted only one issue while the National title ran 36 [until 1949] and spawned a host of imitators.

Fawcett continued to increase its superhero line, giving *Captain Marvel Jr.* his own title and also introducing the eponymous star of movies and radio in the first issue of *Captain Midnight*. Meanwhile, Mary Marvel debuted in *Captain Marvel* #18.

In the meantime, Gleason continued to steer clear of both superheroes and funny animals. Having launched *Captain Battle* in 1941, it changed the title to *Boy Comics* with #3 and introduced Crimebuster. The comic continued until 1956 [119 issues], amending its title to *Boy Illustories* with #43. Gleason also premiered *Crime Does Not Pay*, the first all-crime comic book and another trendsetter, as was MLJ's Archie Comics, which introduced "America's favorite teenager."

MLJ also retitled its 1941-launched *Special Comics,* which became *Hangman Comics*—promoting the hero introduced in *Pep Comics* #17 to his own comic, but only to #9 [1943] when he lost top billing to the Black Hood. Dell debuted *War Heroes* and *War Stories*, the

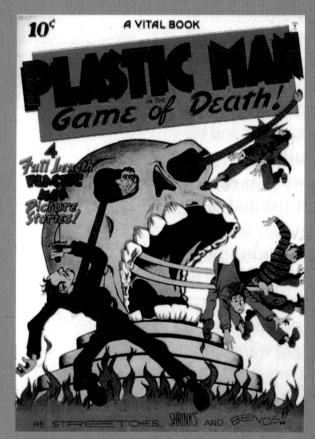

Plastic Man #1 [Vital Publications, 1943]. Jack Cole's stretchable hero moves into his own title.

first comic books to deal with World War II.

The Catechetical Guild Educational Society also began releasing comic books, publishing the first ongoing title with a religious theme. *Topix Comics* offered Bible tales and morality lessons alongside stories of saints and Catholic heroes.

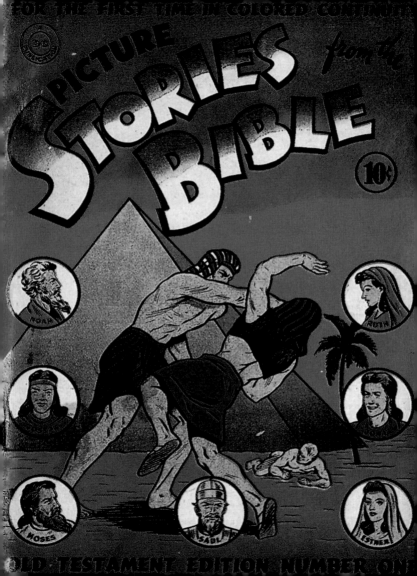

In 1943, Quality kept the superhero market fresh by allotting *Plastic Man* his own title to complement his *Police Comics* appearances. Hillman contributed some all-but-forgotten heroes with *Clue Comics,* while Harvey—publishing as Family Comics—reciprocated in the first issue of its *All New Comics.*

Timely's only new titles of the year were *All-Select Comics*, a second anthology which featured its top three superheroes, and *Kid Komics,* which introduced Captain Wonder before it became complementary to the Young Allies' own title.

Over at Fawcett, *Ibis the Invincible* was promoted to his own title, while the newspaper strip's *Don Winslow of the Navy*—who had also appeared in novels, on radio, and in a 1942 movie serial—and dime novel cowboy *Hopalong Cassidy* were each given a comic book of their own. In addition, Flying Cadet Publications arrived with *Flying Cadet Comics*—"aviation for student airmen."

But even while sales of superhero comic books were still increasing, by 1944 publishers were beginning to look toward others trends.

While *A-1 Comics*—an anthology intended to showcase new characters and series—was the first title from Magazine Enterprises [ME], R. B. Leffingwell came and went with *Jeep Comics*—a blend of war and fantasy—as did the U.S. Camera Co. with its half photos/half strip *Camera Comics* and Will H. Wise and its real-life adventure title, *It Really Happened.*

Left: Picture Stories From The Bible #1 [1942].

By 1945, although Fawcett launched *Mary Marvel* into her own title and into *Marvel Family Comics* alongside Captain Marvel and Captain Marvel Jr., new hero titles were fairly thin on the ground.

Those that did surface—such as Archie's *Miss Liberty*, Holyoke's *Miss Victory*, and Marvel/Timely's *Miss America*—concentrated on patriotic heroines or, like Avon's first comic book, *Miss Cairo Jones*, featured a tough female private eye.

It was also in 1945 that Gaines sold off his superhero properties to DC and launched Educational Comics, which was devoted to his long-time dream of using comic books as a teaching aid. He was now planning such worthy titles as *Picture Stories from the Bible*, *Picture Stories from American History*, and *Picture Stories from Science*.

After four years of war, the American public no longer felt the need for godlike heroes. Instead, it was desperate to see the feats of the ordinary Joe, the man in the street who had gone off to fight the Axis Powers, who had tamed the Wild West or who kept crime off the streets. The mythical exploits of the superhero was on the wane.

Educational titles grew in number during 1946. Among them were *Real Fact* (DC) and George A. Pflaum's *Treasure Chest Comics*, which was aimed at Catholic school students. Marvel's *Blonde Phantom* was one of very few superhero titles launched that year or in the following year, 1947, when the demand for romance comics began to blossom, a trend that continued into 1948.

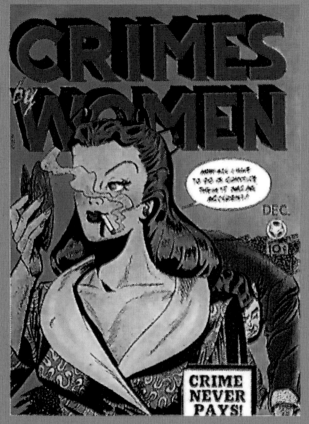

Crimes by Women #4 [Fox Features Syndicate, 1948].

Crime spree

That year also saw westerns coming to the fore as sales of Fawcett's *Hopalong Cassidy* soared. DC reacted by giving singing cowgirl-cum-movie star *Dale Evans* her own title, launching *Western Comics* and converting its *All American Comics* from a superhero title to *All American Western*. Other stars of movie westerns to get their own comic book included *Tim Holt* at ME while *Tom Mix* joined Cassidy at Fawcett. Marvel responded by creating its own cowboy heroes, debuting both *Kid Colt, Outlaw* and *Two-Gun Kid* in their own titles.

But if 1948 was a good year for cowboys, it became a far better one when virtually every publisher turned to crime. Among the many titles launched in the crime wave that followed were Ace's *Crime Must Pay the Penalty*, *Crimes by Women* [Fox], Hillman's *Crime Detective Cases*, *Authentic Police Cases* [St. John], *All-True Crime Cases* [Marvel], and DC's *Gang Busters*. At the forefront of the trend was William Gaines who, having inherited Educational Comics— now Entertaining Comics—from his father, began publishing such titles as *Crime Patrol* and *War Against Crime* as well as two westerns—*Saddle Justice* and *Gunfighter*—and *Moon Girl*, an adventure comic.

But even as the publishers reaped the rewards of a still-expanding market, forces were gathering in opposition. The first rumblings of discontent at the unhealthy material in comic books were being heard in the media. Unheeded, they would drive the industry to the brink of extinction.

Young romance was the thing in 1949. Although DC gave *Superboy* his own title that year, Marvel dropped the superheroes from *Human Torch*, *Blonde Phantom,* and *Sub-Mariner Comics* and retitled them *Lost Tales*, *Lovers,* and *Best Love*, respectively.

But the groundswell of media opinion was growing as the public became increasingly

alarmed at some of the objectionable material seemingly being offered to their children via comic books. But sales were still rocketing, and no one was really listening other than to the sound of the cash registers.

In 1950, Bill Gaines launched EC Comics as an Entertaining Comics imprint. Its first three titles—*Vault of Horror*, *Crypt of Terror,* and *Haunt of Fear*—sparked a demand for horror comics that would add fuel to the growing criticisms about comic book content. They also were pivotal in garnering EC a reputation for quality that is still used as a benchmark today.

EC also capitalized on the increasing demand for science fiction with *Weird Fantasy* and *Weird Science*, while DC debuted *Strange Adventures*, and newcomer Youthful Magazines launched with *Captain Science*. EC's other new titles for 1950 were *Crime Suspenstories* and the meticulously researched, Harvey Kurtzman-edited *Two-Fisted Tales*, a war comic that hit the newsstands at the same time as Marvel's more prosaically titled *War Comics*.

Eagle in the U.K.

Humor comics were still in vogue in Britain, although some titles had taken to including an adventure strip or two in the mix. J. B. Allen had even published two action titles, but, despite lasting until 1959, neither *The Comet* (launched in 1946) nor *Sun* (1947) had much impact on the market.

The situation changed dramatically with the arrival of *Eagle* in 1950. Published by Hulton

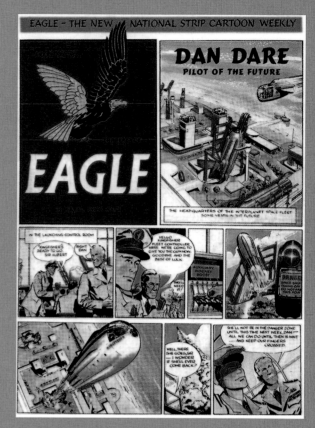

Eagle #1 [Hulton Press, 1950].

Press and masterminded by the Reverend Marcus Morris and artist Frank Hampson, it was a high-quality tabloid that featured a variety of role models from Dan Dare, the cover-featured Pilot of the Future, to police constable PC49 via Luck of the Legion and Jeff Arnold and his Riders Of The Range.

A huge success with sales hitting a million

THE HOTSPUR

BOOK for BOYS
1975

THE BLACK SAPPER FACES THE
MYSTERY MAN FROM THE FLAMES

per issue within the first few months of its launch, it inspired Hulton and Morris to launch companion titles, each aimed at a different young audience. After the aptly titled *Girl* [1951] came *Robin* [1953]—intended for younger boys and girls—and *Swift* [1954], a nursery title. In keeping with the *Eagle* ethos, they took a moral—almost preaching—stance, unlike the imitators that the success of the Morris/Hampson title immediately spawned.

Amalgamated Press premiered *Lion* in 1952, even cover-featuring Captain Condor, a Dan Dare clone, and followed up two years later with a companion title, *Tiger*. *Valiant* [1962], *Hurricane* [1964], *Jag* [1967], and *Jet* [1971] followed AP's amalgamation with IPC [the International Publishing Corporation].

Produced in the cheaper traditional British format rather than Eagle's higher-quality photogravure process, they were aimed at a broader audience and went more for action and adventure than for moralizing.

D. C. Thomson also took the same route, converting its illustrated text titles *The Hotspur* and *The Wizard* over to AP-style of adventure comic strips in 1959 and 1970, respectively. It also added *Victor* [1961] and *Hornet* [1963].

Unlike their America counterparts, British comics were produced weekly. Partly for this reason, they were all anthologies, generally containing a number of 3- to 4-page strips. They featured a mixture of stories covering such genres as war, sport, western, and S.F. with characters ranging from Alf Tupper, the

Hotspur Book for Boys 1975 [D. C. Thomson].

Tough of the Track and Roy of the Rovers via the Wolf of Kabul and Battler Britton to Captain Hurricane, Pancho Villa, and Robot Archie.

Even the girls' comics followed a similar formula, although titles such as *Bunty* [1958], *Judy* [1960], *June* [1961], *Diana* [1963], and *Mandy* [1967] concentrated more on boarding school life, ballet dancing, and horses in such strips as The Four Marys and Sandra of the Secret Ballet to counter such *Girl* features as Kitty Hawke and Penny Wise.

While *Diana* was something of a mold breaker in that it contained horror stories, these were more stylistically comparable with the spooky mystery tales DC featured in such titles as *House of Mystery* and *House of Secrets* during the 1960s than they were to the ghouls and gore bloodlettings that had become commonplace in U.S. comic books in the 1950s.

By 1951, horror had become the next big thing in American comic books. American Comics Group [ACG] launched *Forbidden Worlds* to complement its 1948 and pre-EC *Adventures into the Unknown*, while Marvel debuted *Strange Tales*. Harvey came out with *Witches Tales* and *Chamber of Thrills*, and a Canadian publisher, Superior Comics, added *Strange Mysteries* and *Adventures into Fear*. SF was also booming with DC launching *Mystery in Space* and Avon bringing out *Earthman on Venus*, *Space Detective*, and *Rocket to the Moon*.

On the war front, EC had added a second Kurtzman-edited title, *Frontline Combat*, while Atlas (Marvel) had launched *Battle* and *Combat Kelly*, but it was in '52 that war became another

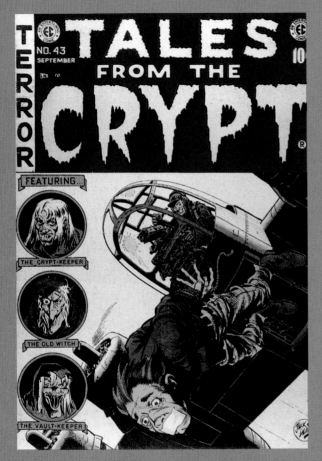

Tales from the Crypt #43 [EC Comics, 1954].

boom genre in the U.S. market. Atlas premiered *War Adventure*, *War Action*, and *Combat* up against DC's *Star Spangled War Stories* and *Our Army At War*, while *War Heroes*, *War Fury*, *Battle Cry*, and *Fighting Leathernecks* came from Comic Media, Dell, Stanmor, and Toby.

Seduction of the innocent

Crime comics had hit their peak so, with horror still in demand, Atlas converted *Amazing Detective Cases* to a horror title even while Hillman was offering both genres in *Monster Crime Comics*.

Although the U.S. comic book market continued to expand across almost every genre, 1953 is best remembered as the year of the 3-D comic—a fad that came and went in less than 12 months and, more significantly, for the end of Fawcett comics.

After a 12-year-long legal battle with DC and with superhero comic book sales falling, the Captain Marvel publisher called it a day. It folded its entire line, settling with the Superman publisher out of court.

The decision had an effect on the U.K. comics industry. L. Miller had been publishing British versions of *Captain Marvel* and related titles. With no new material coming from America, he had a writer/artist rework the concept as *Marvelman*, who, as Britain's first homegrown superhero, debuted in 1954.

In America, 1954 is associated primarily with just one event—the publication of Dr. Fredric Wertham's book *Seduction of the Innocent*, with far-reaching consequences that still reverberate through the comics industry today.

The psychiatrist's treatise—which linked comic books to juvenile delinquency—was the spark that lit the flame of the American

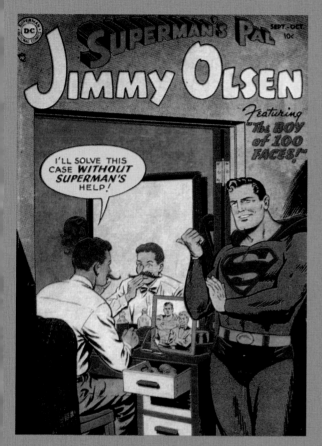

Superman's Pal, Jimmy Olsen #1 [National Periodical Publications, 1954].

public's concern about the content of these publications. It led to public hearings in front of the U.S. Senate Subcommittee to Investigate Juvenile Delinquency in the United States and ultimately to the publishers creating the self-regulating Comics Code Authority to protect the industry from government regulation.

The immediate effects of the Code were to enervate virtually every comic beyond the mildest and least offensive and to all-but annihilate horror and crime titles. Publishers left the industry in droves over the next two years. Among them were EC, Fiction House, Gleason, Avon, and Ace, either sent to the wall, moved into other areas of publishing, or, like Quality, having sold out to a competitor.

1954 was also the year in which Marvel tried to resuscitate the superhero, reviving *Sub-Mariner Comics* for nine issues, although *Human Torch* and *Captain America Comics* lasted only three each. At the same time, Simon and Kirby created *Fighting American* for Headline, but that lasted only seven issues. DC's *Superman's Pal, Jimmy Olsen* was to prove far more successful.

Having already toned down existing anthologies to comply with the Code, the following year DC and Charlton both chased the now disenfranchised horror audience with the Code-approved *My Greatest Adventure* and *Unusual Tales,* respectively, although DC was also slightly more adventurous. It also launched *The Brave and The Bold* as an anthology featuring such historical heroes as Robin Hood and the Viking Prince.

With science fiction still proving popular, 1956 saw the launch of *Tales of the Unexpected* from DC, *World of Suspense*, *World of Fantasy*, *World of Mystery*, and *Mystical Tales* from Marvel and *Out of this World* and *Mysteries of Unexplored Worlds* from Charlton. DC also added *House of Secrets* and launched the title that would help revive the superhero genre.

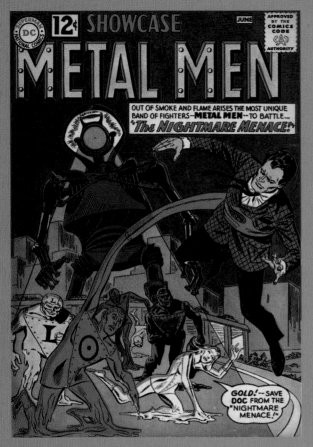

Showcase #38 [DC Comics, 1962]. The second appearance of the Metal Men.

Dawn of the Silver Age

Kicking off as a tryout series purportedly responding to reader demand, the first three issues of *Showcase* featured firemen, wild animals, and frogmen, but #4 opened the door to the Silver Age, premiering a new version of the Flash. He appeared just under a year after J'Onn J'Onzz, the Martian Manhunter—the first new superhero DC had introduced since the 1940s—but his impact was far greater.

Showcase almost immediately became a tryout title featuring revamped versions of now defunct Golden Age heroes as well as existing characters and new concepts. After the Flash, over the next five years came Manhunters, Kirby's Challengers of the Unknown, Lois Lane, Space Ranger, Adam Strange, Rip Hunter, the Silver Age Green Lantern, Sea Devils, and a revamped Aquaman. By late 1959, DC had converted *The Brave and the Bold* to another showcase title. By 1961, Suicide Squad, the Justice League of America—a Silver Age update on the Justice Society of America—Cave Carson, and the Silver Age Hawkman had all debuted in that series.

The Flash made it to his own title after four tryouts, though beaten to the punch by *Lois Lane*, Superman's girlfriend, who got that promotion in 1958, a year earlier. Almost all of the superheroes that followed the Flash and Lane in *Showcase* and *The Brave and the Bold* got their own titles—or series in other titles, as did the Silver Age version of the Atom, the Metal Men, and many others that followed.

The Silver Age was now underway, and heroes rather than genres were coming to the fore once again. In 1959, seeing the success DC was having with its superheroes, Archie

Showcase #4 [National Periodical Publications, 1956]. The first appearance of Silver Age Flash.

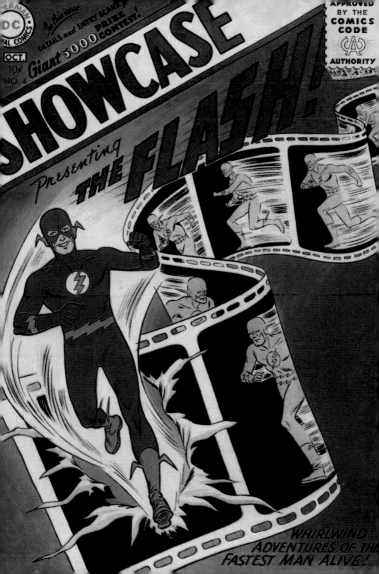

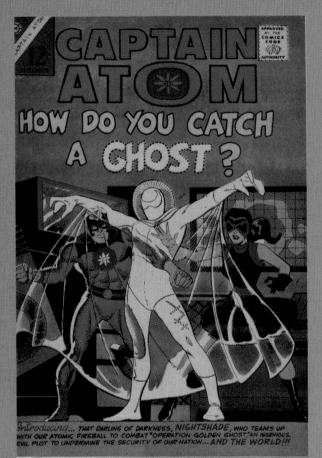

Captain Atom #82 [Charlton Comics, 1966].

had the *Shield* revived by Simon and Kirby, who then went on to create the *Fly* for the mainly humor publisher. Marvel, meanwhile, was adding to its anthologies with *Tales to Astonish* and *Tales of Suspense* as it had expanded its western titles in 1957 with *Kid Slade Gunfighter*, *Kid from Texas*, and *Kid from Dodge City*.

The following year, Charlton, which in 1957 had added *Battlefield Action*, another war title, became the third superhero publisher when artist Steve Ditko introduced Captain Atom in *Space Adventures* #33 while ACG added *Unknown Worlds*, its third science fiction title.

If all that had happened in 1961 was that Archie had added another superhero title, *Adventures of the Jaguar*, and Marvel had premiered an S.F. anthology, *Amazing Adventures*—later *Amazing Adult Fantasy*—it would have been an unremarkable year. As it was, 1961 saw Marvel return to superheroes, revitalizing an increasingly staid industry.

When, working with artist Jack Kirby, Stan Lee launched *Fantastic Four*, comics would never be the same again. Blending super-heroes and soap opera in an irreverent style, the pair followed up in 1962 with Incredible Hulk and Thor—in what had until then been an S.F. anthology, *Journey into Mystery*—while the writer and Ditko introduced the Amazing Spider-Man in the last issue of *Amazing Fantasy* (formerly *Amazing Adult Fantasy*).

Newcomer Gold Key also offered its first superhero in *Dr. Solar, Man of the Atom*. From then the heroes came thick and fast. In 1963, DC came out with *Doom Patrol* while Marvel offered its own superteam, the *Avengers*, as well as the *X-Men*, *Iron Man*, *Doctor Strange*, and *Daredevil*. Lee and Kirby even took an iconoclastic approach to war in their over-the-top *Sgt. Fury* and His Howling Commandos.

With both Marvel and DC continuing to

bring back Golden Age heroes—DC by revamping and Marvel by reviving—Charlton did the same, resurrecting *Blue Beetle*—who had also had a short-lived return in 1955—and reuniting Ditko with *Captain Atom*.

By the mid-60s, a real superhero renaissance was underway with Archie reviving the *Web*, the *Shield*, the *Hangman*, *Steel Sterling*, and *Captain Flag* while Tower entered the arena with *T.H.U.N.D.E.R. Agents*. But by 1969, the superhero market had again peaked and publishers were looking for the next trend.

Direct market

With sales of comic books in general tumbling, the U.S. industry was heading for a crisis. The solution came from an unexpected source—the underground "comix" movement. In many case, these often self-published titles were distributed through outlets other than the regular newsstands, inspiring New Yorker Phil Seuling to create an alternative distribution network for mainstream comics. He chose to sell them direct to specialist comics stores and dealers on a firm-sale basis rather than through the newsstand on the riskier and more expensive sale or return terms.

Where once fans were viewed as a nuisance, the freak minority, constantly pointing out minor errors, rambling on about continuity and wanting comics to evolve, they were now looking like the lifeblood of the industry.

But the comics themselves were becoming more like T.V. soap operas, getting closer to

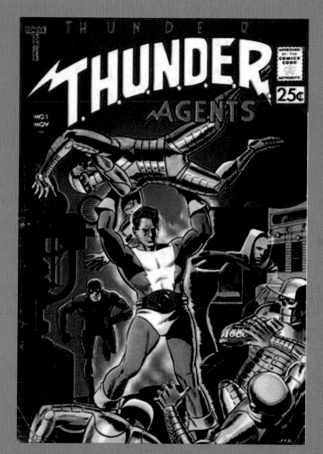

T.H.U.N.D.E.R. Agents #1 [Tower Comics, 1965].

their roots as serialized adventure strips, and regularity of supply became of paramount importance. Until the Marvel Age of Comics, it hadn't mattered if an issue was missed, each one featured only self-contained stories.

As newsstand sales continued to fall, the direct market, as it became known, gained an

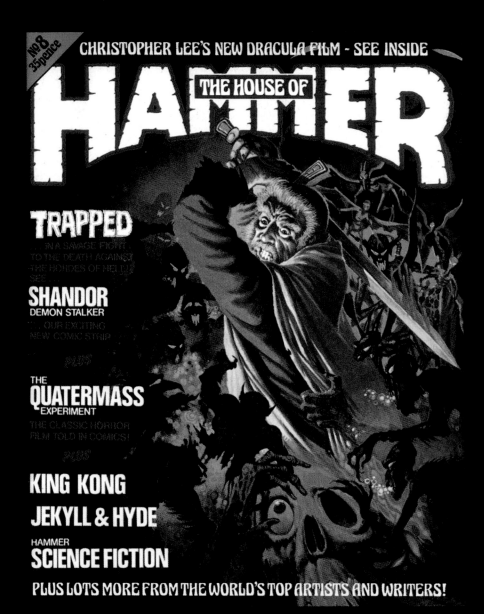

No 8 35pence

CHRISTOPHER LEE'S NEW DRACULA FILM ~ SEE INSIDE

THE HOUSE OF HAMMER

TRAPPED
IN A SAVAGE FIGHT
TO THE DEATH AGAINST
THE HORDES OF HELL!
SEE . . .

SHANDOR
DEMON STALKER

. . . OUR EXCITING
NEW COMIC STRIP

PLUS

THE
QUATERMASS
EXPERIMENT

THE CLASSIC HORROR
FILM TOLD IN COMICS!

PLUS

KING KONG

JEKYLL & HYDE

HAMMER
SCIENCE FICTION

PLUS LOTS MORE FROM THE WORLD'S TOP ARTISTS AND WRITERS!

increasing importance to the publishers, but it also served to focus ever more closely on superhero comic books to the detriment of various other genres.

Falling sales were also affecting the British industry where, by the early 1970s, *Hurricane*, *Eagle*, *Jag*, *Wizard*, and *Jet* were among the titles to have folded. Licensing was becoming increasingly important to U.K. publishers, but even such titles as *T.V. Century 21* and its successors, *T.V. 21 & Joe 90,* and *Countdown* (later *T.V. Action*), which featured new stories based on such highly popular Gerry Anderson TV series as *Thunderbirds*, *Supercar,* and *Captain Scarlet* (as well as on the likes of *Star Trek*, *Doctor Who*, *The Saint*, and *Hawaii Five-0*), were unable to survive.

But, with most of the sales going to children, there was no likelihood of something similar to the direct market to act as a safety net for U.K. titles, which continued to vanish from the newsstands. *Lion*, *Hornet*, *Valiant*, *Hotspur*, and *Tiger* were all gone by the mid-80s, although *Victor* hung on until 1992.

The only saving grace was *2000 A.D.* A science fiction comic launched in 1977 following *Action* [1976]—aborted because of controversy over the level of violence—it is still going today and has even spun off *Judge Dredd Megazine*, one of the very few hero-driven British comics.

Warrior was published in Britain between 1982 and 1985 by Dez Skinn, who had

Left: House of Hammer #8 [General Book Distribution, 1977].

previously edited *House of Hammer*, *Dr. Who Weekly*, and *Hulk Comic*. These earlier titles enabled him to put together a team who, through such strips as *Father Shandor*, *Absalom Daak*, *Nightraven*, and *Captain Britain*, became the foundation of a magazine which—with *2000 A.D.*—was responsible for opening America up to a wealth of U.K. writers and artists.

Meanwhile American publishers in the 1970s were still releasing new titles but, with talented fans now writing and drawing many of the comics for distribution through fan-run companies who sold only to the fan-owned speciality comic shops, comic books were becoming increasingly targeted toward the committed fan/collector rather than the casual reader. Effectively comic books became increasingly introverted and incestuous, preaching to the converted and encouraging the market's continuing shrinkage by becoming more and more impenetrable to the general public.

In America, the 1970s gave rise to a wide variety of highly acclaimed comics ranging from *Conan the Barbarian* [Marvel, 1970] to Kirby's 1971 *Fourth World* saga at DC—*Forever People*, *New Gods,* and *Mister Miracle*. Marvel—which had begun to dominate the industry—also went through crazes, reviving horror through such titles as *Tomb of Dracula* and *Werewolf by Night* [1972], *Ghost Rider* [1973], and *Man-Thing* [1974], and getting on the martial arts bandwagon with *Master of Kung Fu* [1974] and *Iron Fist* [1975]. It also launched a number of black-and-white magazines—among them *Savage Tales* [1971] and *Monsters*

Unleashed [1973] and *Deadly Hands of Kung Fu, Planet of the Apes*, and *Savage Sword of Conan* [1974]—aimed at older fans.

DC premiered *Swamp Thing* [1972] and revived Fawcett's Captain Marvel in *Shazam!* [1973]—prevented by Marvel's registration of the Captain Marvel name from relaunching Cap's own title. The Batman publisher also gave pulp hero the *Shadow* his own title while Marvel revived *Doc Savage* from the pulps.

In 1975, Marvel changed the nature of the industry yet again. Its revival of *X-Men* would lead to a top-selling franchise that would come to dominate the direct market sales charts into the next century. Catering to the fans, Marvel also revived its World War II team of Captain America, the Human Torch, and the Sub-Mariner in *The Invaders*, and DC gave the Justice Society its own title back, reviving *All-Star Comics* with #58.

From self-publishing to independents

1975 was also the year that Chip Goodman—son of former Marvel publisher Martin Goodman—launched Atlas/Seaboard. Little more than a Marvel clone, it released almost 30 titles, none lasting more than four issues.

But, inspired by the underground comix and by a desire for something fresher than superheroes, fans were looking for an alternative. The action/adventure market had become dominated by Marvel and DC—the big two—with Charlton, virtually their only competitor, but now a shadow of its former self.

The solution was simple; the fans began to create their own alternatives. Either by offering creator-ownership deals to such fan favorites as Howard Chaykin, Jim Starlin, and Frank Brunner as Mike Friedrich did with his *Star*Reach* [1974] or by self-publishing like Dave Sim with *Cerebus the Aardvark* [1977] or Wendy and Richard Pini with *Elfquest* [1979]. The problem for such comics was their limited appeal, low print runs dictating a black-and-white product to keep costs manageable and the cover price competitive.

In the midst of this minirevolution, National Lampoon, Inc. launched a mass-market English-language version of *Metal Hurlant*. Part of a new wave of adult comics sweeping Europe, the French magazine was influenced as much by underground comix as it was by the cultural changes of the time. Debuting in 1977, its American counterpart was *Heavy Metal*, a glossy S.F. anthology that is still running today.

Three years after *Heavy Metal* premiered, Pacific Comics issued the title that was to bring about a sea change in the U.S. comics industry. Offering a disenchanted Jack Kirby creator-ownership, it launched his *Captain Victory and his Galactic Rangers* in 1982.

Sold as firm sale only through the direct market, it was an immediate success and established Pacific as the first of a new breed of independent publishers of color comics.

Today the miniseries is a staple of every publisher but the first—the three-issue *World of Krypton*—was not published until 1979.

Marvel did not publish its first direct-market exclusive until the following year. The fact that *Dazzler* #1 sold in excess of 400,000 copies only underscored just how important the speciality shops market was now becoming.

Although Pacific went out of business in 1983, it had blazed a trail that many were ready to follow. Some indies, as they are known, still publish in black and white, but the bulk of comics released by Eclipse, First, Dark Horse, Comico, Image, Valiant, Malibu, Avatar Press, Oni Press, Chaos! Comics, Harris Comics, and the many others that have come—and in many cases gone—since the demise of Pacific have been in full color.

As a result of the independents and pressure from writers and artists, both Marvel and DC also now offer creator-ownership contracts. Generally not available on projects tied to the company's core superhero universes, they are more usually associated with specific imprints and comics aimed at a more mature audience.

The rise of such mature readers' imprints and of the independents has also led to a softening of the focus on superheroes. They are still predominant, but other genres such as crime and horror are now more widely available than they have been since the 1950s. Even westerns have made the occasional comeback.

A time for change

But direct market has its downside as well. The concentration on superheroes and committed fans has led to a loss of interest in comics as a medium and resulted in the fan base withering at its roots. The neglect of the newsstand has meant fewer and fewer casual readers discovering comics, and even those that do find many of the titles impenetrable—cluttered with years of continuity and trivia of interest only to the long-time comics reader.

One newcomer in particular is turning back the tide. Launched in 2000, CrossGeneration Comics is expanding the audience for comics beyond the established shops. Its rapidly expanding superhero-free line incorporates science fiction, mystery, horror, and fantasy in such titles as *The Path*, *Sojourn*, *Ruse*, *Route 666*, *Way of the Rat*, *The First*, and *Mystic*.

But CrossGen has an uphill struggle. Not only is the market still dominated by Marvel and DC but—even though some creators can help sales—the industry is still driven by its characters. Making the task even more difficult, the top-selling and most-recognizable heroes are still icons such as Batman and Superman, other Golden Age creations—or their Silver Age avatars—or the likes of Spider-Man, the Hulk, the X-Men, and others created by the Lee-Kirby-Ditko trio in the '60s.

Comic book heroes from the last 30 years or so just don't seem to have penetrated the public consciousness in the same way as their never-to-be-forgotten predecessors.

Chapter 1
Male Heroes

Whether ostensibly battling for truth and justice, righting wrongs, or rescuing those in peril, larger-than-life comic book heroes cater to adolescent power fantasies. And, in line with the times as much as anything else, those heroes—whether battling through the jungles or shooting across space, from Captain America to Spider-Man—were usually male.

3-D Man [1977]

If you're going to create a 1950s hero for a 1970s comic, then why not give him a 1950s gimmick? At least, that could have been writer Roy Thomas's logic when he retroactively introduced the garishly costumed character into continuity in *Marvel Premiere* #35.

With an origin that included Marvel's original alien race—the Skrulls—test pilot Chuck Chandler acquired three times the abilities of the best of the human race. The downside was that he was reduced to a red and a green image on his brother's glasses and could manifest himself only when Hal wore the specs, making the two images one.

One of Marvel's all-but-forgotten heroes, he could survive as 3-D Man for only three hours, having to return to Hal's glasses or perish.

711 [1941]

Sentenced to life, convict 711 is really D.A. Daniel Dyce, who switched places so his friend and double Jacob Horn could be present when his wife gives birth. Unfortunately, Horn is on trial and dies on the way to see his wife, leaving Dyce holding the baby, as it were.

Dyce tunnels his way out of prison to find that everyone has forgotten about him. Rather than try to put his life back together, he returns to the prison and pursues a battle against crime, returning to his cell every night. He leaves a calling card with his victims, with the number 711 featuring a mirror with cell bars painted on it so each criminal can look upon their ultimate fate.

711 first appeared in *Police Comics* #1 [1941]. He was killed by racketeer Oscar Jones and his death avenged by Destiny—as chronicled in #15—who took over his slot in the Quality comic with #16.

Adam Strange [1958]

Introduced in a story written by Gardner Fox and drawn by Mike Sekowsky and Bernard Sachs, the archaeologist made his first appearance in DC's *Showcase* #17. Teleported to the planet Rann after accidentally being struck by the Zeta beam, he saved the planet from invaders. He also fell in love with Alanna, daughter of Sardath, the scientist who had created the ray in an attempt to establish communication with Earth.

Strange was returned to Earth when the beam's power wore off. But Sardath had told him exactly when and where the next beam would strike, and the interplanetary warrior was set to make the first of many return visits to Rann via the Zeta beams which had been transformed it into teleportation rays on their passage through space.

Following two more *Showcase* appearances, Strange was given his own feature. Beginning in *Mystery in Space* #53 [1959], it ran until 1965's #102. Since then he has had only a few short solo adventures but is a frequent guest star in other DC Universe titles.

Akira [1982]

Katsuhiro Otomo commenced his incredible 2,160-page saga of the boy with the potential to be the most powerful psychic of all in the December 6, 1982 issue of Japan's biweekly published *Young Magazine*.

Set in Neo-Tokyo 31 years after a super-bomb destroyed the original city during World War III, the black-and-white *Akira* is a ground-breaking sci-fi epic that opened the Western world to manga (Japanese comics). It tells how the hero is rescued from a military project researching paranormal powers and devastates Tokyo during the escape. With the aid of one of his rescuers, he creates the Great Tokyo Empire, curing and aiding the survivors of his attack, until the remnants of the Western world become aware of his powers and set out to destroy him and his followers with biochemical weapons.

A translated version of Otomo's serial—colored for the U.S. market—was launched by Marvel's Epic imprint in 1988. Running to 38 issues, it was instrumental in introducing the manga style to American readers.

American Flagg [1983]

Another postapocalypse hero, lawman Rueben Flagg was a hero like none before. The one-time star of a pornographic TV series in which his holographic image still plays a Sexus, he is drafted to the dystopian Chicago of 2031 and into the real Plexus Rangers. The one seemingly honest person in the city, he's more afraid than brave but he sets out to clean up the town after his new boss, Sheriff Hilton Krieger, is murdered.

Aided by a talking cat named Raul and Luther, his dumb robot deputy, he tackles gangs and violent politics in a world of media overload, exotic drugs, and economic depression while working for a Mars-based government that couldn't care less.

Created by Howard Chaykin, Flagg was introduced in the first issue of his own title. The series—a blend of science fiction and crime noir—ran 50 issues although the writer/artist stopped drawing it with #26 and writing it with #32. In 1988, he took the comic back for the last three issues and for a relaunch that lasted only 12 [until 1989].

The Angel [1939]

Alphabetically at least, artist Paul Gustavson's costumed crime fighter is Marvel Comics' very first superhero.

He debuted in *Marvel Comics* #1 published by Timely Comics, the earliest name by which the giant now known as Marvel did business. It was the company's first comic book and also introduced such better-known characters as Sub-Mariner and the Human Torch as well as the more obscure Ka-Zar the Great, Jungle Terror, and the Masked Raider.

Continued on page 54

45

Barbarians: Swords and Sorcery

Comics fans' suggestions that Roy Thomas should read the pulp fiction of writer Robert E. Howard led to the popularity of a genre not previously tried successfully in comics.

Howard—a regular contributor to *Weird Tales* between 1924 and his suicide in 1936—is often credited as the creator of sword and sorcery fiction. It didn't take long for the Marvel writer to see the comic book potential inherent in this particular literary subgenre, and especially in a character that the author had created in 1932.

In 1970, Thomas teamed up with British artist Barry Smith [now Windsor-Smith] for a story in the fourth issue of Marvel's *Chamber of Darkness* anthology. Entitled *Sword and Sorcerers*, it was to represent the very first appearance of Howard's most famous creation, Conan, in all but name.

Howard's bloodthirsty Cimmerian was to get his own title later that year. Written by Thomas and drawn by Smith, **Conan the Barbarian** was something of a gamble for Marvel. The star did not have any special powers and lacked much by way of principles. But the gamble paid off.

Conan the Barbarian was to last until 1993, a total of 275 issues, with Conan going on to star in several miniseries until 1999. After a number of fill-ins—including a reprint of the *Chamber of Darkness* story—Smith left the title with #24. His place was taken by John Buscema, an artist who was to remain associated with it and the character for more than 15 years.

While Conan is the archetypal sword and sorcery protagonist, Edgar Rice Burroughs' **John Carter of Mars** did beat him into comics by some 18 years. Although a science fiction rather than fantasy hero, his adventures did include many of the trappings of the genre Howard created even though his first appearance—in Burroughs' 1912 *All-Story Magazine* serial, the six-episode *Under the Moons of Mars*, published as *A Princess of Mars* in 1917—predates the Conan author's first foray into the world of sword and sorcery by nearly two decades.

A former Confederate officer, Carter was transported to Barsoom (Mars) where he swung his sword in defense of the beauteous humanoid princess, Dejah Thoris, and as the champion of a civilization beset by the barbaric Tharks. Tackling wizards, scientists, and bizarre creatures, he first appeared in comics in Dell's *The Funnies* #30–56 [1939–41]. The stories from #34 [1940] on were illustrated by E.R.B.'s son, John Coleman Burroughs, who went on to write and draw all 69 episodes of a *John Carter of Mars* newspaper strip launched by United Features Syndicate in 1941.

Dell was next to bring the Virginian gentleman to comics, publishing three issues of *John Carter of Mars*—numbers #375, 437, and 488 under its *Four Color Comics* umbrella title—between 1952 and 1953 with Jesse Marsh drawing the first issue. DC acquired the licence 20 years later, featuring Carter in *Tarzan* #207–209 [1972], *Weird Worlds* #1–7 [1972–73], and in *Tarzan Family* #62–66 [1976].

The following year, Marvel took over, launching a *John Carter, Warlord of Mars* title that lasted 28 issues until 1979.

While Thomas and Smith were still collaborating on *Conan the Barbarian*, Gil Kane was looking at other possible ways of marketing comics.

Published by Bantam in 1971, only one volume of **Blackmark** was released although Fantagraphics uncovered the second episode of Kane's saga of a hero who united the people of a war-ravaged world after the artist's death. Complemented by a reissue of chapter one, this was published in a larger, more acceptable format in 2002.

But both Blackmark and the comic book Conan had been preceded not only by John Carter but also **Nightmaster**, a DC hero that was sword and sorcery through and through.

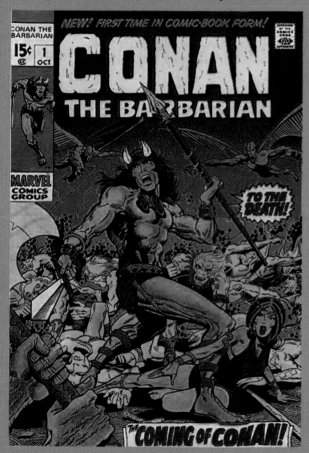

Conan the Barbarian [Marvel Comics, 1970]. First comicbook appearance of Robert E. Howard's Cimmerian.

Created by writer Denny O'Neil, he was rock singer Jim Rook who, together with his fiance Janet Jones, is magically transported to the other dimensional kingdom of Myrra in *Showcase* #82 [1969].

Armed with the enchanted sword which can be lifted only by one of his family, Rook and his companions—the albino guide Boz, and the giant barbarian Tickeytarpolis Troutrust—overthrow the evil warlocks attempting to conquer the kingdom. Although the first chapter in the series was penciled by Jerry Grandenetti, Nightmaster is better known for its final two episodes, which were drawn by Bernie Wrightson.

More obscure is the Filipono comics creation **Voltar**. Although he even predates Nightmaster in comics, he wasn't introduced to American readers until 1977 when Comics & Comix published *Magic Carpet* #1, a black-and-white comic dedicated to the character Alfredo Alcala and writer Manuel Avad had debuted in *Alcala Fight Comix* [1963].

The stories—enhanced by Alcala's intricate artwork—were also published in the U.S. in issues #2–9 of Warren's *The Rook* magazine [1979–81]. Bill DuBay, writing as Will Richardson, provided a new English-language story over the Filipino's art.

Early in 1971, Marvel introduced its second Howard hero. Making his first major comic book appearance in *Creatures on the Loose* #10—after a brief mention in *Conan the Barbarian* #1—was **Kull**, an Atlantean warrior who had seized the throne of the decadent kingdom of Valusia in a bloody coup. His

Creatures on the Loose #10 [Marvel Comics, 1971].

stories were set in a pre-Cataclysmic Age that predated Conan's Hyborian Age.

The newly crowned king moved into his own title shortly after. Retitled *Kull the Destroyer* with #11, *Kull the Conqueror* was not the healthiest of comic. Canceled after just two

issues, it was revived in 1972 only to be canceled again with #15 [1974]. Resurrected for a second time in 1976, the series finally bit the dust with 1978's #29.

Between issues #2 and 3, Kull appeared in *Monsters on the Prowl* #16 [1972]. A *Kull the Conqueror* relaunch in 1983 was to last just 10 issues until 1985.

Next to join the Marvel fray was **Thongor of Lemuria**. Something of a Conan clone, the Lin Carter creation's career paralleled the Howard character's own as adventurer, mercenary, thief, and eventually king. Introduced by the author in *The Wizard of Lemuria* [Ace, 1965], the first of six novels, Thongor made his comic book debut in *Creatures on the Loose* #22 [1973] in a series that lasted until #29.

DC's second venture into sword and sorcery was about as successful as Thongor's. Launched virtually simultaneously with the Carter hero's entrance into comics, *Sword of Sorcery* [1973] folded after just five issues.

The title starred **Fafhrd and the Gray Mouser**. Created by S.F. author Fritz Lieber, the brawny barbarian northman and the wily apprentice to a now-dead wizard were introduced in another six novels that began in 1970 with **Swords and Deviltry** [Ace].

Later in 1973, Howard Chaykin's **Ironwolf** made his entrance in *Weird Worlds* #8. He is Lord Ironwolf of Illium. His planet is the main supplier of antigravity wood used in the manufacture of starships.

Refusing the command of the Empress to let aliens have the wood, he is condemned as a traitor and outlaw. Taking off in his ship he destroys Illium's forests and becomes a freedom fighter. Although overtly a space opera, Ironwolf had all the trappings of a sword and sorcery saga.

It may have been that blend that brought it —and *Weird Worlds*—to an end with #10. Almost 20 years later, Chaykin—in collaboration with cowriter John Francis Moore and artists P. Craig Russell and Mike Mignola— returned to bring the saga to a conclusion. His *Ironwolf: Fires of the Revolution* graphic novel was published by DC in 1992.

Ironjaw was the next to enter the arena. Created by writer Michael Fleisher, this metal-mouthed barbarian was even worse than Conan in the morals department. Published by Atlas/Skywald—a pretender to the Marvel throne—he battled to regain his kingdom through four issues of his own 1975 title.

Immediately following Ironjaw's debut, Atlas introduced a second contender for Conan's crown in his own title. Like Ironjaw, **Wulf the Barbarian** was to last only four issues. Written and drawn by Larry Hama, only the volume of blood and guts made it anything other than a weak copy of the Howard hero's Marvel comic. A third Atlas sword and sorcery comic, *The Barbarians*, lasted just one issue.

DC then turned to a 6th- or 8th-century— scholars disagree—mythic poem about Beowulf as the inspiration for its next entry in the sword and sorcery stakes. Written by Michael Uslan and drawn initially by Ricardo Villamonte, **Beowulf** was only very loosely based on the original story. It lasted just six issues [1975–76].

First Comics published a more faithful adaptation of the epic poem in 1984. Its first graphic novel, *Beowulf* was written and drawn by Jerry Bingham.

DC's next attempt debuted one of the comic world's few original sword and sorcery heroes. Another Conan wannabe, **Claw** arrived in 1975 in his own title. To distinguish him from other barbarians, he had a demon hand which protects him whether he likes it or not.

Right on Claw's heels came another DC character who went straight into his own title. Written by Paul Levitz and drawn by Steve Titko and Wally Wood, **Stalker** #1 introduced the eponymous hero who made a pact with the war god of his home planet.

His soul torn from him the instant the agreement was reached, Stalker realized the price was too great. The now great warrior fought to reclaim it only to learn the god could only be defeated if Stalker could end all war, the source of the god's power.

Stalker was revived in 1999's *The Justice Society Returns* event where it was revealed that after three centuries of wandering, he could end all war only by putting an to end all intelligent life. And that is what he does . . . traveling from world to world and from dimension to dimension.

Claw the Unconquered lasted just 12 issues and *Stalker* only four, but the Howard character Marvel thrust into the spotlight just a few months later was to have a somewhat lengthier career than both of them combined.

Based upon *Red Sonya of Rogatine*—a fiery-tressed Russian Howard created for *Shadow of the Vulture*, a 1934 contribution to *Oriental Stories* and set during Suleyman the Great's siege of Vienna in 1529—Thomas and Smith's **Red Sonja** was transplanted to the Hyborian Age. In 1975, after first appearing in *Conan the Barbarian* #23 [1973], the she-devil with a sword was given her own series in *Marvel Feature* #1 to 7.

This was immediately followed by the launch of *Red Sonja* in 1977. Canceled in 1979, that title was relaunched in 1983, following a two-part mini. Canceled after four issues, the latest *Red Sonja* was resurrected in 1985 for a final nine editions.

Introduced at the same time as Marvel shone the spotlight on Red Sonja was DC's most successful sword and sorcery hero. Created by writer/artist Mike Grell, **Warlord** made his debut in *First Issue Special* #8.

Warlord is Travis Morgan, a lieutenant colonel in the U.S. Air Force. Forced to bail out over the Yukon, he passes through a dimensional barrier into Skartaris, an underground land populated by warriors, wizards, monsters, and dinosaurs.

Hooking up with Princess Tara of Shamballah, he moved into his own series—originally to be titled *Savage Empire*—in 1976, learns to be equally at home fighting with a sword as with his pistol and becomes the great hero the people call Warlord.

Revived in 1992 as a six-issue miniseries written and drawn by Grell, *Warlord* ran 133 issues until 1988 although Grell drew only the first 52 and #59 and stopped writing the comic with #68 [1983].

Almost a year after Warlord debuted, DC followed up with a heroine. Thrust straight into her own title was the 18-year-old **Starfire**. Another sword and science saga, *Starfire* is set on a world that has been invaded by two warring aliens races, the Mygorg and the Yorg.

Created by writer David Michelinie, Starfire was only the second of DC's female

> **"While Conan is the archetypal sword and sorcery protagonist, Edgar Rice Burroughs' John Carter of Mars did beat him into comics by some 18 years."**

superheroes after *Supergirl* [1972] to get her own solo title since *Wonder Woman* [1942]. *Starfire*—which lasted only eight issues [1976–77]—was penciled by Mike Vosburg.

Another character who, like Red Sonja, began comic book life in *Conan the Barbarian* was Moorcock's **Elric of Melniboné**, who had featured with Howard's hero in issues #14–15.

Thomas and artist P. Craig Russell adapted the first novel in Moorcock's saga of the albino warrior he had introduced in 1965's *Stormbringer*. Serialized in *Epic Illustrated*, *The Dreaming City* was later published as *Marvel Graphic Novel* #2 [1982]. Pacific Comics then picked up the rights to this aspect of the

author's Eternal Champion, publishing Thomas and Russell's six-issue adaptation of *Elric of Melniboné* [1983], which was an alternative title for *The Dreaming City*.

The rights to the character then moved to First Comics who featured Elric in adaptations of *Sailor on the Seas of Fate* [1985], *Weird of the White Wolf* [1986], *The Vanishing Tower* [1987], and *The Bane of the Black Sword* [1988]. P. Craig Russell was to return to the character in 1997 to adapt Moorcock's *Stormbringer* across seven issues which were copublished by Dark Horse and Topps.

One notable original comic book entry in sword and sorcery stakes was Chris Claremont and artist John Bolton's **Marada the She-Wolf**. Originally conceived as a Red Sonja yarn, the story of a Celtic warrior woman who grew up in barbarian lands and trained as a swordswomen in the Amazonian way was serialized in black and white in *Epic Illustrated* #10–11 [1982]. It was later colored for publication as the *Marada the She-Wolf* graphic novel in1985.

Grell returned to sword cum science in 1982 when he premiered **Starslayer** at Pacific Comics. Turning the premise of his earlier Warlord somewhat on its head, the series featured a barbarian transported to the far future rather than a modern man marooned in a barbaric land.

From #7, *Starslayer* was published by First who kept the series going until #34 [1985]. Grell wrote and drew only the first seven issues and handed over the writing to John Ostrander as of #11.

Britain's only contribution to the world of sword and sorcery comic books was deeply rooted in Celtic myth. Created by Pat Mills and artist Angie Kincaid and introduced in *2000 AD* Prog 330, Celtic warrior king **Sláine** has warp spasms. Brought on by extreme emotions, these are monstrous berserker rages when the power of the Earth seethes through him.

After years of wandering with his ax Brainbiter and Ukko the drawf who chronicles his tales, Sláine united the Tribes of the Land of the Young and became the first High King of Ireland. After ruling wisely for seven years, he was ritually put to death, in accordance with ancient tradition, so he could be at one with the Earth Goddess.

Once in the Otherworld, Sláine traveled through time to defend the Earth Goddess in future eras. Now grown weary of his travels and yearning to be master of his own destiny once more, he has emerged from the Otherworld—only to discover sour times have befallen his former kingdom.

Another somewhat different concept was introduced by writer Christy Marx and artist Mike Vosburg who's **Sisterhood of Steel** debuted at Epic, Marvel's creator-owned imprint, in 1984.

Set on another world in something akin to our own Hellenic Age, it centers on the island of Ildana, the home to a clan of warrior women. The series focuses on Boronwe, a 16-year-old Novice of the Sisterhood, as she competes to win her place in the ranks as a full Sister Warrior.

Truncated by Marvel after eight issues following a dispute over censorship with Marx, the *Sisterhood of Steel* next appeared as a 1987 Eclipse Comics graphic novel. Subtitled as *Boronwe: Daughter of Death*, it was illustrated by Peter Ledger.

But whatever the competition, Howard's Conan was the supreme champion. Not only did he have his own long-running color monthly but he was also the star of the first five issues of Marvel's black-and-white *Savage Tales* magazine after which he was accorded his own *Savaged Sword of Conan*—which lasted 235 issues from 1974 to 1995. *Conan Saga*, a companion title reprinting color *Conan the Barbarian* stories, was launched in 1987, running 97 issues until 1995.

On top of this, stories of the barbarian in later life were told in *King Conan*—later retitled *Conan the King*—which ran 55 issues from 1980 to 1984 and 14 issues of *Conan the Adventurer*, a title based on an animated TV series, were published between 1984 and 1985. There was even a *Conan the Barbarian* newpaper strip. Written by Thomas and drawn by John Buscema and Ernie Chan, it ran from 1978 to 1980.

"Conan The Barbarian was something of a gamble for Marvel."

Right: Warlord #47 [DC Comics, 1981].

Despite 100 appearances in the title, which became *Marvel Mystery Comics* with #2, very little is known about the adventurer who used his cape to glide and soar. No origin was ever given to the character—a weak rip-off of The Saint, Leslie Charteris's pulp hero.

Animal Man [1965]

The explanation of how the movie stuntman Buddy Baker gained the ability to use the power of any animal in his immediate vicinity was a simple 1960s DC story of spaceships and alien radiation.

But that origin—told as part of his first appearance in *Strange Adventures* #180—was to get a massive reconstruction when he was revived for Vertigo, DC's mature readers imprint, in 1988.

All-but forgotten after a short series of back-up stories in *Strange Adventures* and the occasional guest appearance, Animal Man was resurrected by writer Grant Morrison not only as a champion of animal rights but also as the star of his own title.

For the revised origin, the writer explained how Buddy Baker came by his power to take on the abilities of animals, twisting the original version to demonstrate that the aliens turned him into a morphogenetic field deliberately rather than—as first postulated—as the result of an accident.

Although Grant Morrison eventually left the title after #26, Vertigo's *Animal Man* was to run for another 63 issues until 1995.

Ant-Man II [1979]

Not the first to use the identity, cat burglar, ex-con, and electronics expert Scott Lang became a superhero almost by accident.

Lang's daughter Cassandra had a life-threatening heart defect, one that could only be corrected by Dr. Erica Sondheim. But the doctor was a prisoner of the mutant head of Cross Technological Enterprises who needed her to treat his own heart condition. To rescue Sondheim and thus to save his daughter's life, Lang breaks into the home of Dr. Henry Pym, the original Ant-Man.

Using Pym's costume, shrinking gas, and the cybernetic helmet with which he controlled insect life, Lang frees the doctor and sets about returning the stolen equipment. But his mission has been monitored by Pym—in his new guise of Yellowjacket—who graciously allows him to keep it.

Lang made his first appearance as Ant-Man in Marvel Premiere #47–48 in a story by David Michelinie and artists John Byrne and Bob Layton. He has since become a perennial guest star, even replacing Reed Richards in the Fantastic Four for a time. He also joined Heroes for Hire shortly before that team disbanded.

Aquaman [1941]

Despite being one of its longest surviving characters, DC's King of the Seven Seas has never made the grade as a major superhero.

Abandoned to die by King Trevis, of the mythical underwater city of Atlantis, because his fair hair was believed to link him to the Curse of Kordax, the baby Orin was the only one of his people who was able to breathe on land and underwater.

The son of the mysterious sorcerer Atlan and Queen Atlanna of Atlantis, he was raised by dolphins until—as a teenager—he was to encounter his first human, a lighthouse keeper named Arthur Curry. Taking the boy in, Curry raised him as his own son, teaching him about the surface world and renaming him Arthur Curry after himself.

Eventually rediscovering the city of his birth, the young Arthur—who was now the superhero known as Aquaman—became a founding member of the Justice League of America as well as assuming his rightful place as the King of Atlantis. In addition to his aquatic superpowers, having lost his left hand to deadly piranha fish(!), he was to replace it with a cybernetically controlled harpoon created for him by S.T.A.R. Labs.

Introduced in *More Fun Comics* #73, the Aquaman character was created by editor Mort Weisinger, who revealed him to actually be the son of a scientist who had trained him to live underwater.

When the character was relaunched in *Adventure Comics* #260 [1959], his origin was revised to make him the human/Atlantean son of Arthur Curry and Atlanna, although even that version has gone the way of that of many other DC characters in the revisionist wake of *Crisis on Infinite Earths* [1985].

Arak [1981]

Fresh from a 15-year stint as a writer for Marvel where he had become virtually synonymous with Conan the Barbarian, Roy Thomas was looking for a DC outlet for his love of the sword and sorcery genre. With artist Ernie Colon, he created Arak Red-Hand, a Quontauka Indian who is taken to Europe by Viking explorers.

Set during the 8th century on an alternate Earth where magic exists and historical events do not necessarily parallel our own, his adventures eventually lead the son of He-No, the god of thunder, and Star-of-Dawn to become an ally of Charlemagne. Subsequently killed in battle, he is resurrected by his father who bestows supernatural powers upon him.

Arak debuted in a 16-page insert given away with *Warlord* #48, previewing his own title, *Arak, Son of Thunder*, which ran 50 issues until 1985.

Luther Arkwright [1978]

Bryan Talbot's hero is one of the very few to cross from the world of underground comix to the mainstream.

Introduced by Talbot in the first issue of Galaxy Media's *Near Myths* anthology, Arkwright is the psychically gifted agent of the force responsible for monitoring the myriad realities of the multiverse. A dashing

Continued on page 60

The Many Faces of Batman

It took nigh on 40 years for DC to bring Batman back to his grim and gritty roots, and he went though a number of changes along the way.

Created by Bob Kane—some say with assistance from Bill Finger—Batman first appeared in *Detective Comics* #27 [1939]. Prompted by the success of Jerry Siegel and Joe Shuster's Superman to come up with his own costumed hero concept, the artist took his inspiration from the 16th-century batlike flying machine drawings of Italian Renaissance man Leonardo da Vinci and mixed in elements from such movies as Douglas Fairbanks' *The Mask of Zorro* [1921], *The Bat Whispers* [1930], and the 1931 now-classic *Dracula* with Bela Lugosi in the lead role.

The origin, which revealed that Bruce Wayne became Batman after his parents' murder, was an afterthought. It was added in *Detective Comics* #33, six months after the character— first known as the Bat-Man—was introduced. In his early appearances, he had many parallels to his modern-day counterpart, except that the 21st century Dark Knight does not carry a gun or kill criminals. He did both in 1939.

The first major change to Batman's persona came in 1940 with the introduction of Robin in *Detective Comics* #38. The archetypal kid sidekick, the Boy Wonder's presence changed the tone of the series dramatically, lightening it and his mentor. Batman lost the gun almost as soon as Robin appeared, never carrying it again after the first issue of his own title premiered very shortly after publication of his ward's debut.

Even Batman's nemesis was looking to turn over a new leaf. Introduced in *Batman* #1, by 1942 the Joker forsook killing in favor of practical jokes.

New villains such as Two-Face [*Detective Comics* #66, 1942] and the Scarecrow [*World's Finest* #3, 1941] were introduced, but while they looked bizarre, they still had some of the fearsome nature of those like Doctor Death and the vampiric Monk who had come before.

Right: DC Comics' Dynamic Duo.

Still others—like the Penguin [*Detective Comics* #58, 1941] and Tweedledee and Tweedledum [*Detective Comics* #74, 1943]—were wackier than anything Batman had encountered before and, as the decade drew on, their numbers increased with the Riddler [*Detective Comics* #140] and the Mad Hatter [*Batman* #49] both arriving in 1948.

Also lightening the tone was Vicki Vale. Making her debut in 1948 [*Batman* #45], she was to become a regular girlfriend for Bruce Wayne, Batman's alter ego.

The later 1940s also saw the start of a trend towards more fantastic stories with Batman and Robin being sent on the first of more than 30 trips through time in *Batman* #24 [1944], becoming interplanetary policeman in #41 [1947] and encountering flying saucers in #63 [1951]. The trend escalated throughout the 1950s with science fiction elements—such as the Caped Crusader's Planet X counterpart [#113, 1958]—being introduced on an almost regular basis.

That decade also saw a temporary expansion of the Bat-family. First to appear was Ace, the Bat-hound [*Batman* #92, 1955] followed by the Batwoman [*Detective Comics* #233, 1956] and the interdimensional imp known as Bat-Mite [*Detective Comics* #267, 1959]. The last such addition, the first Bat-Girl, arrived just a little later—in 1961's *Batman* #139. By 1964, sales were on the slide and editor Julie Schwartz was brought in to revamp the character. The turning point was *Detective Comics* #327, which introduced not only cosmetic changes to the Batman costume but also the injection of

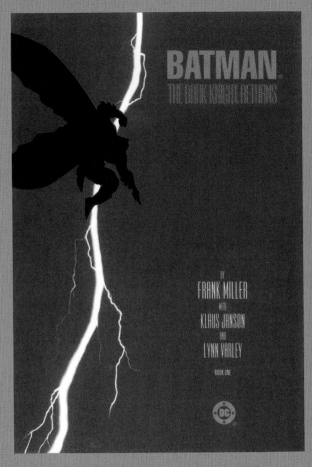

Batman: The Dark Knight Returns #1 [DC Comics, 1986]. Frank Miller's masterful reworking of Batman begins.

mystery into the story lines. Schwartz was of the opinion that the world's greatest detective —as Batman was often referred to—would be at his best when given some detecting to do.

Writer John Broome and artist Carmine Infantino were assigned to implement the overhaul but, successful although they were initially, their efforts were defeated by the premiere of the *Batman* T.V. show in 1966. The success of that series brought pressure to introduce its campy elements into the comic book. Sales of the comics certainly did increase as a result but only as long as the T.V. show was on the air.

When the T.V. *Batman* was canceled in 1968, a further makeover of the comic hero proved necessary. This time writer Denny O'Neill and artist Neal Adams rose to the challenge, injecting an air of realism into the stories. Dispensing with all the fantasy trappings and even sidelining Robin, they sent the world's greatest detective out to combat a more realistic kind of villain.

They also introduced a new archenemy for Batman. Ra's Al Ghul debuted in *Detective Comics* #232 [1971] and has become as much a part of the Dark Knight's mythos as the Joker or the Batcave. When some of Batman's earlier costumed foes were reintroduced, they came with a new edge that made them deadlier and more villainous than before.

Although Adams drew only a handful of issues, he and O'Neill had restored the correct mood for the Batman, setting the tone of both *Batman* and *Detective Comics* for almost the next 15 years.

In 1986, Frank Miller wrote and drew a four-parter, which was to radically change the way in which Batman was interpreted. Set in the near future, the classic *Batman: The Dark Knight Returns* features a Batman who comes out of retirement to stem the disintegration of an increasingly lawless America. His use of extreme measures reveals him to be grimmer and grittier, a vigilante closer to Kane's original concept that modern-day readers could relate to.

Miller's reinterpretation has extended into the regular series. Since 1986, among other things Batman has had to contend with the Joker murdering the second Robin—the first quit to go solo as Nightwing—and crippling the second Batgirl [introduced in *Detective Comics* #359, 1967], his own back being broken by a new villain, Bane, and the destruction of Gotham City by earthquake. But these events form part of a milieu that have helped make Batman probably the most popular of America's comic book superheroes.

"In his early appearances, he had many parallels to his modern-day counterpart, except that the 21st-century Dark Knight does not carry a gun or kill criminals. He did both in 1939."

adventurer, sensual lover, and deadly assassin, he eventually becomes almost godlike as he travels the different dimensions and prevents the destruction of the universe.

His story—inspired by Michael Moorcock's Jerry Cornelius novels—took over 10 years to complete. Talbot continued his tale—a blend of science fiction, espionage, and supernatural genres—in *Pssst!* [1982] before the entire 9-issue saga was published by Valkyrie as the black-and-white *The Adventures of Luther Arkwright* [1987]. An American edition followed in 1990 from Dark Horse Comics, which also published Talbot's 1999 sequel.

The nine-issue *Heart of Empire* is set 23 years after the events of the original series. It introduces Arkwright's only living offspring, Princess Mary Victoria Elizabeth Boudicca Cordelia Miranda Arkwright Stuart, who is psychically gifted like her father. Her mother, Queen Anne, is being hunted by the Pope's chief assassin, and she will become a target herself if control of the British Empire isn't handed over to the Vatican.

Astro Boy [1952]

A 21st-century Pinocchio, Atom-Taishi (Ambassador Atom) is an android created by Dr. Tenna to replace his dead son. Abandoned, he is taken in by Dr. Ochanomizu who trains him to be a crime fighter.

Atom-Taishi—later Tetsuwan-Atom (Mighty Atom)—was created by Osamu Tezuka, often referred to as the Walt Disney of Japan. The character first appeared in *Shonen Magazine* where his strip ran until 1968. He became the star of Japan's first animated TV series—also by Tezuka—in 1963 and it is this vehicle which introduced him to American audiences for whom he was renamed Astro Boy and his manufacturer, Dr. Atom.

In 1965, America's Gold Key published a single issue of *Astro Boy* and followed the TV tie-in by featuring the character in *March of Comics* #285. *The Original Astro Boy* followed these 22 years later. Originated in the U.S., the Now Comics title ran for 19 issues between 1987 and 1989.

Atom I [1940]

The five-foot tall Al Pratt—known as Atom Al to his pals—gets mugged and loses his girlfriend as a result. Befriending a bum—which had an entirely different connotation back then—he's paid back when his newfound friend reveals himself to be a former trainer of championship boxers who helps him to develop his fighting skills. Using his newly acquired talent, Pratt becomes a costumed crime fighter adopting his nickname for his alter ego.

A founding member of the Justice Society of America, he gained bona fide super strength and an "atomic punch" after a 1948 encounter with a radioactive villain.

Introduced in *All American Comics* #19, the Atom was closely associated with that National Periodicals [DC] title until #72 [1946] when, after a short hiatus, he moved over to *Flash*

Comics. There he was a regular from #80 [1947] to #104 [1949]. During the Golden Age he also appeared in *Big All-American Comic Book* #1 as well as in issues of *Comic Cavalcade* and *Sensation Comics.* Revived along with other members of the J.S.A. in *Flash* #139 [1963], he is still an active member of that team today.

Atom II [1961]

After his reinvention of the Flash, Green Lantern, Justice Society of America, and Hawkman, the Atom was the fifth Golden Age concept to get a 1960s makeover from DC editor Julius Schwartz.

Where his 1940s counterpart was merely diminutive, Ray Palmer gained the ability to shrink himself to microscopic size using the properties of a white dwarf star. Created by Schwartz with writer Gardner Fox and artist Gil Kane, the Silver Age Atom debuted in *Showcase* #34 [1961]. After three consecutive appearances in the DC tryout, he gained his own series in 1962 and J.L.A. membership the same year [in *Justice League of America* #13].

Although *Atom* was canceled in 1969 after 45 issues, the tiny titan continues to be a player in the DC Universe. He regained his own title— *Power of the Atom*—in 1988 but it was short-lived, canceled the following year with #18. During 1994's *Zero Hour* event, he was zapped by the villainous Extant's chronal energy and de-aged. The now youthful hero then went on to join the Teen Titans.

Azrael [1992]

Once the latest in a centuries-old line of assassins for the Order of St. Dumas, the alter ego of Jean Paul Valley was genetically engineered and hypnotically trained from childhood with "The System" to become one of the most efficient killing machines born.

Created by Denny O'Neill and artist Joe Quesada and introduced in DC's 1992 four-parter *Batman: Sword of Azrael*, he saved the Dark Knight's life and became his protégé.

For a while after Bane broke his mentor's back in 1993, Azrael served as a replacement Batman. He was given his own title in 1995 in which he destroyed the order and gained control of himself against his conditioning, which had resulted in two deaths while he served in Batman's place. Now an Agent of the Bat, Azrael works for the Dark Knight seeking to redeem himself in Batman's eyes. *Azrael* is to be canceled when it hits #100 in 2003.

A-X [1994]

When both the police and the crooks are after you, are you hero or villain? That was the dilemma posed by Marv Wolfman and artist Shawn McManus who introduced their amnesiac protagonist in their creator-owned *The Man Called A-X.* A five-parter for Malibu's Bravura imprint, it featured a heavily armed

Continued on page 64

Black Panther: African-American Superhero

It's uncertain whether Stan Lee deliberately set out to name Marvel's first African-American representative after the militant civil rights group that was prominent at the time.

In collaboration with artist Jack Kirby, the writer introduced the Black Panther in *Fantastic Four* #52 [1966]. In his secret identity he was T'Challa, the king of Wakanda, a modern industrial African nation that was important in many ways, being the only known source for the alien metal Vibranium.

After a lengthy period as a member of the Avengers, the Black Panther was granted his own series. Beginning in *Jungle Action* #5 [1974] with a reprint of *Avengers* #62, it was written by Don McGregor from #6 with 13 of the episodes illustrated by Billy Graham. A young African-American artist, Graham would go on to work on *Luke Cage, Hero for Hire* [1972], who was Marvel's first African-American hero to star in his own title.

Very little had been revealed about the Wakandan superhero's background in the eight years since he made his debut, and McGregor seized upon the opportunity to extrapolate about the country's culture, history,

mythology, and geography. He did all this within the scope of *Panther's Rage*, a serial that dealt with the repercussions of a rebel uprising led by Eric Killmonger. It ran from #6 to 18 and was followed by a second epic, *The Panther vs. the Klan* in which T'Challa returns to America and becomes embroiled in a feud between two rival organizations, the Dragon Circle and the Ku Klux Klan.

Despite the acclaim being garnered by McGregor's *Jungle Action* stories, the series was canceled to make way for a *Black Panther* comic to be written and drawn by his co-creator, Jack Kirby.

Unfortunately, the man regarded as the King of Comics chose to ignore everything that McGregor and his collaborators had so carefully constructed. Instead, he reverted to old-fashioned heroic adventures.

Thankfully Kirby left with #12, midway through the next serial where the Panther gained telepathic powers as he battled a mad

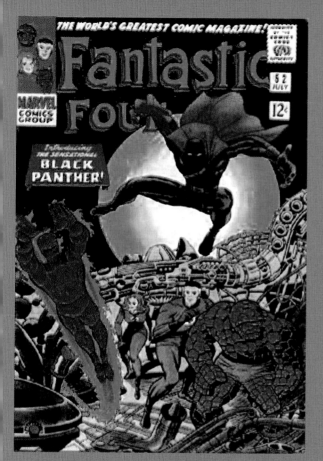

Fantastic Four #52 {Marvel Comics, 1966].

penciled by Denys Cowan, another African-American, it dealt frankly with apartheid, utilizing the Panther Spirit as a metaphor for the rage many African-Americans felt under the regime practiced at the time by South Africa.

In 1988, McGregor returned to the character he is most closely associated with for a serial about the Panther's search for his long-lost mother. Panther's Quest was drawn by veteran comics artist Gene Colan and ran in *Marvel Comics Presents* #13–37. It was followed by another four-issue mini.

Also written by McGregor, *Black Panther: Panther's Prey* [1991] was drawn by another African-American artist, Dwayne Turner. It involves King T'Challa in a further attempt to usurp his rule, this time via the introduction of crack cocaine into the kingdom and then by attempting to destroy the nation's wealth—the Vibranium mound.

Then, in 1998, Marvel Knights decided to relaunch the Wakandan king in his own comic book. Spearheaded by African-American writer Christopher Priest, *Black Panther* has been one of the most highly acclaimed Marvel titles in recent years. Blending politics, corruption, civil wars, refugees, and a coup d'état in Wakanda, Priest kicked off with a 12-issue tale of deceit, betrayal, and conspiracy. He continues today, focusing on a king who must constantly be on guard in order to protect his wealthy, technologically advanced African nation from all manner of enemies who covet its achievements, from elements within the U.S. government to age-old hatreds close to home.

scientist. Hannigan, Bingham, and Day moved in, but Marvel pulled the plug with #15 [1979].

Returning to his role as a perennial guest star and occasional Avengers member, the Black Panther next starred in an eponymous 1988 four-parter. Written by Peter B. Gillis and

and seemingly indestructable behemoth who hears voices instructing him to destroy all the criminals in the City of Bedlam.

Wolfman and McManus revived the character for DC in 1998 when the relaunched *The Man Called A-X* lasted just eight issues.

Aztek:
The Ultimate Man [1996]

Raised in the South American Andes by the mysterious Q-Society, Uno had been trained since birth to be the champion of Quetzalcoatl, the god of light. Elevated to the peak of human potential backed up by an occult-engineered helmet, he is the latest in a long line to assume the destiny of averting the apocalypse by battling the Shadow God Tezcatlipoca.

Created by writers Grant Morrison and Mark Millar, he made his debut in the first issue of his own title in which he assumed the identity of Curt Falconer. Unwilling to sit around waiting for Tezcatlipoca, he became a superhero, serving for a short time with the Justice League. *Aztek: The Ultimate Man* was canceled in 1997 after just 10 issues.

Aztec Ace [1984]

A time-traveling collector of ancient artifacts whose companion is a disembodied head, he is constantly striving to thwart the efforts of an organization intent on undermining history.

While doing so, he is forced to deal with momentary imbalances, paradoxes he refers to as "doxy glitches." Created by writer Doug Moench, *Aztec Ace* was introduced in the first issue of his own title, an Eclipse series that lasted until #15 [1985].

Badger [1983]

Created by writer Mike Baron and initially drawn by Jeffrey Butler, Norbert Sykes is a Vietnam veteran who suffers from multiple personality disorder. One of those personae is Badger, a vigilante and martial arts expert who communicates with animals and swings between reason and psychosis.

Introduced in the first issue of his own title, he is accompanied on his adventures by Ham, a 5th-century Welsh weather wizard with whom he escaped from a Wisconsin mental hospital. Traveling with them is Daisy Fields, their former psychiatrist who begins to wonder if either of them really is insane.

Launched by the short-lived Capital Comics, the series moved to First Comics—which also published a *Badger Goes Berserk* four-parter [1989]—with #5 [1985] where it continued until #70 [1991].

With Baron at the helm, the character next starred in two 1994 Dark Horse miniseries before Image began publishing *The Badger* in 1997 as a black-and-white title, picking up the numbering with #78. The comic was canceled the same year with #81.

Black Condor I [1940]

An orphan, Richard Grey Jnr was raised by black condors in the mountains of Outer Mongolia following the murder of his archaeologist parents. After teaching himself to fly by imitating the birds, he came to America to fight crime. At the behest of a national security advisor, he adopted the identity of assassinated Senator Thomas Wright to whom he bore a close resemblance.

Introduced in *Crack Comics* #1 in a story by Will Eisner and artist Lou Fine, he appeared in the first 31 issues of the Quality title.

Black Condor entered the DC Universe in 1973's *Justice League of America* #107 as a member of Freedom Fighters. The team, which also featured Uncle Sam, Doll Man, Human Bomb, Phantom Lady, Ray, Black Condor, had its own title, which ran 15 issues [1976–1978].

Black Condor II [1992]

Created by Brian Augustyn and artist Rags Morales, Ryan Kendall is the end result of more than 200 years of experimentation by The Society of the Golden Wing to discover a way for man to fly.

After many years of failure, the Society's leader, billionaire Creighton Kendall, began performing experiments on his grandson, beginning by mutating him while still in the womb, tailoring his genetic makeup to the Society's specifications. Treatments involving chemicals and radioactivity coupled with physical training continued until the final treatment—administered on his 21 birthday—left him in an apparent coma for two years. During that time, Ryan learned of the Society's sick and twisted motivations and fled when he regained consciousness.

Introduced in the first issue of his own series, which ran 12 issues until 1993, Black Condor lives in New Jersey's Pin Barrens natural forest preserve where Ned Jones, a Native-American park ranger, has to persuade him to use his powers of telekinesis and telepathy in the cause of justice. He has been a member of both the Justice League of America and Primal Force.

Black Goliath [1975]

Introduced in *Avengers* #32 [1966], African-American biochemist Bill Foster was hired to assist Hank Pym, the discoverer of the height-altering Pym Particles, who could not shrink below 10-feet tall. After finding a cure for Pym's condition, Foster continued until he was able to synthesize the growth compound.

Tony Isabella and artists George Tuska and Dave Hunt transformed Foster into a superhero in Marvel's *Power Man* #24 [1975] and then—with Vince Colletta replacing Hunt—thrust him into his own title. *Black Goliath* was canceled after just five issues. Black Goliath then joined the Champions, a Los Angeles superteam that also included Angel, Iceman, Hercules, and the

Continued on page 78

Kirby's Magnum Opus

Disillusioned by a lack of credit for his part in cocreating the Marvel Universe and almost all of its major inhabitants, Jack Kirby quit Marvel in 1970.

After more than a decade during which he drew everything from monster strips and westerns to superheroes and helped make the self-styled House of Ideas America's number one comic book publisher, he left for what his long-time partner Stan Lee jokingly referred to as the Distinguished Competition.

Kirby—who had already worked for DC Comics during the 1940s and 50s—was enticed back by editorial director Carmine Infantino who offered him the chance to write, draw, and edit his own material. The offer was exactly what the artist was looking for. Until then he had spent his entire working life collaborating with a writer—first Joe Simon and then Lee—and he was more than ready for creative independence.

The result was an epic saga unlike anything previously seen. It encompassed four titles and began when Kirby took over *Superman's Pal Jimmy Olsen* with #133 [1970]. Dispensing with the title's lighthearted approach, he proceeded to lay the groundwork for an epic fans came to call The Fourth World Saga and many consider his magnum opus.

In early 1971, the first issues of Kirby's *New Gods* and *Forever People* hit the stands and the saga began in earnest. *Mister Miracle* followed a month later.

New Gods was the core title. It told how the Old Gods died and their planet split in two with one half becoming New Genesis and the other Apokolips. It also revealed the pact that kept the two worlds at peace—how Darkseid, the villainous ruler of Apokolips, and New Genesis's benevolent Highfather exchanged their infant sons, each agreeing to bring the other's boy up as their own.

Darkseid's son Orion was the focus of the series. Brought up in the utopian splendor of New Genesis, he was given to berserker rages as his genetic heritage forced itself upon him. His adopted planet's champion, he went to war against his real father who was desperate to gain possession of the Anti-Life Equation hidden somewhere on Earth.

In contrast to *New Gods*, *Forever People* was a lighthearted romp. It featured Mark Moonrider, Serifan, Big Bear, Vykin, and Beautiful Dreamer, five youngsters—the then-

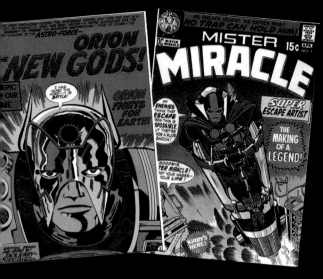

Jack Kirby's Fourth World: Left, splash page to New Gods #1; Right, Mr Miracle #1.

54-year-old Kirby's version of hippies—who had been transported from different eras on Earth to New Genesis. Armed, like all the gods of New Genesis, with a supercomputer known as Mother Box, they had the ability to combine themselves to become the Infinity Man, but they treated the war with Apokolips as just some sort of game.

The star of *Mister Miracle* was Orion's opposite. Highfather's son, Scott Free escaped from Apokolips orphanage where Darkseid had abandoned him and made his way to Earth. There he adopted the guise of a super-escape artist, Mister Miracle, but could not escape his heritage.

He becomes more and more embroiled in the coming Apokolips/New Genesis war after Granny Goodness—the head of the orphanage

—sends her elite troops Lashina, Stompa, Bernadeath, and Mad Harriet—collectively known as the Female Furies—to bring back the first boy to escape her clutches. Later he joins forces with and marries Big Barda, the Female Furies' former leader.

Although Kirby's epic lasted less than three years, its legacy of technology like the Mother Boxes and the interdimensional Boom Tubes and characters with names such as Desaad, Lightray and Funky Flashman—a thinly disguised parody of Stan Lee—has become an integral part of the DC Universe. Indeed, the malevolent Darkseid has become one of its major villains and both Orion and Mister Miracle have served in the Justice League.

In 1985, Kirby returned to DC to bring an end to The Fourth World Saga as he had originally envisioned. His 64-page *The Hunger Dogs* [DC Graphic Novel #4] was an ultimately disappointing end to a highly regarded series.

Over the years, DC has made several attempts to resuscitate all three of the series Kirby created, but these have been to varying degrees of success. None has been able to entirely capture the grandeur and sense of cosmic scale that the writer/artist many call the King of Comics was able to instil.

"Its legacy of technology . . . has become an integral part of the DC Universe."

Captain America

Beaten to the punch by The Shield, Uncle Sam, and Minute Man among others, Captain America may not be the first of America's patriotic superheroes but he is the best known.

Created by the legendary writer/artist team of Joe Simon and Jack Kirby, Cap was initially going to be named Super American. His debut in *Captain America Comics* #1 [1941] was to prove an immediate hit. Sales of the title rocketed to nearly a million copies per issue almost immediately, pushing Timely [now Marvel] into the top rank of comics publishers.

Uniquely for the time, the new Sentinel of Liberty did not posess a superpower nor had he trained himself to the peak of fitness. Instead he was puny 4-F army reject Steve Rogers who volunteered to be the subject of an experiment. He became the first recipient of the supersoldier serum, being given the drug just moments before its inventor is killed by Nazis and the formula lost for ever.

With four issues of his own title under his belt, Cap also began appearing in *All-Winners Comics* from its first issue. An anthology title, it was to see him form the team along with the comic's other stars—the Human Torch, Namor the Sub-Mariner, Bucky,Toro, the Whizzer, and Miss America. The All-Winners Squad featured only in the title's last three issues, in 1946.

In 1975, writer Roy Thomas and artist Frank Robbins retroactively showed a team consisting of Cap, the Torch, Namor, and their sidekicks operating during World War II. Beginning in *Giant-Size Invaders* #1, these stories continued in the regular *Invaders* title that ran 40 issues until 1979.

During the Second World War, such was the patriotic superhero's popularity that he also appeared in the first five issues of *Young Allies* [1941]—a teen team title that featured his teen sidekick Bucky and the Human Torch's sidekick Toro—as well as in *USA Comics* and *All-Select Comics*.

After the war, Steve Rogers returned to civilian life, taking up a career first of all as a policeman and later as a teacher. The stories turned to crime and human interest and then to horror. But peacetime didn't suit the super soldier. With interest in superheroes dropping, falling sales brought an end to *Captain America Comics* with #75 [1950]. He did not even feature in the final two issues, actually titled *Captain America's Weird Tales*.

During the postwar years, the star-spangled

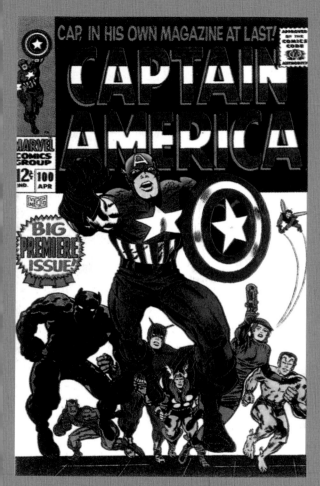

Captain America #100 [Marvel Comics, 1968].

sentinel also featured in *Marvel Mystery Comics* between 1947 and 1949 and *Blonde Phantom* in 1947. Marvel also revived the All-Winners Squad for an appearance in the one and only issue of the relaunched *All-Winners*

Comics. The revised lineup was Cap, the Sub-Mariner, the Torch, and the Blonde Phantom.

In 1954, Marvel relaunched *Captain America Comics* with #76. Subtitled "Commie Smasher," the series lasted just three issues. Then, in 1964, Stan Lee decided to resurrect Captain America as part of Marvel's superhero renaissance, following a tryout by an imposter in *Strange Tales* #114 in 1963.

He brought him back in *Avengers* #4, explaining that he had been frozen in ice since the end of World War II. Cap—a mainstay of Marvel's superteam since his revival—soon gained his own series. Beginning in *Tales of Suspense* #59 [1964], it ran to #99 and then continued in *Captain America* #100 [1968].

The series ran until 1996 with #454. Among high points is a run by writer Steve Englehart in which he explained the appearance of Captain America and Bucky in the '50s and even addressed the Watergate scandal.

Marvel canceled Captain America as part of a company-wide makeover by some of the founders of Image Comics. The series was relaunched in 1996, then again in 1998. That last comic was itself canceled in 2002 to make way for Captain America to be relaunched as a Marvel Knights title in the wake of events on September 11, 2001 and the subsequent wave of patriotism that engulfed America.

"Marvel canceled Captain America as part of a company-wide makeover."

Captain Britain

It is somewhat ironic that the U.K. adventure comics industry continues to wither while sales of imported American superhero titles remain buoyant. For that reason, there is a distinct lack of British-grown superheroes and most creators of such characters have worked through American publishers.

Marvelman [1954] may be the first created specifically for British consumption but he was a reworking of America's Captain Marvel. The U.K.'s first truly original superhero appeared in 1976, although even then it took an American publisher to provide the impetus.

Already set up in Britain to reprint its U.S. comics, Marvel was looking to originate material specifically for the British market. The result was *Captain Britain*, who debuted in his own weekly title in 1976.

Lying near death in the circle of stones on Darkmoor known as the Siege Perilous, Brian Braddock is bombarded with mystical energy and superhuman strength by Merlin and the Goddess of the Northern Skies. Unfortunately, Braddock's alter ego and the series followed too closely the Captain America formula.

With no real appeal to or affinity with its intended audience, Captain Britain was canceled the following year with #39.

And that could have been the end of the matter if not for Dez Skinn, later to provide the impetus for Quality's 1982 revival of Marvelman. Skinn commissioned a Black Knight strip from Steve Parkhouse and artist John Stokes, with the suggestion that they incorporate Captain Britain into the serial on the basis that the origins of both heroes were tied to Merlin (or Merlyn). They reintroduced him as an amnesiac who accompanied the Knight on his quest through the realm of Otherworld, regaining his memory shortly before the series ended in 1980 with the final issue of the retitled *Incredible Hulk Weekly* prior to its integration into *Spider-Man Weekly*.

But Captain Britain had proved sufficiently popular than he was given his own series when Marvel U.K. revamped one of its reprint titles in 1981. Making his professional debut on *Captain Britain* was Alan Davis, an artist whose name was to become inextricably connected

Captain Britain [Marvel Comics, 2002].

with the British hero. He redesigned the costume, which, together with his star-scepter, Merlin had transformed into a lattice of mystical "micro-circuitry."

Captain Britain's new adventures began in Marvel *Super-Heroes* #377. Dave Thorpe wrote

the initial episodes, but it was when writer Alan Moore came on board to team up with Davis that the series really took off.

Moore's first action was to rewrite the origin, making Merlin the powerful guardian of the universe. He also gave Captain Britain a metaphysical connection to Otherworld—which he established as being sited at the nexus of reality, where science and sorcery exist as one. The writer also retroactively made Braddock's father the greatest hero of the Captain Britain Corps; an elite cadre of heroes Merlin had founded to safeguard the infinite alternate realities.

Moore and Davis stayed together on the strip when *Marvel Super-Heroes* was relaunched as *The Daredevils* and when that title was merged into *Mighty World of Marvel* later in 1983. Although Captain Britain appeared in *MWoM* #7–16, Moore bailed after #13 when Davis took over writing as well as drawing the strip.

In 1985, Marvel U.K. premiered *Captain Britain Monthly*, an anthology on which writer Jamie Delano joined Davis. It concluded with #14.

By now an occasional guest star in the American-controled Marvel Universe, Captain Britain's next major role was as the leader of a British-based spin-off from the *X-Men*. *Excalibur*—created by Claremont and Davis—ran 125 issues from 1988 to 1998.

"The series followed too closely the Captain America formula."

How a Marvel Became a Miracle

It may be hard to believe, but the story of one of Britain's most internationally acclaimed superheroes begins with the most successful superhero of America's Golden Age of Comics.

Conceived by Fawcett Publications editor Bill Parker and visualised by C. C. [Charles Clarence] Beck, Captain Thunder was renamed Captain Marvel when it was found the former name was already in use.

Given the wisdom of Solomon, strength of Hercules, stamina of Atlas, power of Zeus, courage of Achilles, and speed of Mercury by uttering the mystic word "Shazam!" (an acronym of the heroes' initials), young Billy Batson and his alter ego, the World's Mightiest Mortal, debuted in *Whiz Comics* #1 in 1940.

The somewhat surreal stories—with talking tigers, an intellegent earthworm called Mr. Mind, and the like—struck a chord with comic buyers, and Captain Marvel became the biggest-selling superhero of the time with sales peaking at almost 1.4 million an issue. The Big Red Cheese—as he was known—was given his own title, *Captain Marvel Adventures*, while continuing to appear in *Whiz*. Additions to the Marvel Family were introduced, including

Captain Marvel Jr. and Mary Marvel—both of whom got series of their own—as well as such whimsical members as Uncle Marvel and Lieutenant Marvels.

But, possibly spurred by the Fawcett hero outselling its own Superman, DC was unhappy with the perceived similarities and, in 1941, instigated a lawsuit claiming copyright infringement. The case came to court in 1948, when the ruling went in Fawcett's favor.

DC appealed, and in 1951 a new trial was granted. However, with legal costs mounting and sales of superhero comics falling, Fawcett decided to discontinue its line of comics before the second trial. In 1953, it settled with DC (which now owns the rights to Fawcett's characters) out of court. The last *Captain Marvel* comics appeared the same year.

Where does Britain fit into this? Well, Fawcett's decision to pull the plug had a major impact on Len Miller, a London publisher who held the license to reprint the American company's

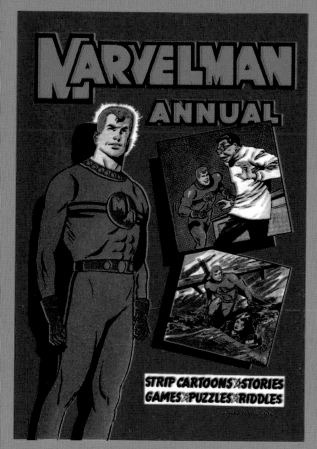

Marvelman Annual [L Miller & Son, 1954].

The *Marvelman* comic proved equally successful. Launched in 1954, it ran continuously until 1963. A short-lived companion title—*Marvelman Family*—followed in 1956 but was canceled in 1959.

Fast forward to 1982. Another London-based publisher, one-time Marvel U.K. head Dez Skinn decides to revive one of his boyhood heroes for his anthology comic, *Warrior*. The reinvention of Marvelman as a far more realistic superhero is the work of Alan Moore, who went on to produce such acclaimed comics as *Watchmen* and *Batman: The Killing Joke*—and artist Garry Leach.

With Moore establishing himself in the forefront of comic book writers for his work on DC's *Swamp Thing*, Eclipse Comics—who changed the hero's name to Miracleman rather than risk a legal confrontation with the all-powerful Marvel Comics—picked up the strip for American publication.

The first issue of *Miracleman* hit the U.S. market in 1985, the year *Warrior* ceased publication. It had much the same effect on fans as Captain Marvel's *Whiz Comics* debut had had on an earlier generation of readers.

By issue #6, Eclipse had republished all the *Warrior* material and Moore began to write new stories exclusively for the American title. With #16, he left the series, handing it on to Neil Gaiman, another vaunted British writer who took the series in a different direction with the next issue.

Gaiman—best known for his work on *The Sandman*—continued with the series until 1992, when Eclipse went into bankruptcy.

material in the U.K. With two big-selling titles in jeopardy, Miller turned to writer/artist Mick Anglo to rescue the situation. He came up with Marvelman; a science-based version of the U.S. superhero, his secret identity was Mike Moran, a youngster who gained his powers by saying "Kimota!" ("atomik" backward).

Rise of the Independents

By the mid-1970s, DC and Marvel's domination of the action hero end of the comic book market was all but total but, with the advent of creator-owned comics, led by young writer Mike Friedrich, the tide was about to turn.

Charlton was but a shadow of its former self, Gold Key was concentrating almost exclusively on its Disney and similar titles, Archie had cut back to its humour comics, and *T.H.U.N.D.E.R. Agents* publisher Tower Comics had been and gone. Warren was carving a niche for itself with *Creepy*, *Eerie*, and *Vampirella*, but these black-and-whites were not aimed at the same audience as the Big Two's color comics.

But a seed had been planted by the underground comix movement of the late 1960s, one that was to have a lasting impact on the industry even though the comix themselves had not directly affected what is now referred to as the mainstream publishers.

Most of the titles produced by R. Crumb, Gilbert Shelton, and the other underground cartoonists were self-published or, at best, funded by a grassroots publisher. In 1974, Bud Plant agreed to publish a series being written and drawn by Jack Katz, an artist who had worked for Marvel in the 1950s. The black-and-white *The First Kingdom* premiered in 1974 and ran 24 issues, until Katz completed the saga in 1986. It was the first of what came to be referred to as ground level comics.

It was also creator-owned, a concept that was an anathema to Marvel and DC at the time, but not to the new breed of writers and artists entering the industry from comics fandom.

A young writer himself, Mike Friedrich was well aware of his contemporaries' desire to own their creations. He made creator-ownership an integral part of *Star*Reach*, a black and white anthology he launched later in 1974. Across its 18 issues he published work by a number of writer/artists who continue to be highly regarded within the industry. Among them were Howard Chaykin, P. Craig Russell, Jim Starlin, and Walt Simonson.

Others followed in his wake. Launched in 1975, Sal Quartuccio's *Hot Stuf'* magazine ran sporadically until the early 1980s. It featured contributions from the underground comix artist Rich Corben and comics veterans Alex Toth and Gray Morrow. Joe Kubert's White Cliffs Publishing-produced *Sojourn* premiered in 1977. A tabloid-sized magazine that lasted for just two issues, it showcased the work by various luminaries such as Kubert, John Severin, and Sergio Aragones.

Even Spider-Man cocreator Steve Ditko got in on the act, self-publishing such titles as *Mr A* [1973] and *Wha...?!* [1975]. He had also—along with Al Williamson, Frank Frazetta, Roy Krenkel, and Wally Wood among others—contributed to *Witzend*. Created and published by Wood who premiered it in 1966, the black- and-white magazine is considered to be the first prozine and one of the earliest creator-owned projects. The last issue [#13] was published in 1985.

By the time Friedrich wound up *Star*Reach* in 1979, he had launched two more anthologies —*Imagine*, which numbered Spider-Man co-creator Steve Ditko among its contributors, and the anthropomorphic *Quack!*—and Lee Marrs' *The Further Fatty Adventures of Pudge, Girl Blimp*. None outlived *Star* Reach,* but all were integral in establishing a viable alternative to the mainstream giants Marvel and DC.

Dave Sim was a regular contributor to Friedrich's anthologies. In late 1977, he began writing, drawing, and publishing *Cerebus the Aardvark*. Initially a funny animal parody of Roy Thomas and Barry Smith's *Conan the Barbarian* [Marvel, 1970], the black-and-white comic has transcended its roots to become a highly regarded story of an aardvark who becomes Prime Minister, Pope, and a drunk. Sim is still producing the saga, which he intends to bring to a planned conclusion in 2004's #300.

Fantasy Quarterly [1978] swiftly followed Sim's first issue of *Cerebus*. Another black-and-white anthology, it folded after just one issue but it featured the first appearance of what was to become another long-running independent title, Wendy Pini's *Elfquest* [1979].

In September 1978, Eclipse Comics burst on the scene with Don McGregor and Paul Gulacy's *Sabre*. Often called America's first graphic novel, it appeared at almost the same time as another contender for that title, Will Eisner's *A Contract with God* [Baronet Books].

Another champion of creator's rights, Eclipse more than Friedrich's Star*Reach Productions was the forerunner of today's independent publishers. Initially publishing in black and white, it built up a line that included Scott McCloud's *Zot!*, P. Craig Russell's *Night Music*, Steve Gerber and Gene Colan's *Stewart the Rat*, McGregor and Marshal Rogers' *Detectives Inc.* and the *Eclipse Monthly* anthology.

But, while Cerebus, Elfquest and the Eclipse titles—like Warren's magazines—sold to the comic fan looking for something beyond DC and Marvel's superhero-dominated output, their black-and-white format limited their appeal. It all changed in 1981 when Pacific Comics published the first issue of *Captain Victory and the Galactic Rangers*.

Written and drawn by comics legend Jack Kirby, the series was followed in 1982 by a

wealth of other color comics including Neal Adams' *Ms. Mystic*, Sergio Aragones' *Groo*, and Mike Grell's *Starslayer* as well as anthologies like *Alien Worlds* and *Twisted Tales* and a showcase title, *Pacific Presents*.

Pacific lasted only two years but it changed the shape of the industry. By the end of 1982, First Comics had also entered the game with the first issue of *Warp*, the start of a line of color titles that was to grow to include John Ostrander and Tim Truman's *Grimjack* [1984], Chaykin's *American Flagg!* [1983], and Grell's *Jon Sable, Freelance* [1983], and *Starslayer*, taking over the latter when Pacific collapsed in 1983. The First roster also featured *Badger, Nexus,* and *Whisper*.

Three titles were picked up from Capital Comics' short-lived black-and-white line—and *E-Man,* formerly with Charlton.

First also acquired Pacific's rights to publish adaptations of Michael Moorcock's *Elric of Melniboné* novels, while Eclipse took over Groo and Dave Stevens' *The Rocketeer*—a serial that had run as backups in both *Starslayer* and *Pacific Presents*.

Eclipse also picked up *Alien Worlds* and *Twisted Tales,* using them as the nucleus for an embryonic color line that would expand to incorporate such other titles as *Miracleman* (Warrior's *Marvelman* retitled for the U.S. market) [1985], *Airboy* [1986], *Aztec Ace* [1984], *DNAgents* [1983], Truman's *Scout* [1985], and horror novelist Clive Barker's *Tapping the Vein* in 1990.

In 1986, Eclipse and First were joined by Dark Horse, although that newcomer initially concentrated on black-and-white comics with a more experimental approach rather than the traditional superhero material. In addition, by that time Comico—a company that began publishing black-and-white comics in 1982— had converted its line to color.

By the mid-1990s, Dark Horse had grown from strength to strength but First, Eclipse, and Comico were all gone and others had risen to take their place. Image is still going but Valiant has folded and Malibu has been swallowed up by Marvel. Even more have come and gone but still new publishers flourish, independent of Marvel and DC . . . Avatar Press . . . Oni Press . . . Chaos! Comics . . . Bongo Comics . . . Harris Comics . . . CrossGeneration Comics . . . for every one that falls, two more seem to spring up in its place.

"A seed had been planted by the underground comix movement of the late 1960s, one that was to have a lasting impact on the industry."

Right: The Destructor #1 [Atlas/Seaboard].
Origin and first appearance of the Destructor.

Black Widow, appearing in *Champions* #11–13 [1977]. In 1978, he appeared in *Defenders* #62–65 but did not stay with the nonteam.

Changing his name to Giant-Man in *Marvel Two-in-One* #54 [1979], he continued until he lost his powers in issue #85 [1985] of that title.

Black Hood [1940]

Shot while investigating a robbery for which he has been framed, Kip Burland is rescued by a hermit who helps the cop heal. Determined to clear his name, he gets him into top physical shape and learns "all of science and all of knowledge, in order to make himself the world's greatest fighter against crime!" Donning the Black Hood to protect his identity from the police and from criminals, he rides the Hoodcycle, a motorcycle which can convert into other vehicles.

Created by MLJ editor/writer Harry Shorten, the heavily pulp-influenced Black Hood was introduced in *Top Notch Comics* #9 in a story by Cliff Campbell and artist Al Camy. He remained in that series until #44 [1944] by which time it had been renamed *Top-Notch Comics Laugh*. He also appeared in all nine issues of *Jackpot Comics* [1941–43] and gained his own title in 1943 when *Hangman Comics* became *Black Hood Comics* with #9. It was retitled *Laugh Comics* with #20 [1946], but the Black Hood had left with the previous issue.

MLJ's second most popular hero after the Shield, between 1944 and 1947 the Black Hood also appeared in *Pep Comics* .

He resurfaced in 1960 in *Adventures of the Fly* #7, subsequently making occasional appearances in other Archie (formerly MLJ) comics, until he became a charter member of The Mighty Crusaders, a team that first appeared in *Fly-Man* #31–33 [1965] before moving into its own title, which lasted only seven issues until 1966.

Black Hood II [1983]

When Archie relaunched *The Mighty Crusaders* in 1983 as a Red Circle title, it featured a new Kip Burland as the Black Hood. A detective, he was the nephew of the Golden Age version, who was now renamed Matt Burland, who told him that crime fighting was a family tradition that dated back to Europe in the 18th century.

Armed with his pepper-box pistols and mounted on a motorcycle, Kip became the modern-day Black Hood. He appeared in all 13 issues of *The Mighty Crusaders* until it was canceled in 1985 and also in 1983's *The Black Hood,* which lasted only three issues.

Black Hood III & IV [1991]

Introduced in the 1991 *Impact Christmas Special* in a story by Mark Wheatley and artists Rick Burchett and Mike Chen, the third Black Hood was an African American named Hit Coffee. He was killed off in the first issue of *The Black Hood*, a series that revolved around

the hood empowering its wearer, heightening their abilities only in that it allows them to think more clearly and quickly, and to know instinctively how to make the best use of their talents and potentials.

Coffee was replaced by teenager Nate Cray in the second issue of *The Black Hood*, a title canceled in 1992 after 12 issues.

Black Knight II [1953]

Toby published a one-shot *Black Knight* comic in 1953, but it was eclipsed by the Atlas [Marvel] title that followed two years later.

Lasting only five issues until 1956, it featured Sir Percy of Scandia. Created by Stan Lee and artist Joe Maneely, he serves King Arthur of the Round Table in a dual capacity: as an unassuming noble of the court and as his mysterious champion, the Black Knight when he wears a full suit of chain mail armor and carries the magical Ebony Blade. The sword, forged with magic by Merlin from the metal of a mysterious meteorite, appears virtually invulnerable and able to cut through almost any material imaginable.

The blade's enchantments also make it able to dispel other magical barriers, attacks, and enchantments, as well as deflecting, resisting, absorbing, and redirecting all manner of other energy assaults.

But it is also cursed . . . it will inflict great pain upon any enemy who picks it up, but it will bring great tragedy down upon any who uses the Ebony Blade to take a life.

Bloodstone [1975]

The immortal adventurer and mercenary known as Ulysses Bloodstone was born over 10,000 years ago when, as a hunter for a tribe of cave dwellers, he was to encounter Ulluxy'l Kwan Tae Syn, who was the alien keeper of the fabled Bloodstone.

This mystic gem housed the Hellfire Helix, a factor which gave him superhuman strength and endurance but also destroyed his tribe when Bloodstone attempted to acquire its powers for them as well. In a furious rage, he smashed the gem, causing a shard to embed itself in his chest. It is that magical fragment, permanently grafted into his body, which gives the hero his immortality.

Introduced in *Marvel Presents* #1 in a story—written by John Warner and drawn by a crew led by the penciler Mike Vosburg—that continued in #2, he next turned up in the back of the black-and-white *Rampaging Hulk* magazine where he appeared in #1–6 and 8 through 1977 and 1978. His story was brought to a final conclusion during 1989's *The Bloodstone Hunt—Captain America* #357–362—when the shard was removed by a group known as the Conspirators, who he destroyed before he died himself.

More recently, he was featured in a flashback story that appeared in issues #4–7 of *Marvel Universe* in 1998 and his daughter, Elsa, was the star of a 2001 *Bloodstone* four-parter.

Continued on page 86

DC: Home of Dead Characters

Even death is not final for comic book heroes.

Although most recover from their deadly encounter with the Grim Reaper, there are some that reach their true potential only once they have faced that final curtain. Most of these seem to haunt the DC Universe. The first of these heroes from beyond the grave also happens to be the foremost.

Resurrected from the dead to become one of the most omnipotent heroes in the DC pantheon, Detective Jim Corrigan was another of the characters conceived by Superman co-creator Jerry Siegel. Designed by artist Bernard Baily, the supernatural hero also known as the Wrath of God first appeared in National Periodicals' *More Fun Comics* #52 [1940]. A charter member of the Justice Society of America, the **Spectre**'s solo adventures lasted until #10 [1945].

Revived in *Showcase* #60 [1966], the all-powerful Spectre was the one of the few DC Golden Age heroes to gain their own title in their original incarnation. Lasting only 10 issues, this outing was eventually followed by a similar but far more controversial run as the star of *Adventure Comics*, which adopted the prefix Weird for the duration of the character's

stay. Written by Michael Fleisher and drawn by Jim Aparo, issues #431–440 [1974–75] of the title saw a return to the 1940s avenging spirit with the Spectre meting out justice by turning criminals into wood and running them through an electric buzz saw or cutting them in half with giant scissors.

After 12 years as a guest star, the *Spectre* was again given his own title. Running 31 issues from 1987 to 1989, it was followed three years later by a third attempt to make the Wrath of God a comic book star in his own right. Written by John Ostrander and drawn mainly by Tom Mandrake, the 1992 series was the Spectre's most successful and succeeded in redefining the character's place in the DC cosmos.

When *The Spectre* ended in 1998 after 62 issues, Ostrander brought Corrigan's mission on Earth to an end. But as with many a good comic book hero and villain, a way was found to bring the Spectre back to "life." The now-deceased Hal Jordan—the Silver Age Green Lantern—has adopted the mantle and stars in the latest Spectre title, launched in 2000.

Right: The Spectre #15 [DC Comics, 1988].

Second to arrive was one of the few non-DC dead heroes. Somewhat similar to the Spectre, MLJ's **Mr. Justice** first appeared in *Blue Ribbon Mystery Comics* #9 [1941].

In 1040, Prince James of England was assassinated, his spirit trapped within Castle Firth where he died because his destiny remained unfulfilled. Flash forward a thousand years and the castle is dismantled and shipped to America for safekeeping. James's spirit is freed when the ship is sunk by a U-boat.

Making his way to America and calling himself Mr. Justice, James seeks to protect others from the fate that befell him. At his command are the powers of the spectral plane like flight and being able to travel underwater.

The Royal Wraith as he was sometimes known remained in *Blue Ribbon Mystery Comics* until it was canceled with #20 [1942]. He also appeared in all nine issues of *Jackpot Comics* [1941–1943]. Revived in the mid-1960s for appearances in issues #4, 5, and 9 of Archie's *Mighty Crusaders*, in the latter he teamed up with Steel Sterling and the Jaguar for the only appearance of The Terrific Three.

In 1942, National debuted the unfortunately named **Gay Ghost**—now referred to as the Grim Ghost for obvious reasons—in the first issue of *Sensation Comics*.

Created by Gardner Fox and artist Howard Purcell, in life the Gay Ghost had been Keith Everet, the Earl of Strethmere, who was shot and killed in Ulster in 1700 as he was riding to meet his love, Deborah Wallace. In the afterlife his spirit is met by his ancestors, who use the power of their concentrated wills to send him

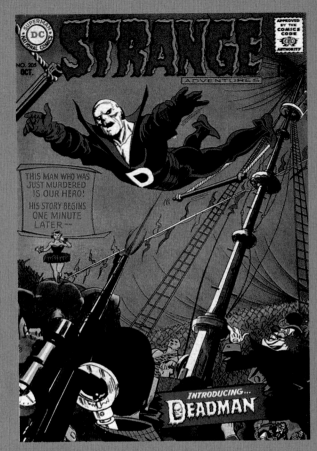

Strange Adventures #205 [National Periodical Publications, 1967].

back to Earth to "avenge the evil that men do." The only catch—he can't actually return to Earth until Deborah dies for good . . . and she keeps being reincarnated.

Finally, in 1941, Charles Collins—the American pilot boyfriend of Wallace's direct

descendant—is killed by Nazi spies. Everet, unable to wait any longer, enters Collins' body and, reanimating it, uses it and his supernatural powers—which include super strength, flight, and the ability to become immaterial—to capture the killers.

As Collins, Everett returns to America with the current Deborah Wallace—a dead ringer for his love. There he uses his powers to fight evil and spies. He last appeared in *Sensation Comics* #42 [1945].

Hot on his heels came the **Ghost Patrol**, three members of the French Foreign Legion who were killed when their sabotaged plane exploded while they were dropping their bombs in the desert rather than on innocent villagers as they had been ordered. Marooned on the plane as ghosts instead of going on to their final reward, they decided to use their new status to fight the Germans and, after the war, ordinary criminals.

As ghosts they could fly, walk through walls, and act invisibly. They could also materialize but were vulnerable in that form. First appearing in *Flash Comics* #29, the Patrol continued in the DC series until its cancellation in 1949 with #104.

Next up was **Kid Eternity** who became a DC character by default when the publisher acquired Quality Comics in the mid-1950s. The nameless Kid was killed when his grandfather's merchant marine ship was sunk by a U-boat's torpedo. Arriving in Heaven, he is greeted by the angelic but portly Mr. Keeper, who explains that his death shouldn't have happened and he was supposed to live

another 75 years. By way of recompense, Mr. Keeper gives the Kid the power to summon anyone from mythology or history by uttering the word "Eternity." Accompanied by Mr. Keeper, the Kid returns to Earth where he gains the ability to become solid and fights crime, evil, and Nazis with assistance from the likes of Hercules, Atlas, Sir Launcelot, Merlin, and the father of hypnotism, Dr Fredric Mesmer.

Making his first appearance in *Hit Comics* #25, he stayed in the title until 1949. His own title ran 18 issues from 1946 to 1949.

In 1991, writer Grant Morrison and artist Duncan Fegredo reinvented the character for a three-part *Kid Eternity* series, which offered a grimmer version of the youthful hero. The revision kept the old origin with one twist—the Kid went to Hell rather than Heaven when he died, and Mr. Keeper and the historical figures he has been summoning were, in fact, demons.

Following on from the mini, a Vertigo *Kid Eternity* series followed in 1993. Written by Anne Nocenti and drawn in the main by Sean Phillips, it was canceled in 1994 with #16 but not before confirming the Kid to be brother of Freddy Freeman, Captain Marvel Jr.'s alter ego.

DC went for the more traditional type of ghost when it launched its **Haunted Tank** series in 1961. Created by writer Robert Kanigher, the tale of the World War II Sherman tank named Jeb Stuart after its commander, and haunted by the ghost of cavalry officer Jeb Stuart, ran in *G.I. Combat* for 26 years.

Beginning in #87 [1961], the strip appeared in virtually every issue until the title was

canceled with #288 [1987]. Among the notable artists associated with it during its long run were Joe Kubert, Irv Novick, and Ross Andru, but *The Haunted Tank* is best remembered for the work of Russ Heath and the remarkable run by Sam Glanzman who worked on 134 consecutive episodes, from #154 until its demise.

As if to prove that DC couldn't keep its monopoly on dead heroes, American Comics Group [ACG] introduced **Nemesis** in *Adventures into the Unknown* #154 [1966].

Created by Shane O'Shea—a pseudonym for editor Richard Hughes who also wrote the series—and artist Kurt Schaffenberger, the spectral avenger was originally Steve Flint, an ex-detective working with the Department of Justice to bring down "the Mafia Chief of the United States." In an origin drawn by Pete Costanza and clearly inspired by the Spectre's, he is killed while pursuing the mobster but given a reprieve by the Grim Reaper upon arriving in the Unknown.

Returning to Earth as Nemesis, Flint is appointed its permanent guardian and uses his powers of super strength, flight, and invisibility together with his ability to grow to giant size to travel through time and communicate telepathically to fight crime. Despite being dead, Nemesis can be drowned, burned, and rendered unconscious by certain gases and poisons. Exposure to strong light can deprive him of all his powers. Nemesis's stay in *Adventures into the Unknown* concluded in 1967 with issue #170.

Not to be pushed out of the hero morgue, DC

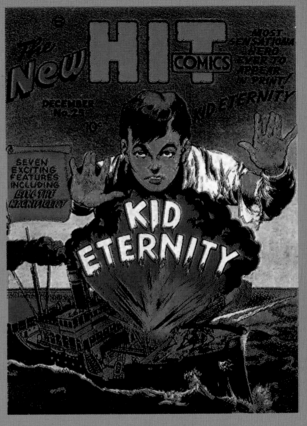

Hit Comics #25 [Quality Comics, 1942].

debuted the aptly named **Deadman** in *Strange Adventures* #205 [1967]. The saga of Boston Brand started out as something of a supernatural version of T.V.'s *The Fugitive* as the deceased circus aerialist hunted for his one-armed murderer.

Created by Arnold Drake and artist Carmine Infantino, the Deadman series in *Strange*

Adventures is highly regarded for Neal Adams' illustration of the other episodes in the run, from #206 to its end with #216 [1969]. Brand's episodic search for his killer was not concluded until later that same year in *The Brave and the Bold* #169.

With his ability to take over any one he needed to, Deadman is an obvious choice for a guest star, a role he has played fairly regularly since his original storyline was wrapped up. He has also starred in a four-issue miniseries [1986] and a brace of two-parters [1989 and 1992]. Preceded by the five-issue *Deadman: Dead Again*, his first ongoing series was launched in 2001, but *Deadman* was canceled after only nine issues.

Marvel wannabe Atlas/Skywald got Michael Fleisher to create its own dead hero. The writer—who had revamped DC's Spectre to great effect in *Adventure Comics*—conceived the idea of an 18th-century highwayman who disguised himself as the **Grim Ghost** and was tried and hanged after being betrayed by a would-be lover.

Given his life of crime, it's hardly surprising that Matthew Dunsinane ends up in Hell where the Devil makes him an offer—burn for eternity or return to Earth and harvest the souls of evildoers. Dunsinane decides the second option to be the more prudent course of action and pursues his new career—in stories drawn by Ernie Colon—through the three issues of *The Grim Ghost* [1975].

The Crow was writer/artist James O'Barr's own dead hero. Debuting in the 1989 first issue of Caliber Comics' showcase anthology *Caliber Presents*, the resurrected vigilante went on to star in a five-issue series. Unfortunately, the small indie publisher was unable to complete *The Crow* [1989], and the black-and-white project was picked up and completed by Tundra.

It repackaged the story of Eric Draven—who returns from the dead as a spirit of vengeance determined to exact terrible revenge on the villains that murdered him and his girlfriend and their drug pusher bosses—as a three-parter in 1992.

Various other incarnations of the Crow have been the focus of a handful of miniseries published by Kitchen Sink Press between 1996 and 1998. Image/Todd McFarlane Productions also produced an ongoing series. Launched in 1999, *The Crow* lasted only 10 issues and did not see the year out.

McFarlane also gave the world his own dead hero. The writer/artist's *Spawn*, mentioned more fully elsewhere, was a best-selling comic book title throughout the 1990s.

An honorable mention should go to **NoMan**, who isn't actually dead but neither is he alive. With his own body now deceased, Dr. Anthony Dunn—an elderly member of T.H.U.N.D.E.R. Agents—can switch his mind from one super-strong android body to another. Equipped with a cloak of invisibility, the 76-year-old scientist is virtually immortal, as long as he can shift his mind out of an android before it is destroyed.

Created by Wally Wood, NoMan first appeared in the first edition of *T.H.U.N.D.E.R. Agents* in 1965. He gained his own two-issue series in 1966.

Blue Beetle I [1939]

The second superhero after Superman to receive his own title, the costumed crime fighter was rookie cop Dan Garrett. Donning a blue chain mail outfit, he started his career in the first issue of *Mystery Men* where he was an ordinary masked lawman until he began taking Vitamin 2X.

Promoted from the back of the Fox Features Syndicate comic, this blatant copy of the Green Hornet became the cover feature from #7 [1940] until the series folded with #31 [1942] by which time he had already gained his own title. Launched in 1939, *The Blue Beetle* lasted until 1948. It was relaunched in 1950 for a further three issues.

Created by artist Charles Wojkowski—who worked as Charles Nicholas—the Beetle also appeared in all seven issues of *Big 3* [1940–42] and in *All Top Comics* in 1947 and '48 as well as single issues of other Fox Features comics.

A *Blue Beetle* newspaper strip was also intended to be one of the main features in Fox Publications' aborted *Weekly Comics Magazine* [1940]. Intended to be a comic book-sized giveaway supplement, three issues were produced although none were circulated.

Blue Beetle II [1964]

Having acquired the rights to several of the by-then defunct Fox Feature Syndicate's heroes, Charlton Comics retitled *The Thing* and published issues #18–21 of *Blue Beetle* in 1955. Although the first two were reprints, #20–21 featured new stories. When Dan Garrett next resurfaced in 1964, he was a completely different character. Reinvented by Joe Gill and artist Tony Tallarico, he was an archaeologist who gained enhanced strength and vision when he said "Kaji-Dha" while holding a scarab amulet found in an Egyptian tomb.

Not particularly successful, Charlton's relaunched *Blue Beetle* comic was canceled in 1965 after just five issues, only to be relaunched for a further five issues mere months later. The second run was numbered #50–54 as, quirkily, Charlton retitled *Unusual Tales* for the revival.

Blue Beetle III [1966]

When Ted Kord debuted as the crime-fighting hero, he inherited the mantle from a now dead Ted Garrett [see Blue Beetle II] who was murdered by Kord's uncle.

Created by artist Steve Ditko, the Kord Beetle made his debut in the back of *Captain Atom* in a series that ran from #83–86 [1967] with Charlton reviving the Blue Beetle title shortly after. This latest incarnation ended in 1968 after the seemingly obligatory five issues.

Subsequently, DC acquired Charlton's superheroes and relaunched *Blue Beetle* in 1986 following Kord's resurrection in 1985's *Crisis on Infinite Earths*. Somewhat more successful than its Charlton predecessors, it ran 24 issues until 1988. A one-time member of

Justice League International, Kord is a regular guest star around the DC Universe although not often seen these days in his secret identity.

Blue Bolt [1940]

They say lightning doesn't strike twice, but it did in Fred Parrish's case, the second time while he was flying a plane.

Surviving the subsequent crash, he regained consciousness in Dr. Bertoff's subterranean laboratory, who saves Parrish and gives him the ability to project lightning. Actually, Bertoff wanted him to use the power to repel an invasion by the hordes of the Green Sorceress.

The costumed hero was conceived by Joe Simon who was joined by artist Jacob Kurtzberg—better known as Jack Kirby—on the second issue of *Blue Bolt*. It was the start of a partnership that was to see the Simon and Kirby duo become a comic book legend.

Blue Bolt ran a total of 119 issues to 1953 with Star Publications taking over from Funnies Inc. with 1949's #102. In #19 [1942], Lois Blake gained similar powers to Parrish and became his costumed aid.

Cable [1990]

Created by Louise Simonson and artist Rob Liefeld, Nathan Dayspring Summers has one of the most convoluted histories in Marvel Comics, and that's really saying something for a company which is so renowned for its complex continuity. As a baby, the son of Scott Summers (a.k.a. Cyclops) and his first wife Madelyne Pryor, the clone of Jean Grey, was infected with a techno-virus by Apocalypse. To save his life, he was taken 2,000 years into the future by one of the Clan Askani, who came to the past to save him.

He was raised by Cyclops and Grey, who had been brought forward in time by Mother Askani—a.k.a. Rachel Summers, the child of Cyclops and Phoenix, from another time line. After his surrogate parents had returned to the past, Summers became linked with The Professor, a sentient orbiting space station that may be Ship, the old spaceship that housed X-Factor. This link gives him the ability to teleport—or bodyslide—himself to anywhere in the world he might choose.

He eventually wound up battling himself in the form of Stryfe, a Nathan clone manufactured by his mortal enemy the seemingly immortal Apocalypse. When Stryfe escaped into the past, Nathan followed him with the intention of preventing his own future being shaped by the Apocalypse of the present day. Adopting the name Cable, he then became the leader of the New Mutants, a team which he was to mold into the paramilitary outfit called the X-Force.

After parting company with the young team, Cable joined the X-Men for awhile but eventually went solo.

Introduced in *New Mutants #87*, he appeared in that title until #100 [1991] when it was

Continued on page 94

Diabolik: The First Comic Book Antihero

From Wolverine and The Punisher to Britain's own master thief the Spider, the idea of the antihero—the hero who moves outside the law—is now a staple of the comics scene. But it was not always the case, and the very first comic book antihero, Italy's Diabolik, caused an uproar when his comic first appeared in 1962.

The brainchild of two Milanese sisters, Angela and Luciana Giussani, Diabolik himself was no hero in the traditional sense; in fact he was a cunning, vicious thief, and, despite a "mature readers" cover warning, the comic's violence and amorality outraged Italian society.

Diabolik wore a mask and skintight catsuit, just like a superhero, but he was very much a bad guy, meting out vengeance on whomever crossed his path. Beyond a deadly ability with his dagger, Diabolik's greatest weapon was his mastery of disguise, which he achieved through an ingenious use of plastic masks.

Two other characters are central to the strip: his faithful accomplice and paramour, Eva Kant, and the dogged Inspector Ginko, his doppelgänger adversary. Cleverly realizing that the public would tire of a totally evil hero, the Giussanis allowed Diabolik his own twisted morality, so his enemies were those that were even worse than him—drug pushers, corrupt politicians, the greedy and unscrupulous.

Visually, the comic has always been stylish and modern, with the 60s strips in particular having a hip, iconic edge. The Giussani sisters initially both published and wrote the strip, but its success allowed additional writers such as Alfredo Castelli, Mario Gomboli, and Patricia Martinelli to come in. The comic's definitive artist has been the talented Sergio Zaniboni, with Enzo Facciolo, Franco Paludetti, Glauco Coretti, and others also contributing.

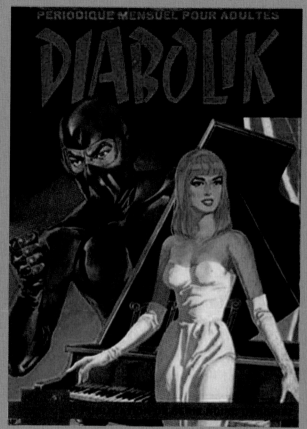

Diabolik #1. The first French issue.

two frames per page, soon became synonymous with violence and sex. This was increasingly the case following the success in 1966 of Giorgio Cavedon's sadistic Isabella, which in turn ushered in a new wave of *fumetti per adulti* ("mature reader" comics).

However, despite, or because of, its notoriety, *Diabolik*'s popularity remains undimmed to this day, supported by an army of fans and merchandise. In 1968, the legendary Mario Bava directed the stylish movie adaptation, *Danger Diabolik*, starring John Phillip Law and Marisa Mell. More recently, in the year 2000, an animated cartoon version proved to be too controversial for Fox in the U.S.A. but became a massive hit in France and elsewhere in Europe. Translations of the comic had earlier appeared across Europe, and a number of issues have recently been released in the United States.

In Italy itself, *Diabolik* still comes out three times a month: a new, unpublished adventure, a first reprinting, *Diabolik R*, and a second reprinting, *Diabolik Swiss*—the "Swiss" being the sound of the character's dagger—rom the title's earliest days. This strategy ensures that each new generation of comics fans gets hooked. Who says that crime doesn't pay?

Inevitably, *Diabolik*'s success spawned a whole industry of imitators in what became known as the *fumetto nero* (black comics) genre. First on the scene was the "skeleton"—costumed Satanik, soon followed by a female thief Kriminal, both created by the team of Magnus and Bunker. The *fumetto nero* format of 128 pocket-sized, black-and-white pages, with

"Despite, or because of, its notoriety, Diabolik's popularity remains undimmed to this day."

A Decade of Change

It could only happen in the funny books. Hardened fans preserve their collections alphanumerically in acid-free clear plastic bags with stiff and equally acid-free backing boards.

The fact they cannot be read is almost like buying a Rolls Royce and never taking it from the showroom for fear of devaluing it. And the fans categorize everything, with a Golden Age, a Silver Age, and even the more recent Bronze Age and Platinum Age.

In comics, specifically U.S. comics, its Golden Age years cover the wild youth of the industry, before and during World War II, when it seemed every publisher and printer was in search of art studios to supply them with the latest superhero. Top sellers regularly broke the million copies an issue mark, appealing to both wide-eyed school kids and equally wide-eyed soldiers looking for invulnerable idols.

So, the top-selling years of the 1940s earned the title of being The Golden Age of Comics. But that period quickly became tarnished as television became a mass-audience bandwagon to jump on and comics almost totally jettisoned their own creations in favor of licensed T.V. spin-offs and replicates. And, naturally enough, it was the biggest publisher of the Golden Age that revitalized the industry in the mid-1950s. Hardly innovating, DC

Comics created a second wave of success for the country's contemporary icons by relaunching the superhero, while western, war, crime, horror, and romance titles were on the wane and science fiction was still a comparatively new genre.

J'Onn J'Onzz Manhunter from Mars was herald to the new age, quietly launching as a six-page strip in the back of the Batman-starring *Detective Comics* #225 in November 1955. But it took a full 22-page revamp of The Flash in tryout title *Showcase* (#4, September 1956) to achieve sufficient critical and sales impetus for Green Lantern, Hawkman, The Atom, The Spectre, and more to follow suit.

Superman, Batman, and *Wonder Woman*, the only titles to have survived the 1950s cull, prospered as part of this revival for superfolk as did back-up strips *Aquaman* and *Green Arrow* which had struggled over the years. For DC, this Silver Age peaked with the reworked *Justice Society of America* superteam as *The Justice League of America*.

With the much-vaunted success of DC's new superteam, a rival company which had various

90

names over the years—Marvel, Timely, and Atlas the best known—proved once more that it could also have been named Carbon Comics. Whenever a new genre achieved success, Marvel immediately launched its imitators. In crime, romance, war, and western, Marvel never innovated but rapidly replicated.

However, in 1961 it did so with panache. In launching its own superteam, *The Fantastic Four*, it found a formula in flawed superheroes which it successfully duplicated for the *Amazing Spider-Man* (an insecure superhero), the *Incredible Hulk* (a misunderstood monster), *Iron Man* (who had everything; money, looks, brains, and a piece of shrapnel lodged in his heart), the Silver Surfer (who made the supreme sacrifice to save his planet and lost his beloved in doing so), the X-Men (mirroring racial bigotry with mutant heroes as a metaphor), and many more.

Marvel's gimmick of aiming at teenagers through its "with-it" approach and imperfect heroes made DC Comics' infallible creations appear bland by comparison. While conservative DC editors scoffed at the almost antiestablishment approach of Marvel men Stan Lee, Jack Kirby, and Steve Ditko, the 1960s became a decade of change for comics, as it had throughout all the entertainment media.

Eventually, DC's sales suffered so badly by comparison, that—along with many other new or revived companies—it hired various Marvel freelancers in a desperate attempt to emulate the latter publisher's style as the superhero once more became America's dominant face of the comic book genre.

Detective Comics #255 [National Periodical Publications, 1955].

Had the term "Golden Age" not already been applied to an earlier period of the industry, this period from 1955 to the late 1960s would surely have been worthy of the title. As it was, it had to settle for the somewhat less worthy appellation and be remembered—though remembered fondly—as The Silver Age of Comics.

Dial H for Hero

In 1966's House of Mystery #156, DC introduced "the boy who can change into 1,000 superheroes"—a hero every one of its adolescent male comic book readers could identify with.

Young Robby Reed is something of a science prodigy who lives with his grandfather in Littleville, Colorado. One day he discovers a mysterious artifact constructed of an unknown alloy, bearing a 10-letter dial with a strange inscription on it. Deciphering the symbols, he learns that dialing H-E-R-O transforms him into some kind of superhero while dialling O-R-E-H restores him to normal.

Created by writer Dave Wood and artist Jim Mooney, the Reed strip appeared in the DC anthology until #173 [1967]. Among the heroes, heroines, aliens, and such that he became were the Gemini Twins, a living sponge named Zeep, Robby Robot, the Human Star-Fish and the toddler-sized Mighty Moppet. He also served to introduce Jack Cole's Plastic Man to 1960s readers, transforming himself into the stretchable Golden Age hero in #160.

As an early example of reader interaction, the gimmick behind Reed's transformations was that fans could send in their suggestions. for the heroes. Among those who participated was Harlan Ellison, who went on to become a renowned S.F. author.

While he was active, Reed learned that dialling V-I-L-L-A-I-N would have the obvious result while a female pal of his got her desire when she dialed H-E-R-O-I-N-E. While losing a battle with the villainous Shirkon of the Many Eyes, Robby dialed S-P-L-I-T but, instead of escaping as he intended, he was transformed into two separate entities, the good Wizard and the evil Master.

The Wizard takes care of Shirkon for him, but the Master sends the H-dial into oblivion, putting an end to Reed's superhero career.

DC revived Dial H for Hero 14 years later in Adventure Comics. Previewed with its own 16-page insert in Legion of Super-Heroes #272 [1981], there was one major difference between the new series and its predecessor, there were two lead characters—Christopher King and Victoria Grant—each of whom posessed their own dial.

Also, this time round, DC made a much bigger deal of the reader involvement angle from the outset; the heroes in the stories were actually designed by fans. Written by Marv Wolfman and drawn by Carmine Infantino, the

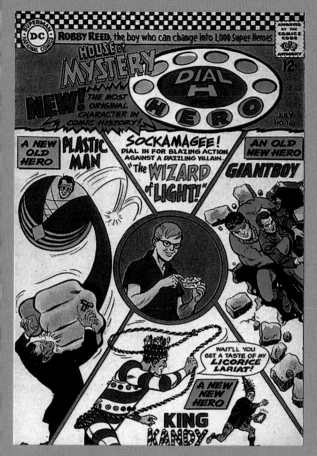

House of Secrets #160 [National Periodical Publications, 1966].

Jimmy Gymnastic, Mister Thin, Plant Mistress, and Purple Haze to battle a variety of super-villains created by the Master, who sought their dials for himself. Although the evil villain believed he had destroyed the Wizard, he had only transported him to another plane of existence where he continued to search for the original dial. Finally discovering its whereabouts, the Wizard uses it to dial himself and the Master back into one being.

This restored Reed promptly gifted his dial to King and Grant's friend Nick Stevens, confirming he no longer had any desire to continue the superhero life.

A budding artist, Stevens' own superhero designs had been credited as the source of inspiration for the characters King and Grant conjured up when they dialed H-E-R-O, heroes who—like Reed's—just happened to have the requisite powers to battle what ever menace they were currently facing.

Bounced from *Adventure Comics* after #490 [1982], *Dial H for Hero* continued as a backup in *New Adventures of Superboy,* where it ran from #28 until the title's 1984 finale with #54.

King went on to use his dial as a member of Teen Titans West. Although the origin of Reed's has never been revealed, it is known that the original H-Dial continues to exist into the 30th century where it was utilized against the Legion of Super-Heroes.

new storyline began when a mysterious voice led the duo to the dials, which were secreted in the attic of a house in Fairfax, New England.

King and Grant spent most of their time conjuring up the likes of Any-Body, Gold Girl,

"The heroes in the stories were designed by fans."

canceled to make way for *X-Force,* where he remained until #18 [1993].

An enormously popular character, he had already starred in 1992's two-issue *Cable: Blood and Metal* but was finally granted his own ongoing series when he made his departure from the team title.

Launched in 1993, *Cable* lasted 107 issues, canceled to make way for *Soldier X* in which the big gun carrying Askani's Son—potentially the most powerful telepath on the planet—sets out to combat terrorism and other such real-world problems.

Captain Atom I [1960]

The first superhero created by Steve Ditko—in this case with writer Joe Gill—debuted in Charlton Comics' *Space Adventures* #33.

U.S. Air Force officer Captain Allen Adam was disintegrated in a nuclear explosion but pulled himself back together again. Now an invulnerable being of pure radiation, he has the ability to fly as well as superstrength and can make himself invisible.

Using his powers to fight Communism in outer space and on Earth, he appeared in the back of *Space Adventures* #33–40 and 42 [1961]. Four years later he was given his own comic—the previously titled *Strange Suspense Stories.* This ran from volume 2 #78 to volume 2 #89 [1965–67].

Captain Atom II [1986]

Following its 1983 acquisition of the Charlton superheroes, DC Comics launched its own version of the Joe Gill/Steve Ditko creation.

Cary Bates and artist Pat Broderick reworked the origin to be that of Captain Nathaniel Adam. A U.S.A.F. officer, in 1968 he had been wrongly convicted of treason and murder. Offered a pardon in return for taking part in an extremely dangerous project, he was flung 18 years into the future where he discovered that not only did he now possess extraordinary abilities but that he'd been written off as dead.

Agreeing to act as a superhero for the government, he was a founding member of Justice League International. Although his first appearance in the DC Universe was in 1985's *Crisis on Infinite Earths*, the new Captain Atom was not actually introduced until he debuted in his own series.

DC's *Captain Atom* was canceled in 1991 after 57 issues.

Captain Marvel II [1967]

The last of Marvel Comics' 1960s superheroes to be created by Stan Lee—with artist Gene Colan—the Kree Captain Mar-Vell was sent to scout Earth's potential as a threat to the technologically advanced alien race. However, the real reason for his existence was that the name was out of copyright and up for grabs

and Marvel's lawyers had suggested the trademark should be grabbed.

Introduced in *Marvel Super-Heroes* #12 in a story continued in #13, he graduated to his own title in 1968. Initially masquerading as a superhero, he sided more and more with humans, which resulted in him being exiled to Earth by the Kree.

With 1969's #17, the series took a change of direction as Mar-Vell became cosmically aware but also intimately linked with Rick Jones. Reminiscent of the relationship between Billy Batson and Fawcett's Captain Marvel, the Kree captain was trapped in the Negative Zone until the former "sidekick" of the Incredible Hulk clashed his "Nega-bands," which caused him to swap places with Mar-Vell.

In 1982 Marvel launched its *Marvel Graphic Novel* series with *The Death of Captain Marvel*. Written and drawn by Jim Starlin who had revived the fortunes of Mar-Vell's own title with a run of critically acclaimed stories on a cosmic scale in #25–34, it featured the death of the hero after a battle against cancer. Acclaimed throughout the comics industry, it went to three printings.

Captain Marvel IV [1993]

Genis Mar-Vell is the son of Marvel Comics' first Captain Marvel. Introduced in *Silver Surfer Annual* #6 in a story by Ron Marz and artist Joe Phillips, Genis was given his father's Nega-bands and adopted the name Legacy.

After a number of guest appearances—most notably in the regular *Silver Surfer* series—he graduated to his own comic in 1995. Despite continuing to use the Legacy sobriquet, the series was entitled *Captain Marvel*. It lasted six issues but shortly after its 1996 cancelation Genis took to calling himself... Captain Marvel.

A further *Captain Marvel* comic was launched in 2000 only to be canceled—with #35—and relaunched in 2002.

Congo Bill [1940]

Introduced in *More Fun Comics* #56 as an explorer, the jungle adventurer went on to became a noted naturalist who refused to kill any animal unless left with no other choice.

Created by Whitney Ellsworth and artist George Papp, Congo Bill appeared in National Periodicals Publications' *More Fun* until #67 [1941] when he transferred across to *Action Comics*. He continued in the latter title until 1959 when his series took a drastic change of direction, adopting a more fantastic tone with the introduction of Congorilla.

Bill had his own title during 1954–55 although it lasted only seven issues. In 1999, Scott Cunningham and artist Danijel Zezelj revived *Congo Bill* as a four-parter. A Vertigo, DC's mature readers imprint, title, it put a much darker edge on the legend of the golden gorilla and the great white hunter.

Continued on page 98

Green Lantern: Superheroes and Drugs

Social commentary in comics is nothing new. Jerry Siegel and Joe Shuster's earliest Superman stories tackled such topics as capital punishment, wife beating, corruption in high places, and workers' rights.

In the 1950s, many EC Comics stories dealt with social inequality and racial prejudice and, in his highly acclaimed *Master Race* [Impact, 1955], Bernard Krigstein tackled the then-delicate issue of the Holocaust. But it was in 1970 that the medium became a platform on which to address the concerns of an increasingly politicized youth movement.

Given a free hand when offered DC's *Green Lantern*, writer Denny O'Neill and penciler Neal Adams took the ailing series in an entirely new direction, first of all bringing in Green Arrow, giving the one-time Batman knockoff a new persona to go with the visual makeover he had received some months previously [in *Brave & Bold* #85, 1969].

They transformed Green Arrow into a radical liberal, as a counterpoint to the establishment conservative that they depicted as the stance of the ring-wielding Green Lantern.

O'Neill, Adams, and the penciler's regular inker, Dick Giordano, began their stint on the title with #76. They opened with a sequence in which Green Lantern saves a businessman from attack only to discover that the victim is a corrupt slumlord, intent on evicting his elderly tenants. One of the tenants, an aging African American, confronts the DC hero with, "I been readin' about you . . . How you work for the blue skins . . . and how on a planet someplace you helped out the orange skins... Only there's skins you never bothered with . . . the black skins! . . how come?! Answer me that, Mr. Green Lantern," to which the only response is a shamefaced, "I . . . can't . . ."

That scene set the tone as, accompanied by Green Arrow and an Oan (one of the blue-skinned Guardians of the Universe), Green Lantern sets out to look for America and discover more about humanity.

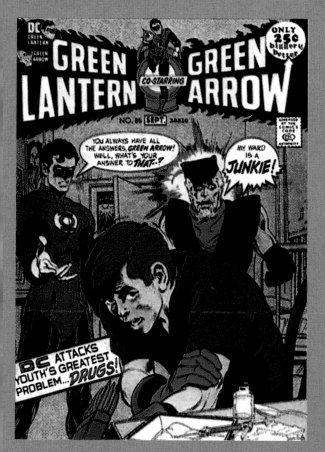

Green Lantern/Green Arrow #85 [DC Comics, 1971].

Across the next 13 issues O'Neill and his collaborators dealt with a wide variety of topical issues including pollution, the lot of Native Americans, religious sects, and overpopulation. They also tackled racial prejudice, introducing John Stewart—an African American and the Guardian's choice to replace Hal Jordan should he ever be unable to fulfill his duties as the current Green Lantern of Sector 2814. But it was in 1971's #85 and 86 that they reached their creative zenith.

The two-part story revealed that Speedy— Robin to Green Arrow's Batman—was hooked on heroin. A brutal and honest portrayal of addiction, many consider this high point of O'Neill and Adams' run a comic book classic.

Just months before the problem was confronted in the now retitled *Green Lantern/Green Arrow*, Marvel was also tackling the growing use of drugs by the nation's youth. In *Amazing Spider-Man* #96 to 98, Stan Lee and pencilers Gil Kane and John Romita chronicle how the wall crawler battles with the Green Goblin while trying to save the life of his drug-damaged best friend.

The fact that the three-parter dealt with the evils of drugs meant nothing to the Comics Code Authority, a self-governing body set up by publishers in response to criticism directed at the industry in the 1950s. Its code forbade absolutely any mention of drugs, whether for good or ill. Risking the wrath of his distributors, Lee published without the Code's seal of approval. Not only did he receive the support of the media and the public, he also succeeded in bringing about changes to the code, which was finally updated to remove some of its more ludicrous restrictions.

Despite O'Neill and Adams' best efforts, *Green Lantern/Green Arrow* was canceled with #89 [1972] following a virtually all-reprint #88. Three decades later, it is still considered a benchmark of the medium.

Congorilla [1959]

A ring bequeathed to him by a dying witch doctor gave Congo Bill the ability to trade identities with a golden gorilla. The former hunter began a series of adventures in which he transferred his mind into the great ape's body that ran through *Action Comics* [1959–60] and then in *Adventure Comics* [1960–61].

A *Whatever Happened to Congorilla?* story in *DC Comics Presents* #27 [1980] was followed in 1992 by a *Congorilla* four-parter.

The Creeper [1968]

Investigative T.V. journalist Jack Ryder made his debut in *Showcase* #73,

Via a serum implant, Ryder has the ability to transform himself instantaneously into his bizarrely costumed alter ego who has greatly enhanced strength and reflexes.

Created by Steve Ditko with writer Don Segall, the one appearance in the DC Comics tryout comic gained him his own title. *Beware the Creeper* was launched in 1968 only to be canceled in 1969 after six issues. One of the DC Universe's perennial guest stars, Ryder also starred in *First Issue Special* #7 [1975], next getting his own back-up series in *Adventure Comics* in 1976, *World's Finest Comics* 1978–79 and *Flash* #318–323 [1983].

He regained a series of his own in 1997, and *The Creeper* was finally canceled in 1998 after just 11 issues.

Daredevil I [1940]

Tortured by the thugs who murdered his parents, Bart Hill grew up mute but made it his mission "to destroy the forces of crime and evil." An acrobat, he armed himself with a boomerang—a reminder of one of the scars he bears—and a metal-spiked belt, and became the crime-fighting Daredevil.

Created by Charles Biro, he first appeared in an eight-page story in Lev Gleason Publications' *Silver Steak Comics* #6. By the following issue, he seemed never to have lost his voice in the first place, and his earlier inability to speak was never referred to again. He continued to appear in the Gleason comic until #17 [1941], although his own title premiered prior to his departure.

With its first issue actually titled *Daredevil Battles Hitler*, *Daredevil Comics* ran 134 issues until 1956. As of #18 [1943], Daredevil gained a new origin. Now he had been lost in the Australian Outback as a child and adopted by a tribe of aborigines who instructed him in the fine art of boomerang throwing.

Daredevil II [1964]

After an accident involving radioactive material, young Matthew Murdock lost his sight but gained compensatory superpowers; all his other senses have been enhanced to the point where his blindness is no handicap.

By day a lawyer, by night a crime-fighting

vigilante, in both roles he serves the underprivileged, putting Hell's Kitchen, a New York slum, under his personal protection.

Daredevil debuted in the first issue of his own title, a series that ran 380 issues until 1998. *Daredevil* was only canceled to make way for its immediate relaunch as a Marvel Knights series.

The highly acclaimed new title highlights the fact that the Man without Fear functions best in a milieu closer to reality than that of most of his Marvel Universe peers.

Darkhawk [1991]

Christopher Powell has a magical amulet that allows him to transform into his armored alter ego. He came by the amulet as he discovered his police officer father was taking bribes from a mobster and uses its powers to atone for his father's misdeeds. A former member of the New Warriors, he also served for a short while with the Avengers' West Coast unit.

Tom DeFalco and artist Mike Manley created the Narvel Comics hero and introduced him in the first issue of his own series. *Darkhawk* was canceled in 1995 with #50.

Deathlok II [1990]

Created by Dwayne McDuffie and Gregory Wright, Michael Collins is a scientist who believes he is developing cybernetic limbs for the disabled. When he learns he is working to create a cyborg killing machine, he winds up with his brain operating it.

Introduced in an eponymous 1990 Marvel Comics four-parter, he went on to star in his own ongoing series. *Deathlok* ran 34 issues from 1991–94.

Demon [1978]

The offspring of the Arch-fiend Bellial of Hell, Lord of Lies and Raan Va Saath, ancient spirit of deceit, was placed under the control of his half-brother, the magician Merlin who used the Demon as a force for good while he served King Arthur of Camelot.

Upon the fall of the kingdom, Merlin chose to bind his demonic sibling within a living prison rather than have him fall into the hands of the enchantress Morgan LeFay or left to roam free across a defenseless world. For his human prison, the sorcerer chose Jason Blood, who gained immortality and magical powers but lost all memory of his dual nature.

Created by Jack Kirby, Etrigan was introduced in the first issue of DC Comics' *The Demon*, a series that lasted 16 issues until 1974. Featured in backups in *Detective Comics*, he next starred in his own eponymous four-parter in 1987.

A serial in issues of the *Action Comics Weekly* anthology followed and then, in 1990, the revival of *The Demon* as an ongoing series, canceled in 1995 after 57 issues.

Continued on page 104

Hank Pym

Hank Pym's first appearance was in The Man in the Ant Hill, a 1962 Jack Kirby and Dick Ayers-drawn story in issue #27 of Tales to Astonish.

A typical one-shot story for one of Marvel's monster anthologies and almost certainly written by Stan Lee, it featured scientist Pym who discovered a fluid which, evaporated, created a gas that could shrink a man down to the size of an ant. When he used it on himself, he ended up trapped in an anthill.

That he returned less than a year later in *Tales to Astonish* #35 is attributed to the sales spike his appearance on the earlier cover had created. In a story plotted by Lee, scripted by his brother Larry Lieber, and drawn by Kirby and Ayers, Pym, replete with a costume and a cybernetic helmet, now retained his normal full-size strength when he shrinks down to tackle communist agents.

Settling in as the lead feature in *Tales to Astonish*, Ant-Man was joined in #44 [1963]—in a story plotted by Lee, scripted by Ernest Hart (as H. E. Huntley), and drawn by Kirby and Don Heck—by a woman who would play a major role in his life. Janet van Dyne was the only daughter of scientist Vernon van Dyne, who had asked Pym to help him on a project to contact other planets for intelligent life. After contacting Pym, van Dyne was approached by him as Ant-Man to become his partner.

As the Wasp, van Dyne is able to shrink down to insect size and grow wings on her back, which enable her to fly, as well as antennae from her forehead, enabling her to communicate with and control insects.

Ant-Man and the Wasp, mutually attracted from the start, stayed together as partners shortly after helping form the Avengers along with Thor, Iron Man, and the Hulk.

Just months after he and Van Dyne became founding members of that team, Pym introduced the second of his superhero identities. He made his first appearance as Giant-Man in *Tales to Astonish* #49 [1963] in a story by Lee, Kirby, and Heck after he discovered that with his formula—dubbed Pym Particles—he could also increase his height to 30 feet with a corresponding increase in strength. He now felt less overshadowed by Thor and Iron Man when working with the Avengers.

Right: Tales to Astonish #27 [Marvel Comics, 1962]

Tales to Astonish #35 [Marvel Comics, 1962].

The Ant-Man series running in *Tales to Astonish*—enamed *Giant-Man* with #49—ended with #69 [1965], so it was in Avengers #28 [1966] that Pym announced his third new identity . . .Goliath. In a story by Lee, Heck, and Frank Giacoia (as Frank Ray), Pym and the

Wasp return to the team after quitting in #16.

Years later, as depicted in *Avengers* #59 [1968] Pym, who was undergoing severe mental stress, had an accident in his labratory, breathing in chemical fumes. His sanity warped and created a fourth identity: Yellowjacket, in which he used his shrinking ability along with a bioenergy gun.

In a story by Roy Thomas and artists John Buscema and George Klein, he announced that he had killed Pym, kidnapped van Dyne, and forced her to marry him. Brought back to his right mind, he and his wife agreed to stay together, despite the less than satisfactory circumstances of their union.

As his mental problems worsened, Pym returned once again to the Avengers, only adding to his stress by his determination to prove himself alongside the heavyweights of the team. As depicted in *Avengers* #213 by Jim Shooter and artists Bob Hall and Dan Green, he built a robot to destroy the Avengers—one installed with a failsafe he could activate to save the day—but the ploy failed, and it was the Wasp who saved the team. Pym promptly quit, and the Wasp filed for divorce.

He found his body could not handle the stress of constant size changing, and he retired from costumed crime fighting. He still joined the Avengers, however, when they opened their West Coast branch in order to oversee the facilities and scientific research.

Pym is now reconciled with van Dyne and back with the Avengers . . .as Goliath.

Right: Tales to Astonish #49 [Marvel Comics, 1963].

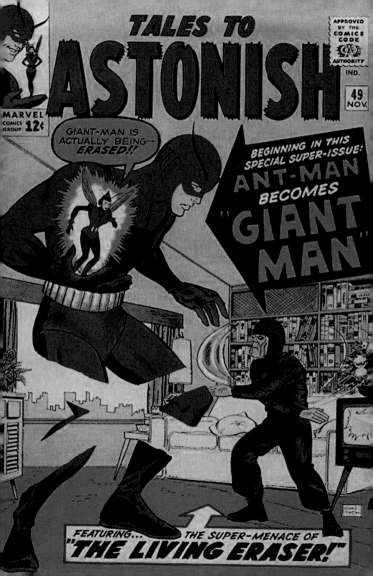

Doctor Solar [1962]

Gold Key's Dr. Phillip Solar became a superhero in pretty much the same way as Captain Atom who preceded him by two years —he pulled himself back together after being disintegrated in a radioactive explosion.

Introduced in the first issue of *Doctor Solar, Man of the Atom*, the eponymous hero was created by Paul S. Newman and artist Bob Fujitani. The series was canceled in 1969 after 27 issues but revived by Whitman Publishing for a further run of four issues during 1981–82.

Although Gold Key did not usually indulge in crossovers, the Man of the Atom also appeared in *The Occult Files of Dr. Spektor* #14 [1975].

Doctor Strange [1963]

At one time a brilliant but arrogant neuro-surgeon, Steven Strange was introduced as Marvel Comics' Sorcerer Supreme in *Strange Tales* #110 by Stan Lee and artist Steve Ditko.

Strange—who had become a wandering vagrant after a car accident—ended up in Tibet seeking The Ancient One, a legendary healer. Taking him in, the old man healed his soul rather than his hands and taught him the ways of magic and the supernatural.

After an appearance in #111, Strange continued to be featured in *Strange Tales* until 1969, although the comic had been retitled Doctor Strange. A charter member of the Defenders, the founder of the Secret Defenders,

and a frequent Marvel Universe guest star, his next series of adventures appeared in *Marvel Premiere* [1972–74] and continued into a new Doctor Strange title—which ran 81 issues from 1974 to 1987—and then through all 19 issues of a revived *Strange Tales* [1987–88].

Marvel launched *Doctor Strange, Sorcerer Supreme* in 1988. Canceled in 1996 with #90, it was followed in 1999 by a Marvel Knights four-parter simply titled *Doctor Strange*. The Master of the Mystic Arts also starred in *Marvel Graphic Novel* #23—*Doctor Strange: Shamballah* [1986] and went on to share the top billing with the Fantastic Four's nemesis in 1989's *Doctor Strange and Doctor Doom: Triumph and Torment*.

Green Arrow [1941]

When he was introduced in National Periodical Publications' *More Fun Comics* #73, Oliver Queen was nothing more than a Batman clone who happened to use a bow and a quiver full of trick shafts including gas arrows, time bomb arrows, and . . . the boxing glove arrow.

Created by editor Mort Weisinger, the Emerald Archer remained in *More Fun* until #107 [1946]. One of the few to survive the postwar slump in interest in superheroes, GA moved from that title to *Adventure Comics* where he featured from 1946 to 1961.

Contemporary with his *More Fun* series, Green Arrow was also appearing in *Leading Comics* as a member of the Seven Soldiers of Victory. In 1942, he gained a second solo

series in *World's Finest Comics*. This ran from 1946 to 1965. In 1977, he returned to the back of the title for a second run till 1980.

Overlooked as a potential member when the Justice of League of America was formed, he joined the team in the 1961 fourth issue of its own title. Justice League of America was to be his only venue from 1965 until 1970 when he hooked up with another emerald hero for the classic *Green Lantern/Green Arrow* series that ran in *Green Lantern* from 1970 to 1972 and continued in the back of *Flash*.

This was followed by a sporadic series of backups in *Action Comics*, which led to a co-starring role for Green Arrow in *Green Lantern* when that title was relaunched with #90 in 1976. The reteaming of the two heroes continued until 1979. In 1982, Queen moved into the back of *Detective Comics* where he appeared until 1986.

A *Green Arrow* four-parter had slipped out almost unnoticed in 1983, but in another four-issue series, writer/artist Mike Grell's *Green Arrow: The Longbow Hunters* thrust the archer into the limelight after years as one of DC's secondary heroes.

Published in 1987, it took a darker approach and led to his own ongoing series after more than four decades. Launched in 1988, *Green Arrow* lasted 137 issues although Queen had died in #101, replaced by his illegitimate son Conner Hawke. The title was canceled in 1998. When it was relaunched in 2001, to much acclaim, the new *Green Arrow* debut brought with it the original Emerald Archer returned from the dead.

Green Hornet [1936]

The masked crime fighter is Britt Reid, publisher of *The Daily Sentinel*. He is the son of Dan Reid, the Lone Ranger's nephew, and funds both his newspaper and his extracurricular activities from the family silver mine where the famed Western hero obtained the material for his bullets.

The Green Hornet was created by writer Fran Striker—who developed the Lone Ranger in collaboration with George W. Trendele for a 1936 radio show that was initially broadcast on a Detroit station but syndicated nationally from 1938.

He was an obvious ancestor of Batman who followed in 1939. He has a youthful sidekick in his martial arts expert valet/chauffeur Kato, pursues criminals in a souped-up car he calls Black Beauty, and uses a variety of gadgets including a gas pistol, which fires sleep-inducing pellets.

He made his comic book debut in 1940's *Green Hornet Comics* #1. With the first six issues produced by Helnit Publishing and the remainder by Family Comics, it was canceled in 1949 with #47.

After next starring in Dell's *Four Color Comics* #496 [1953], the masked vigilante went on to appear in all three issues of Dell Publishing's short-lived *Green Hornet*. A tie-in with the 1966 *Green Hornet* TV series, the 1967 comic book lasted only three issues.

Continued on page 108

Jon Sable: Freelance Children's Author

Lured away from Pacific Comics, Mike Grell was persuaded to hand his Starslayer over to writer John Ostrander and artists Lenin Desol and Mike Gustovich to free himself to create a more traditional superhero for the fledgling First Comics. What the creator of DC's Warlord came up with was nothing like what had been anticipated.

The First management might have been expecting something in the vein of the time-tossed barbarian of Grell's Starslayer or even akin to Warlord's Travis Morgan—a hero adrift in a strange land at the center of the Earth—but what they got bore no similarity to either.

Not only did Grell's new hero have no powers, but bucking the trend toward a darker kind of vigilante as exemplified by Frank Miller's work on Daredevil, former Olympic pentathlete Jon Sable was a retired mercenary with a conscience.

Introduced in the first issue of *Jon Sable, Freelance* [1983], he masquerades as best-selling children's author B. B. Flemm between taking on assignments that were too dangerous or too specialized for less gifted men. A bodyguard, detective, and adventurer, he had left his mercenary days behind him to take up a career as a ranger in an East African safari park. But when poachers killed his wife and children, he set off on a trail of revenge that led him to a life as a soldier of fortune and a new home in New York.

The writer/artist peppered his comic—and Sable's double life—with an interesting array of supporting characters, among them his book illustrator Myke Blackman who, despite the name, was a very attractive woman (not unlike the author's agent and lover, Eden Kendall). Neither character was aware of Sable's alternative life unlike the

septuagenarian stuntman Sonny Pratt who does his best to assist.

Introduced later in the series [#11, 1984] was Lady Margaret Graemalcyn, an allusion to Greymalin, the witch's feline familiar in Macbeth. A cat burglar and semiregular character, Grell spotlighted her in the two issues of a *Maggie the Cat* comic he wrote and drew for Image in 1996.

As of #44, Grell confined himself to writing *Jon Sable, Freelance* utilizing a variety of artists including Judith Hunt, Mike Manley, and Bill Jaaska to illustrate his stories. The series was canceled with #56 [1988] but relaunched immediately as *Sable*.

But Grell had left his creation for a long run on *Green Arrow* following his acclaimed reworking of the DC archer for 1997's *Green Arrow: The Longbow Hunters* three-parter. Taking his place on the new series was longtime comic book writer Marv (*Tomb of Dracula*) Wolfman. Jaaska drew many issues of the relaunch. Retitled to tie in with CBS's short-lived *Sable* T.V. series starring *The Relic's* Lewis Van Bergen as Sable (also known as Nicholas Flemming for the show) and, in her first role, *Lethal Weapon's* Rene Russo as Eden Kendall, it concluded with #27 [1990].

Grell—who featured a version of his freelancer in *Green Arrow* #15–16 and reintroduced the real thing in issues #5–8 of his Image series *Shaman's Tears* [1994]—returned to the character in 2000. A revised and updated version of the origin story, *Sable* is the first in a planned series of novels to be published by Forge.

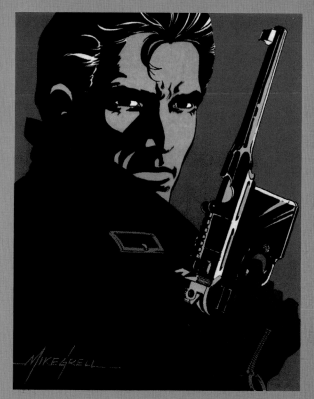

Mike Grell's mercenary turned children's author, Jon Sable.

"Bucking the trend toward a darker kind of vigilante ... former Olympic pentathlete Jon Sable was a retired mercenary with a conscience"

In 1989 Now Comics revived the title but made *Green Hornet* more of a generational saga, featuring various members of the Reid and Kato families across the decades. It published numerous miniseries starring various incarnations of the masked crime fighter and/or his sidekick, but its core *Green Hornet* comic ran from 1989–90 and, relaunched, from 1991 to 1995.

Green Lantern I [1940]

Conceived by artist Martin Nodell, Green Lantern was fleshed out by writer Bill Finger who had done a similar job working on Batman for Bob Kane.

With an ancient Chinese lamp and a ring which, placed in contact with the lamp once every 24 hours, gave him the ability to do almost anything within his imagination, Alan Scott was outfitted in green trousers and red shirt and boots, plus a black mask and purple cape. Green Lantern first appeared in *All American Comics* #16, the start of a series that lasted until 1948 [#102].

Within months of his debut, G.L. also moved into *All-Star Comics* as of #2. Becoming a charter member of the Justice Society of America when the original superteam got together for the first time in the following issue, Green Lantern was to appear in the title until 1951.

His own title debuted in 1941. *Green Lantern* lasted 38 issues until 1949. It was complemented by appearances in *Comic*

Cavalcade #1–29 [1942–48] as well as in *All-Flash* #14 and *Big All-American Comic Book* #1 [1944]. Reintroduced into the DC Universe in *Flash* #129 [1962], the Golden Age Green Lantern—now known as Sentinel—continues to serve with the J.S.A.

Green Lantern II [1959]

As his predecessor followed Flash at *All-American Comics,* so did the new Emerald Crusader follow the Silver Age incarnation of the Scarlet Speedster.

Having decided to revive Green Lantern, editor Julie Schwartz felt a S.F. origin would sit better with contemporary readers. Accordingly he drafted in writer John Broome and—with artist Gil Kane creating the look—together they established the genesis of a millennia-old galactic force for law and order.

Introduced in *Showcase* #22, test pilot Hal Jordan—a charter member of the Justice League of America—went on to two more appearances in the DC Comics tryout comic before graduating to his own series in 1960. *Green Lantern* lasted a total of 205 issues until 1986, although it had been canceled in 1972 with #89 and revived only in 1976. Four years after its second cancellation, the title was relaunched from #1.

Although the 1990 Green Lantern series is still extant, it no longer features Jordan as the eponymous hero, Jordan having become the villainous Parallax, eventually sacrificing himself to save the Earth [*Final Night* #4,

1996]. He has since been resurrected as the current Spectre.

Green Lantern III [1994]

Kyle Rayner possesses the last remaining power ring, formed by the Guardians of the Universe from the remains of Hal Jordan's.

Introduced in *Green Lantern* #48, the youngster was given the ring by the sole surviving Guardian, who literally picked him off the street [#50]. Created by Ron Marz and artist Darryl Banks, Rayner was a member of the New Titans before replacing his predecessor as a member of the Justice League of America.

Grendel [1982]

The masked assassin and antihero who carries a dual-bladed spear—introduced by Matt Wagner in *Comico Primer* #2—is less a person and more an institution.

The Grendel saga spans the past, present, and future but begins with a youngster known only as Eddie. He was a child prodigy and gifted sportsman who changed his name to Hunter Rose while in his midteens, then establishing the Grendel identity and hiring himself out to the New York underworld.

Via high-tech global entertainment, Grendel enters the psyche of the entire human race and ultimately to the entity replacing Satan in the eyes of the Christian Church, which had

returned to dominance in the aftermath of World War III

After expanding on his initial theme in a 1983 Grendel three-parter, Wagner continued in the back of *Mage* between 1983 and 1986 and then in an ongoing *Grendel* series. Launched in 1986, it lasted 40 issues to 1990. In 1992, following the demise of Comico, Wagner took his saga to Dark Horse Comics, initially for *Grendel: War Child*, a 10-issue series that took place a further 500 years into the future. Since then, through Dark Horse, Wagner has continued to produce miniseries and specials.

Hawkman [1961]

A Silver Age reworking of the winged hero Gardner Fox and artist Dennis Neville introduced in 1940's *Flash Comics* #1, Katar Hol was a winged policeman from Thanagar in the Polaris system, giving an S.F. twist to yet another Julie Schwartz-driven revival of a magic-based Golden Age hero.

Revamped by Fox and artist Joe Kubert, Hol and his police officer wife Shayera, a.k.a. Hawkgirl, had been sent to Earth in pursuit of an alien criminal. Their costume was, in fact, the Thanagarian police uniform—giant hawk wings plus an antigravity belt.

Introduced in *The Brave and the Bold* #34, it took Hawkman four years and appearances in the DC Comics showcase series as well as in the back of *Mystery in Space* [1963–64] before

Continued on page 112

A Quarter-Century of S.F. Adventure

In Britain, 1977 is remembered for the explosion of punk rock and the first Star Wars movie. But it also marked the birth of one of the U.K.'s most celebrated comics, 2000 AD.

The weekly science fiction anthology was launched by IPC, one of the country's major publishers. IPC anticipated forthcoming films like *Star Wars* and *Close Encounters of the Third Kind*, creating an interest in science fiction action adventure stories among boys aged 7–11. *2000 AD* was developed by freelance writer Pat Mills to capitalize on that.

The writer had helped launch two previous titles for IPC—the war-themed *Battle Picture Weekly* in 1975 and the ultraviolent, anti-authority *Action* in 1976. These had highlighted the moribund nature of British comics. *Battle* and *Action* abandoned safe old formulas for a new wave of anarchic antiheroes. But *Action* went too far and had to be withdrawn from sale after complaints from parents, retailers, the media, and M.P.s.

Mills took the lessons learned from *Battle* and *Action* to create his most successful launch. *2000 AD's* initial strips were inspired by the popular contemporary films and television,
each given a sci-fi twist. For example, *The Six Million Dollar Man* became M.A.C.H. 1, a British spy aided by compu-puncture hyper-power. *Rollerball* became future sport saga *Harlem Heroes*. Most successful of the new characters was *Judge Dredd*, a futuristic "Dirty Harry"-type character created by John Wagner and Carlos Ezquerra.

The new launch succeeded all expectations, becoming a smash hit. Attempts to replicate *2000 AD* with subsequent launches *Starlord* and *Tornado* failed—both were merged into the weekly title. By the end of the 1970s, *2000 AD* had built up a stable of great characters like Robo-Hunter—a detective stalking deviant droids, inspired by *The Maltese Falcon's* Sam Spade—bounty hunting mutant Strontium Dog, and the A.B.C. Warriors (a team of robots inspired by *The Magnificent Seven*).

The comic had the good fortune to launch just as a new generation of great artists was emerging, looking for a place to showcase

their talents. *2000 AD* unearthed outstanding illustrators like Brian Bolland, Dave Gibbons, Kevin O'Neill, and Mike McMahon—all of whom went on to successful careers in U.S. comics. During the 1980s, the comic did the same for the writers, helping develop the careers of scribes like Alan Moore, Alan Grant, and Grant Morrison.

The comic's popularity peaked in the early 1980s, but it maintained weekly sales of 100,000 copies throughout the decade while all its rivals were dead or dying. The combination of great writing, innovative art, and compelling characters, plus the comic's science fiction theme, helped it stay way ahead of the competition.

2000 AD became a springboard to American comics, the perfect portfolio. Soon U.S. publishers were wooing the top talents with better pay, more recognition, and the promise of royalties. IPC never paid royalties.

Nearly 100 graphic novel collections of strip from *2000 AD* were published, while the comic's characters got exploited on video games, t-shirts, and various other forms of merchandising. But artists and writers, the creators responsible for the actual source material, did not receive a penny.

IPC sold *2000 AD* to British entrepreneur Robert Maxwell in 1987. His company eventually introduced royalty payments by 1990, but the damage had already been done. Several creators refused to work for the comic again. The British retail marketplace became

Right: Tharg, the editor of 2000 AD.

increasingly competitive. *2000 AD* abandoned its cheap and cheerful black-and-white pulp origins for a full-colour, glossy package, but the stories and art struggled to match the quality of the glory days.

In early 1992 the comic was acquired by Danish publisher Egmont, a company more used to printing the exploits of family-friendly Disney characters. The cover price was aggressively driven upward, sales went into decline, and a disastrous change of distributor cost the comic nearly 20,000 in just a few weeks. An $85 million *Judge Dredd* film starring Sylvester Stallone gave *2000 AD* a brief boost in 1995, but the sales figures continued to decline.

In 2000 the comic was sold to the video game development company Rebellion, which has managed to begin a slow revival of the comic's fortunes. *2000 AD* celebrated its 25th anniversary in February 2002, and continues to be published every week, recently passing the landmark of 1,300 issues.

he gained his own title. Launched in 1964, *Hawkman* was canceled in 1968 after 27 issues, the Flying Fury joining his diminutive Justice League of America associate in the retitled *Atom and Hawkman* from issue #39 to 45 [1968–69].

The last incarnation of Hawkman in *Crisis on Infinite Earths* and *Zero Hour: Crisis in Time* has now been consigned to continuity limbo and semireplaced by an imposter, a Thanagarian spy named Fel Andar. A revised Katar Hol version of the Winged Wonder debuted in *Hawkworld* #1 [1989].

Hulk [1962]

Stan Lee and artist Jack Kirby's superhero has become one of Marvel Comics' most recognizable characters.

Caught in the blast of a gamma bomb he had invented, scientist Bruce Banner was transformed into a huge behemoth with incredible strength and little intellect. Unable to control his transformations or the rages that accompany them, Banner is a victim of his circumstances.

Introduced in the premiere issue of his own title, he became homeless when Incredible Hulk was canceled in 1963 after only six issues.

A charter—but soon departed—member of the Avengers, the Hulk plays an integral role in the Defenders. Given his own series in *Tales to Astonish* #60, the Green (originally Grey) Goliath remained in the comic—retitled *Incredible Hulk* with #102 [1968]—until its cancellation in 1999. Relaunched almost immediately as *Hulk*, the still-extant title became *Incredible* with #12 [2000].

A tie-in of sorts with the *Incredible Hulk* T.V. show, Marvel also featured him in his own magazine. *Rampaging Hulk*—truncated to *Hulk* with 1978's #10—ran for 27 issues from 1977 until 1981. A second, comic book-sized *Rampaging Hulk* was launched in 1998 and canceled in 1999 after only six issues.

Iron Man [1963]

At first glance billionaire industrialist Tony Stark is the archetypal playboy secret identity but, unlike many of his peers, he is as hands-on in his day job as he is when he dons the high-tech armor of Iron Man. Stark puts Iron Man, purportedly his bodyguard, on the Stark Industries payroll, thus making him the first corporate superhero.

Introduced in *Tale of Suspense* #39 by Stan Lee and Larry Lieber and artist Don Heck, Iron Man's bulky prototype armor was designed by Jack Kirby. Iron Man continued to appear in *Tales of Suspense* until 1968 in #99. *Iron Man & Submariner* #1 followed. Effectively the next Iron Man issue of *Tales of Suspense*, it segued into the first issue of the Armored Avenger's own title. Launched in 1968, *Iron Man* continued until 1966. Like many other long-running Marvel Comics titles of the time, it was canceled only to make way for the *Onslaught* and *Heroes Reborn* events.

A charter member of the Avengers,

Shellhead as he is known, had his own *Heroes Reborn* title, which ran 13 issues from 1996 to 1997. At the conclusion of the event, *Iron Man* was relaunched in 1998.

John Constantine [1985]

The seedy, down-at-the-heel occultist was initially introduced by Alan Moore and artists Steve Bissette and John Totleben in *Saga of Swamp Thing* #37 but fleshed out by Jamie Delano and artist John Ridgeway in the pages of his own series, Hellblazer.

Despite his impoverished appearance, he is an important player in the supernatural arenas of the DC Universe, although these days his influence is confined to the Vertigo "mature readers" imprint.

After becoming a regular member of the *Swamp Thing* supporting cast, Constantine graduated to his own comic in 1988. This was titled *Hellblazer* although the name has no relevance, being no more than an identifying label for the series. With #63 [1993], the DC Comics title formed part of Vertigo's founding lineup. Still extant, it is the longest running of all the imprint's comics.

Lone Wolf and Cub [1970]

Kozure Okami (literally "A Wolf and His Cub") takes place in mideastern Japan, sometime in the 17th century. It is the story of Ogami Itto and his infant son, Daigoro.

The former high executioner of the realm, Itto is seeking vengeance on the Yagyu clan for the murder of his wife. Forsaking his life as a samurai, he and Daigoro take on the role of paid assassins.

Cited as a major influence by many American creators—most notably Frank Miller, the manga (Japanese comics) series was created by writer Kazuo Koike and artist Goseki Kojima for the weekly *Manga Action*. First appearing in August 1970, the saga ran until 1976 and filled almost 8,500 pages.

When reprinted in book form in Japan, it became an instant best-seller with over 5 million copies sold.

Marshal Law [1987]

Created by Pat Mills and artist Kev O'Neill, and set in the near-future San Futuro eight years after the earthquake they call the Big One, the adventures of Marshal Law began in an eponymous 1986 six-parter which was published by Epic Comics, Marvel Comics' creator-owned imprint.

Continuing the series in Epic's *Crime and Punishment: Marshal Law takes Manhattan* one-shot [1989], the creators then brought their superhero killer home to Britain where he appeared in Apocalypse's *Marshal Law: Kingdom of the Blind* one-shot [1990] before becoming one of the major features of *Toxic*. Launched in 1991 by the publisher

Continued on page 126

Judge Dredd: Lawman of The Future

Britain's best-known comic character of the past 25 years was created by Canadian-born John Wagner and Spanish artist Carlos Ezquerra.

And while the future lawman is inextricably linked with *2000 AD*, the weekly premiered without him. Dredd did not make an appearance until Prog 2 [1977] in a story drawn by Mike McMahon, which so upset Ezquerra that it would be another five years before readers would see the character's designer illustrate a Judge Dredd strip.

Located in what was once the United States during the 22nd century, Joe Dredd is judge, jury, and executioner in Mega-City One. A vast megalopolis with a population of more than 400 million, the city sprawls down the eastern seaboard of the former U.S.A.

The developer of *2000 AD*, writer Pat Mills came up with the Judge Dredd name although he originally intended it for a totally different character. Wagner based the Mega-City lawman whose stock phrase is "I am the Law!"

on Clint Eastwood's hard cop antihero from the 1972 and 1974 *Dirty Harry* movies, adding the fascist overtones in response to Britain's move to the right in the late '70s. The writer also suggested that Ezquerra use the David Carradine character from *Death Race 2000* [1975] for his visualization of Dredd.

Wagner and Alan Grant, his later writing partner on the strip, populated Dredd's world with increasingly bizarre and outrageous villains such as the megolamiac Judge Caligula, the human/robot hybrid Mean Machine Angel, and the Dark Judges—Judge Death, Judge Fire, Judge Fear, and Judge Mortis —beings from another dimension who believe that the only way to stop laws being broken is to eradicate all life.

While Dredd himself is depicted as totally humorless, the writers were not above injecting

black humor into the stories. *The Cursed Earth Saga* [1978]—in which, paralleling the movie based on Roger Zelazny's *Damnation Alley*, Dredd crosses a radioactive wasteland inhabited by mutants, outlaws, and deadly wildlife to deliver an antidote to the plague victims of Mega-City Two—featured a burger war between McDonald's and Burger King. Threat of legal action over the use of company trademarks has prevented the sequence—published in *2000 AD* Prog 71 to 72—from ever being republished. Later in the same storyline, Progs 77 and 78 had the Jolly Green Giant, Speedy the Alka-Seltzer Boy, the Michelin tire man, and other such parodies of brand mascots. These episodes have also never been reprinted.

Reprints have been an integral part of the Dredd success story not only in Britain with titles such as *The Complete Judge Dredd* and a lengthy line of graphic novel collections but also in America where two different publishers —Eagle and Quality—each reformatted *2000 AD* material for the U.S. market.

With the announcement that Sylvester Stallone was to star in a *Judge Dredd* movie, DC acquired the Dredd license and began originating material for American readers. Unfortunately, despite Wagner and Grant's initial involvement, the use of untested U.S. talent with a complete lack of understanding of the character, coupled with the flawed nature of the Stallone version, meant that neither *Judge Dredd* nor *Judge Dredd: Legends of the*

Law lasted long past the film's 1995 premiere.

In Britain at around the same time, Fleetway premiered *Judge Dredd: Lawman of the Future*. Aimed at younger readers, it too was a failure and lasted only 23 issues. However, despite four relaunches, the title's big brother, *Judge Dredd Megazine* has been running continuously since 1990.

Although Wagner and Grant are the two writers most closely associated with Dredd and Wagner continues to script his exploits, others have also handled the Mega-City cop over the years. Notable among them is Mills, who rewrote Wagner's script for the premiere issue after it was deemed too violent. Garth Ennis, Mark Millar, and Grant Morrison also wrote *Judge Dredd*, a launching pad to international success with U.S. publishers and elsewhere, for them as well as for such artists as Brian Bolland, Mick Austin, Steve Dillon, Ian Gibson, Cam Kennedy, and Colin Wilson.

Right: The meanest Judge in Mega City.

Kid Sidekicks: At the Side of the Heroes

Red Ryder's Little Beaver may have been the first comic strip kid sidekick, but there is no indication as to why the strip's creator Fred Harman chose to introduce the young Native American alongside his cowboy hero.

But it is known that the original—and most famous—comic book sidekick was conceived to give the hero someone to talk to. **Robin** was born out of writer Bill Finger's frustration with scripting stories where the protagonist had no one to confide in. Bob Kane's solution was to introduce a kid into the *Batman* stories, one whose name the Batman creator's assistant, Jerry Robinson, claims credit for.

Whoever actually did what at his conception, Dick Grayson a.k.a. Robin—with a costume and persona based to some degree on Errol Flynn's portrayal of the English outlaw in 1938's *The Adventures of Robin Hood*—made his debut in *Detective Comics* #38 [1940].

Wolfman and Perez's *New Teen Titans* was a revival and revamping of a series DC had tested in 1964's *The Brave & The Bold* #54. Conceived by editor George Kashdan and writer Bob Haney, that issue—drawn by Bruno

Premiani—simply brought Robin together with two other teenage sidekicks, **Kid Flash** and **Aqualad**. The trio's next appearance—in Haney and Premiani's #60 [1965]—added **Wonder Girl** to the mix and saw them dubbed the Teen Titans for the first time. The group gained its own title in 1966 following a third tryout—written by Haney and drawn by Nick Cardy—in *Showcase* #59 [1965].

Introduced by John Broome and artist Carmine Infantino in *Flash* #110 [1960], Kid Flash was Wally West. West has grown up to become the new Flash, replacing Allen, who died during 1985's *Crisis on Infinite Earths*.

Now known as **Tempest**, Aqualad first showed up in *Adventure Comics* #269 [1960]. Introduced in a story by Robert Bernstein and

Right: Teen Titans #1 [National Periodical Publications, 1966].

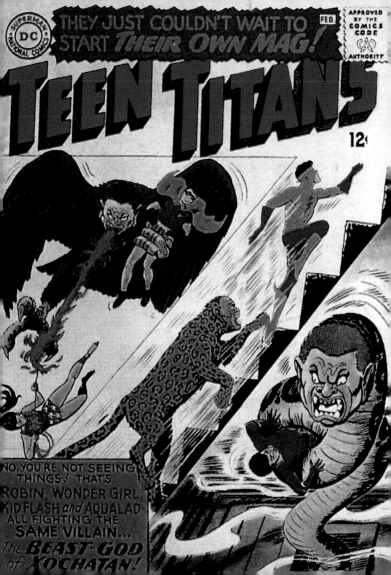

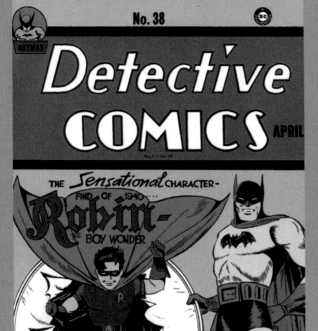

Detective Comics #38 [National Periodical Publications, 1940].

artist Ramona Fradon, he was found by Aquaman, who became a father figure to the young boy Garth. Like his mentor, he cannot go without contact with water for longer than one hour without asphyxiating.

When she joined the Teen Titans, it was actually Wonder Girl's debut outside the pages of *Wonder Woman*, where she had been introduced in #107 [1961]. That story by Robert Kanigher and the Ross Andru/Mike Esposito art team proceeded from the notion that she was the younger version of the comic's eponymous star. Her appearance in *Brave and Bold* #60 established her as a contemporary of her own adult self—a continuity glitch that would take years to resolve.

Although Green Arrow's **Speedy** appeared in *Teen Titans* #4 and 11, he did not join the team until 1969 [#19] although his omission from the formation of the team was considered such an oversight that he was retroactively shown to have been with the Titans since the beginning via a continuity implant. That story, *In the Beginning . . .* appeared in *Teen Titans* #53, the last issue of the series. Written by Bob Rozakis and drawn by Juan Ortiz and John Fuller, it was the untold origin of the team featuring Robin, Kid Flash, Aqualad, Wonder Girl, and Speedy in action together pre-*Brave and Bold* #54.

Over its 53 issues and 12 years, *Teen Titans* also featured Hawk and Dove as well as introducing Gabriel and the Joker's daughter Harlequin. It also chronicled the return of Kathy Kane, the original Batgirl as well as the formation of an offshoot, Titans West.

When Wolfman and Perez revived the concept in 1981, the *New Teen Titans* began a move away from the kid sidekick gang that led to the title being relaunched as *The Titans* in 1999. The original five are still present but now they are Nightwing, the Flash, Tempest,

Arsenal (Speedy), and Troia and have little to do with their mentors. Also in the team are Starfire, Cyborg, Damage, Argent, and Jesse Quick, who are nobody's understudies.

When Raven, the daughter of a human woman and Trigon the Terrible—a powerful extradimensional being—called together the New Teen Titans, Robin, Kid Flash, and Wonder Girl were among the founding members, but it was the introduction of a batch of newcomers which made the team grow and mature beyond the semblance of change that is all too common in comic books. Called forth—in a 16-page preview in *DC Comics Presents* #26— to join the young veterans were the Tamaran princess, Starfire, and Vic Stone, a cyborg. Also joining was an ex-member of the Doom Patrol, Garfield Logan. Better known as Beast Boy, he changed his sobriquet to the Changeling.

Hugely popular, at the height of its success the team was appearing in two monthly titles while a spin-off series, *Teen Titans Spotlight* [1986–88] featured various members in solo action. The main title became *New Titans* with #50 and was canceled in 1996 [with #130]. A companion title, *Team Titans*, ran 24 issues from 1992 to 1994. It featured a group of time-tossed teenagers from a bleak future sent on a mission to kill Donna Troy a.k.a. Wonder Girl.

A new *Teen Titans* series was launched in 1998. Featuring none of the original members, it was canceled in 1998 after 24 issues, replaced the following year by *The Titans*.

Courtesy of writer Doug Moench and the artistic pairing of Don Newton and Alfredo Alcala, Jason Todd stepped into Grayson's

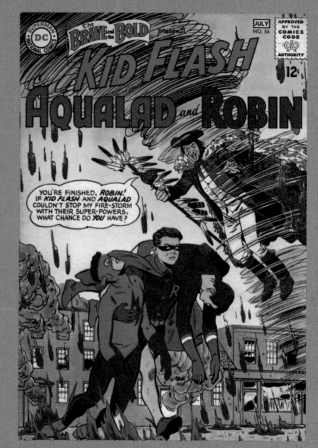

Teen Titans #1 [National Periodical Publications, 1966].

shoes as the Dark Knight's youthful partner in *Batman* #369 [1984]. Introduced in 1983's *Batman* #357 in a story by Gerry Conway, Newton, and Alcala, Todd was then a small boy who tried to steal the wheels off the Batmobile. Todd's parents were apparently dead, his

father killed by Two Face after messing up a job, it transpired, his mother was still alive but being blackmailed by the Joker. The Clown Prince of Crime beat Robin and left him to die in an explosion in a cliff-hanger ending to the penultimate episode of *A Death in the Family*. A four-part story written by Jim Starlin and drawn by Jim Aparo and Mike DeCarlo, it ran in *Batman* #425–428 [1988]. As a publicity gimmick, fans telephone voted as to whether he should live or die with those in favor of his death winning by the narrowest of margins— 50.4% to 49.6%.

Third to adopt the Robin mantle was Tim Drake. Created by Wolfman and artist Pat Broderick, he first appeared in *Batman* #436 [1989], becoming the junior partner in the Dynamic Duo in 1990 [#442] in a story written by Wolfman and Perez.

While Grayson had gone solo as Robin in *Star Spangled Comics* #65–130 [1947–52] and between 1969 and 1982—occasionally teamed up with Batgirl (Barbara Gordon)—in semi-regular back-up stories that appeared at various times in *Detective Comics, Batman,* and *Batman Family*, it was not until 1991 that Robin (Drake) became the star of his own five-issue comic. Robin was followed in 1992 by the four-issue **Robin II** and, a year later, by the five-issue *Robin: Cry of the Huntress* before an ongoing series was launched in 1993. The monthly *Robin* is still running, after 100 issues.

The current Robin is a member of Young Justice, which, unlike the original Teen Titans, is not a hangout for kid sidekicks. Created by Todd DeZago and artist Todd Nauck, aside from Batman's junior partner, its founding lineup consisted of Superboy and the young superspeedster from the future, Impulse. Subsequently the membership has expanded to include Secret, Arrowette, and another Wonder Girl.

The team, which gained its own title the same year, first appeared in 1998's *Young Justice: The Secret* one-shot.

Mere months after Robin's arrival, Marvel— or Timely as it was at the time—debuted the first of its kid sidekicks, in *Human Torch Comics* #2 [1940]—in a story written and drawn by Carlos Burgos, who had created the Human Torch the year before.

Christened Thomas Raymond, Toro was born to Fred Raymond, an expert in flameproofing, and his scientist wife Nora Jones. As **Toro** grew up, his parents learned he was immune to fire.

Following the death of his parents at the hands of the Asbestos Lady, Toro was taken in by circus fire-eaters, incorporating him into their act. The resulting publicity brought him to the attention not only of his parents' killer but also of the Human Torch, whose proximity caused Toro to burst into flame, revealing that he had powers similar to the fiery android.

Toro joined the Human Torch, now his legal guardian, as his crime-fighting partner. He also fought alongside Captain America's sidekick, **Bucky**, in *Young Allies Comics*. Launched in 1941, the series featured the two superhero sidekicks tackling crime aided by a kid gang

Left: Adventures of Captain America #4 [Marvel Comics, 1992].

The Young Allies in Kid Komics #3.

consisting of four caricatures: Knuckles (the tough guy), Tubby (the fat kid), Jeff (the stereotypical bespectacled bookworm), and—for presumed "comic" relief—Whitewash Jones, an African American.

Young Allies ran 20 issues until 1946, being subsumed into *All-Winner's Comics* for that title's 21st, and final, issue. Bucky and Toro had

already been appearing in the title with their adult counterparts and had joined them when they formed the All-Winners Squad along with the Sub-Mariner, Whizzer, and Miss America in the penultimate issue—#19, there was no #20.

Marvel pushed Knuckles and Whitewash into the spotlight to launch a companion title to *Young Allies* in 1943 but Toro, Bucky, and the rest of the gang joined them with the second issue of *Kid Komics*. Also in those first two issues was Subbie, a kid-sized version of the Sub-Mariner who has not been seen or heard of since.

Also introduced in *Kid Komics* #1 was **Captain Wonder** who debuted with a kid sidekick, **Tim**, embarking on a crime-fighting career that lasted only until *Kid Komics* #2.

As for Toro, although he and the Human Torch eventually got back together again—and even saw more retroactive World War II action alongside the Sub-Mariner and Captain America and Bucky in *The Invaders* [1975–79] —his place as the android's sidekick was usurped by **Sun Girl**.

Introduced in the same month that Toro bowed out of *Human Torch Comics* [with #31], Sun Girl debuted in the first issue of her own comic, using a sunbeam ray to blind and confuse miscreants. Sun Girl lasted only three issues. Nothing was revealed about her secret identity, either in that title or during her partnership with the Man of Flame. However, 1990's *Saga of the Human Torch* retroactively showed her to be Mary Mitchell, personal secretary to Jim Hammond, the Human Torch's secret identity. Introduced in *Captain America Comics* #1 alongside Joe Simon and Jack

Kirby's Sentinel of Liberty, Bucky was to prove much sooner than Jason (Robin) Todd that being a kid sidekick could be a deadly game.

James Buchanan Barnes was a ward of the state who accidentally learned that Steve Rogers was Captain America. After undergoing intensive training, he frequently partnered the Super Soldier during the Second World War. In *Captain America Comics* #66 [1948], he is shown being wounded and his place taken by Golden Girl—Betsy Ross, a W.A.C. and secret government agent working for the F.B.I. Chosen as Bucky's replacement by Cap, Ross appeared in *Captain America Comics* #1–75 but as Golden Girl only in #66–69 and Marvel Mystery Comics #88 [1948].

However, contradicting the later stories, when Stan Lee and Jack Kirby resurrected Captain America in 1964 [*Avengers* #4], they retroactively depicted Bucky's death.

As well as his work with Captain America, the Invaders, and the Young Allies, and in *Kids Komics*, Bucky was also responsible for the formation of the Liberty Legion. Although not a member of that team, he brought together the Patriot, Whizzer, Miss America, Red Raven, the Thin Man, Blue Diamond, and Jack Frost initially to fight the Invaders who had been brainwashed by the Red Skull. First appearing in *Marvel Premiere* #29 in a story by Roy Thomas and artist Don Heck, they remained together as the home front equivalent of the Invaders.

With kid gang comics proving so popular and following Timely's lead with Simon and Kirby's *Young Allies Comics*, MLJ put Dusty the Boy Detective and Roy the Super Boy together as the **Boy Buddies** in a Paul Reinman-drawn story in the first [1941] issue of *Special Comics*, a series retitled *Hangman Comics* with #2 and *Black Hood Comics* with #9.

Dusty first appeared in *Pep Comics* #11 [1941] in a story by Harry Shorten and artist Irv Novick. Orphaned when his father was killed during one of the Shield's cases, he was adopted by the patriotic superhero and— despite having no superpowers—became his sidekick. Roy was also an orphan, one who was taken under the wing of Blaine Whitney, a.k.a. The Wizard who trained him to be his sidekick. Introduced by Shorten and artist Edd Ashe in *Top-Notch Comics* #8 [1940], he was also wihout any superpowers.

Just months after MLJ launched its Boy Buddies, Holyoke debuted Jack Grogan and artist Charles Quinlan's **Little Leaders**—a team formed by Mickey, the Kitten, and other youngsters—in *Cat-Man Comics* #8 [1942].

Katie Conn is an orphaned 11-year-old girl who is adopted by David Merrywether, a.k.a. Cat-Man. She is already an accomplished acrobat, so he trains her to fight crime, puts her in a cat costume, and calls her Kitten. She also has no powers and first appeared in a Quinblan-drawn tale in *Cat-Man Comics* #5 [1941]. Very little is known about Mickey (Matthews) beyond the fact that the Deacon saved his life and made him his sidekick in the story—written and drawn by Al Ulmer—in *Cat-Man Comics* #1 [1941] that debuted them both.

A month after the Little Leaders came the **Newsboy Legion**, a DC kid gang that was also

a bunch of sidekicks. Another batch of Simon and Kirby creations, Tommy, Scrapper, Bigwords, and Gabby assisted the Guardian—who they knew was cop Jim Harper—from *Star Spangled Comics* #7 until #63, appearing without the hero in #58 and 64 [1947].

The 1941 first issue of that title introduced a duo that turned the kid sidekick formula on its head. Created by Joe Siegel and drawn by Hal Sherman, the **Star Spangled Kid** was boy millionaire Sylvester John Pemberton III.

The Star Spangled Kid did gain a sidekick closer to his own age for awhile. In *Star Spangled* #81, Pemberton's parents adopted Merry Creamer who had discovered his secret identity and joined him as **Merry the Girl with 1,000 Gimmicks**—replacing his other pal Stripsey who had fortuitously broken his leg—by the following issue. Created by writer Otto Binder, she had no superpowers but used everything from sneezing powder to sticky-glue shooters in her adventures with the Kid, which ended with #90 [1949], his last appearance in *Star Spangled*.

The Star Spangled Kid and Stripsey were also members of the Seven Soldiers of Victory. The team—which also featured Green Arrow and Speedy, the Crimson Avenger, the Shining Knight, and the Vigilante—appeared in all 14 issues of *Leading Comics* [1942–45]. **Wing**, the Crimson Avenger's young sidekick, joined the group with #6. A martial arts expert and valet to Lee Travers, the Avenger's alter ego, he first appeared in *Detective Comics* #20 [1938] at the same time as his crime-fighting partner. *Star Spangled* #7–23 [1942–43] featured writer

Mort Weisinger's "human hand grenade," TNT, debuting in *World's Finest Comics* #5 [1942], complete with sidekick, **Dan the Dyna-mite**.

Retroactively, TNT and the Dyna-Mite were inducted into the All-Star Squadron [*All-Star Squadron* #31–32, 1984]. Following his senior partner's death in *Young All-Stars* #1 [1987], Dan continued as a member of that team.

Just months after TNT and Dan the Dyna-Mite made their entrance, Lev Gleason introduced its own kid gang in *Boy Comics* #4 [1942]. **The Little Wise Guys**—consisting of Dodo, Muggsy, Frank, Gimp, and Specs—disappeared after the following issue.

However, in their place in *Daredevil Comics* #13, published in 1942, came two runaways, Meatball and Scarecrow, who hooked up with two other youngsters, Peewee and Jock C. Herendeen III, to form another gang called the Little Wise Guys.

Created by writer/artist Charles Biro, they became Daredevil's sidekicks and crime-fighting apprentices. As time passed, he came to take a less active role in the stories until, with #70 [1951], when they ousted him from his own title. The Little Wise Guys remained in *Daredevil Comics* until the series was canceled in 1956 with #134.

Very much a product of more innocent times, kid sidekicks are a thing of the past, even if some of them continue to thrive today.

Right: Daredevil Comics #16 [Lev Gleason Publications, 1943].

Apocalypse, the full-color weekly was canceled after only 31 issues.

Marshal Law next turned up back in the U.S.A. at Dark Horse Comics, which reprinted most of his U.K. appearances for the American market as well as featuring him in new miniseries including a crossover with *The Mask* [1998]. He has also starred in a comic book crossover with Pinhead from Clive Barker's *Hellraiser* movies [Epic, 1993] and with Image Comics' *Savage Dragon* [1997].

The Punisher [1974]

While many Golden Age heroes killed criminals in their earliest appearances, it wasn't until Frank Castle appeared on the Marvel stage that there was one who made a career out of assassinating them.

Making his debut in *Amazing Spider-Man* #129, the former Vietnam vet became the Mob's nemesis when his family were murdered after witnessing a gangland execution. Created by writer Gerry Conway and designed by John Romita Sr., the Punisher was inspired by author Don Pendleton's series of *Executioner* novels, the first of which was published in 1968.

The Marvel vigilante finally came into his own in 1986 when he starred in his own title. The five-issue *Punisher*—by writer Steven Grant and artist Mike Zeck—proved hugely popular, leading to the character starring in three monthly titles and a wealth of spin-off one-shots and miniseries. It also opened the

floodgates to a decade of a more vicious kind of antihero.

Hard though it may be to believe, at the height of his popularity, the Punisher was even teamed up with Archie Comics eponymous flagship character, the eternal teenager, in a story that was not played for laughs.

Robot Archie [1952]

The world's most powerful mechanical man made his debut in the first issue of *Lion* in *The Jungle Robot*, a 25-part serial by Ted Cowan and artist Alan Philpott. Designed and built by Professor C. R. Ritchie, the robot was controlled by his nephew, Ted Ritchie.

After that initial story was concluded in 1952, it was five years before Archie would return to the pages of the weekly British comic. When he did come back in 1957 in *Archie the Robot—Explorer*, it was only for an initial 22 issues but, with #299, he began a run that continued unbroken until *Lion* was canceled in May 1974. He was revived in 1990 for a one-shot story in the *Classic Action Holiday Special*.

Silver Surfer [1966]

The Sentinel of the Spaceways was intended as a throwaway character. Harbinger of Galactus, he was introduced into Stan Lee's plot for *Fantastic Four* #48 by artist Jack Kirby who thought the godlike planet eater should have a herald-cum-scout.

The Surfer was originally Norrin Radd. A native of the utopian Zenn-La, he offered to aid the planet devourer in his never-ending quest for worlds to consume in return for the safety of his home planet.

Exiled on Earth by Galactus for siding with humanity, the Surfer was eventually freed to roam the stars again. After numerous appearances in the F.F., he gained his own series. Launched in 1968, *The Silver Surfer*—by Lee and penciler John Buscema—was canceled on 1970 with #18. It was followed in 1978 by a Lee and Kirby reunion on *The Silver Surfer: The Ultimate Cosmic Experience*, a graphic novel published by Fireside Books.

A member of the Defenders and a frequent Marvel Universe guest star, Radd was extremely popular with Marvel fans. Lee collaborated with writer/artist John Byrne on a 1982 *Silver Surfer* one-shot but he didn't get his own series again until 1987—allegedly because of Lee's reluctance to let anyone else write the character.

Premiering with writer Steve Englehart at the helm, the relaunched *Silver Surfer* was canceled in 1998 after 147 issues. In 1988, shortly after the new series premiered, Marvel's Epic Comics imprint published a *Silver Surfer* two-parter by Lee and French artist Moebius.

The character also featured in several Marvel Graphic Novels—*Silver Surfer: Judgment Day* [1988, by Lee and Buscema], *Silver Surfer: The Enslavers* [1990, by Lee and artist Keith Pollard], *Silver Surfer: Homecoming* [1991], and *Silver Surfer: Dangerous Artifacts* [1996].

Solar

Licenced from Gold Key, the Man of the Atom was given a far more radical makeover than Valiant gave to either Magnus or Turok.

The Valiant hero was originally Dr. Phil Seleski, whose interest in physics had been sparked by reading Gold Key's *Doctor Solar Man of the Atom* as a boy in the 1960s. Now heading up the development of an experimental fusion reactor, he suffers the same fate as the Gold Key hero and similarly reconstitutes himself with godlike energy powers. But he doesn't have control of the forces at his command and unleashes them, killing everyone on Earth.

Thrown through time and space, he emerges in an alternate universe where he merges with his counterpart and prevents the accident occurring there. Adopting the guise of his comic book hero, he winds up not only battling Spider Aliens who are attempting to invade Earth but also preventing one of his colleagues from eradicating all existence.

Introduced in the first issue of his own title, Solar 's adventures were initially written by Jim Shooter and drawn by Don Perlin and Bob Layton. *Solar, Man of the Atom* was canceled in 1996 with #60. Acclaim Comics has since published two one-shots: *Solar, Man of the Atom* and *Solar: Man of the Atom—Revelations* as well as *Solar: Man of the Atom—Hell on Earth*, a 1998 four-parter.

Continued on page 132

Warrior: British Comics Come of Age

With fewer than 30 issues in its three-year existence, Warrior was never an enormous success with the general public, but comic fans adored it, and its influence is still being felt today.

The magazine was the brainchild of Dez Skinn, an industry veteran who had come through the ranks at Fleetway, Top Sellers—where he edited *House of Hammer*—and Marvel U.K. While at Marvel, he had initiated a line of all-new strips and, seeing the talent out there, decided that the time was right for a British comic aimed at a more mature audience. Through his newly formed Quality Publishing Company, Skinn released the black-and-white *Warrior* on an unsuspecting world in 1982.

From its first issue, the comic was dominated by the writing of Alan Moore, who scripted both Marvelman and V for Vendetta, creating the stars Laser Eraser and Pressbutton. *Marvelman*, drawn by Garry Leach and, later, Alan Davis, transformed Mick Anglo's jokey 50s strip into comics' first realistic superhero.

Coined by Skinn as an anarchistic revision of Churchill's World War II slogan, "V for Victory," *V for Vendetta*, by contrast, was set in a near-future fascist Britain straight out of Orwell's *1984*. The eponymous hero dressed in a Guy Fawkes costume and started the series off with a bang by blowing up the Houses of Parliament. From there, he brought down the country's corrupt rulers one by one.

Moore had first written about the psychotic half-cyborg bounty hunter Axel Pressbutton in a strip for the music magazine *Sounds*, but for *Warrior* he gifted him to Steve Moore and artist Steve Dillon. Together with the glamorous Mysta Mystralis (Laser Eraser), Pressbutton embarked on a series of demented intergalactic romps which provided a nicely comic counterpart to *Warrior's* grimmer tales. One of the pair's many adversaries, Zirk—a flying, sweating cross between an egg and a pig—soon graduated to its own occasional strip, and *Marvelman* similarly spawned a few companion features, most notably The Warpsmiths and Big Ben.

Rounding out the rest of the comic were a succession of fantasy or sword-and-sorcery

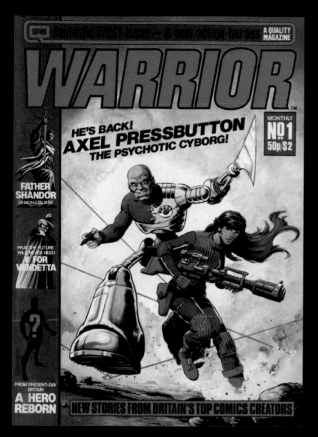

Warrior #1 [Quality Communications, 1982].

strips, most notably the long-running *Father Shandor* by Steve Moore and David Jackson. Shandor had earlier appeared as a vampire hunter in *House of Hammer's* adaptation of *Dracula, Prince of Darkness*—the 1966 movie starring Christopher Lee—but for *Warrior* the doughty priest tackled a terrifying array of demons, led by the seductive Jaramsheela.

Shandor's mix of horror and temptation was heady stuff for a British comic, and right from the start distributors had problems with how to handle the title, its subject matter being clearly aimed at a more mature audience.

Undaunted, Skinn's creators dreamed up a steady stream of features, including Steve Parkhouse's contemplative fantasy *The Spiral Path*, the gritty sci- fi strip *The Twilight World* by Steve Moore and Jim Baikie, and, best of all, Alan Moore's British reply to *The Adams Family*, *The Bojeffries Saga*.

However, a legal complaint from Marvel Comics over the name Marvelman resulted in that strip being replaced by the Spanish S.F. strip *Bogey*. Deprived of its main selling point, the comic was soon canceled. In its last year, *Warrior* introduced a number of excellent text features—mostly interviews with comic creators—and was artistically as good as ever, but sadly it was simply ahead of its time.

However, part of Skinn's plan was to licence *Warrior* strips worldwide and, while it died in Britain, many of its features were reprinted in Europe and the U.S. Marvelman, now called Miracleman, enjoyed a lengthy run at Eclipse Comics, as did Pressbutton, and in both cases reprints were followed by new material. V for Vendetta was finally concluded in a miniseries for DC. New tales of the Warpsmiths, Bojeffries, Zirk, and Father Shandor also appeared in the slick anthology *A-1*.

Most significantly, *Warrior* brought a new generation of British talents to the world's attention and showed how comics could evolve for a new and more mature audience.

The Life and Death of a Manhunter

He may have appeared in only six issues of Detective Comics, but Archie Goodwin and artist Walt Simonson's Manhunter was a benchmark in comic book history.

Launched in 1973, the *Manhunter* series was a thrilling blend of martial arts, mystery, and action. It was Simonson's first major professional assignment, a stand-alone story that still had strong ties to DC continuity. It ran as a backup in issues #437 to 442, moving up to the title's lead feature to conclude in #443 [1974], an extralength episode that also starred Batman.

Manhunter is a clone of Paul Kirk, a big game hunter who turned to tracking men after his friend, Police Inspector Donovan, was murdered. Created by Joe Simon and Jack Kirby, he donned a costume and, as Manhunter, chased his prey through *Adventure Comics* from #73 to #92 [1942–44].

Interestingly, Kirk was originally named Rick Nelson. The change of name—which seems to have been made for no discernible reason—meant he ended up with the same identity as the Manhunter who preceded him in *Adventures Comics*. Created by writer/artist Ed Moore, this earlier version was not a costumed crime fighter but instead wore plainclothes as he tracked down criminals. He appeared in issues #58–72 [1941–42].

Shortly after World War II and returning to his original occupation, the second Kirk was killed by a rampaging elephant. His body was recovered by the Council, a mysterious group of 10 scientists who believed they needed to save mankind from itself. They resurrected Kirk by cloning him and, over the next 25 years, genetically engineered him to have a "healing factor." They then had him trained in ninjutsu by Asano Nitobe, the art's greatest living master, with the intention of making him head of its enforcement branch. But Kirk, having learned of the Council's use of assassinations and vigilante tactics to achieve its aims, has other ideas.

Hunted by an army of his exact duplicates, he joins forces with Interpol inspector Christine St. Clair. Trying to stay one step

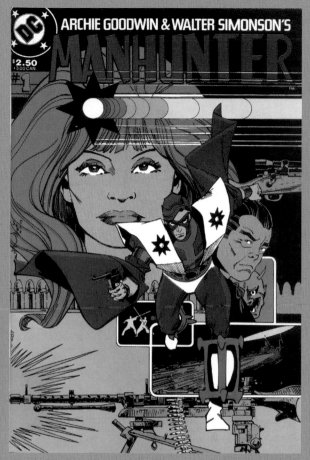

Manhunter #1 [DC Comics, 1984] reprints the entire Archie Goodwin/Walt Simonson saga from Detective Comics #437–443.

Paris. The trail leads to Gotham City where Batman—investigating the death of a friend—becomes embroiled in Manhunter's quest.

Unlike many comic book superhero sagas, especially of the time, *Manhunter* was intended to tell a complete story. It ended not only with his mission accomplished but also with the death of Manhunter and of all but one of his clones—which would later resurface in 1976's *Secret Society of Super-Villains* #1.

Over the years, Goodwin and Simonson had resisted demands for a sequel to their highly acclaimed opus but finally agreed. Unfortunately, although Goodwin had plotted the story, he died on March 1, 1998 after a long battle with cancer. Rather than see it go unpublished, Simonson completed the 23-pager which saw print in *Manhunter: The Special Edition* trade paperback.

This 1999 collection reprinted the original six episodes with a silent final instalment—left without the captions and dialogue Goodwin was unable to provide.

ahead of the doppelgängers' assassins on his trail and to prevent his prospective employers' plans coming to fruition, he races round the globe from the Himalayas to Istanbul and

"Unlike many comic book superhero sagas, especially of the time, Manhunter was intended to tell a complete story."

The Spider [1965]

In physical appearance, he may look something like a Vulcan descendant of *Star Trek*'s Mr. Spock—or of Marvel Comics' Sub-Mariner—but one of the strangest heroes in the history of British comics wanted nothing more to be the King of Crime in America, the place where his adventures were set.

Introduced in the June 26, 1965 issue of *Lion*, the black-clad Spider went on to change sides, taking to catching crooks rather than trying to be king of the underworld.

For many years it was believed that Jerry Siegel created the Spider but, while the Superman cocreator did write some of his adventures, the master criminal who became a hero was actually created by Ted Cowan. Drawn by Reg Bunn, the Spider appeared in *Lion* until December 8, 1973, although the series was reprinted from April 22, 1972.

The Spider also appeared in all the even numbered issues of the digest-sized *Fantastic Series/Stupendous Series* published by Fleetway between 1967 and 1968 [#1–26]. He was last seen in 1992's *2000 AD Action Special*.

Thor [1962]

Until the coming of Stan Lee and artist Jack Kirby's Thor—in *Journey into Mystery* #83—little use had been made of the Norse legends, so the writer and artist were able to go whole hog. They created not only a Marvel Comics interpretation of the Thunder God but of Odin and all the other gods and demons as well as the realm of Asgard itself. They even based many stories on the actual legends, such as Ragnorak, the end of the world.

A charter member of the Avengers, the Thunder God remained in *Journey into Mystery*—retitled *Thor* with 1966's #126—until its cancellation with #502 [1996]. *Thor*—with a new identity—was relaunched in 1998 following *Onslaught* and *Heroes Reborn*, two interlinked virtually company-wide events intended to restructure the Marvel Universe, effectively resetting its clock.

Turok [1954]

In pre-Columbus America, two Kiowa hunters stumbled upon the subtropical Lost Land and discover that dinosaurs still survive there.

Introduced in Dell Publishing's *Four Color Comics* #596, the pair fought to stay alive for more than 25 years, battling dinosaurs and cavemen. After a second *Four Color* appearance in 1955, the Native American graduated into his own title. The Kiowa warrior also appeared annually between 1973 and 1975 in the giveaway *March of Comics*.

In 1992, Turok was revived in Valiant's *Magnus, Robot Fighter* #12 with the Lost Valley—as the Lost Land was also known—now revealed to be an alien dimension.

During the company-wide Unity crossover that—among other things—set up the ongoing *Turok, Dinsoaur Hunter* series launched in

1993, the dinosaurs became bionisaurs, given sentience via intelligence-boosting implants. The Valiant title lasted 47 issues during which Turok—and the bionisaurs—were transplanted to the 20th-century jungles of Columbia.

Valiant—which metamorphosed into Acclaim Comics—published numerous *Turok* miniseries and specials. These continue sporadically as tie-ins with Acclaim Entertainment's hugely popular Turok computer games.

V [1982]

"Me? I'm the King of the Twentieth Century. I'm the Bogeyman. The Villain. The black sheep of the family. I do not have a name. You can call me 'V'." Thus spoke the enigmatic protagonist of *V for Vendetta*, a serial created by Alan Moore and artist David Lloyd for Quality Communications' *Warrior* magazine.

Debuting in the first issue of the black-and-white British anthology, it was set in the dystopian then-future of 1997 when Britain is under the heel of Norsefire, a fascist, racist government. The Guy Fawkes mask-wearing V's actions are motivated by a desire for vengeance rather than the need to destroy the regime, although that is the end result.

Incomplete when *Warrior* was canceled with 1985's #26, the story was eventually concluded when DC Comics published a 10-issue *V for Vendetta* title in 1988. From #7 on, the color comic featured the previously unpublished final chapters in the saga.

Martian Manhunter

While most historians look to the introduction of the Flash in Showcase #4 [1956] as the beginning of the Silver Age of Comics, its roots can be traced back to the previous year.

Detective Comics #225 introduced J'Onn J'Onzz, Manhunter from Mars, DC's first new superhero since the 1940s. With his science fiction-based origin, he was the harbinger of things to come.

Unlike the new heroes that were to follow him, the Martian Manhunter wasn't so much a reworking of a Golden Age character as a virtual duplicate of an existing one, being not much more than a green-skinned Superman.

To be fair to his creators—writer Joe Samachson and artist Joe Certa—they tried not to make the similarities too obvious, but making him a shape-changer while increasing his powers beyond Superman's with limited telepathy and the ability to make himself invisible for a short period of time really didn't fool anyone. Neither did substituting fire for kryptonite as his Achilles' heel.

When he was introduced, it was as an alien accidentally teleported to Earth by a robot brain created by Professor Mark Erdel. His sudden appearance caused the scientist to drop dead of a heart attack. Effectively marooned on Earth, he adopted a human guise

and took up employment as a police officer named John Jones. A founding member of the Justice League of America, he appeared as a backup in *Detective Comics* until #326 [1964] when his series moved across to *House of Mystery* with #143. He remained in that title until #173 [1968] when it was revamped for one-time stories with a supernatural bent.

Beginning with *Detective Comics* #311 [1963], J'Onzz was often accompanied on his adventures by his sidekick Zook. A cute other-dimensional creature, he had sensitive antennae and a variety of small superpowers, including the ability to change his body temperature. In more recent continuity, Zook is a sentient shape-shifting Martian flower, which makes up the "fabric" of the Martian Manhunter's current costume.

Very much a second-stringer living in Superman's shadow, J'Onzz didn't get his own title until 1988. A four-parter, it was followed in 1992 by a three-issue miniseries that looked at his life as Jones during the 1950s and by a 1996 one-shot. In 1998, John Ostrander and Tom Mandrake launched

Martian Manhunter #33 [DC Comics, 2001].

J'Onzz in his first ongoing series in his 40-plus-year history. Among the other things the writer and artist—who had previously revamped DC'S Spectre to great effect—reworked Martian Manhunter's origin to take account of past inconsistencies.

In the revised version, J'Onzz was the last surviving member of his telepathic race, a change that had been made partially to take account of the knowledge that Mars was a dead planet for certain. He had been transported by Doctor Saul James Erdel's teleportation device, not only through space but also through time, to an era centuries after the Martians had been wiped out by a plague started by J'Onzz' twin brother. Rather than dying of a heart acttack as per the original origin, Erdel destroyed his own device and seemingly died in the ensuing explosion.

It had also been established that Martian society had at one time been divided between the more philosophical Green Martians and the militaristic Pale Martians—more of a philosophical distinction than a physical one, as race and gender have little true meaning for a species that can shape shift between male and female or pale and green with only the underlying psychological aspects truly remaining. For interfering with evolution on Earth—and thus preventing humankind from reaching its true superhero potential—the Pale Martians had been exiled to the other-dimensional Still Zone. They would return to plague J'Onzz.

The new origin also removed his weakness to fire, explaining it as a psychosomatic reaction to events he witnessed during the Great Plague.

Although *Martian Manhunter* only ran for 36 issues until 2001, J'Onzz—now a pivotal player in the Justice League of America—no longer plays second fiddle to Superman.

From Out of the East

The Kung Fu craze didn't really catch on until the early 1970s, but comics' first martial arts superhero debuted several years earlier.

Judomaster was World War II army sergeant Rip Jagger. Trapped behind enemy lines on a Japanese-held island, he was rescued by guerrillas who taught him the skills of karate, judo, and jiu-jitsu.

Created by writer/artist Frank McLaughlin, he first appeared in the 1965 fourth (and last) issue of Charlton's *Special War Series*. His move into his own comic the following year resulted in *Gunmaster* being retitled Judomaster—a comic book tradition to do with subscriptions and postal licenses—for his 10-issue run [#89-98] which ended with the title's cancellation.

Judomaster—along with most other Charlton heroes—was acquired by DC in the early 1980s. He was introduced into the DC Universe in 1985's *Crisis on Infinite Earths* although he's rarely been seen since.

Eight years after *Judomaster* first appeared and following the worldwide success of Bruce Lee's *Enter the Dragon* movie [1973], Marvel decided to jump on the kung fu bandwagon, introducing the son of Fu Manchu in the 1974 fifteenth issue of *Special Marvel Edition*. Until then a superhero reprint series, it was retitled

Master of Kung Fu with #17 and lasted until 1983's #125. Although created by Steve Englehart and Jim Starlin, Shang Chi was brought to prominence by another writer/artist team, Doug Moench and Paul Gulacy, whose work on the title is considered to be a high point of 1970s comics.

Not content with a single two-fisted hero, five months after premiering its *Master of Kung Fu*, Marvel introduced a martial arts team.

Debuting in the 1974 first issue of the black-and-white *Deadly Hands of Kung Fu* magazine, the multiracial **Sons of the Tiger** consisted of three martial arts school students whose dying sensei gave them a jade pendant each which endowed them individually with their combined strength.

The series ran until the black & white magazine was canceled in 1977 [with #33]. For a short while, it also featured the White Tiger. The first Puerto Rican superhero, the amulets gave him the power of their three previous owners. A month after the *Sons of the Tiger* first appeared, **Iron Fist** debuted in *Marvel Premiere* #15 [1974].

Special Marvel Edition #15 [Marvel Comics, 1973].

More of a traditional superhero than Shang Chi, young Danny Rand was raised in K'un-L'un, a Shangrila-cum-Brigadoon-style land that could be entered from Earth only once a decade. At the age of 19, he gained the superhuman power of the "iron fist" after a rite of passage which involved him slaying a dragon. Leaving the Himalayan sanctuary, he returned to the United States to avenge the deaths of his parents.

Not as successful as his predecessor, this Roy Thomas and artist Gil Kane creation gained his own title after a run on *Marvel Premiere* that concluded with 1975's #25. Following *Iron Fist's* cancellation with #15 [1977], he teamed up with Luke Cage in *Powerman* [#48], forming Heroes for Hire within the retitled *Powerman and Iron Fist*. Since that title ended with #125 in 1986, he's been a perennial guest star around the Marvel Universe with a slight raise in prominence when Marvel revived the Heroes for Hire concept as a more ambitious superteam for its own short-lived series. *Heroes for Hire* lasted 19 issues until 1999.

It took DC a year to follow Marvel's leap onto the martial arts bandwagon but, by 1975, the craze was already passing its peak. Not only was the publisher late in getting on board, it didn't even do so with an original property.

Based on the novel *Dragon's Fists* by Jim Denny (a.k.a. comic book writer Denny O'Neil), **Richard Dragon, Kung Fu Fighter** was the story of a reformed petty thief who joined the secret agency G.O.O.D. after being taught the martial arts by the O-Sensei. It was to last only 19 issues, although Dragon occasionally pops up in the DC Universe.

If DC was late getting in on the act, Atlas/Seaboard was even later, if only by a couple of months. The short-lived Marvel knockoff *Hands of the Dragon*, the last of the 1970s kung fu titles, lasted but a single issue.

Monsters, Demons, the Undead, and Marvel

There had been vampires, werewolves, zombies, and similar harbingers of evil in comic books in the past but never before as the stars of their own titles.

This had certainly been the case since the 1954 implementation of the Comics Code Authority, which had exterminated them via its General Standards. That all changed late in 1971 when the code relaxed its restrictions, among other things diluting clause 5 to:

"Scenes dealing with, or instruments associated with walking dead, or torture, shall not be used. Vampires, ghouls and werewolves shall be permitted to be used when handled in the classic tradition such as Frankenstein, Dracula, and other high caliber literary works written by Edgar Allen Poe, Saki, Conan Doyle and other respected authors."

Marvel, via Stan Lee's antidrugs story in *Amazing Spider-Man* #96–98 [1971] had been instrumental in prompting the changes. Already dabbling in horror and the supernatural with such 1969 anthologies as *Chamber of Darkness* and *Tower of Shadows*, it seized the opportunity to up the stakes with the creation of a bunch of horrific antiheroes.

With horror movies typified by *Count Yorga, Vampire* [1970], Ken Russell's *The Devils* [1971], Vincent Price in *The Abominable Dr. Phibes* [1971], and Amicus's EC-adapted *Tales of the Crypt* [1972] as well as Hammer flicks such as *The Vampire Lovers* [1970], *Countess Dracula* [1970], and *Dr. Jekyll and Sister Hyde* again proving popular, the move also made sound commercial sense.

Marvel had already moved to get round the Code, launching *Savage Tales* in early 1971. A black-and-white magazine aimed at a more mature audience, the anthology was outside the CCA's remit.

Although the cover of that title's first and only issue for more than two years featured a particularly bloodthirsty rendition of Robert E. Howard's Conan, the magazine also marked the first appearance of Man-Thing, a shambling, once-human mound of rotting vegetation which went on to its own color series. The character was conceived by Roy

Thomas as his tribute to S.F. author Theodore Sturgeon's short story *It* and to the *Heap,* Hillman's muck monster of the 1940s.

Thomas was also instrumental in the introduction of the second of Marvel's monstrous 70s heroes. In collaboration with artist Gil Kane, the writer debuted Michael Morbius in *Amazing Spider-Man* #101 [1971].

Described as a living vampire, **Morbius** can be viewed as a somewhat tentative approach to the changing code. Although his looks, abilities, and need to drink blood were commensurate with those of the traditional bloodsucker, his origin had no mystical overtones. His curse was self-inflicted. A scientist, he sought to cure himself of a rare blood disease with unfortunate side effects.

In 1973, Marvel launched a line of black-and-white horror magazines. Morbius began his solo career in the first issue of *Vampire Tales,* where he was an almost continual feature until the title folded with #11 [1975]. He also followed Man-Thing into *Adventure into Fear.* His series ran in that title from #20 [1974] until it too was canceled in 1975 [with #31].

As part of a 1990 plan to market different facets of its universe more easily, Marvel compartmentalized all its heroes, branding the supernatural ones part of its Midnight Sons line. For that quasi-imprint, it resurrected the character Morbius, who became a regular in the *Midnight Sons Unlimited* anthology that lasted nine issues from 1993 to 1995. He also gained his own title. Launched in 1992, *Morbius the Living Vampire* was also canceled in 1995, after 32 issues.

Morbius: The Living Vampire #1 [Marvel Comics, 1992].

Shortly after Morbius made his debut, Marvel introduced a more traditional horror creature in Jack Russell, who was otherwise known as **Werewolf by Night**.

Thomas also had a hand in this werewolf's creation, handing over his basic idea of Spider-Man combined with 1950s horror flick, *I was a Teenage Werewolf,* to writer Gerry Conway who fleshed the character out over his first three appearances, in *Marvel Spotlight* #2–4 [1971–72] and the first four issues of the *Werewolf by Night* title that followed shortly after. The origin of the Transylvanian born Jacob Russoff involves his werewolf-bitten great-grandfather, a mystical book known as *The Darkhold*—which would be the subject of the 16 issues of a *Darkold Midnight Sons* title between 1992 and 1993—Dracula, and a family curse that, after his 18th birthday, turns Russoff/Russell into a werewolf for three days every month when the moon is full.

Hunted and feared but more misunderstood than evil, Russell manages to kill only bad guys during his lycanthropic rampages. His series lasted 43 issues. Canceled in 1977, *Werewolf by Night* introduced Marvel's version of Batman—Moon Knight, a soldier of fortune hired by The Committee to hunt the werewolf down—in #32 [1975]. It also changed direction when Russell became a crime fighter after gaining the ability to transform himself at will, although the bestial side still dominated at full moon, thanks to the mystic entity known as *The Three Who Are All* [#38–41, 1976].

In 1998, after more than 20 years as an occasional guest, Russell was again given his own title. Revived as a mature readers title under the newly established and short-lived *Strange Tales* imprint, the revived *Werewolf by Night* was folded into the relaunched *Strange Tales,* but the anthology—which he shared with the resurrected Man-Thing—lasted two issues.

Another 1970s horror resurrected under the Midnight Sons brand was **Ghost Rider**, who was originally Johnny **Blaze**, a stunt motorcyclist who made a deal with Mephisto to save his stepfather "Crash" Simpson from cancer.

But, as with all such contracts with the Devil, there was a catch . . . Simpson died in an accident instead. Blaze becomes possessed by the demon Zarathos and transformed into a fiery skull atop a skeleton clad in leather biker's gear and riding a flaming motorbike. As Ghost Rider, Blaze possesses superhuman strength and has the ability to create walls of flame, throw fireballs, and overwhelm the victim with psychic trauma brought on as a result of their past misdeeds.

Created by Gary Friedrich and artist Mike Ploog—who also drew *Werewolf by Night's* first 12 appearances—Ghost Rider debuted in *Marvel Spotlight* #5 [1972] and stayed until #11 [1973] when he graduated to his own title. *Ghost Rider* lasted 81 issues [until 1983] and concluded when Blaze drove Zarathos from his body. Between 1975 and 1978, Ghost Rider appeared in *The Champions*, sitting uneasily alongside such other members of this West Coast superteam as Angel and Iceman—two former X-Men—the demigod Hercules and Black Widow, a former Communist agent.

When Ghost Rider returned as a *Midnight Sons* title in 1990, the look had been updated and the alter ego changed. The demonic biker was now teenaged Danny Ketch who had become mystically linked with a Spirit of

Vengeance who declared his mission to be to punish all who spill innocent blood. The new 'Rider is a violent vigilante who forces criminals to feel the pain they inflicted on their victims.

Conceived by writer Howard Mackie, the relaunched series lasted 93 issues until 1998. It was complemented by *Ghost Rider/Blaze: Spirits of Vengeance*. The title—which ran 23 issues from 1992 to 1994—teamed the 1990s Ghost Rider with the now mortal Johnny Blaze, who was actually Ketch's long-lost brother.

It also introduced **Vengeance**, who starts out as the demonic biker's evil opposite. Like Ghost Rider and Blaze, former cop Michael Badilino possesses a third of a mystic medallion. His piece transforms Badilino into Vengeance, a bigger, meaner version of Ghost Rider—who can shoot spikes out of his head and body—while Blaze's allows him to absorb some of Ghost Rider's hellfire and channel it through his shotgun and knife.

After the team title's cancellation Blaze went solo, first in the 1993 four-parter, *Blaze: Legacy of Blood* and the following year as the star of an ongoing series canceled after 12 issues. In 2001, Marvel resurrected Blaze as Ghost Rider—repossessed by Zarathos after losing his wife and family—for a six-issue mini.

Marvel next turned to the archetypal vampire, Bram Stoker's **Dracula**, who debuted in the 1972 first issue of *Tomb of Dracula*. The initial inspiration was Stan Lee's but it was left to Conway and artist Gene Colan—who was to remain with the title until 1979 when it was canceled after 70 issues—actually to transfer the vampiric Count to comics.

The writer left after four issues, replaced by Silver Age great Gardner Fox who wrote only #5 and 6. Marv Wolfman took over with #7, remaining on *Tomb of Dracula* until its end. Rather than concentrate solely on Dracula, a creature both noble and honorable despite his lust for blood, they also focused on a team of vampire hunters that dogged his heels.

Inherited from Conway, they were the Count's direct descendant Frank Drake, his partner Rachel van Helsing, granddaughter of his original nemesis Abraham van Helsing, her elderly guardian Quincy Harker, wheelchair-bound after a lifetime of vampire hunting, and Taj, the mute Indian giant who served both van Helsing and her guardian.

First appearing in #10 [1973] Blade was possibly the most successful comic book character introduced at Marvel in the past 30 years. Although unable to hold onto his own title for any length of time, **Blade** has been the star of two movies, both of which have scored very big at the box office.

A human/vampire hybrid, the vampire-slaying African American has his own agenda —to destroy Deacon Frost, the bloodsucker that killed his mother as she was giving birth to him. He went solo in *Vampire Tales* #8–10 [1974–75] and then had the third [1975] issue of the black-and-white *Marvel Preview* magazine all to himself. He also featured in the anthological #8, the *Legion of Monsters* issue, sharing it with Morbius among others.

All but dropping out of sight, Blade was revived in 1992 in a team title that also featured two other *Tomb of Dracula* alumni—

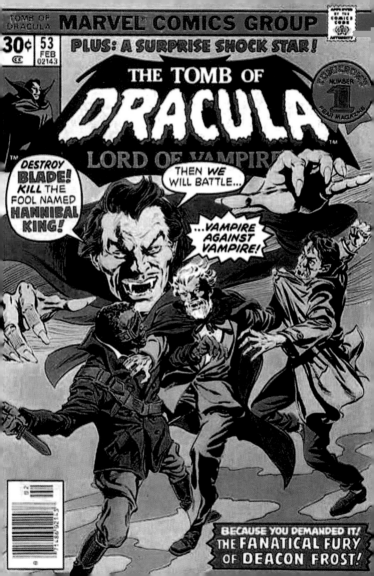

Drake and **Hannibal King**. Introduced in ToD #25, the latter has enhanced strength, speed, and reflexes as a result of his encounter with Frost. He is also able to transform into mist, command rats, and change into a wolf or bat.

Following the cancellation of Midnight Sons' *Nightstalkers* with #18 [1994], Blade gained his own title. *Blade the Vampire Slayer* was short-lived, canceled in 1995 after just 10 issues.

Since then Marvel has made a number of abortive attempts to establish the vampire slayer in his own title. In 1998 *Crescent City Blues*, a Blade the Vampire Hunter one-shot preceded *Blade: Sins of the Father*, an adaptation of the *Blade* movie starring Wesley Snipes as the Daywalker and an ongoing series that was aborted after just three issues. A *Blade: Vampire Hunter* series followed in 1999. It lasted only six issues as did *Blade*, a 2002 series published by Marvel's MAX—mature readers—imprint and intended to take advantage of the release of Snipes's *Blade 2*.

Marvel also made a number of attempts to emulate the success of Wolfman and Colan's *Tomb of Dracula*, beginning by reviving the title for a short six-issue run in 1979–80. The publisher even got the writer and artist back together for a four-issue series via Epic, its creator-owned imprint. Intended to pick up the story from the vampire Count's death in ToD #70 and to ignore the error of judgment made in making him a Marvel-style villain and a foe of the X-Men, the 1991 *Tomb of Dracula* was titled *Day of Blood, Night of Redemption*.

Left: Tomb of Dracula #53 [Marvel Comics].

Wolfman and Colan also reunited for *Curse of Dracula* [1998], a three-issue series in which they attempted to continue their version of the saga at Dark Horse but without the supporting cast who were Marvel copyright characters. In the same year, Glenn Greenberg and penciler Pat Oliffe produced *Dracula: Lord of the Undead* for Marvel. Another three-parter, it was intended to spotlight the return of the archetypal vampire after Doctor Strange had first eliminated and then resurrected vampirism in the Marvel Universe.

It was Thomas's idea to follow Dracula with another horror icon, **Frankenstein's Monster**. This time he handed the assignment over to Friedrich and Ploog, who adapted Mary Shelley's novel across the first four issues of *The Monster of Frankenstein*—retitled *Frankenstein's Monster* with #5—as they explained the author's story was a true tale disguised as fiction and then continued to chronicle the journey of Victor von Frankenstein's monstrous creation at first across 19th-century Europe and then, in other hands, in contemporary America.

Frankenstein's Monster was canceled in 1975 with #18. The monster was also featured in a series of stories in issues #2–10 of *Monsters Unleashed*, another of Marvel's black-and-white magazines. Set between *Frankenstein Monster* #12—which jumped the story from the 19th to the 20th century—and #13, the strip recounted its earliest adventures in the new century.

With the wholesale cancellation of its horror magazines in 1975, Marvel used up all its inventory material in *The Legion of Monsters*.

143

Blade: Crescent City Blues #1 [Marvel Comics].

This 1975 one-shot featured not only the monster but also introduced the **Manphibian** —a centuries-old creature, hunted by mankind but seeking only the murderer of its life mate— in its one and only appearance and continued

Thomas and artist Dick Giordano's adaptation of Stoker's Dracula from *Dracula Lives!* #5–9. Launched in 1973, the first of Marvel's black-and-white horror magazines, *Dracula Lives!* featured the Count in historical and contemporary stories plus articles on Dracula movies. It was followed by *Monsters Unleashed*, which, besides Frankenstein's Monster, featured Man-Thing and Werewolf by Night and introduced Robert E. Howard's sword-wielding puritan, Solomon Kane.

Doubling the line, two more horror mags were launched almost immediately; *Tales of the Zombie* and *Vampire Tales*—which featured Blade and Morbius strips and introduced **Satana** in issue #2. She is the sister of Daimon Hellstrom, who debuted at virtually the same time but in *Marvel Spotlight* #12 [1973]. Demon/human hybrids, they are the children of a union between Satan and a mortal woman.

The younger of the two, Satana can levitate, mentally control others, and project bolts of mystical "soul fire" that cause excruciating pain, and she is also a master sorcerer.

A minor character, apart from occasional supporting roles in her brother's series, Satana's other appearances have been pretty much limited to solo stories in *Vampire Tales*, *Marvel Premiere,* and another black-and-white magazine, *Haunt of Horror*.

Her brother, on the other hand, was one of the more successful of Marvel's supernatural heroes. Better known, for obvious reasons, as the **Son of Satan**, he appeared in Marvel Spotlight until #24, graduating immediately to his own title in 1975.

Created by Friedrich and artist Herb Trimpe, Hellstrom was abandoned by his father when Satan took Satana to Hell with him. Growing up among mortals, he decides to become a priest, but his father reveals his true ancestry to him, telling him he is part devil. Hellstrom also learns that, as a result of his heritage, he has a Darksoul. This grants him great physical strength, the ability to radiate soul fire, and to communicate with the dead. He can also perform exorcisms, fly, and travel back and forth through time.

Turning his back on his father, he sets himself up as a demonologist. As much superhero as supernatural, in 1974 he began working frequently as a member of the Defenders, continuing with that nonteam until 1983—this being long after *Son of Satan* was canceled with #8 in 1977.

In 1993, writer Rafael Nieve and artist Michael Bair rescued Son of Satan from near oblivion and put him back in his own series. The retitled *Hellstrom: Prince of Lies* was an attempt to update the character specifically for the mature readers market, making him more grim and foreboding.

British writer Warren Ellis came on board with #12 and had Hellstorm set himself up in opposition to both Heaven and Hell, claiming that the two entities were the enemies of humanity. By the time the series ended with #21 [1994], the Son of Satan had replaced his father as master of Hell.

Lilith was another female horror who went solo in *Vampire Tales*. Introduced in *Chillers Giant Size* #1 [1974], she was Dracula's daughter, a vampire who not only had powers that were far greater than any other of the species (apart from her father) but also had none of the weaknesses.

Very much a *Tomb of Dracula* supporting character, her solo appearances have been restricted to *Vampire Tales*, *Dracula Lives*, *Marvel Preview,* and in the final two issues of the *Tomb of Dracula* magazine.

When Stan Lee handed Roy Thomas the task of launching a magazine titled *Tales of the Zombie*, Thomas found just the right creature for the cover feature . . . Simon Garth, a character created by Bill Everett for a one-shot story in *Menace* #5 [1953].

A despotic boss, Garth is killed by his gardener, Gyp, who has him resurrected as one of the undead under his control. Gyp then loses the talisman that allows him to control the zombie and is the first to die at his hands. The talisman passes through many hands before Garth is able to make amends for his life and find eternal rest. The series, written by Steve Gerber, ran until issue #9, but the zombie has since walked in *Bizarre Adventures* #33 and made an appearance in the first issue of 1998's truncated *Strange Tales* revival.

Having already tackled Dracula and Frankenstein's Monster, Marvel next turned to the third horror movie staple, the **Mummy**.

Acting on another suggestion from Lee, Thomas passed the concept on to Gerber and artist Rich Buckler, who introduced the *Living Mummy* in *Supernatural Thrillers* #5 [1973]. Originally N'kantu, the chief of the Swarili, he and his tribe were enslaved by the Egyptians

and commanded to build a pyramid for the Pharaoh, Aram-Set. Learning that the Pharaoh plans to kill them all once the pyramid is complete, N'Kantu leads an unsuccessful rebellion that results in the Pharoah's death. As punishment, the high priest Nephrus has N'Kantu's blood replaced by a special serum that keeps him conscious but immobile. Swathed in bandages, he is entombed in a sarcophagus and remains hidden beneath the sand until the paralysis wears off. But three millennia have passed before that occurs, and his incarceration has sent him insane.

Initially running amok through the streets of Cairo, he is rendered unconscious by a broken power line. Lying in a coma for several weeks returns his sanity for the beginning of a series of stories that ran in *Supernatural Thrillers* from #7 until the title's cancellation with #15 [1975]. Since then, the Living Mummy has occasionally been spotted in other Marvel titles.

Immediately after the Living Mummy came **Man-Wolf**, Marvel's second quasi-horror creation. As an astronaut, John Jameson was involved in a lunar landing during which he discovered a red gemstone which he had made into a pendant when he returned to Earth. Unfortunately, when the light of the full moon first touched the gem, it grafts itself onto Jameson and transforms him—reducing his intelligence, heightening his senses, and giving him superstrength and reflexes as well as deadly claws and fangs.

Introduced in *Amazing Spider-Man* #124 [1973], Man-Wolf was created by Conway and artists Kane and John Romita. He appeared in the next two issues of the web slinger's title before being launched into his own series beginning in *Creatures on the Loose* #30 [1974]. Kicked off by writer Doug Moench and artist George Tuska, the story changed direction dramatically when David Kraft and artist George Perez—making his professional debut—came on board with #35.

With #36, they sent Man-Wolf on a space adventure, which took him to the extra-dimensional Other Realm, the origin of his moonstone. There Jameson retained his personality and intelligence as the Man-Wolf. From the inhabitants of Other Realm he learned the stone had been created centuries before so their dying lupine Stargod could pass his powers on to his successor. On Earth it was only partly able to transform Jameson into the new Stargod, but now he reached his full potential. Following the ending of *Creatures on the Loose* with #37 [1975], Kraft and Perez concluded their serial in *Marvel Premiere* #45–46 [1978–79].

After returning to Earth and various guest appearances—mainly in *Amazing Spider-Man*—he was again teleported to Other Realm where he became the Stargod to save the dimension from destruction. Returning once again to Earth, with no memories of his time as the Stargod, in *Spectacular Spider-Man Annual* # 3 [1983], he underwent a biomagnetic treatment, which caused his body to reject the moonstone.

In 1973, Marvel had returned to its pulp roots with the launch of the digest-sized *Haunt of Horror*. Featuring text stories illustrated by Ploog and Frank Brunner among others, the

experiment lasted just two issues. The title was revived as the fifth of Marvel's black-and-white horror magazines the following year.

Coming as the horror boom was on the wane, the anthology—premiered with a mix of strips and prose stories intended for #3 of its digest-sized predecessor—lasted just five

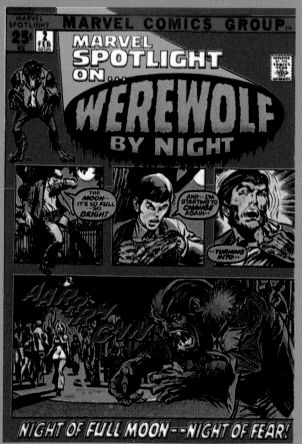

Marvel Spotlight #2 [Marvel Comics, 1972].

issues. Canceled with its brethren in 1975, it introduced **Gabriel the Devil Hunter** in #2.

Created by Moench and artist Billy Graham, Gabriel Rosetti turned to the priesthood after his wife and unborn child were killed in a house where every door and window was locked from the inside.

After being ordained, Gabriel is possessed by Catherine, the demon responsible for the death of his wife. The act of grabbing a red hot cross and pushing it against his bare chest—and the faith it represented—succeeded in driving the demon from Gabriel.

Shortly after he encounters Desadia. A woman who speaks with the voice of his dead wife, she becomes Gabriel's partner in his career as an exorcist, which continues, after the cancellation of *Haunt of Horror*, into the last issue of *Monsters Unleashed*.

By the time Gabriel became a regular in *Hellstrom*—after making only sporadic appearances across the previous 18 years—the forces of evil had taken Desadia from him.

Marvel next turned to voodoo or more specifically to **Brother Voodoo**. Created by writer Len Wein and artist Gene Colan, who introduced him in *Strange Tales* #169 [1973], he was Jericho Drumm. He returned to his native Haiti after 12 years, only to discover his brother Daniel—a powerful Houngan or voodoo priest—dying from a voodoo spell cast by a Zobop (false god), who called himself after Damballah, the snake spirit. Under the tutelage of Papa Jambo, Jericho revives the spirit of his brother and takes revenge on the Hougan who killed his brother. With his

newfound abilities, Brother Voodoo can tap into the power of the Loa (spirit gods of voodoo) and call upon his brother's spirit to either coinhabit his body, thus doubling his strength—or even possess the bodies of others.

With #174, the seven-foot-tall **Golem** took up residence in *Strange Tales,* and Brother Voodo moved into *Tales of the Zombie* where he appeared in #2 and 10. Since then he has been a semiregular in the Marvel Universe, most notably in *Tomb of Dracula*, *Werewolf by Night,* and *Doctor Strange* and other such titles with a supernatural bent.

Of late he has also been something of a regular in the Black Panther series, which was launched by Marvel Knights in 1998.

Based on a Hebrew legend, Marvel's Golem was created in the 15th century, in the city of Prague, by Judah Loew Ben Bezazel who carved it out of rock and breathed life into it by supernatual means. He then set the creature against those responsible for his people's plight, and it fought for them until "there was justice for his people in the city of Prague."

In the modern day, it was discovered in the desert by an archeological expedition led Professor Abraham Adamson, who repeated the spell to revive it before dying as the result of an attack by Arabs. The Golem rescued the rest of the party who shipped it to America. There an old enemy of the Golem's, Kaballa the Unclean, learned of its revival and sought to claim it for himself.

The story, which had continued in *Strange Tales* #176 and 177, was concluded in #11 of *Marvel Two-in-One* published in 1975, when Kaballa fled and the Golem finally returned to its original inert state.

Marvel next transformed a failed heroine into a were-creature named **Tigra**. Originally the Cat, Greer Grant Nelson was introduced in *Claws of the Cat* #1 by Linda Fite and artists Marie Severin and Wally Wood. After undergoing a physiological conditioning program, Nelson emerged from the battery of treatments endowed with a number of superhuman physical capabilities.

After pursuing a crime-fighting career in the four issues of her own short-lived title and in *Marvel Team-Up* #8 and *Marvel Preview* #21, Nelson next appeared in *Giant-Size Creatures* #1 [1974] where she learned that Dr. Tumolo—the head of the conditioning program—was a member of the Cat People, humanoids who had magically evolved from cats in Europe during the Middle Ages.

An attempt by the subversive organization HYDRA to steal the formula for "The Final Secret" (otherwise known as the Black Plague)—a bacterial culture that had been developed by Tumolo's ancestors—from the scientist resulted in the Cat being shot with "alpha radiation." To save Nelson's life, Tumolo and the Cat People mystically transformed her into the legendary half-human, half-cat warrior they called the Tigra.

Initially using a cat's head amulet to control her transformation, Nelson has become accustomed to being Tigra and is almost never seen these days in her human form. A regular member of the Avengers and its West Coast affiliate, she is a perennial guest star

throughout the Marvel Universe and even served alongside the Fantastic Four for a while.

In 2002, Tigra was finally granted her own series, a four-parter, one of Marvel's Avengers Icons minis.

The last of Marvel's 70s horror characters is also one of the most obscure. Introduced by Scot Edelman and artist Rico Rival in *Dead of Night* #11, the **Scarecrow** was to have been a recurring feature in *Monsters Unleashed,* but the magazine was canceled before its first appearance. The creature is a Fear Lord, existing in an unknown form, in an unnamed realm that exists within the Painting—which is its portal to Earth.

Very little is known about its origin or why it creates a scarecrow body for itself each time it comes to Earth to combat demon worshippers. Intended as the main feature in *Dead of Night*, it next appeared in *Marvel Spotlight* #26 [1976] when the original series—previously a reprint title—was canceled after it debuted. The main story was wrapped up in *Marvel Two-in-One* #18 in 1976, although the Scarecrow has occasionally been sighted since.

The final gasp of Marvel's 1970s horror boom came with *Marvel Premiere* #28, which featured the unlikely teaming of Ghost Rider, Man-Thing, Morbius, and Werewolf by Night as the **Legion of Monsters**.

Brought together by Bill Mantlo and artist Frank Robbins, they tackle the malevolent Starseed who had spectacularly created a mountain on Hollywood's Sunset Boulevard. And then, after just four years, the horror fad had passed—at least until the 1990s when

Marvel began its *Midnight Sons* resuscitations of various titles. There was also, in 1991, **The Legion of Night**, which delved into the supernatural from a slightly different angle.

A two-parter written by Gerber and drawn by Whilce Portacio, The Legion of Night was the story of Charles Blackwater's revenge against the Fellowship, a religious cult that had him gruesomely killed. He was saved at the last moment by the mysterious Omen, which offered him the prize of life if he would promise to serve the night, terrorizing those who committed their evil in the sunlight, those who feared nothing.

With a link to the physical world established, Omen—who had once served the Fellowship's master—set about assembling his Legion of Night. When he called them together, the mystical team consisted of Ariann, the precognitive shadow-reader; Jennifer Kale, the sorceress who had once been a friend to the Man-Thing; Martin Gold, a writer for *Cruel Fate* magazine; Doctor Katherine Reynolds, a professor of psychiatry whose psychic powers had caused her to be committed to a mental asylum; and Chan Liuchow, who, as a student thirty years before, had awakened the dreaded Fin Fang Foom from its slumber to save China from Communism. It was Fin Fang Foom—a monster that Stan Lee and Jack Kirby had created for *Strange Tales* #89 in 1961, just prior to the debut of the Fantastic Four—the Fellowship planned to rouse.

They intended to allow the dragon to transform the world into its dream, which it would then devour.

Muck Monsters

There must be something about the shambling pile of sentient vegetation that S.F. author Theodore Sturgeon introduced in his 1940 short story, It! that appealed to writers of comics if not also to their readers.

The first comic book muck monster appeared in Hillman's *Air Fighters Comics* #3 [1942]. Introduced by Harry Stein and artist Mort Leav in a Skywolf story, **The Heap** was once World War I fighter ace Baron Eric Von Emmelmann.

Shot down over Poland's Wassau Swamp on October 12, 1918, his corpse slowly merged with the surrounding morass until nothing was left but his will to live. And live again he did, 20 years later when—as a mindless mass of rotting vegetation—he rose from the swamp.

A recurring character in *Air Fighters*, he killed only farm animals—for the oxygen in their blood—and such human bad guys as Nazis and Japanese officers. He even returned to the air, flying a fighter against the Germans and traveling to Japan and China to battle the Japanese before making his way to the United States to tackle crime.

He got his own series in *Air Fighters*—now retitled *Airboy Comics*—in 1946, becoming a semiregular cover feature in the 1950s. He remained in the title until volume 10 #4 [1953].

Revived in 1970 in the second issue of Skywald's black-and-white *Psycho* magazine, this time the Heap was Jim Roberts, a crop duster who crashed into tanks of SHP-OP, a nerve gas stored at the secret government base known as Zone 19. Emerging, he had become a gelatinous humanoid blob.

Skywald brought its Heap back in *Psycho* #3–7 and 10–13 [1973] and also published a one-shot *Heap* comic [1971] that featured a story by Robert Kanigher and artist Tom Sutton.

Again fading from the scene, the shambling creature was resuscitated in 1986 when Eclipse Comics relaunched *Airboy* with the original creature as a supporting character in #3–5 and 24–30 [1987]. It also appeared in two one-shots: *Airboy/Mr. Monster Special* [1987] and *Target Airboy* [1988].

Following Eclipse's liquidation, Todd McFarlane Productions acquired the rights to the Hillman properties and, in 1992, featured the Heap in issues #73–75 of its Image-published *Spawn* title. Revamped by

McFarlane, his cowriter Brian Holguin and artist Greg Capullo, this new version—with the character originally an American derelict—appears to have no connection with either of its popular predecessors.

In something of a synchronous event—that

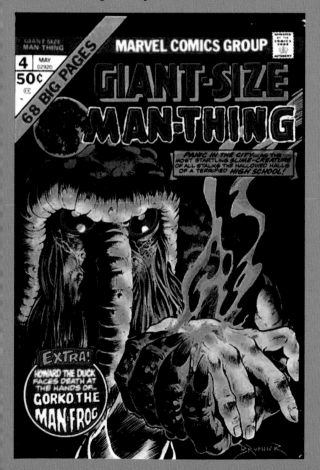

Giant-Size Man-Thing #4 [Marvel Comics, 1975].

might have had more to do with the respective writers sharing an apartment—both Marvel and DC introduced their own ambulating piles of muck and vegetation in 1971 with the self-styled *House of Ideas,* beating the Batman publisher to the punch by just about a month.

Man-Thing debuted in the first issue of Marvel's black-and-white *Savage Tales* magazine. Created by Roy Thomas as a tribute to Sturgeon's *It!,* the muck monster's debut was written by Gerry Conway with art by Gray Morrow. It told how scientist Ted Sallis been trying to recreate the Super Soldier serum that produced Captain America when—close to success—his isolated laboratory in the Florida Everglades is attacked by agents of AIM—Advanced Idea Mechanics—intent on getting the formula for the subversive organization.

Injecting himself with the only sample of the serum, Sallis fled into the swamp where he should have died. However, mystic forces at what is later revealed to be the Nexus of All Realities combine with the chemicals to transform the scientist into an unthinking behemoth whose flesh has been replaced by the swamp's vegetable matter.

Following appearances in *Astonishing Tales* #12–13 and *Monsters Unleashed* #5, the empathic Man-Thing gained his own series beginning in *[Adventures into] Fear* #10 [1972] which came into its own when writer Steve Gerber came on board the following issue.

He used the unthinking creature as an observer or a catalyst and only rarely as the focus of his stories. He showed how the Man-Thing could sense emotion in others and

would act without conscious thought to protect the innocent and put an end to the negative emotions of hatred, violence, anger, and most especially fear. As the narrator of each story would state—"Whoever knows fear burns at the Man-Thing's touch."

In 1974, following *Fear #19*—an issue that introduced the cult hit Howard the Duck—Man-Thing moved into his own title. Canceled in 1975, *Man-Thing* ran 22 issues although a 1979 relaunch lasted only 11, and a 1997 one only eight, before it was folded into a revived *Strange Tales* [1998], which was itself canceled after just two issues.

DC fared better with its **Swamp Thing** title although it took a few years to gain a regular audience. Created by Len Wein and artist Berni Wrightson, Swamp Thing made his entrance in a one-shot story in issue #92 of the *House of Secrets* mystery anthology. Garnering enough response to be granted its own title, the creature's origin was changed from that of a man who came back from the grave as a muck monster to something akin to Man-Thing's.

Deep in the Louisiana bayou, scientist Alec Holland had also been seeking a formula—one that would put an end to famine by "making forests out of deserts"—when he is attacked by subversives after his discovery. The ensuing explosion that destroys his laboratory hurls Holland's lifeless chemical-covered body into the swamp, which regenerates it as a huge humanoid mass of walking vegetation.

Closer to the mainstream than Marvel's Man-Thing—Swamp Thing even encountered Batman in issue #7—the series began to

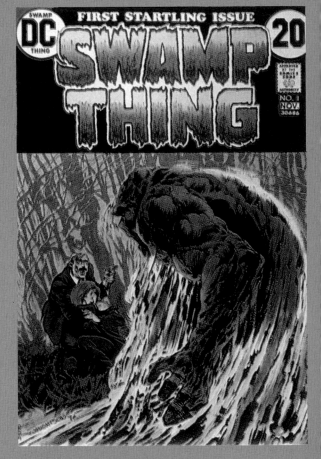

Swamp Thing #1 [National Periodical Publications, 1972].

founder when Wrightson quit after issue #10 [1974]. When Wein left three issues later, the writing was on the wall. *Swamp Thing* was canceled in 1976 with #24.

DC relaunched the title in 1982 as *The Saga*

of *Swamp Thing* to tie in with the release of the muck monster's Wes Craven-directed movie. The series was plodding along until British writer Alan Moore took over with #20 [1984]. The following issue he introduced his revisionist approach, throwing out everything that had gone before as he explained that Holland had not been restored to life as the Swamp Thing. Instead, the bayou vegetation— driven wild by Holland's biorestorative formula—had absorbed his memories.

As laid down by Moore, Swamp Thing was not a reanimated corpse but an earth elemental. He wrote the creature as a purposeful plant with its own deep-felt strong ecological opinions.

With its more adult themes, Moore's *Swamp Thing*—the title was truncated with #39— became the cornerstone of DC's mature readers imprint when Vertigo was launched in 1993. The first issue under the new imprint was #129 but—even though the British writer had left with #64—the title continued until 1996.

A new *Swamp Thing* comic was launched in 2000. Its star was Tefé, the 15-year-old human/hybrid daughter of Swamp Thing— with an assist from John Constantine—and Abigail Holland. A plant elemental who has power over all kinds of vegetation, she first appeared in *Swamp Thing* #65 [1987] in a story by Rick Veitch and inker Alfredo Alcala. Her series lasted just 20 issues until 2001.

John Albano and artist Jack Sparling introduced Marvel wannabe Seaboard/Atlas's **Bog Beast** in 1975's *Tales of Evil* #2. A humanoid that actually appeared out of a tar

pit, it also appeared in #3 and in *Weird Tales of the Macabre* #2.

Before Man-Thing, Thomas had already been inspired by Sturgeon's *It!* to introduce a villainous muck monster. **The Glob** first appeared in *Incredible Hulk* #121 [1969]. A prototype for the introduction of Man-Thing, the story explained how a convict, Joe Timms, was brought back to life by a barrel of radioactive waste.

A retelling of the story by Tom Field and artists Gary Barker and Mark Farmer in #389 [1992] replaced Timms with Sumner Beckwith —a scientist who was trying to recreate the Super Soldier formula that Ted (Man-Thing) Sallis was working on. Experimenting on himself with the formula transformed Beckwith into the new Glob.

"Man-Thing could sense emotion in others and would act without conscious thought to protect the innocent and put an end to the negative emotions of hatred, violence, anger, and most especially fear."

The Flag-Waving Patriotic Superstars

Although Captain America is the best known of the stars and stripes-wearing fraternity of patriotic superheroes, he was neither the first nor by no means the last.

IT LOOKS LIKE WE GAVE THEM THE SLIP, EH, POISON IVAN?

The honor of being leader of the pack goes to the **Shield**, who preceded the Joe Simon/Jack Kirby creation by 14 months. Making his first appearance in MLJ's *Pep Comics* #1 [1940], he was FBI agent Joe Higgins whose father had created a formula code-named SHIELD, acronym for Sacrum, Heart, Innervation, Eyes, Lungs, and Derma.

Setting out to avenge the death of his father, Higgins makes use of the compound which, combined with a special suit, gives him super-strength, the power to leap incredible distances, and the ability to withstand both gunfire and temperatures of up to two thousand degrees Fahrenheit.

Turned to iron while battling the Eraser, he was resurrected by the Comet in the 1960s. Resuming his life as a superhero, he replaced

Left: Fighting American and Speedy [Headline Publications, 1954].
Right: Uncle Sam Quarterly #3 [Quality Comics, 1942]

his son who was serving as the Shield with the Mighty Crusaders.

Conceived by editor Harry Shorten and first drawn by Irv Novick, the Shield appeared in *Pep Comics* #1–65 [1948] and in *Shield-Wizard Comics* #1–13 [1940–44].

Ironically, Simon and Kirby also revived the Shield—in 1959—but their version lasted only the two issues of *The Double Life of Private Strong* [Archie]. Like the original Shield, Strong also served in the Mighty Crusaders.

Appearing immediately after the original Shield was the **Eagle**. Debuting in Fox's *Science Comics* #1 [1940], little is known about Bill Powers, who donned a flag-colored costume to fight against the Nazis and their American sympathizers. His adventures ran in all eight issues of the Fox Features title.

Also predating Captain America is Quality Comics' **Uncle Sam**, who arrived just four months behind the Eagle. Based on the character in James Montgomery Flagg's famous World War I recruiting poster, the hero was created by Will Eisner. A manifestation of the American psyche, he has superstrength, can leap huge distances, has limited precognition, and can't be photographed.

Uncle Sam appeared in *National Comics* until #45 [1944] and simultaneously in his own *Uncle Sam Quarterly,* which ran eight issues between 1941 and 1944. Acquired by DC along with other Quality properties, he turned up in *Justice League of America* #107 [1977] as part of a team of Quality heroes that had their own 15-issue *Freedom Fighters* series [1976–78]. Renowned painter Alex Ross also

Origin and reintroduction of The Shield [Archie Publications, 1959].

gave him a Vertigo makeover for an Uncle Sam two-parter in 1997.

Debuting just before Captain America was **Minute Man**, introduced in Fawcett's *Master Comics* #11 [1941]. Having no superpowers,

Private Jack Weston wants to do more to fight the Germans and begins attacking the enemy.

Created by an unknown writer and artist Charles Sultan, he appeared in *Master Comics* until #49 [1944]. A member of the Crime Crusaders Club, he also had his own three-issue title between 1941 and 1942. Minute Man was revived in issue #12 [1995] of *The Power of Shazam!*—a DC title starring Fawcett's Captain Marvel—in which the patriotic hero became an occasional guest star.

Introduced at virtually the same time as Captain America was **U.S.A.**, or the Spirit of Old Glory as she was also known. Comicdom's first female patriotic superhero, she debuted in *Feature Comics* #42, where her adventures ran for just seven issues. Very little is known about Quality's patriotic superheroine, who wielded a flame-throwing torch of liberty.

Captain America's debut sparked a wave of patriotic heroes. Four months after came Captain Courageous (Banner Comics) and Captain Freedom (Speed Comics). Then Marvel introduced the Patriot (Marvel Mystery Comics), following quickly with Major Liberty and the Defender [both debuting in *USA Comics* #1] with Quality bringing on Miss America [*Military Comics* #1] and Harvey its own distaff patriot—the Spirit of '76 [*Pocket Comics* #1]—at the same time.

Behind them came even more. By the end of 1941, the list of patriotic superheroes had grown to include Captain Victory, Captain Flag, Fighting Yank, Major Victory, Miss Victory, U. S. Jones, Yank and Doodle, Yankee Doodle Jones, Yankee Boy, and Yankee Eagle.

"Uncle Sam...was based on the character in James Montgomery Flagg's famous World War I recruiting poster, the hero being created by Will Eisner."

The Road to Image

Historically, newspaper strips had always run credits, and trailblazing EC Comics had allowed artists to sign their work in the early 1950s.

However, it wasn't until the early 1960s, when Marvel started naming the writers and artists working on its superhero titles, that comics creators began to be associated with their own material. With recognition now guaranteed, the 1970s saw an influx of new talent into the industry. Many of the newcomers were fans, and their fans delighted in the work of their peers.

With sales falling, publishers anxious to increase revenues at whatever cost began marketing the creators—especially the artists—at least as much, if not more, than the heroes the industry was founded upon. If only they could have foreseen what lay ahead.

By the late 1980s, it was all about the artists and the power was falling into their hands, particularly at Marvel, which had always had a more fan-based audience than DC.

In 1988, as part of a foolhardy boost of creator power, Marvel launched *Punisher War Journal* as a showcase for the artistic talents of Jim Lee. In 1990 it followed up with *Spider-Man*, a new title specifically for fan-favorite artist Todd McFarlane to write and draw. Across several different versions and with a second printing, the first issue sold over two million copies, becoming the best-selling comic book in U.S. history. But that record was to be broken in less than a year with the publication of *X-Force* #1. Drawn by another hot young artist, Rob Liefeld, the comic—which came bagged with one of five different collector cards—sold almost four million comics without including its second printing. A month later that record, too, was shattered as the five alternate cover editions of the Jim Lee-drawn *X-Men* #1 racked up sales of over seven million copies. Creator power had well and truly arrived.

In early 1992, McFarlane, Lee, and Liefeld together with four other top-selling creators—Marc (Wolverine) Silvestri, Uncanny X-Men's Whilce Portacio, Erik (Spider-Man) Larsen, and Guardians of the Galaxy's Jim Valentino—walked into then Marvel Comics president Terry Stewart's office and threatened to form their own company if they did not get more favorable terms. Denied any improvement, they quit, then walked across the street and told DC the same thing, "We're starting our own company."

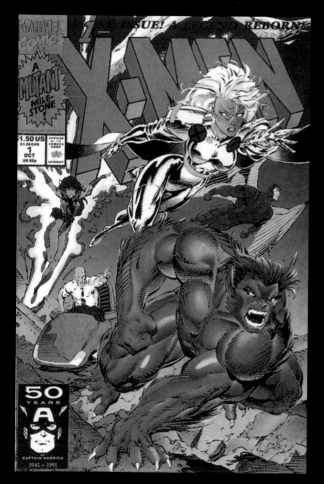

X-Men #1 [Marvel Comics, 1991]. The best-selling U.S. comic of all time.

Six of them—personal reasons had forced Portacio to bail out early on—formed Image Comics. Its maiden publication was the first issue of Liefeld's *Youngblood* which went on to sell over a million copies, establishing a new record for an independent (i.e., non Marvel or DC comic). Sales of McFarlane's *Spawn* #1 exceeded 1.7 million when it hit the stands a month later. A phenomenon had been born.

Lee followed with *Wild C.A.T.S: Covert Action Teams*, Silvestri with *Cyberforce*, Valentino with *ShadowHawk,* and, in 1993, Larsen with *Savage Dragon*. Everything they did turned to gold, but the rot began to set in, Image having no infrastructure, editors, or production backup.

Emulating Marvel and DC, writers and artists were brought in to work on spin-off titles while others were asked to produce their own creator-owned titles, but very soon books began to run seriously late, the quality began to fall off, and the sales followed suit. However, even though industry pundits were convinced that Image would not last and that its founders would soon be begging for their Marvel jobs back, the company was now established as America's third biggest comic book publisher.

Having recently celebrated its 10th anniversary, it's now more of a cooperative publishing house with a wide variety of creator-owned titles from a plethora of writers and artists under its wing. As for the founders, Larsen is the only one still working on his original Image property. Lee sold his comics and WildStorm studio off to DC. McFarlane is concentrating more on manufacturing toys than comics. Silvestri's Top Cow Productions is still creating comics for Image. Liefeld departed, set up Maximum, then Awesome, and Valentino now serves as Image Comics publisher.

Sandman: From Gas Guns to Dreams

Since the first Sandman was introduced way back in 1939's Adventure Comics #40, there have been three distinct versions of the DC hero created by Bert Christman and writer Gardner Fox.

The first was wealthy socialite Wesley Dodds who used part of his fortune to develop a gas that was both "truth serum" and narcoleptic agent as well as a gas gun to spray it at criminals. Donning a mask to protect himself from his gas, he fought crime in the streets of New York and the pages of *Adventure Comics* until 1946 [#102].

Dodds had acquired a kid sidekick, Sandy Hawkins a.k.a. the Golden Boy, in *Adventure Comics* #69 [1941], an issue in which he also adopted a costume more befitting a superhero courtesy of editor Whitney Ellsworth and artist Chad Grothkopf. From #72 to 91, Joe Simon and Jack Kirby took over the strip, centering many of the Sandman's cases on dreams.

A founding member of the Justice Society of America, this Sandman also appeared in *All Star Comics* [1940–41], *World's Finest Comics* [1941–42] and both issues of *New York World's Fair Comics* [1939–40]. He was revived in 1966 during the JSA's third Silver Age adventure— *Crisis between Earth-One and Earth-Two* [*Justice League of America* #46] by Fox and artists Mike Sekowsky and Sid Greene.

Although he continued to appear from time to time with his old team, a series of strokes all but incapacitated Dodds, who took his own life as revealed in *JSA Secret Files* #1 [1999] by David Goyer and James Robinson and artists Scott Benefiel and Mark Propst.

In 1993, Matt Wagner reinvented Dodds for Vertigo, DC's mature readers imprint. The writer's *Sandman Mystery Theater* eschewed the superheroics in favor of a noirish look at crime fighting in the late 30s. Mainly drawn by Guy Davis, the series ran 70 issues until 1999.

In 1995, Wagner teamed up with painter Teddy Christiansen for *Sandman Midnight Theater*. This Vertigo one-shot was coplotted

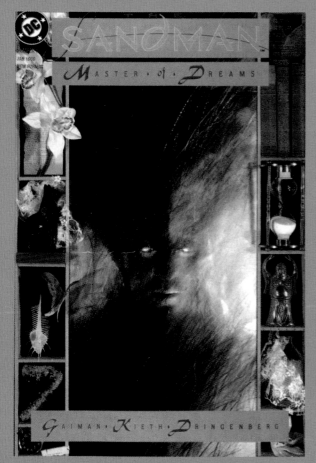

The Sandman #1 [DC Comics, 1989].

the Dreaming, his vast undefined realm, he can summon sleep and create dreams from gentle fantasies to dark nightmares. A member of the Endless, Dream is brother to Destiny, Despair, Desire, Death, Destruction, and Delirium.

A mythic multi-award-winning fantasy that integrated Shakespeare with horror, humor, and family drama in stories from across the ages, The Sandman was Gaiman's dream. The writer concluded with #75 in which Morpheus died and was replaced by a new Dream.

Launched as a DC title, with #47 and the start of Vertigo, *The Sandman* was the foundation on which the success of mature reader's imprint rested. Its popularity inspired numerous spin-offs, not only miniseries but such ongoing titles as *The Books of Magic*, *The Dreaming,* and *The Sandman Presents* . . . umbrella title.

Sandman Midnight Theater linked the 1939 and 1989 Sandman together by establishing that Morpheus was responsible for Dodd's crime-fighting career. The special showed how Morpheus haunted Dodds' dreams, showing him visions of criminals and grave injustices until he began acting on them.

In between the Dodds and Morpheus versions of the Sandman, Simon and Kirby returned to the character, introducing another version—a superhero who was something of a bridge between the two.

Debuting in the 1974 first issue of his own title, this Sandman was the guardian of our sleep. His job was to prevent evildoers from using our dreams for their own ends. Overly simplistic, even for the 70s, *The Sandman* was canceled in 1975 after only six issues.

by British writer Neil Gaiman, who had introduced the third and most successful incarnation of the Sandman in 1989.

Cocreated by artists Sam Kieth and Mike Dringenberg, Gaiman's Sandman is Morpheus, the Lord of Dreams. From his restored castle in

Spawn: From Assassin to Hellspawn

The first truly successful comic book creation in more than 30 years came, not from either of the big two publishers, but from an upstart company formed by seven creators who wished to control their own destinies.

One of the seven was Todd McFarlane, an artist whose 1988 issue of *Spider-Man* #1 had sold over two million copies. He and his break-away colleagues formed Image Comics in early 1992, and it would only be a matter of months before he created the comic that would transform him into a multimillionaire when the first issue of *Spawn* peaked with sales exceeding 1.7 million.

Something of a savage and gruesome update of the Michael Fleischer/Jim Aparo 1970s version of DC's Spectre, far from representing the Wrath of God, Spawn was on Earth to do the Devil's work.

For many years Al Simmons was a proficient and cold-blooded assassin for a covert government operation. The agency's best man was killed by the mercenary known as Chapel on the orders of his boss, Jason Wynn, who he accused of an abuse of power.

Following his death, Simmons is brought before the Malebolgia, a being as close to pure evil as one might encounter, short of Evil Incarnate itself. The creature resides in the Eighth Sphere of Hell—also known as the

From the second edition of Spawn.

Malebolge. With its seemingly fathomless capacity for evil, the Malebolgia has created an army of Hellspawns throughout time-space, which it plans to use at Armageddon in battle against the forces of Heaven.

Impressed by the acts of evil Simmons

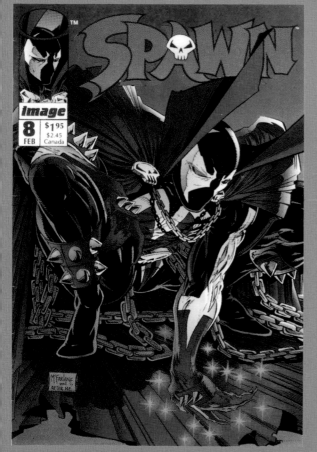

Spawn #8 [Image Comics/Todd McFarlane Productions, 1993].

perpetrated during life, Malebolgia offers him a deal to Join him and be allowed to return to Earth. Simmons signs the pact only to learn why you shouldn't make deals with the Devil.

He is indeed sent back to the living world, but he is still dead, a Hellspawn, his body composed of Necroplasm—the very material that makes up Hell itself. Worse still, it's five years after his death and his widow is now married to his best friend. Discovering he is equipped with extremely powerful but finite powers as Spawn, Simmons sets out to extricate himself from his predicament, which predictably brings him into conflict not only with the Malebolgia but such of the creature's minions as the Violator. He also has to battle Angela, a 100,000-year-old angel who specializes in hunting and exterminating Hellspawn while fighting Malebolgia and his former boss, now transformed into the Anti-Spawn as the result of heavenly intervention.

Although McFarlane has been continually reducing his involvement in *Spawn* and is now only cowriting the stories and working on the covers, the series was one of the best-selling titles in the U.S. direct comic book market for almost 10 years. It became the focus for a line of comics that grew to encompass *Spawn: The Dark Ages*, *Spawn the Undead*, *Sam & Twitch*, *Hellspawn*, and *Curse of Spawn*. It also became the foundation of a hugely successful line of action figures manufactured by McFarlane Toys, a company the artist formed in 1994.

In 1997 it spawned (!) a live-action movie and an animated T.V. series, which ran for three seasons on HBO in America from 1997 to 1999.

Spider-Man

Although there is now evidence to the contrary, legend has it that the superhero who was to become Marvel's flagship character—and one of the best-loved in comic book history—was almost discarded before his career got off the ground.

As the result of a distribution deal involving DC, Marvel was allowed only eight titles a month. With the launch of *Fantastic Four* and *Incredible Hulk* taking it up to its allocation, the suddenly revitalized publisher was forced to introduce its next wave of heroes as features within its now flagging line of monster comics. In mid-1962, Marvel's version of the Norse Thunder God made his entrance in *Journey into Mystery* #83, to be followed just weeks later by the debut of *Spider-Man*.

Bitten by a radioactive spider, bookish bespectacled high school student—or nerd in today's vernacular—Peter Parker made his first appearance as the wall crawler in *Amazing Fantasy* #15, the final issue of an anthology that had started out as *Amazing Adventures* in 1961. Changing its title to *Amazing Adult Fantasy* with #7, the comic went through a final name change for its swan song.

Spider-Man was a throwaway character, one publisher Martin Goodman didn't want published, one supposedly disposed of by being made the cover feature on the last issue of a comic that was being canceled because sales were falling.

Astonishingly, or so the legend goes, *Amazing Fantasy* #15 was one of the best-selling issues Marvel had ever had up to that time. As a result, the wall crawler was given his own title. The third Marvel superhero comic, *Amazing Spider-Man* premiered early in 1963.

The spider bite gave Parker the proportional strength and agility of an arachnid as well as its ability to walk on walls and ceilings and an uncanny sixth, or spider, sense. Creating a disguise, the Spider-Man costume, and using his scientific knowledge to create a sticky web fluid and mechanical devices to eject it, the teenager set off to make some money as a wrestler. Too preoccupied with his new skills to assist in the capture of a fleeing thief, his

Amazing Fantasy #15 [Atlas Magazines/ Marvel, 1962]. The origin and first appearance of Spider-Man.

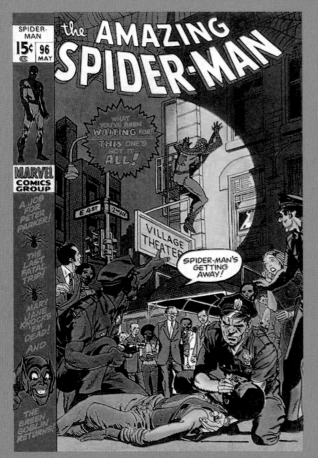

Amazing Spider-Man #96 [Marvel Comics, 1971]. The drugs-related three-parter not approved by Comics Code Authority begins.

triumph turned to tragedy when the same felon later robbed and killed his Uncle Ben.

Although he subdued his uncle's murderer, he realizes that his life has changed with the

acquisition of his spider abilities. As the penultimate caption of his origin story eloquently put it, "With great power there must also come—great responsibility!"

That 10-page origin was written by Stan Lee, who went on to script all but two of the first 110 issues of *Amazing Spider-Man*. The *Amazing Fantasy* strip was initially to have been drawn by Jack Kirby, but Lee felt his approach was too bold and dynamic. Seeking something a bit more offbeat and edgy, he asked Steve Ditko—another of Marvel's monster artists—to illustrate it instead and the rest, as they say, is history.

Ditko also drew *Amazing Spider-Man* #1–38 [1966] before he quit the title, reputedly unhappy at his lack of credit for input into the story. He was replaced by John Romita, who drew 62 issues between #39 and 119 [973].

Since those early days, Spider-Man has often appeared in three regular titles a month as well as numerous spin-off miniseries, graphic novels, and one-shots. *Marvel Team-Up*—a title in which the web slinger and the Human Torch would alternately share costar with another Marvel hero—premiered in 1972, but it was not long before the wall crawler had ousted the young Fantastic Four member.

The title was canceled in 1985 after 150 issues, replaced by *Web of Spider-Man*, his third ongoing monthly title. His second, *Peter Parker, Spectacular Spider-Man*, had been launched in 1976.

Spider-Man was the subject of Marvel's first venture into comics magazines, although 1968's *The Spectacular Spider-Man* lasted only

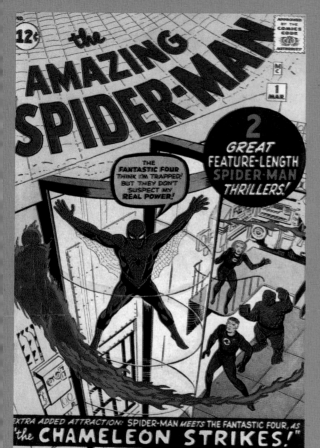

Amazing Spider-Man #1 [Marvel Comics, 1963]. The web-slinger gets his own title.

with the Man of Steel in *Superman vs. the Amazing Spider-Man* [1976] and *Marvel Treasury Edition: Spider-Man/Superman* [1981].

From 1974 to 1982, Marvel issued 57 issues of *Spidey Super Stories*. Published in co-operation with the Children's Television Workshop—producers of the *Sesame Street* T.V. show—its simplified stories were designed to encourage children aged 6 to10 with their reading and were a complement to Spider-Man's appearances in *The Electric Company*.

The first issue of a new adjective-less Spider-Man title launched in 1990 with writer/artist Todd McFarlane at the helm became the best-selling comic book in American history up to that time. It sold over 2-1/2 million copies across several versions and a second printing.

The 2002 *Spider-Man* movie further enhanced the character's marketability, being one of the box office success stories of the decade and assuring comic book and other sales an even greater lease on life.

two issues—both drawn by Romita and Jim Mooney—even though it went to color for the second. He was also the self-styled *House of Ideas'* representative in the first two Marvel/ DC superhero crossovers, sharing top billing

"The spider bite gave Parker the proportional strength and agility of an arachnid as well as its ability to walk on walls and ceilings and an uncanny sixth, or spider, sense."

Introducing the Starman Family

It's doubtful that the artist Jack Burnley gave any thought to who would succeed Ted Knight, let alone the possibility that he was creating a dynasty, when he and writer Gardner Fox first introduced the amateur astronomer as Starman in the sixty-first edition of Adventure Comics in 1941.

Another in the seemingly never-ending line of bored playboys, Knight invented a gravity rod, which "utilizes the powerful-infra-rays from the distant stars." With it he can overcome gravity and fire bolts of energy.

The guardian of Opal City, Starman appeared in *Adventure Comics* until #102 [1946] with many of his stories written by S.F. author Alfred Bester. A member of the Justice Society of America, he also featured in *All Star Comics* #8–23 [1941–44] and was revived in the Silver Age in 1964's *Crisis on Earth-Three* [*Justice League of America* #29], the JSA's second Silver Age adventure.

Diagnosed with terminal cancer, Knight sacrificed himself by transporting an enormous bomb into the outer reaches of the atmosphere, where he died in the subsequent explosion [*Starman* #72, 2000]. Although he made semiregular appearances with the JSA up until his death, it was revealed in a 1994 Starman story that Knight had passed the mantle on to his eldest son David, only for David to die at the hands of Golden Age Starman's old enemy, the Mist.

However, as was later explained, David was snatched through time just moments before his death to become Opal City's Starman from December 1951 to January 1952.

In one of the more confusing pieces of post-*Crisis on Infinite Earths* continuity fixing, David was used to explain Starman II, who had been introduced in *Detective Comics* #247 [1957].

Right: Adventure Comics #61 [National Periodical Publications, 1941].

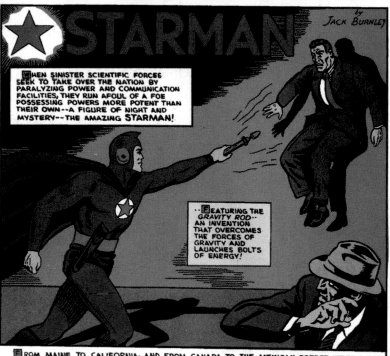

★ STARMAN

by JACK BURNLEY

WHEN SINISTER SCIENTIFIC FORCES SEEK TO TAKE OVER THE NATION BY PARALYZING POWER AND COMMUNICATION FACILITIES, THEY RUN AFOUL OF A FOE POSSESSING POWERS MORE POTENT THAN THEIR OWN--A FIGURE OF NIGHT AND MYSTERY--THE AMAZING STARMAN!

..FEATURING THE "GRAVITY ROD".. AN INVENTION THAT OVERCOMES THE FORCES OF GRAVITY AND LAUNCHES BOLTS OF ENERGY!

FROM MAINE TO CALIFORNIA, AND FROM CANADA TO THE MEXICAN BORDER, WEIRD EVENTS OF DIRE CONSEQUENCE TRANSPIRE. THE PEOPLE OF A GREAT NATION ARE ON THE VERGE OF PANIC, FOR THE VERY FOUNDATIONS OF THEIR LIVES ARE BEING BLASTED FROM UNDER THEM.

TELEGRAPH WIRES GLOW WHITE-HOT AND MELT INTO CONSUMING FLAME!

ALL TELEPHONE COMMUNICATION ENDS AS THE NATION'S SWITCHBOARDS FAIL!

THE BOARD IS DEAD! NO COMMUNICATION WITH ANY OTHER CITY!

THOSE SPARKS! RED-HOT!

1

Created by Jack Schiff and Sleldon Moldoff, this hero was in fact Bruce Wayne, who had dropped his Batman guise in order to catch a renegade scientist.

Despite the fact that this hero's one-time appearance was eradicated by 1985's *Crisis on Infinite Earths*, it was decided that he had been operative for a year and was actually two separate individuals: David Knight and Dr. Charles McNider, a.k.a. Dr. Mid-Nite.

After Ted Knight suffered a nervous breakdown, McNider replaced him throughout most of 1951, training David to take over the role after the younger Knight had been transported through time.

This version of **Starman II** made his first full appearance in *Starman 80-Page Giant #1* [1999] in a story by James Robinson and artist Wade von Grawbadger.

On the basis of that 1999 one-shot, David Knight should be Starman II and **Starman III**, but three others claimed the name in between his two sessions with the cosmic rod and none of them were members of his family.

First up was Mikaal Tomas. Introduced in *First Issue Special #12* [1976], he was a blue-skinned alien. A member of the warrior elite of a race originating on Talok III, he chose to defend Earth against an invasion by his own people. He had the ability to fly and shoot energy blasts by harnessing a sonic crystal created by his people.

Created by Gerry Conway and artist Mike Vosburg, he did not appear again until *Starman #3* [1994], where it was revealed that he had been in a drug-induced stupor since a short-

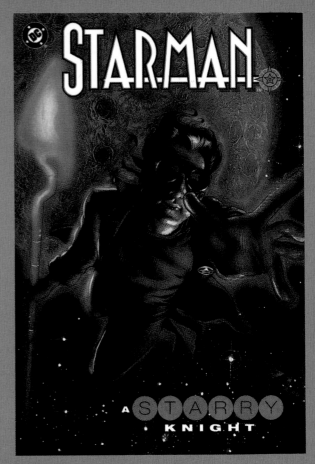

Starman trade paperback volume 7: A Starry Knight [DC Comics, 2002].

lived crime-fighting career following his defeat of his brethren. Now a regular member of the Starman supporting cast, he was finally discovered being exhibited as a freak in a carnival run by a demon incubus.

Starman IV was introduced in *Adventure Comics* #467 [1980] in a series that ran until #478 [1980]. Created by Paul Levitz and artist Steve Ditko, he was Gavyn, Crown Prince of Throneworld. Put to death in accordance with custom after his sister was selected as his father's successor, he was rescued by a mysterious being named M'ntorr. Prophecy suggested that Gavyn would die four deaths, so M'ntoor trained him to use the powers that had manifested themselves at the time of his execution. Armed with the ability to survive in space, travel at light speed, and absorb stellar energy, which he focused into energy blasts, he became champion of the Crown Imperial, eventually ascending to the throne.

He gave his life defending his home planet from an antimatter wave during Crisis. However, this was only his second death, and his soul traveled to Earth, where it struck Will Payton. In that instant, Will apparently died and Gavyn took on his identity, with no memories of his previous life.

As was told in 1988's *Starman* #1 by Roger Stern and artist Tom Lyle, Payton gained the ability to fly and channel cosmic energy into bolts of energy through his hands after being hit by an energy beam from outer space. This also gave him extraordinary strength, made him nearly invulnerable and able to impersonate others by molding his features.

His series ran 45 issues until 1992. He was apparently killed battling Eclipso in *Eclipso: The Darkness Within* #2 but, as was also revealed later, he actually wound up on Gavyn's home world.

His fate was to be revealed in a new *Starman* series launched in 1994. This featured the **Starman VI** who had been introduced in *Zero Hour: Crisis in Time* #1 [1994]. Created by James Robinson and artist Tony Harris, he was Jack Knight, son of Ted and brother of David, who reluctantly took up the cosmic rod after his sibling's death.

The series, which was brought to a planned conclusion in #80 [2001] with Jack retiring from the superhero game, also cleared up the mystery of the Gavyn/Payton incarnations of Starman while leaving the matter of which of them actually lived on Throneworld unresolved.

"Another in the seemingly never-ending line of bored playboys, Knight invented a gravity rod, which 'utilizes the powerful-infra-rays from the distant stars.' With it he can overcome gravity and fire bolts of energy."

Stretchable Superheroes

With Plastic Man, Jack Cole captured not only the action and drama of the superhero but also the humor that was the original province of the comics.

Introduced in Quality's *Police Comics* #1 [1941], the pliable crime fighter was originally Eel O'Brian. A crook shot while he and his gang were robbing a chemical factory, he also got splashed by a vat of acid, which got into his wound.

After escaping, he recovered consciousness to discover that his entire body had become elastic and pliable like, as he put it, a rubber band. Having a change of heart about his current career, he dons a costume and a pair of wraparound sunglasses and sets off after the gang that deserted him on his first step toward becoming a crime fighter.

But fun was never far away as Cole—who wrote and drew most of **Plastic Man's** early adventures—had the hero he initially wanted to call India Rubber Man become a bouncing ball, use his arms as lassos, transform himself into a suitcase or a Broadway showgirl in his pursuit of evildoers. With *Police Comics* #13 [1942], the writer/artist debuted Woozy Winks, a strange, rotund man. Perennially dressed in straw hat, polka dot shirt, and baggy trousers, this ex-con was to become Plas's sidekick. He

even had his own superpower: having saved a mystic from drowning, he was protected from harm by nature, which would send thunderstorms, earthquakes, and tornadoes when he was in peril.

Plastic Man appeared in the first 102 issues of *Police Comics* until 1950 when the series was given over to crime. He also gained his own title in 1943. Plastic Man ran 52 issues until 1955.

DC acquired Plas along with Quality's other heroes in the mid-1950s. After a tryout in the *Dial H for Hero* story in 1966's *House of Mystery* #160, the Batman publisher relaunched the Plastic Man comic later that same year. Initially written by Arnold Drake and drawn by Gil Kane, the series failed to capture the sense of cartoonish slapstick humor Cole had engendered and was canceled in 1968 after just 10 issues.

Plastic Man was revived in 1976, with DC picking up the numbering from the previous series. While the stories—initially by Steve Skeates and then by John Albano—were weak, penciler Ramona Fradon managed to recreate

Plastic Man #1 [National Periodical Publications, 1966]. The official Silver Age debut of Jack Cole's stretchable hero.

"Plastic Man's purpose was to assimilate the weird and wacky hero into continuity, enabling him to operate alongside the likes of Batman and Superman in the 'real' DC Universe."

artists Hilary Barta and John Nyberg followed in 1988. While getting close to Cole's original vision, Plastic Man's purpose was to assimilate the weird and wacky hero into continuity, enabling him to operate alongside the likes of Batman and Superman in the "real" DC Universe. In that it succeeded and—still as off-the-wall as ever—Plas is now a regular member of the Justice League of America.

By the time that Plastic Man appeared, Timely had already introduced two pliable heroes of its own.

In addition to Plastic Man, there were numerous other stretchable superheroes. These included **Flexo The Rubber Man**, **Thin Man**, **Strechable Sleuth**, **Elongated Man**, and **Elastic Lass**.

Cole's visual style, but even this did not stop the plug being pulled again after a further 10 issues. *Plastic Man* ended with #20 [1977].

A four-issue miniseries by Phil Foglio and

A Universe To Call Their Own

As the 1980s drew to a close, the newly established publishers were headed by actual lovers of the genre. And in the early 1990s, nearly every one of them decided they wanted their own line of superheroes.

The first and most successful of the challengers to Marvel and DC's supremacy was the Valiant Universe.

It was conceived by Jim Shooter who—while still Marvel's editor in chief—had come up with the idea of celebrating the Marvel Universe's 25th anniversary by creating a new set of superheroes and establishing them in a universe only fractionally different from our own. Dubbed The New Universe, Marvel introduced it in 1986 across eight interrelated series with such titles as *Nightmask*, *Spitfire and the Troubleshooters*, *Kickers Inc.* and *Mark Hazzard: Merc*. Like later attempts to manufacture a full-blown cosmos, it did not last long. Half the line was canceled during 1987 and the final four—*Psi Force*, *Star Brand*, *D.P.7,* and *Justice*—in mid-1989.

Following that experience, Shooter not only took things more slowly with his Valiant

Universe but also licensed existing characters to provide the foundation.

Shooter began in 1991 by launching a series with Magnus, Robot Fighter as its eponymous star and followed it with a title starring Doctor Solar, now renamed Solar, Man of the Atom. Both were 1960s heroes who had originally been published by Gold Key, although it was only at Valiant that the characters were established as being in the same universe. *Magnus, Robot Fighter* #5 [1991] introduced Rai. Despite being the first original Valiant Universe hero, the futuristic character was the third to gain his own series, preceded by Harbinger and X-0 Manowar, both of whom debuted in their own titles. Shadowman followed as did Turok, Dinosaur Hunter. Also

Right: Archer & Armstrong #11 [Valiant, 1993]. Solar, Man of the Atom takes centre stage.

from the Gold Key stable, his history dates back to 1954 when he first appeared in Dell's *Four Color* #596.

Over the next two years, Valiant launched a further eight titles, but by 1996, sales had plummeted and a revamp was in order. The line was trimmed back to five monthly titles—*Magnus, X-0, Shadowman, Bloodshot,* and *Ninjak.* Following their high-profile walkout of Marvel, the Image cofounders each created their own superhero universe.

While Todd McFarlane did little to expand beyond his *Spawn* title for some years and Erik Larsen and Jim Valentino both remained determinedly low key, Rob Liefeld went overboard. His *Youngblood* [1992]—Image's maiden title—led to spin-offs and new series galore. Among them were *Team Youngblood, Youngblood: Strike File, Brigade, Glory, Supreme, Bloodstrike, Newmen,* and *Prophet.*

Through his WildStorm Studio, Jim Lee created his own cosmos based around another two supergroup titles—*WildC.A.T.S: Covert Action Teams* and *StormWatch* [1993]—Marc Silvestri who produced Cyberforce and its spin-offs via his Top Cow Productions.

Silvestri's universe still exists, but Cyberforce finally bit the dust in 1997 and his world is now a much different place, presented in such supernatural series as *The Darkness* and *Witchblade.*

Valiant and Image comics were so popular at their peak that two more publishers were tempted to try their luck in 1993.

Malibu launched its Ultraverse line at

"The failures won't stop others trying but, in the meantime, Marvel and DC's superhero universes continue to reign supreme."

virtually the same time as Dark Horse debuted its grandiosely titled *Comics' Greatest World* via a four-weekly promotion consisting of four comics per week—each introducing a new character or team. Some—like Pit Bulls, Monster, Mecha, and Titan, never even made it into their own title—while others were only featured in a miniseries or one-shot.

Among the longer lasting titles to come out of the launch were *X* and *Barb Wire* which lasted from 1994 to 1996, but the major success was *Ghost* which, with a 1998 relaunch, ran from 1995 into 2000.

Malibu's Ultraverse did not last as long. Such titles as *Hardcase, Sludge,* and *The Solution* were canceled in mid-1995 while the others—including *Prime, Firearm, Mantra,* and *The Night Man*—were relaunched, some as no more than miniseries. None lasted beyond 1996 when Marvel acquired Malibu, and by 1997, the Ultraverse was a fading memory.

Right: Harris Comics celebrates Dracula's 100th with a Vampirella special (1977).

Superman: Is It a Bird, Is It a Plane … ?

Everyone knows the story of the Decca A&R man who turned down The Beatles, but how many are aware that one of the 20th century's greatest icons was rejected for five years before finally making it into print?

The Superman story begins in 1933 when Jerry Siegel and artist Joe Shuster introduced a bald-headed villain of that name in the third issue of their self-published fanzine, *Science Fiction*.

Later the same year the Cleveland-based teenagers recycled the name for a crime-fighting hero they had created as the focus of a full-length comic book story. They presented it to a publisher who turned it down.

Undaunted, the pair tried again. In 1934 Shuster decided to make Superman—now an alien—the star of a newspaper strip. The Clark Kent secret identity was a joint effort.

The new Superman was an archetype, replete with special powers, flashy costume, and alter ego. He was the first superhero. But that didn't help Siegel and Shuster. Even after beginning to work professionally, supplying stories to DC, they were still unable to get anyone to publish the character.

Thus it was to remain, until 1938 when DC cofounder/publisher Jack Leibowitz asked the McClure Syndicate's Max Gaines if he could help with material for the then in development *Action Comics*. Gaines—who had already rejected the Siegel and Shuster strip—sent it to editor Vin Sullivan, who bought it simply because it looked different.

DC printed 200,000 copies of *Action Comics* #1. With Superman featured on the cover, it proved to be a hit even though the main story was the newspaper strip cut up and repasted to fit the comic book format. By #7—Superman's second cover appearance—the title was selling half a million copies per issue and went on to hit almost a million at its peak.

In the summer of 1939, Superman was given his own title. Beginning as a quarterly and

Right: First appearance of Superman.

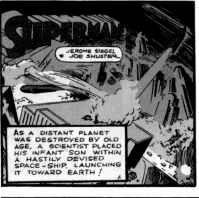

SUPERMAN

JEROME SIEGEL
JOE SHUSTER

As a distant planet was destroyed by old age, a scientist placed his infant son within a hastily devised space-ship, launching it toward Earth!

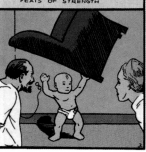

When the vehicle landed on Earth, a passing motorist, discovering the sleeping babe within, turned the child over to an orphanage.

Attendants, unaware the child's physical structure was millions of years advanced of their own, were astounded at his feats of strength.

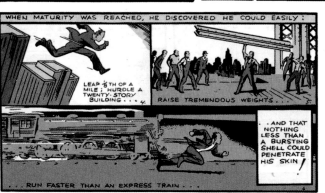

When maturity was reached, he discovered he could easily:

Leap 1/8th of a mile; hurdle a twenty-story building...

Raise tremendous weights...

...Run faster than an express train...

...And that nothing less than a bursting shell could penetrate his skin!

Early, Clark decided he must turn his titanic strength into channels that would benefit mankind. And so was created...

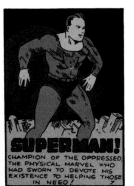

SUPERMAN!

CHAMPION OF THE OPPRESSED, THE PHYSICAL MARVEL WHO HAD SWORN TO DEVOTE HIS EXISTENCE TO HELPING THOSE IN NEED!

A SCIENTIFIC EXPLANATION OF CLARK KENT'S AMAZING STRENGTH

Kent had come from a planet whose inhabitants' physical structure was millions of years advanced of our own. Upon reaching maturity, the people of his race became gifted with titanic strength!

--Incredible? NO! For even today on our world exist creatures with SUPER-STRENGTH!

THE LOWLY ANT CAN SUPPORT WEIGHTS HUNDREDS OF TIMES ITS OWN

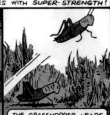

THE GRASSHOPPER LEAPS WHAT TO MAN WOULD BE THE SPACE OF SEVERAL CITY BLOCKS

containing mainly reprints of the stories from *Action Comics*, *Superman* become an even greater success. That same year saw the debut of the Superman daily newspaper strip. A radio series, *The Adventures of Superman* premiered in 1940 followed by Superman animated cartoons produced by Fleischer Studios for Paramount in 1941.

When he first appeared, the hero, also known as the Man of Steel and the Last Son of Krypton, was "faster than a speeding bullet, more powerful than a locomotive, able to leap tall buildings in a single bound," and as the years passed his powers grew until he could travel through space and time, move planets, and stand in the heart of a sun. Invulnerable to everything but kryptonite—radioactive chunks of his home planet—and magic, Superman had become almost godlike in the world of comic book superheroes.

The coming of an older and more sophisticated audience in the late 1960s was a turning point for Superman. It became necessary to reduce his powers, to make him more vulnerable, more human, in order to increase the drama in the storytelling and retain the readership.

Editor Julius Schwartz had the answer. He drafted writer Denny O'Neil who, in *Superman* #233 [1971], eradicated kryptonite—and, thus, a corny plot device— and introduced an other-dimensional energy

creature who leached the Man of Steel's powers. But the changes didn't last. As time passed, Superman began to regain his powers and by the late 1980s he was at his peak—and losing readers.

A total revamp was needed, and writer/ artist John Byrne was commissioned to it.

In 1986, just two years shy of the Last Son of Krypton's 50th anniversary, DC took the unusual step of canceling both *Action Comics* and *Superman*, replacing them with *The Man of Steel*, a six-issue series in which Byrne revised Superman's origin, kept his adoptive parents alive, and successfully updated the mythos.

His series was followed by the relaunch of the original two titles and the premiere of a new *Superman* series, the original having been retitled *Adventures of Superman*. A fourth series, *Superman: The Man of Steel* was added in 1991, effectively making the Man of Steel's adventures weekly, something all but unknown in the monthly based U.S. market.

Since then, DC has killed off Superman [*Superman* #75, 1992], resurrected him, brought one of comicdom's longest lasting love affairs to a climax—marrying Clark Kent to Lois Lane in 1995—and split him into two electric-powered Supermen [*Superman* #123, 1997] before returning him to normal.

As we entered the 21st century, Brainiac— one of Superman's long-time foes—recreated Metropolis as a high-tech futuristic city. In 2001, his archenemy, Lex Luthor, became president of the United States. Superman's never-ending battle for truth, justice, and the American way continues.

The Man of Steel #1 [DC Comics, 1986]. Writer/artist John Byrne's Superman overhaul begins in earnest.

Built For Speed

Prevailing wisdom has it that Superman can run just as swiftly as the the Fastest Man Alive, but when he debuted he was only just faster than a speeding locomotive, so it was hardly surprising that, in the rush to create new and different heroes, someone should come up with one whose only talent was the ability to run as fast as lightning.

That someone was in fact the team of Gardner Fox and artist Harry Lambert—replaced by Everett Hibbard after two issues—who introduced **the Flash** in All American Comics' *Flash Comics* #1 [1940]. He was college student Jay Garrick who acquired superspeed after accidentally inhaling hard water fumes.

Able to achieve a speed so fast that he cannot be seen, he can catch bullets in flight and dig deep trenches simply by running on the spot. Rather than wear a mask, he hides his identity by maintaining an inner vibration that makes his features a blur.

Flash Comics was canceled in 1949 with Garrick having featured in all 104 issues. A founding member of the Justice Society of America, he also appeared in *All-Star Comics* #1–7, 10 and 24–57 [1940–51].

Also moving swiftly into his own title was the **Silver Streak**, who was only two months behind the Flash. He made his entrance in Your Guide Publications' *Silver Streak Comics* #3 [1940] in a story drawn by Jack Binder and possibly written by Joe Simon.

He was a young taxi driver, slain by giant bugs after being hired to race the superfast Silver Streak. Resurrected by the car's owner, a swami, he is despatched to learn who is sending the insects and why.

With #4, Jack Cole (as Ralph Johns) took over the strip. Drawing it as Ralph Johns, he named the hero the Silver Streak, gave him a costume, and had him injected with a "secret fluid ... that gives him the power to overcome the law

Right: Flash Comics #1 [All American Comics, 1940]. The origin of the Flash and Hawkman, too.

of gravity and travel through the air at great speeds." In his campaign against crime, the Silver Streak is aided by Whiz, a falcon dubbed "the fastest bird alive" after receiving an injection of the superhero's blood.

Having taken over from Cole, Bob Wood gave the Ace of Speed a kid sidekick in the shape of Micky O'Toole. Taken under the hero's wing and injected with his secret fluid, he first appeared as Mercury in *Silver Streak* #11, changing his name to Meteor with the following issue.

Silver Streak Comics became *Crime Does Not Pay* with #22, but Silver Streak and Meteor were already gone. They last appeared in issue #19 [1942].

Right on the Silver Streak's heels came Worth Publishing's **Human Meteor**. Making his debut in *Champion Comics* #6 [1940], he was Duke O'Dowd, a soldier in the French Foreign Legion.

On a trip to Tibet in #8—in a story drawn by George Appel—he meets an ancient master who hands him a "wonder belt." This creates a contra-magnetic field that repels anything metal and gives him superspeed.

His career as the Human Meteor, which began in *Champion Comics* #9, continued until the series—retitled *Champ Comics* with #11—was canceled with 1944's #29.

The Human Meteor "returned" in the 1993 *Invaders* four-parter. The new version was still Duke O'Dowd, but now he had crashed in the Himalayas near the lost city of Bayakura, whose inhabitants taught him how to mentally control atoms. He used the ability to fly and

fought with the Nazis against Marvel's World War II superteam.

Breathing down the Human Meteor's neck came Fiction House's **Lightning**. Introduced in *Jumbo Comics* #15 [1940], Fred Larkin was a career soldier and son of a general who had somehow acquired the ability to run at superspeed and fire electricity from his fingers. Superstrong, his adventures ran in *Jumbo Comics* until #41 [1942].

It took Timely [now Marvel] over a year to catch up with its competitors with the **Whizzer** not arriving until 1941. His debut in *U.S.A. Comics* #1 was written by Stan Lee and drawn by Al Avison but, given that his uncanny speed is credited to a transfusion of mongoose blood, it's hardly surprising that no one recalls—or will own up to—creating the character.

The Whizzer—a.k.a. Bob Frank—was also featured in *U.S.A. Comics* #2, 4, 6, 8–12 and 14–17; *All-Winners Comics* #2-5, 7–11, 13–19, and 21; and *All-Select Comics* #3–5, 7.

In 1976, Roy Thomas and artists Don Heck and Vince Colletta retroactively created the Liberty Legion as a home front version of Marvel's World War II superteam, the Invaders —itself a continuity implant—with the Whizzer among its members.

In *Avengers* #69 [1969], Thomas—together with artists Sal Buscema and Sam Grainger— introduced an evil analogue of DC's Justice League of America. Among its members was a version of the Flash known as … the Whizzer.

Just over a year later in *Avengers* #85 [1971], Thomas—this time in collaboration with artists John Buscema and Frank Giacoia—debuted

the Squadron Supreme. A heroic parallel to the J.L.A., the team went on to feature in its 12-issue maxi-series. Its recreation of the Flash—also known as the Whizzer—was Hiram Stanley, who developed a pill that gave him superspeed. By the time *Squadron Supreme* launched in 1985, Stanley had been replaced by Stanley Stewart.

Right behind the Whizzer in the Golden Age came **Johnny Quick**, the most unique of the superspeedsters. Introduced in National Periodical Publications' *More Fun Comics* #71, newsreel photographer Johnny Chambers gains his power by reciting a secret formula: 3X2(9YZ)4A. Another—Z25Y(2AB)6—turns off the ability, which also enables him to fly.

Created by Mort Weisinger and drawn by Mort Meskin, his series ran in *More Fun* until #107 [1946]. It then moved to *Adventure Comics*, where it appeared in #103–204 and 206–207 [1946—54], outlasting the Flash's run by three years.

Retroactively, his World War II adventures also included membership in the All-Star Squadron, a team that first appeared in a 16-page prelude to its own title included with *Justice League of America* #193 [1981]. Created by Thomas and artists Rich Buckler and Jerry Ordway, the All-Star Squadron would eventually come to include all the members of the Justice Society of America and virtually every other costumed crime fighter active on Earth-2 [the world inhabited by the Golden Age heroes of the DC Universe] in 1942.

The Earth-2 concept was introduced in Flash of Two Worlds [*Flash* #123], a comic book classic in which a new version of the eponymous hero vibrated through a dimensional barrier and into a parallel world where he encountered his Golden Age namesake who—until then—had existed for him only as a hero in a comic.

This new—or Silver Age—Flash had first appeared in *Showcase* #4 [1956]. The idea of editor Julie Schwartz, he was actually created by Robert Kanigher and penciler Carmine Infantino, who had drawn some of the Golden

"Allen died during *Crisis on Infinite Earths* and was replaced by Wally West, his one-time sidekick Kid Flash."

Age Flash's later adventures. A modernized, streamlined version of the original, police scientist Barry Allen—or the Scarlet Speedster as he was sometimes known—gained his powers when a bolt of lightning struck his laboratory, knocking over a cabinet of unknown chemicals onto him.

A founding member of the Justice League of America, the Fastest Man Alive appeared in the first 223 issues of the team's title from 1960 to 1984 as well as a handful of later issues. He gained his own title following three more try-outs in *Showcase*. With the numbering picked up from *Flash Comics*, the Flash ran 246 issues from #105 to 350 [1959–85].

Allen died during *Crisis on Infinite Earths* and

**Flash: Blood Will Run trade paperback
[DC Comics, 2002].**

was replaced by Wally West, his one-time sidekick Kid Flash, who picked up the mantle in the final issue of that 1985 12-parter. A member of both the Titans and J.L.A., he is also the star of DC's third Flash title, launched in 1987.

It was eight years after the Silver Age Flash made his entrance when another speedster entered the arena—on the wrong side.

Together with his sister, the Scarlet Witch, **Quicksilver** made his debut in 1964's *X-Men* #4 as a member of Magneto's Brotherhood of Evil Mutants in a story written by Stan Lee and drawn by Jack Kirby and Paul Reinman.

Later continuity indicated that Pietro, a mutant whose power was superspeed, and Wanda Maximoff were the children of the Whizzer—who had resurfaced in *Giant-Size Avengers* #1 [1974]—and his wife, the former Miss Liberty, Madeline Joyce. However, that was later disproved—or contradicted—when their true parents were revealed to be Magneto and his wife.

An occasional member of the Avengers having first been part of the team from *Avengers* #16–104 [1965–72], Quicksilver married the Inhuman, Crystal, and lived with her, their daughter Luna, and the rest of the Inhuman's royal family on the moon until the breakdown of the marriage. He then joined X-Factor [*X-Factor* #71, 1991], leaving that government-sponsored team [#85, 1992] to eventually return to Marvel's premiere super-team [*Avengers* #374, 1994]. But, still unhappy, he became the leader of the Knights of Wundagore—in a Quicksilver series that lasted 13 issues from 1997–98—before joining his father on the island of Genosha.

Quality had premiered its own Quicksilver way back in 1940 and *National Comics* #5 but—despite a nine-year run at the time—this particular speedster didn't make much impact

until he returned in 1993. Created by Jack Cole and artist Chuck Mazoujian, little was ever revealed about the masked speedster. Dubbed the King of Speed, he was a former circus acrobat turned crime fighter, and his career ended in *National Comics* #73 [1949].

Then he resurfaced in *Flash* #76 [1993] in a story drawn by Greg LaRocque and Roy Richardson. As explained by writer Mark Waid, in the early 1800s, Quicksilver was an Indian scout. Imbued with superhuman speed by his tribe's dying shaman, he became known as Ahwehota—He Who Runs Beyond the Wind.

Years later, running faster then he ever had before, Windrunner as he was now called, ended up several decades into his future. From then on, every time this happened he was transported further up the time stream—adopting a new identity on each occasion—until he eventually arrived in the present day where he is known as **Max Mercury**.

He now serves as an advisor to the current Flash and acts as a trainer and guardian to Bart Allen, the young speedster from the future.

Introduced in *Flash* #91 [1994], the young Allen is the grandson of Barry (the Flash) Allen and Iris West and has inherited his superspeed from his grandfather. Created by Waid and artist Mike Wieringo he was sent into the past to procure the Flash's aid in bringing his metabolism—which had also been working at superspeed—under control. A member of Young Justice, he got his own series, which launched in 1995.

Jesse Quick, the only female super-speedster, made her debut in *Justice Society of America* #1 [1992] in a story by Len Strazewski and artists Mike Parobeck and Mike Machlan. She was born Jesse Chambers, the daughter of Johnny Chambers, a.k.a. Johnny Quick, and Libby Lawrence. Like her father, she uses a spoken formula to attain her speed.

A member of The Titans, she is a regular in both *Flash* and **Impulse**.

"Fred Larkin (a.k.a. Lightning) was a career soldier and son of a general who somehow acquired the ability to run at superspeed and fire electricity from his fingers."

Silver Age Meets Golden Age

When editor Julie Schwartz assigned Robert Kanigher and artist Carmine Infantino to revive DC's ailing superhero line by creating a modern hero based on the company's original Flash, he had no idea of the Pandora's box he was opening. From his first appearance in Showcase #4 [1956], the character was a resounding success.

Green Lantern followed in 1959 [*Showcase* #22] and, two years later, the Atom [*Showcase* #34] and Hawkman [*Brave & Bold* #34].

Shortly before revamping the latter two, Schwartz decided to recreate the Justice Society of America.

Renaming the group the Justice League of America, he brought in Gardner Fox and penciler Mike Sekowsky to launch a team consisting of newcomers Flash and Green Lantern alongside DC's big three: Superman, Batman, and Wonder Woman. The original lineup of members—which made its first appearance in *Brave & Bold* #28 [1960] —also included Aquaman and J'onn J'onzz, Martian Manhunter.

Green Arrow, another of DC's minor heroes joined in the 1961 fourth issue of the J.L.A.'s own title. The Atom followed in #14 [1962] and Hawkman in #31 [1964].

In 1961, Schwartz decided to introduce the 1940s Flash to explain the Silver Age version's decision to use his newfound powers for good rather than ill.

Thus it was in *Flash* #123 that the eponymous hero vibrated himself into a parallel world where he encountered his Golden Age namesake who had existed for him only as a comic book character.

Right: Justice League of America #1 [National Periodical Publications, 1960].

All Star Comics #3 [National Periodical Publications, 1940]. The Justice Society of America—the archetypal superteam —convenes for first time.

A classic tale in comic book history, *Flash of Two Worlds* introduced the unique concept of Earth-2. Written by Fox, it led to two further

meetings. The first—in *Flash* #129— reintro duced even more Golden Age heroes, but it was in #137 [1963] that Green Lantern, Hawkman, Atom, Black Canary, and Dr. Mid-Nite—together with Johnny Thunder— crucially decided to reform the Justice Society of America.

A meeting between the J.L.A. and the J.S.A. was almost inevitable, and it occurred in Crisis on Earth-1. Another Fox story, it ran across *Justice League of America* #21-22 [1963].

Over the years, DC has created Earth-1 counterparts of many of its Golden Age characters, not just heroes but villains too. The multiple Earths concept was also expanded. By 1985 it included:

• Earth-3—Introduced in the second J.L.A./ J.S.A. crossover [1964], this is the home of the Crime Syndicate, which consisted of evil analogues of the J.L.A. members. Its line-up included Ultraman (Superman), Power Ring (Green Lantern), Owlman (Batman), Superwoman (Wonder Woman), and Johnny Quick (Flash). Superman's nemesis, Lex Luthor, was Earth-3's only hero.

• Earth-S—On this world resides the Captain Marvel family acquired by DC from Fawcett Comics. The designation comes from Shazam —the magic word that transforms young Billy Batson into the world's mightiest mortal.

• Earth-X—Here the Nazis won World War II but such former Quality Comics characters as Uncle Sam, Doll Man, Phantom Lady, and The Ray continued to fight for America's freedom. They first appeared in the DC Universe in *Justice League of America* #107 [1977].

• Earth Prime—According to writer Cary Bates [*Flash* #179, 1968], you're standing (or sitting) on it. It's the world inhabited by you, the comic book reader.

But the main problem that Schwartz had created was that Superman, Batman, and Wonder Woman had all continued their adventures uninterrupted from the 1940s. If their Golden Age associates existed on Earth-2, to which Earth did they belong?

The simple answer, in fact possibly the only answer, was to draw a demarcation line. Anything before the mid-1950s was on Earth-2, anything after that on Earth-1. But that meant two Supermans, two Batmans, two Wonder Womans, two Robins, and two Lois Lanes . . . and so on.

For awhile the two worlds coexisted with the Golden Age heroes growing older and developing on Earth-2 while the Silver Age crop remained relatively untouched by the passage of time on Earth-1.

Over time the DC Multiverse became increasingly complex, and the demarcation line between the two was proving to be something of a movable feast.

In 1985 the writer Marv Wolfman and penciller George Perez embarked on *Crisis on Infinite Earths*. A mammoth 12-issue epic, it merged all the Earths into one, killing off a number of DC heroes, including the Silver Age Flash and Supergirl.

However, older comic book fans still mourn the passing of Earths-1 and -2, if not the multitude of parallel worlds that were to follow in their wake.

"But the DC Multiverse was becoming increasingly complex, and the demarcation line was proving to be something of a movable feast."

Wolverine

Armed with a set of razor-sharp claws, Wolverine made his entrance in the final frame of Incredible Hulk #180 [1974] before going head-to-head with the green behemoth in the following issue.

Those first appearances were drawn by series regulars Herb Trimpe and Jack Abel, but ultimately Wolverine's feral look and costume were designed by Marvel art director John Romita, who was also responsible for the Punisher's appearance.

However, it was to be Wein's last-minute decision to make Wolverine a mutant with the power to heal any wound which was to be crucial to the diminutive hero's success.

The writer and Thomas had been discussing the revival of the X-Men with an international lineup, and Wein had tagged his creation as a potential new member.

A mutant with a mean streak, Wolverine next appeared alongside Professor X, Cyclops, and newcomers Storm, Colossus, Nightcrawler, and Thunderbird when the team reformed in 1975's *Giant-Size X-Men* #1. Drawn by Dave Cockrum with help from inker Pete Iro, the story was written by Wein assisted by Chris Claremont, who would be instrumental in Wolverine's success.

Originally conceived as a smart-mouthed teenager, the mutant became older and more experienced when Claremont took over the relaunched *X-Men* with its third issue [#96], thus planting the seeds of a mystery that was to intrigue and excite comic fans for more than 25 years.

Introduced as Weapon X when he first appeared in *Incredible Hulk* #180, nothing was known about Wolverine beyond the fact that his name was really Logan although even that came to be doubted.

His healing ability was given as a reason why he might be far older than he looked. His body had been surgically altered by persons unknown to give him a virtually indestructible adamantium skeleton.

Claremont always refused to do anything other than drop intriguing hints about Wolverine's past. Over the years writers were encouraged to strengthen rather than resolve the enigma that was Logan, resorting to such devices as memory implants to add to his

Incredible Hulk #181 [Marvel Comics, 1974]. Wolverine tackles the Green Goliath in his first major appearance.

Frank Miller fleshed out the mutant's personality by further exploring his past in Japan—initially revealed by the writer and artist John Byrne in *X-Men* #118 [1978]—without giving anything of his origin away.

While continuing to serve as a member of the X-Men, Wolverine was launched into his own title in 1988. Initially written by Claremont and penciled by Marvel legend John Buscema, the series added another dimension to the mutant's personality as he had darker, grittier adventures masquerading as Patch, of the lawless Oriental city of Madripoor.

Shortly before the launch of the monthly *Wolverine* title, the mutant was also made the star of a biweekly anthology. He featured in all but 35 of the first 155 issues of *Marvel Comics Presents,* with #72–84 providing the most revelations about his past up to that time.

Written and drawn by former *Conan the Barbarian* artist Barry Windsor-Smith, the 13-part *Weapon X* serial revealed exactly how Logan had come by his adamantium skeleton and claws and how he had come to be discovered naked and living like an animal in the Canadian wilderness by the forerunners to Canada's superhero team, Alpha Flight.

If anything, Windsor-Smith made Wolverine even more popular. Logan has continued to star not only in Marvel's top-selling *X-Men* titles but in his own title as well.

Something of his early days was finally revealed by Paul Jenkins and artist Andy Kubert in 2001's *Origin* six-parter, but even that leaves a lot of questions unanswered.

growing mystique and popularity. The only one of the new X-Men to be given his own regular title, he initially went solo in a 1982 Wolverine four-parter. Claremont and artist

Chapter 2
Female Heroes

With a cornucopia of heroes catering to adolescent male power fantasies, what would make more sense than to address the other needs of young men with some super-powered sex appeal in the form of shapely amazons of justice? Buxom heroines in skimpy costumes abound in the comic books. Some, like Mary Marvel and Supergirl, are female clones of existing heroes, others totally original creations such as the Black Cat, Wonder Woman, Tank Girl, and Vampirella.

Amethyst [1983]

Amy Winston was 13 before she discovered she was also the Princess Amethyst, rightful ruler of the other-dimensional realm of Gemworld and its 12 royal houses.

She discovers her true heritage after she is kidnapped by the malevolent Dark Opal and taken to Gemworld where, because time passes at a different rate there from on Earth, she emerges as a 20 year old. Dark Opal is an agent of Vandaemon—one of the Lords of Chaos—who wants the young magic wielder destroyed as the latest act in the ongoing war with the Lords of Order.

Amethyst was created by writers Dan Mishkin and Gary Cohn and artist Ernie Colon. She first appeared in a 16-page preview of an Amethyst, Princess of Gemworld 12-parter in *Legion of Super-Heroes volume 2* #296. An ongoing Amethyst series launched in 1985 was canceled the following year after just 16 issues.

Black Canary I [1947]

Robert Kanigher and artists Carmine Infantino and Joe Giella introduced Dinah Drake in a Johnny Thunder story in *Flash Comics* #86. Trained by her widower police lieutenant father to the peak of physical and mental perfection, she follows in her father's footsteps when he dies by donning a blonde wig and a costume and taking to crime fighting.

She appeared in the Johnny Thunder strip until #90 when she shared the billing, supplanting the hero introduced in 1940s *Flash Comics* #1 as of #92. She stayed until the title was canceled in 1949. She was also a member of the Justice Society of America, joining the team in *All Star Comics* #38 [1947] and staying with it until that series was canceled in 1951 with #57.

Drake next appeared along with the rest of the J.S.A. in *Justice League of America* in 1963 by which time she had married private detective Larry Lance. With the death of her husband [in *Justice League of America* #73], Drake joined the J.L.A., gained a "sonic cry," and fell in love with Green Arrow.

Black Canary II [1983]

In 1983, writers Roy Thomas and Gerry Conway felt the need to explain why the Black Canary, who had been around since the 1940s, was no older than the other members of the J.L.A. The simple answer... the J.L.A. version was the daughter of the J.S.A. original.

The answer was simple but the explanation complex. As outlined in *Justice League of America* #219–220—drawn by Chuck Patton and Romeo Tanghal—it involved Johnny Thunder's magical Thunderbolt, an evil Johnny Thunder, the deaths of Larry and Dinah Lance, their daughter, the old J.S.A. villain, the Wizard who had placed a spell on the baby, and the now adult Dinah Lance being given her

mother's memories so she could carry on from where she left off.

But then, two years later, came *Crisis on Infinite Earths* to be followed by...

Black Canary III [1990]

With the origins of the first two Black Canaries so tied to the no longer extant Earth-1 (J.L.A.) and Earth-2 (J.S.A.), an origin was needed for the Black Canary of the remaining world.

That came in *Secret Origins* #50 in which Alan Brennert and artists Joe Staton and Dick Giordano explained how Dinah Drake became the Golden Age Black Canary and a member of the J.S.A., but gave it up when she married Larry Lance. A daughter, Dinah, followed.

Inspired by tales of her mother's adventures and continual contact with her "uncles" and "aunts" in the J.S.A., the younger Dinah wanted to take up her mother's mantle of Black Canary. The new Black Canary became a charter member of the Justice League of America [*Legends* #4, 1987] and eventually fell in love with Green Arrow. She now works with Oracle—the former Batgirl, Barbara Gordon—as a partner in Birds of Prey. She is also a member of both the J.L.A. and the J.S.A.

Black Cat I [1941]

Bored with her life as a successful movie star, Linda Turner becomes hooked on crime fighting after suspecting one of her directors

of being a Nazi spy. Encouraged by her father, she undergoes intense training as a stunt girl then dons a costume fashioned—because her suspect has a phobia about them—after a black cat.

Introduced in the first issue of Harvey's digest-sized *Pocket Comics* in a story by Alfred Harvey and artist Al Gabriele, after the title's cancellation with #4 (1942), she moved into *Speed Comics* where she appeared in #17–38 and 44 [1947]. The most successful superheroine of the Golden Age after DC's Wonder Woman, the Black Cat also featured in issues #6, 9, and 15 of the *All-New Comics* anthology between 1944 and 1947.

Harvey launched her into her own comic in 1946, but she appeared only in *Black Cat Comics* #1–29 [1951] at which point the title—which had already been amended to *Black Cat Western* for #16–19—became *Black Cat Mystery* and turned over to horror stories. Jill Elgin drew the Black story in #1, but it is artist Lee Elias—who illustrated all her other appearances in the title—who is most associated with the character.

Black Cat II [1979]

One-time cat burglar like her father before her, Felicia Hardy became a costumed crime fighter after falling in love with Spider-Man.

Initially without superpowers, her latent potential was released after experiments

Continued on page 200

Bad Girls, Sexy Girls

Comics had always been a medium to feature sexy femmes fatales, although the species had become all but extinct from the mid-1950s onward.

Dr. Frederic Werham's alarmist 1954 book, *Seduction of the Innocent,* and the U.S. Senate Subcommittee on Juvenile Delinquency that its publication instigated led to the Comics Code, the industry's self-imposed Code of Conduct.

Then, in 1969, along came **Vampirella**. The first and foremost of comicdom's "bad girls," the sexy vampire from the planet Drakulon was at the forefront of a wave of similar temptresses some 30 years after she made her debut.

Introduced in the first issue of her own black-and-white magazine, Vampirella was created by committee. Conceived by publisher James Warren—heavily influenced by the French *Barbarella* strip by Jean-Claude Forest—she was given her name by *Famous Monsters of Filmland* editor Forrest Ackerman, who also wrote her first few adventures. Published by Warren beyond the restrictions of the Code by virtue of the format, *Vampirella* was to run 112 issues over 14 years.

The relaxation of the Code had already led to much sexier mainstream heroines, Marvel's Elektra and DC's Starfire of the New Teen Titans being prime examples. But they still had a heroic edge to them. What separated the new breed of bad girl—a term coined as a contrast to the long-standing tradition of good girl art in comics—were not only their increasingly shrinking costumes, their impossibly shaped bodies, and provocative poses on every page but also their attitude. They seemed to have no compunction about killing their adversaries, often in the most grotesque manner possible.

Close on the resurrected Vampi's heels was **Lady Death**. Created by Brian Pulido and artist Steven Hughes for Chaos! Comics, this albino Queen of all that is dead and dying began life as an innocent 15th-century teenager. She was transformed as a result of her father's consorting with demons. Now her mission is to eradicate all life on Earth. Lady Death first appeared in *Evil Ernie* #2 [1992], going to star in the first of numerous miniseries in 1994.

London Night Studios was next out the gate with **Razor**, named after the distinctive blades she wears on her arms. A Queen City crime fighter, she tortures, maims, and kills any criminals who cross her path.

Spawn #9 [Image/Todd McFarlane Productions, 1993].

Introduced in *Razor* in 1992, she was created by writer Everette Hartsoe, who later kills her off before resurrecting his vicious vigilante with a more supernatural edge.

The first *Razor Annual* featured the first appearance of one of 1993's debutantes. **Shi** was created by writer/artist Billy Tucci, who went on to make his oriental avenging angel the cornerstone of Crusade Entertainment, a publishing company he launched in 1994 with the first issue of *Shi: The Way of the Warrior*.

Even The Sandman cocreator/writer Neil Gaiman got in on the act, developing **Angela** for Todd McFarlane's Spawn. His 100,000-year-old angel who specializes in hunting and exterminating Hellspawn first appeared in #9 of McFarlane's Image title. After clearing her name of charges of hunting the eponymous star of the series without a permit and high treason against good, she remained on Earth where she works as a freelance angel.

Also introduced in 1993, in *Youngblood Strikefile* #1, Glory is the daughter of a warrior goddess and a demon lord. An immortal demigoddess, she hails from the Isle of Paradise.

Gaining her own title in 1995, **Glory** also appeared in a number of miniseries and one-shots, among them a crossover with Maximum Press's Avengelyne. Cocreated by Liefeld and Cathy Christian, the model on who she was based, she is similar to Gaiman's Angela, being an angel banished to Earth to assist mankind.

Avengelyne was introduced in her own three-parter, the first of a number of minis and specials in which she starred. Like Angela and Glory, she also encountered the bad girl representative of another publisher. In her case it was Antarctic Press's Warrior Nun Areala who, along with such others as Fatale, Darkchylde, Lady Rawhide, Dawn, and Witchblade, was among the scores of women with attitude who hit the stands in the mid-1990s.

organized by Wilson Fisk, the Kingpin of Crime. These provided her with enhanced agility and speed as well as the ability to alter the probabilities around her, causing bad luck for her opponents. Eventually, she began manifesting other powers—night vision, to name one—but her bad luck ability had an adverse effect on her friends as well, causing Spider-Man to arrange for Doctor Strange to remove it.

A regular member of the Spider-Man cast, the Black Cat was introduced in *Amazing Spider-Man* #194. Created by Marv Wolfman and artist Keith Pollard, she had her own four-parter, *Felicia Hardy: The Black Cat* in 1994.

The Black Orchid [1973]

A flying, purple-clad superstrong enigma, The Black Orchid made her first appearance as a back-up feature in #428 of the relaunched DC Comics anthology title, *Adventure Comics*.

Her real name and hero origin were never revealed as she then faded into relative obscurity within a few issues. A full 15 years later, rising U.K. writer Neil (Sandman) Gaiman revived her in an equally enigmatic three-part 1988 miniseries illustrated by his regular working partner, Dave McKean.

When Vertigo, DC's mature readers' imprint, was launched, Black Orchid was revived once more, fitting in perfectly with the imprint's skewed approach to four-color fantasies. Black Orchid lasted 22 issues from 1993, during which she fought as an environmental hero.

Black Widow [1964]

Despite having been one of Marvel Comics' heroes for decades, the Black Widow was introduced as a 1960s Soviet spy, very much a femme fatale, in *Tales of Suspense* #52.

Her mission was to spy on Stark Industries, protected by owner Tony Stark in his secret identity of Iron Man. Her real name was Natasha Romanoff, later altered to Romanova.

Her conversion to the good guys came when, in her third appearance five issues later, she teamed up with misunderstood superhero Hawkeye. But instead of recruiting him as a pawn, she fell in love and became a hero.

When Hawkeye joined the Avengers, the Black Widow followed, was eventually accepted, and ended up as the team's leader.

The Black Widow gained her own nine-issue series in 1970, sharing *Amazing Adventures with The Inhumans*. She also became girlfriend to Daredevil and led a minor Marvel team named The Champions.

Her most recent run, in two mature readers' *Marvel Knights* miniseries, has significantly elevated her public profile to become one of the publisher's leading 21st-century characters.

Doctor Light [1986]

An early Justice League foe from the 1960s, the original Doctor Light was replaced by a more contemporary character of the same name.

This new Doctor Light is female scientist Dr. Kimiyo Hoshi, who was introduced in the fourth issue of the consolidation of the then sprawling DC Universe title *Crisis on Infinite Earths*.

Hoshi had been observing the cosmic chaos as the parallel Earths were being destroyed when she was accidentally hit by fiery energy from the star Vega. Unsurprisingly, this gave her a superpower, that of starlight.

Donning a costume reminiscent of her forebear, the nevertheless serious and moody scientist soon became involved with the new-look Justice League, finally becoming a member of the team.

Elektra [1980]

She first appeared in *Daredevil* #168, revealed to be a secret love from the hero's college days. Obviously enchanted by oriental martial arts, writer/artist Frank Miller made this Greek-born tough female ninja assassin both the hero's sweetheart and his nemesis.

Despite her instant popularity, readers were shocked when the red-garbed killing machine was herself murdered less than two years later in *Daredevil* #181. But this hasn't stopped her regular appearances ever since, including her rebirth only nine issues later and in an appropriately titled large-format graphic novel, *Elektra Lives Again*, plus two miniseries, reprints, a short-lived continuing series, and a newly launched mature readers title.

Lady Justice [1995]

While popular writer Neil Gaiman has his named emblazoned as part of the cover title in Techno Comics' *Neil Gaiman's Lady Justice*, the *Sandman* author had little to do with the character other than the initial concept.

Lady Justice is the embodiment of the word justice. Whenever there is any injustice, she appoints a female Avatar with a personal connection to the crime or victim who will balance the scales, with the sentence always being death. Each Avatar acquires enhanced strength and reflexes plus a sixth sense of their surroundings, offsetting the limitations of being blindfolded. These Avatars have no hesitation about using any weapon that may come to hand.

Lady Justice has long gray hair and is blindfolded. Her traditional appearance is maintained, with the scales of justice in one hand and a sword in the other. She wears a black robe wrapped in the chains of injustice.

Lady Supreme [1996]

An obvious spin-off from the lead character, Lady Supreme first appeared in Image Comic's *Supreme* #33 under Rob Liefeld's Extreme Studios imprint. As her name implies, she is related to the hero, being his daughter from the future who has inherited his powers

Continued on page 204

The Empire of Horror

After its heyday in the 1950s, the horror comic was banished from the newsstands until Warren Comics raised the genre to new heights a decade later.

Mercurial publisher Jim Warren first rose to prominence beyond the cheesy men's magazines he founded his company on with the 1958 launch of *Famous Monsters of Filmland*, the first magazine devoted to horror and science fiction movies.

Its success encouraged Warren to team up with legendary *Mad Magazine* creator Harvey Kurtzman on the sophisticated humor title *Help!*, which mixed comic strips—by future underground comix legend Robert Crumb among others—with witty satire. The magazine's art editor was a pre-*Monty Python's Flying Circus* Terry Gilliam.

Creepy #32.

Apocryphally, this led to John Cleese appearing in one of the photo strips.

Help! [1960] failed to find a significant audience, but the comics bug had bitten Warren and so, in 1964, he gathered together EC's finest artists and the black-and-white horror comic magazine *Creepy* was born. With intelligent scripts and editing from Archie Goodwin, covers from Frank Frazetta, and wonderful art by Reed Crandall, Angelo Torres, Gray Morrow, and others, the comic was an immediate hit. A companion title, *Eerie* [1965] soon followed, as did a critically praised war title, *Blazing Combat* [1965], although this third magazine was to be short-lived.

Sadly, after three years of excellence, budget restrictions forced most of the creators away, and for the rest of the decade, the line was a poor shadow of its former glory. Out of this malaise, Warren and Famous Monsters editor Forrest J. Ackerman dreamed up the seductive Vampirella as host of a third horror anthology. *Vampirella* [1969] was a hit, and the company was up and running again. Under new editor Bill Dubay, the Warren magazines swiftly

Creepy #3 [Warren Publishing, 1965].

returned to their previous heights with intelligent, taboo-breaking scripts and art by a small army of Spanish artists. From the iconic covers of Sanjulian and Enrich to the art nouveau sword-and-sorcery of Esteban Maroto and José Gonzalez's definitively sexy Vampirella, the Spaniards contributed beautiful artwork throughout the 70s.

Under Dubay, Warren's magazines diversified; *Creepy* concentrated on bone-crunching horror, *Vampirella* focused on female characters such as the shape-changing Pantha, and *Eerie* specialized on serials.

Commercially, the 70s were Warren's strongest period, with its core horror titles being augmented by several other magazines in addition to *The Rook* [1979]. Will Eisner's legendary 1940s *Spirit* strip was reprinted in 16 issues of its own magazine and, with its beautifully painted covers and subtle black-and-white tones, this was probably the character's finest hour. Where *The Spirit* [1974] and *The Rook* provided rollicking, all-ages adventure strips, 1984 [1978] contained a decidedly adult mixture of science fiction and sex. Like much of Warren's late 70s/early 80s material, *1984*—later retitled *1994*—was dominated by another influx of talented artists, in this case from the Philippines, and creators like Rudy Nebres, Alfredo Alcala, and the wildly imaginative Alex Nino were welcome additions to the company.

However, as the 80s dawned, newsstand sales of comics were plummeting, and Warren began to lose ground. While many fine strips were still being drawn, the spark had gone, and more and more issues were filled with reprints. As fans increasingly returned to superheroes, Warren threw in the towel in 1983, and his magazines were canceled. A few years later, Harris Comics bought the rights to Vampirella, and the character has been a fixture on the stands ever since. Recent years have seen a Vampirella movie and increased interest in Warren's back catalog, and so even in death the company's legend lives on.

of invulnerability, superstrength, and the ability to fly, augmented by her own psionic abilities of telepathy and telekinesis, and the ability to enter people's heads to uncover all their secrets.

Once known simply as Probe, she always believed herself to be the end product of a genetic experiment but finally discovered that not only was Supreme her father but the Amazonian heroine Glory was her mother.

In addition to *Supreme*, she has also appeared in her own 1996 two-issue series and as a support character in the *Kid Supreme* miniseries as well as Maximum Press's *Asylum* anthology title.

Magik [1982]

In *The Uncanny X-Men* #160, Pitor Rasputin's (a.k.a. Colossus's) seven-year-old sister Illyana was transported to the magical realm of Limbo. She was held captive by the demon Belasco for seven years, where she gained great powers and created a magical sword. Using the "Soulsword" she overthrew Belasco and took control of Limbo.

She returned to Earth, joining The New Mutants team as Magik and growing magical armor. Then Magik was turned into an evil entity, Darkchilde, by the demon known as N'astirh. Darkchilde was defeated when Illyana transformed herself into a child of light.

She then remerged with her seven-year-old self and negated her Limbo experiences. After her parents were killed, she was taken to the U.S.A. by her brother. There she contracted the magical Legacy Virus and died.

The Soulsword was transferred to Amanda Sefton (a.k.a. Jimaine Szardos) via Illyana's best friend Kitty Pryde. Sefton became leader of Limbo as Magik II and is the girlfriend of the X-Men's Nightcrawler.

Mai, The Psychic Girl [1987]

This classic Japanese character from Kazuya Kudo and Ryoichi Ikegami's manga opus of the same name was a revelation to the Western world. One of the first major series to be translated into English after Otomo's *Akira*, it too dealt with psychic abilities. It was originally published in English by Eclipse in 28 comics and was then collected into four more traditional manga-sized (i.e., squat) graphic novels.

The series told the story of Mai, a simple schoolgirl who inherits devastating mental powers. Torn between leading a normal life and her ultimate destiny against the Western Alliance, Mai goes on a physical and spiritual odyssey. There are many surprises in the story where major characters are eradicated without a second thought.

The tale is about adolescence and facing the responsibility of adulthood. Mai soon proves herself a courageous and extremely likable young woman.

Ms. Tree [1981]

One of comics' few female hard-boiled detectives, Ms. Michael Tree bears the same name as her private eye husband, whose detective agency she inherited when he was shot dead on their wedding night. Since bringing in his killer, her adventures have run for over 20 years, across a range of publishing companies. Created by writer Max Allan Collins, she was designed as a female equivalent to Mickey Spillane's Mike Hammer, to the point where it is hinted that her dead husband was Hammer under another name.

She first appeared, with art by mainstay Terry Beatty, in the May 1981 first issue of the anthology title *Eclipse Magazine*. She was promoted to her own Eclipse-published title, *Ms. Tree's Thrilling Detective Adventures* in 1983, with the title switching to Cerebus publishers Aardvark-Vahnahameim in 1984 and to Renegade Comics the following year. It was canceled in 1989 after 50 issues but picked up the following year by DC Comics, which produced a further ten giant-sized quarterly issues starring Ms. Tree.

Nightshade [1966]

When Charlton Comics made a reentry into the superhero genre, Captain Atom was the company's cornerstone character in whose title new characters were introduced in back-up strips. The popularity of the revived Blue Beetle was such that, when he spun off into his own title, the newly created Nightshade replaced *Captain Atom* #85, having first appeared alongside him in issue 82.

This Steve (Spider-Man) Ditko-created superhero, Eve Eden, was the daughter of a princess of the Nightshade Dimension and had the power to phase in and out of darkness. Adding to her abilities with a trip to Japan to learn martial arts, she became an operative for the covert government agency, the O.S.I., and later a member of Charlton's superhero team, The Sentinels of Justice. When DC Comics bought the Charlton hero lineup, Nightshade became a member of the Suicide Squad and has made irregular appearances ever since.

Rose and Thorn [1970]

Rose Forrest was introduced as a Metropolis-based schizophrenic in her own back-up strip in *Superman's Girl Friend Lois Lane* #105.

When her N.Y.P.D. detective father, Phil Forrest, was murdered by criminal cartel The 100, she vowed to track them down. However, the twist to the episodic story line was that she had no capacity for violent adventure. The shock of the event was so powerful that when she slept, her violent subconscious took over and, covering her blonde hair with a red wig and donning a thorn-covered green costume hidden in a secret panel, she left her apartment for vengeance as the Thorn.

Continued on page 218

The Female of the Species...

Whether it was to protect a copyright or, more likely, just a matter of taking a concept to its logical conclusion, it was not long before publishers began to clone female versions of their male heroes.

Fawcett Comics introduced **Mary Marvel** less than two years after Captain Marvel made his debut in the 1940s *Whiz Comics* #2. She made her first appearance in *Captain Marvel Adventures* #18 [1942], just months after Captain Marvel Jr.—Fawcett's first spin-off from its hugely popular Big Red Cheese (as Captain Marvel was known)—premiered in *Whiz Comics* #25.

Two halves of a locket reunited Billy Batson and Mary Bromfield, who learned that they were siblings, separated shortly after birth following the death of their parents. After rescuing his sister from kidnappers, Batson revealed his Captain Marvel alter ego to her before being subdued and gagged by the gang. Uttering "Shazam!," her brother's magic word, in desperation transforms Mary into a superpowered female who swiftly subdues the felons.

Both brother and sister are mystified by her transformation and look to the old wizard who gave Billy his power for an explanation. He tells them that when Mary says the magic word, she gains powers from the goddesses rather than the gods. Selena gives her grace, Hippolyta strength, Ariadne skill, Zephyrus speed, Aurora beauty, and Minerva wisdom.

After also appearing in *Captain Marvel Adventures* #19, Mary moved into her own slot in *Wow Comics*. Beginning in #10 [1943], after a cameo appearance in #9, she remained in the comic until 1947 and #58. While starring in *Wow* she also took up residence in two other series: *Mary Marvel Adventures* and *Marvel Family Adventures*, in which she teamed up

Right: Savage She-Hulk #1 [Marvel Comics, 1980]. The origin and first appearance of the Hulk's female cousin.

FOLKS, MEET **MARY MARVEL** MY SISTER, WHO WILL APPEAR IN HER OWN MAGAZINE EVERY MONTH! HOPE YOU LIKE HER!

CAPT. MARVEL

Mary Marvel Comics #1 [Fawcett Publications, 1945].

with her brother and Captain Marvel Jr. Launched simultaneously with her own comic—which ran 28 issues from 1945 to 1948 —the team title outlasted both it and *Wow Comics*. Canceled in 1954, it ran for 89 issues.

Resuscitated along with Captain Marvel and Captain Marvel Jr. in *Shazam!* #1 [1973], Mary Marvel was a frequent guest star in the DC title

before being introduced into the DC Universe proper in *Justice League of America* #136 [1976]. She also had her own occasional back-up series in *World's Finest Comics* between #253 and 282 [1978–82].

Post-*Crisis on Infinite Earths*, Mary Marvel was brought into regular continuity in 1994's *The Power of Shazam!* graphic novel. A featured regular in *The Power of Shazam!* series that followed in 1995, she is a frequent guest in other DCU titles.

In one way, Mary Marvel is virtually unique among the female versions of male heroes. Unlike, for instance, her stable mate, Susan Kent, who became **Bulletgirl** to her boyfriend Jim Barr's Bulletman almost two years before Mary joined the Marvel family, she was not burdened by a -woman or -girl suffix simply because Captain Marvel is a name without gender connotations.

Kent, the daughter of a police sergeant, became Bulletgirl via a gravity-regulating helmet Barr made for her after she accidentally discovered his secret identity and insisted she help him fight crime.

Able to fly and repel bullets using the helmet, she debuted in *Master Comics* #13 [1941]. She appeared alongside Bulletman in all but one issue up to #106 [1949] and joined him in his own title, which ran 15 issues— skipping #13—from 1941 to 1946.

Introduced, like Mary Marvel, into DC continuity via the Justice League of America/Justice Society of America crossover that brought all the Fawcett heroes into the DCU, Bulletgirl is now deceased. Her daughter

has succeeded her. Introduced in *The Power of Shazam!* #32 [1997], Deanna Barr first donned her mother's uniform the following year in #43.

Timely's manner of feminizing a hero's name was somewhat more subtle. Introduced in *Marvel Mystery Comics* #82 [1947] as a female counterpart to the Sub-Mariner, Namor's long-lost cousin was named **Namora**.

Also known as Aquaria Nautica Neptunia, she was created, like her cousin, by Bill Everett. The only survivor of a human attack on Namor's kingdom, the Atlantean/human hybrid joined her cousin in his fight against crime. She appeared alongside the Sub-Mariner in *Marvel Mystery Comics* #84–90 and *Sub-Mariner Comics* #23–40 as well starring in the three issues of *Namora Comics* [1948].

Sterile as the result of her interspecies heritage, Namora has a daughter by cloning herself. **Namorita** first appeared in *Sub-Mariner* #50 [1972]. Also created by Everett, she has the same powers as her mother and her cousin.

She is able to breathe underwater, survive ocean depths, swim at great speeds, fly by the use of small ankle wings, and exhibit feats of great strength, durability, and stamina.

A regular guest star in and around the Marvel Universe, Namorita was a founding member of the New Warriors, playing a major role in the majority of the team's adventures across the 75 issues of its first series [1990–96] and all 10 issues of its second [1999–2000].

Batman got his **Batwoman** in 1956, though the relationship was not particularly intense. First appearing in *Detective Comics* #233, she

was Kathy Kane, a wealthy retired circus daredevil who simply wanted to use her money and skills to alleviate boredom by emulating Batman.

She made less than 40 appearances in *Batman, Detective Comics,* and *World's Finest* in eight years, retiring in 1964 [*Detective Comics* #325]. Returning for a series of stories in *Batman Family* #10,11, 13, 14, and 17 [1977–78], she also appeared in *Freedom Fighters* #14–15 before being murdered by the Bronze Tiger in 1979's *Detective Comics* #485.

For awhile between 1961 and 1963, Kane's niece, Betty, played **Batgirl** to her Batwoman. Introduced in *Batman* #139, she made only five appearances, the last of them without her aunt in *Detective Comics* #322. Subsequently, she made a handful of guest appearances in *Teen Titans* #50–52 [1977], *Batman Family* #16 [1978], and *Tales of the Teen Titans* #50 [1985].

Both Batwoman and Batgirl were written out of continuity as a result of 1985's *Crisis on Infinite Earths* 12-parter.

In the mid-1960s, with Betty Kane out of the picture, DC ushered in a new Batgirl, one more in keeping with the more dramatic new direction Batman was being taken in after years of weird and wacky story lines.

Created by editor Julie Schwartz, writer Gardner Fox, and artist Carmine Infantino, the new Batgirl made her first appearance in 1967's *Detective Comics* #359. Adopted by her uncle, Gotham City Police Commissioner James Gordon, after the death of her parents, Barbara Gordon attended a costumed ball as a female version of Batman. There she became

involved not only with the villainous Killer Moth but also with Batman, who offered to take her under his wing.

After a handful of appearances, mainly in *Batman* and *Detective Comics*, Batgirl gained a semiregular back-up slot in the latter title. Beginning in #384 [1969], it ran until 1972's #424. After the occasional guest appearance, she moved into *Batman Family*, appearing in almost all of the anthology's 20 issues [1975–78] before returning to *Detective Comics* for a more regular run of backups that only skipped odd issues between #484 [1979] and #519 [1982], continuing on a more sporadic basis to #533 [1983].

Apart from 1988's *Batgirl Special*, Gordon continued to make the odd appearance as Batgirl until Alan Moore and artist Brian Bolland's *Batman: The Killing Joke* [1988], which saw her gunned down by the Joker. Now confined to a wheelchair, she serves as **Oracle**, gathering information electronically and through a network of agents for Batman.

Gordon's place as Batgirl has now been taken by Cassandra Cain, who debuted in *Batman* #567 [1999]. Created by Kelley Puckett and artist Damion Scott, she was trained from birth by her father David, one of the world's deadliest assassins, to become his assistant and, eventually, his successor. Never taught to speak, she carried out her first hit at the age of nine but was so horrified by what she had done that she fled.

Surviving as a street urchin, she was 16 when she made her way to Gotham, which had shortly before been devastated by an

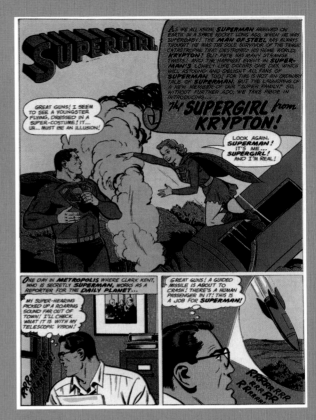

Action Comics #252 [National Periodical Publications, 1959]. The origin and first appearance of Superman's cousin, Supergirl.

earthquake. There Cain was discovered by Oracle, who recognized her unique abilities and recruited her to be one of her eyes and ears in the city designated No Man's Land. Oracle also vouched for her when Batman was looking to fill out the ranks of the Batsquad.

Premiering as the new Batgirl in *Batman:*

Legends of the Dark Knight #120, she made only a few appearances in various Bat titles before being promoted to her own title, the very first ongoing Batgirl series, in 2000.

While Superman had to wait until 1964 for his first Superwoman, his **Supergirl** arrived in 1959. Conceived by editor Mort Weisinger and writer Otto Binder, she was Superman's teenage cousin, Kara, who had escaped to Earth in a similar fashion to him.

Her parents had been among those who survived the destruction of Krypton when the city of Argo was blown into space on a chunk of the planet, which was transmuted into deadly kryptonite. Covering the surface with lead sheeting to protect themselves from the rock's radiation, the city's inhabitants also constructed a dome over their city to provide them with an atmosphere. But tragedy struck when a meteor shower penetrated both the dome and the shielding.

With just a month to live, Kara's father— Superman's uncle Zor-El—builds a rocket ship and, like his brother Jor-El, sends his only child to Earth and safety. She arrived in *Action Comics* #252 and, adopting the secret identity of Linda Lee, goes to live in an orphanage while her cousin trains her in secret in the use of her newfound powers.

With semiregular appearances in *Superman's Pal, Jimmy Olsen* and occasionally in other Superman-related titles, Supergirl also had her own series of backups in *Action Comics*. This ran to #376 with only the occasional skipped issue. She remained Superman's secret weapon until #285 [1962] when her existence was revealed to the world. Leaving *Action Comics*, she became the star of *Adventure Comics*, where she resided from #381 to 424 [1972], with the odd break.

From *Adventure Comics*, the Maid of Steel was elevated to her own series. Canceled in 1973, it lasted just 10 issues. While keeping up a frequent round of guest appearances, from there she moved to a semiregular spot in *Superman Family*, appearing in most issues of the anthology between #165 [1974] and the series' 1982 cancellation with #222.

Daring New Adventures of Supergirl followed. It fared slightly better than its predecessor, running to 23 issues between 1982 and 1984.

Then, following a last handful of guest spots, Kara was gone. Dead. A victim of 1985's *Crisis on Infinite Earths*. Killed off in the seventh issue of the 12-parter by Marv Wolfman and artist George Perez.

Her replacement arrived three years later. Based on Weisinger and Binder's template, John Byrne introduced his new Supergirl in *Adventures of Superman* #441 [1988].

The new Supergirl was created by Lex Luthor as a means of enlisting Superman's aid. Damaged during the futile battle to save that dimension, she is revealed as a mass of tissue that calls herself Matrix. She has comparable powers to Superman and can change shape.

Remaining on Earth, Matrix is asked to rescue Linda Danvers, daughter to a cop and a very religious woman. Arriving too late to save her from being butchered by a satanic cult, she merges her protomatter form with the girl's dying body, making them one. However,

she learns that, as a result of her sacrifice, she is now an Earth-born angel. As such, Supergirl can produce fire herself and can teleport to any place she has visited before.

Subsequently, Danvers and Matrix were parted and Matrix disappeared. Supergirl no longer has the power to shape shift—except from Linda to Supergirl and back—but she has superstrength, superspeed, and the ability to fly as well as all the other talents the original Supergirl possessed. However, these powers are not solar charged but are psychic abilities and therefore require concentration.

A regular member of the supporting cast across all four of the core Superman monthly titles, Supergirl graduated to her own four-issue mini in 1994. An ongoing Supergirl series was launched in 1996. Written by Peter David, it is proving far more successful than any of Kara's titles and is still going in 2002.

As for **Superwoman**, while Lois Lane had been transformed into a superwoman on several occasions from *Action Comics* #60 [1943] onward and Luma Lynai was described as the Superwoman of the planet Staryl [*Action Comics* #289, 1962], the first actually to bear the title was the Superwoman of Earth-3, an Earth where analogues of DC's heroes were the villains. Introduced in *Justice League of America* #29 [1964] in Crisis on Earth-3, a story by Gardner Fox and artist Mike Sekowsky that also featured the Justice Society of America and continued into the next issue, she was the evil version of Wonder Woman, a member of the Crime Syndicate. Her teammates were Ultraman, Earth-3's

Bulletman #1 [Fawcett Publications, 1941].

counterpart to Superman, Johnny Quick (the Flash), Power Ring (Green Lantern), and Owlman (Batman).

Together with Power Ring and Johnny Quick, Superwoman returned in *Secret Society of Super-Villains* #13–14 [1978]. The entire Crime Syndicate reunited for a 1982 story that encompassed *Justice League of America* #207–209 and *All-Star Squadron* #14–15.

Superwoman, the rest of the Crime Syndicate, and all of Earth-3 were eradicated from existence during Crisis.

Even before the Wonder Woman analogue was gone, a new Superwoman entered the DC Universe. She was Kristin Wells, a history professor from the year 2862 who traveled back through time to learn the true identity of Superwoman—only to discover that she was the mysterious heroine!

Created by writer Elliot S. Maggin, this Superwoman appeared in *DC Comics Presents Annual* #2 and 4 [1983 and 1985].

Just as Bulletgirl was Bulletman's similarly powered but weaker companion—or Hawkgirl was Hawkman's—very rarely, if ever, having a life outside his shadow, so was **Fly Girl** the Fly's. Introduced in issue #13 of *Archie's Adventures of the Fly*, she was actress Kim Brand who joins lawyer Thomas Troy on his crime-fighting escapades by virtue of an alien ring that grants her insect-based powers. She appeared alongside him in *Adventures of the Fly*—which changed its name to *Fly Man* in #32—#13–33, 35, and 39 as well as *Laugh Comics* #136–137 and 143, *Mighty Crusaders* [1965] #1–7, *Pep Comics* #153, 155–156, and 158, *Blue Ribbon Comics* #4, *The Fly* [1983] #2–3, and *Mighty Crusaders* [1983] #1–5 and 7–13.

Timely—now Marvel—continued to innovate rather than imitate as when, to protect copyright, Archie Goodwin and artist Sal Buscema introduced the John Romita-designed **Spider-Woman** in *Marvel Spotlight* #32 [1970].

With no connection to Spider-Man beyond the similarity of names, she was Jessica Drew who, as a young girl, had been exposed to radiation poisoning. In an attempt to save her life, her father injects her with a spider blood serum, hoping that the insect's ability to withstand radiation will be passed on to her. At the same time, one of his fellow scientists places her in a cryogenic chamber and subjects her to a genetic accelerator.

Kept in suspended animation until a teenager, she emerges not only cured but possessing superstrength and with the ability to generate potentially deadly bioelectric "venom blasts."

After appearing alongside the Thing in *Marvel Two-in-One* #29–33 [1977], Spider-Woman graduated to her own title in 1978. This lasted 50 issues until 1983 when she lost her power to generate bioelectric blasts and retired from the superhero life.

Her replacement was Julia Carpenter. An operative working for a government agency known as The Commission, as the result of secret experiments she gained greatly enhanced reflexes, endurance, and superhuman strength. She also acquired the ability to adhere to surfaces, climb walls and ceilings, and project a "psionic web," a construct made of pure psionic energy that can cover an area or be used as a rope.

She was introduced in *Secret Wars* #7 [1984] in a story by Jim Shooter and artist Mike Zeck. Following a handful of guest appearances, she joined the West Coast branch of the Avengers, staying with them from 1991 until it disbanded in 1994 [*Avengers West Coast* #70–102]. She subsequently became a founding

member of its successor, appearing in all 22 issues of the *Force Works* comic [1993–96].

Granted her own four-issue miniseries in 1993, she later encountered another Spider-Woman who stole her powers. Teaming up with Jessica Drew, Madame Web, and yet another Spider-Woman—all of whom were targeted by the same woman—she learned her attacker was Charlotte Witter.

A victim of Doctor Octopus's experiments in gene manipulation, Witter possessed superhuman strength, speed, and endurance and had six bony spiderlike arms sprouting from her back.

When Witter was finally captured, Madame Web—her grandmother—performed "psychic surgery" that rendered her powerless. She is now incarcerated in Meridian House, a penitentiary for the criminally insane.

Integral to the story of the final Spider-Woman, who she took under her wing, **Madame Web** is a psychic with sensory powers, including clairvoyance, telepathy, and precognition.

Introduced in 1982's *Amazing Spider-Man* #210, in a story by Denny O'Neil and penciler John Romita Jr., she also has the ability to sense the presence of psionic powers in other beings and to take on astral forms.

Born Cassandra Web, her powers are due to genetic mutation. Blind since birth, she was dependent on a weblike cybernetically linked external life support system due to myasthenia gravis, a disease that erodes the central nervous system, until she took part in the Gathering of the Five when her youth and

Spider-Woman #14 [Marvel Comics, 1979].

health were restored to her.

The final Spider-Woman is Martha "Mattie" Franklin, who debuted in *Amazing Spider-Man* volume 2 #2 [1999] at the same time as the Witter version and was, like her, created by writer/artist John Byrne.

As a result of a mystic ritual performed during the Gathering of the Five and her encounter with the Witter Spider-Woman, she possesses all the powers of the previous spider-women. She can stick to walls, fire bio-electric blasts, create psionic webs, and has tentacles that sprout from her back. The new Spider-Woman also has the powers of Madame Web, giving her psychic sensory ability, including clairvoyance, telepathy, precognition, and the ability to sense psionic powers in others. In addition, she is also able to fly unassisted.

Franklin gained her own Spider-Woman series in 1999. It was canceled in 2000 after 18 issues.

To have mentioned all four incarnations of Spider-Woman and omit Spider-Girl would be a sin, even though she does exist in one of Marvel's alternate futures. Created by former Marvel editor in chief Tom DeFalco and artist Ron Frenz for a one-time story in *What If...* #105 [1998], she is May "Mayday" Parker, the daughter of Peter Parker and Mary Jane Watson and has inherited all of her father's spider-powers.

She was given her own titles months after her debut. The foundation stone of the MC2 Universe, Spider-Girl is the only one of the alternate future series still being published.

Following three years behind the original Spider-Woman came **She-Hulk**. Conceived, like Spider-Woman, specifically for copyright purposes, she was the first character Stan Lee had created in years.

Introduced in the John Buscema-penciled first issue of 1980's *Savage She-Hulk*, she is Jennifer Walters, the cousin of Dr. Bruce Banner, the Incredible Hulk. She developed her Hulk-like powers following a gamma-irradiated blood transfusion from her cousin. Unlike the Hulk, Walters cannot return to her normal human form although she does retain her normal level of intelligence. Almost seven feet tall and green, her skin is highly resistant to injury.

Frequently encountered in and around the Marvel Universe, her first series was canceled in 1982 after 25 issues. A regular member of the Avengers since *Avengers* #221 [1982], she also replaced the Thing in the Fantastic Four, staying with the team until 1987 [*Fantastic Four* #266–300] and was part of an F.F. spin-off team, appearing in issues #12–18 of *Fantastic Force* [1995–96].

In 1989, She-Hulk was granted her second solo series. Somewhat more successful than her original comic, *Sensational She-Hulk* clocked up 60 issues before it was canceled in 1994.

To leave the way we came in, Mary Marvel's 1970s avatar is Ms. Marvel in that both are female versions of Captain Marvel. The only difference is that Mary is based on her brother, Fawcett's 1940s Captain Marvel, where Ms. Marvel is a distaff recreation of Marvel's 1960s hero of the same name.

Designed—like Spider-Woman, who she preceded by a month—by Romita, Ms. Marvel debuted in the 1977 first issue of her own title in a story written by Gerry Conway and drawn by John Buscema. However, her alter ego,

Carol Danvers, was introduced in *Marvel Super-Heroes* #13, the 1968 second appearance of Mar-Vell, the Kree warrior who became known as Captain Marvel.

A former Air Force officer and NASA security chief, Danvers was irradiated by unknown energies from the Kree Psyche-Magnitron during a battle between Mar-Vell and Yon-Rogg, another of his alien race. This radiation eventually augmented her entire genetic structure, giving her superhuman strength, the ability to fly, and a clairvoyant "seventh sense."

The *Ms. Marvel* comic was canceled in 1979 after 23 issues, but by then she was working alongside the Avengers, becoming a member of them in *Avengers* #183 [1979]. Later, after leaving the team, she established close ties with the X-Men until—in a battle with the power-absorbing Rogue—she lost all her powers except for her augmented genetic structure. She was then abducted by the alien Brood, which subjected her to an evolutionary ray. This transformed her into the cosmic-powered Binary [*X-Men* #164, 1982].

In her new form, she could tap the energy of a white hole, radiate heat, light, and the rest of the electromagnetic spectrum as well as gravity. She has heightened perceptions and, by directing the energy release, can fly at near-light speeds. Leaving Earth for space, she joined the Starjammers until an emergency call from the Avengers brought her back to her home planet and to that team.

Renaming herself **Warbird** [*Avengers* volume 3 #4, 1998], she remains a member of the Avengers. Although her powers are now far below their cosmic levels and appear to be continually decreasing, she still has flight, enhanced strength, durability, and the ability to shoot bolts of energy from her hands.

Introduced by Michael Carlin—now vice president of the DC Universe—and penciler Ron Wilson in *The Thing* #27 [1985], Sharon Ventura became the next **Ms. Marvel** in the Paul Neary-penciled #35 [1985], the penultimate issue of the Fantastic Four spin-off title. Offered the chance to join the Grapplers, a female Unlimited Class Wrestling Federation team, she underwent a special strength augmentation process.

She joined the Fantastic Four [in *Fantastic Four* #307, 1987] but was bombarded by cosmic rays in outer space [*Fantastic Four* #310, 1988]. This mutated her into a form similar to that of the F.F.'s Ben Grimm when he was first transformed into the Thing. As the "She-Thing," Ventura is all-but invulnerable.

Ventura finally parted company with the F.F. in *Fantastic Four* #382 [1993]. Little has been seen of her since.

Right: Detective Comics #359 [National Periodical Publications, 1967]. The origin and first appearance of Batgirl.

BATMAN
WITH ROBIN THE BOY WONDER

-- INTRODUCING THE NEW BATGIRL

OUT OF THE SUPER-STAR STUDDED FIRMAMENT OF *GOTHAM CITY*, WHERE *BATMAN* AND *ROBIN* SHINE SUPREME AS MASKED MANHUNTERS-- BURSTS A BRAND NEW LUMINARY-- *BATGIRL!* AND LIKE THAT VERY *BATMAN* AFTER WHOM SHE MODELS HERSELF-- SHE TOO BATTLES CRIME AND INJUSTICE IN A MANNER WONDROUS ENOUGH FOR NEWSPAPERS TO PROCLAIM IN BANNER HEADLINES--

"THE MILLION DOLLAR DEBUT OF BATGIRL!"

NOW THAT I'VE GOT *BATGIRL* OUT OF THE WAY, I CAN GIVE MY FULL ATTENTION TO MY OLD NEMESIS, *BATMAN!*

WHO *IS* THIS *NEW* BATGIRL WHO SEEMS TO HAVE TAKEN OVER MY CRIME-FIGHTING TERRITORY?

As Rose, she has worked with Superman several times, but her secret is known only to psychiatrist Dr. Brad Roberts, who is in love with his patient. Although Rose is unaware of the fact, she is actually a millionaire.

Tank Girl [1988]

This stylish superstar originally appeared as a pinup in Jamie Hewlett and Philip Bond's self-published *Atomtan*, with her first strip work appearing in the seminal *Deadline*. Tank Girl drove around the Australian outback with her kangaroo boyfriend, Booger, getting into various overblown hijinks. Many of the stories have no real meaning or ending but "guest star" a variety of "D-list" British celebrities such as Kenny Lynch.

Tank Girl's gutsy attitude and punk dress sense meant that she soon became the figurehead for the riot grrrl and lesbian movements of the late 1980s/early 1990s. Her public profile was so high she was used to advertise Wrangler jeans. As her popularity grew, she headed stateside and was reprinted by Dark Horse comics in numerous miniseries and new material by DC Comics/Vertigo. Hollywood beckoned and proved that the comic was unfilmable by making a disappointing movie with Lori Petty in the lead role in 1995. She remains a quintessentially British icon and enabled Jamie Hewlett to go on and form the virtual band Gorillaz with Damon Albarn.

The Dazzler [1980]

One of Marvel's totally misconceived attempts to be hip and trendy, the Dazzler was created as a cash-in on the discotheque craze. Unusual for a comic book hero, she originally was conceived as The Disco Dazzler—a mutant disco singer with the ability to generate dazzling psychedelic light blasts.

Instead of dropping the entire idea, only the Disco part of her name was ditched when the sequin-cat suited roller skate-booted heroine made her first appearance in issue 130 of the top-selling *Uncanny X-Men*. It was a high-profile sales boost for her 1981 launched solo series, which somehow continued for 42 issues and included a prestige format standalone graphic novel. In an attempt to rescue an idea gone wrong, the first issue had no less than 11 creators listed.

When the title was canceled in 1986, Dazzler went home as a newly recruited member of the X-Men.

White Queen [1980]

Originally the joint head of The Hellfire Club—a constant foe of Marvel Comics' the X-Men—the first Queen was Emma Frost, who appeared in issue 132, wielding immense psychic powers.

After years of battling the X-Men, she was finally persuaded to become the headmistress of Mutant Highschool. When Emma hit financial difficulties, she was forced to ask her sister

Adrienne for help and ended up giving her the position of headmistress. However, Adrienne tried to kill the students in order to torture Emma and then left the school to assume the mantle of White Queen II. However, this was simply a ruse to enable her to steal millions from The Hellfire Club.

Emma finally shot her sister and descended into alcoholism for a period. She funded many projects for mutant students but became increasingly cold and borderline psychotic. Emma was eventually recalled by Professor X and ended up teaching on the island of Genosha. When this mutant haven was destroyed, she was rescued by the X-Men and, though she initially disdained their motives, soon rejoined their cause.

Wonder Girl [1996]

Cassandra "Cassie" Sandsmark is a precocious California high school student who first appeared in DC Comics' *Wonder Woman* #105 (second series).

It was in *Wonder Woman* #111 that Cassie took on the identity of Wonder Girl, a name DC had used throughout the previous 35 years for a charter member of the Teen Titans who matured into her Donna Troy role. She did this by borrowing Wonder Woman's Sandals of Hermes and Gauntlet of Atlas, which gave her the respective powers of flight and strength.

When summoned to Mount Olympus by the gods, she brazenly asked Zeus for Wonder Woman-like abilities of her own. Impressed by her cheek, Zeus gave her the permanent powers of Wonder Girl. Soon after, she joined the team of Young Justice, with Robin making her team spokesperson. A relationship subsequently began between her and the current version of Superboy.

Zatanna [1964]

DC Comics' Mistress of Magic, the fishnet tights with top hat and tails character was created for the industry's first intertitle crossover story. On a quest to discover the fate of her father—the Golden Age magician Zatara —she enlisted the help of several second-string 1960s DC heroes, which began in 1964's *Hawkman* #4, continuing across The Atom, Batman, and Detective Comics' back-up strip The Elongated Man, before being resolved in Justice League of America #51.

Such was her popularity she won a readers' poll a decade later to become a member of the J.L.A. with issue 161 but, much to the disappointment of her mainly adolescent male fans, discarded her fishnets for more standard superhero garb.

Following a long stint with DC's superteam supreme, she has guest starred in a number of DC's more mature titles including *Hellblazer*, *The Spectre,* and *Books of Magic*. She can conjure up anything from lightning storms to earthquakes but is held back by having to speak her spells backward, which certainly makes reading her speech balloons that much more difficult!

Creators or Creations?

While a handful of comics creators achieved some minor fame through their signatures appearing in comic books during the 1940s, the industry was still a poor cousin to the booming newspaper strip market. But artists and writers, eager to gain experience and compile a published work portfolio, accepted meager wages to create four-color fantasies for a captive young audience.

Without doubt, the publisher was god, and the editor's word was law. Even through to the 1960s, with few exceptions, the actual comics creators were interchangeable and ultimately disposable.

Market leader DC-National rarely credited its writers and artists; unlike the editors and publishers, the hands-on creators were casual work-made-for-hire, with no job security.

But it all changed with Stan Lee. As well as being a talented ideas man, he was the ultimate showman, an Uncle Stan who let readers into his thoughts through his regular Soapbox editorials and his Bullpen Bulletins column.

Perhaps realizing his greatest asset was his talented freelancers, he built them up. He not only credited them, he made them into stars.

Jack "King" Kirby, "Big" John Buscema, "Sturdy" Steve Ditko. Even his lettering artist became "Artful" Artie Simek. Where DC preferred anonymity, Lee flaunted his talented bullpen, letting readers into his conversations with them, telling anecdotes about them, humanizing them. And giving them strength.

But this strength became his undoing. While "ghost" writers and artists had kept titles strong when older creators moved on, Marvel saw an end to such factory-line creating.

Suddenly the question was being asked: Which is more important, the creator or the creation? As well as headers for Batman,

Right: Nick Fury, Agent of S.H.I.E.L.D. #1 [Marvel Comics, 1968]. Psychedelic Steranko cover art.

"Suddenly the question was being asked: Which is more important, the creator or the creation?"

Superman, and all the top characters, special sections in dealer catalogs and lists were given over to "Neal Adams titles," "Steranko comics," and so on.

Readers' tastes were maturing. Suddenly only Batman comics drawn by Neal Adams were of key interest. When the psychedelic art of Jim Steranko left *Nick Fury, Agent of S.H.I.E.L.D*, so did the readers.

When Marvel's leading creator Jack Kirby was lured away to greater creative freedom, the fans that Lee had built up for him followed him. It looked as if the creator was suddenly more powerful.

In the past, top characters had survived poor creators. Now the creator ruled and could play one publisher off against another for increased page rates.

Then a strange thing happened. Once off their key titles, all the top creators floundered. Neal Adams' own company, Continuity Comics, was virtually ignored. Jack Kirby's Fourth World line for DC was prematurely killed. Barry Windsor-Smith, once lauded for his pre-Raphaelite influences on *Conan the Barbarian*, produced nothing enduring through his new GorBlimey Press.

John Byrne, everybody's hero on *X-Men*, found only a small audience for his Dark Horse title, *Next Men*. Bernie Wrightson, once the king of horror on *Swamp Thing*, virtually disappeared. Jim Steranko's pet projects failed. The Spider-Man and Doctor Strange cocreator Steve Ditko, who had also jumped the Marvel ship for DC freedom, didn't even last six months on his new *Hawk & Dove* and *Creeper* titles.

Yet *Batman*, the *X-Men*, *Spider-Man*, *Conan*, and virtually all of the rest continued. New artists replaced the old. The titles recovered and grew under the tender loving care of Jim Lee, Frank Miller, Todd McFarlane, and a raft of new blood weaned on the work of Kirby, Adams, Smith, and Steranko.

Until they too found sufficient fame to go in search of creator control, through their own titles, *WildC.A.T.S, Sin City, Spawn,* and more.

Lee is now drawing Batman for DC, as is Miller—having returned for a sequel to his *Batman: The Dark Knight Returns* best-selling miniseries of more than 15 years ago. McFarlane has work-for-hire writers and artists producing *Spawn* while he concentrates on building his successful new company, McFarlane Toys.

Over 50 years since the creation of these contemporary American gods, the superheroes, they continue to thrive. Three generations of artists and writers have nourished and abandoned them, yet they prosper. In print, on film, and across the Internet, they have proven themselves to be greater than the sum of their parts.

"But it all changed with Stan Lee. As well as being a talented ideas man, he was the ultimate showman, an Uncle Stan who let readers into his thoughts through his regular Soapbox editorials and his Bullpen Bulletins column."

When Superman Meets Spider-Man

Costumed heroes having been encountering each other at least since the Sub-Mariner and the original Human Torch clashed in Marvel Mystery Comics #8 [1940].

They've been forming teams since a few months later when the members of the Justice Society of America came together for the first time [*All-Star Comics* #3]. Even Batman and Superman began teaming up regularly as early as 1954 [*World's Finest Comics* #71]. But all these meetings had no bearing on the supposed lives of the individual characters beyond each adventure.

Then Stan Lee introduced a soap opera element into comics, and heroes began to relate to each other. As the writer and—with Jack Kirby and Steve Ditko—the cocreator of all of Marvel's early output, Lee was in a position to make this comic book world seem more real.

From the moment in 1963 that the Fantastic Four turned up in *Amazing Spider-Man* #1 and the Hulk made an appearance in #12 of the F.F.'s own title, crossovers and guest appearances were to become part of the very fabric of superhero comics.

It wasn't long before Marvel heroes were appearing in each other's titles on a regular basis, and even DC began to integrate its superhero universe into a more cohesive whole.

Then in 1976, Marvel and DC reached a historical agreement to copublish a comic starring their top heroes.

The two New York-based publishers had already collaborated on the tabloid-sized MGM's *Marvelous Wizard of Oz*—a 1975 adaptation of the 1939 movie starring Judy Garland—and issued *Superman vs. the Amazing Spider-Man* in the same format.

Written by Gerry Conway and drawn by Ross Andru and Dick Giordano, it was ultimately followed by two more 10" x 13" specials in 1981: *Batman vs. the Incredible Hulk*

Right: Superman vs. the Amazing Spider-Man [National Periodical Publications/Marvel Comics 1976]. Icons clash in a groundbreaking intercompany crossover.

[DC Special Series #27] and *Spider-Man/Superman* [Marvel Treasury #28].

For their fourth intercompany crossover, Marvel and DC reverted to traditional comic book size. The cumbersomely titled *Marvel and DC Present featuring the Uncanny X-Men and the New Teen Titans* starred in each company's most popular team.

Penciled by then-fan favorite artist Walt Simonson and written by X-Men supremo Chris Claremont, it was a much bigger hit then its predecessors but it was to be the last title copublished by the Big Two for some years.

The end of the DC/Marvel arrangement signaled a brief halt rather than an end to such crossovers. As sales rocketed in the early 1990s, publishers began looking for gimmicks in what was becoming an increasingly overcrowded field.

Seeing major publicity in a crossover featuring their respective heroes, the two most successful companies of the period pooled their resources in 1993 for *Deathmate*. A six-issue series, it brought the Valiant and Image pantheons together to spectacular commercial success. It also opened the crossover floodgates. ...

Virtually every superhero publisher began setting up crossovers with its competitors. Dark Horse's movie licences were utilized to great effect with a variety of heroes—mainly from DC—confronting Aliens, Predators, and Terminators. In fact, Dark Horse's own four-issue *Aliens vs. Predator* [1990] might be seen as a forerunner to the mid-1990s boom that followed *Deathmate*.

Certainly Dark Horse's *Aliens vs. Predator versus the Terminator* [2000] and *Aliens versus Predator/Witchblade/Darkness: Mindhunter* [2000] (or *Witchblade/Aliens/The Darkness/Predator: Mindbridge* as the Image response was titled) give some indication of the incredible lengths that some publishers would go to to squeeze extra mileage out of the crossover concept.

By 1996, DC and Marvel—again working together—took the idea a step further by having the majority of their heroes clash in the four-part *DC versus Marvel* (or *Marvel versus DC*, depending on which publisher produced which issue).

This led to the creation of an Amalgam Universe and a series of one-shots featuring new characters created by amalgamating superheroes from each universe.

Among the many new creations were Spider-Boy (Spider-Man and Superboy), Super-Soldier (Superman and Captain America), Dark Claw (Batman and Wolverine), X-Patrol (X-Men and Doom Patrol), and Challengers of the Fantastic (Challengers of the Unknown and Fantastic Four).

For as long as publishers continue to think of interesting reasons for bringing two or more heroes together, intercompany crossovers will continue to be part of the comics industry.

Aliens vs. Predator vs. the Terminator trade paperback [Dark Horse Comics, 2001].

Sheena: Jungle Queen

American comics fans might claim her as the female equivalent of Tarzan, but Sheena actually made her debut on the other side of the Atlantic.

Conceived by S. M. (Sam) Iger and The Spirit's Will Eisner, the Queen of the Jungle was a deliberate attempt to develop a distaff version of Edgar Rice Burroughs' *Lord of the Apes*. Via their studio, the pair created her for Editors Press Service.

A U.S. company in the business of supplying American weekly newspaper strips to various foreign publications, it was looking for new material to augment the reprints in *Wags*, a tabloid that was distributed throughout what was then the British Empire.

After her full-page serial premiered in *Wags* #46 earlier in 1938, Sheena recrossed the ocean as Fiction House began reprinting the strip—drawn by Mort Meskin and written by Iger under his W. Morgan-Thomas pen name—in *Jumbo Comics* #1.

Making it even more notable as the first comic book to feature Jack Kirby art, that issue also contained reprints of *The Count of Monte Cristo*, *The Diary of Dr. Hayward* and *Wilton of the West* newspaper strips—all three drawn pseudonymously by the future King of Comics. Also featured was *Hawks of the Sea*, a

strip Eisner created for *Wags*.

The first of a bevy of Jungle Queens, Sheena may have been female, but apart from that and her overwhelming popularity, she had little in common with DC's Wonder Woman.

Where the archetypal superheroine—who followed more than two years later—was designed to attract young girls to comics, Iger and Eisner definitely had adolescent males in mind as the target audience, especially when they reduced the costume of the beautiful blonde with an outrageous [42-23-34] figure to little more—and sometimes less—than a leopard-skin halter and mini-skirt.

That revision took place with #10 [1939], the issue after the 10$\frac{1}{2}$" x 14$\frac{1}{2}$" *Jumbo Comics* was reduced to regular comic book size and became color.

Though, like so many others, the origin was subtly altered as time passed, Sheena started out as the daughter of African explorer Cardwell Rivington. Adopted by Koba, a local medicine man who accidentally poisoned her father, she grows up to be skilled in the ways of the jungle.

As an adult, she spends the majority of her time battling evil white hunters, slave traders, Nazi invaders, renegade tribes, and rampaging wildlife in the form of gigantic birds and beasts. That and rescuing her blundering mate—Bob Reynolds, a hapless hunter/explorer—from a variety of sticky situations.

A prime example of the good girl art genre (a term coined in 1977 to describe a style of art that portrays women in a sexually implicit way), within two years Sheena was the undisputed star of *Jumbo Comics*, which began featuring her in original stories drawn by such artists as Bob Powell and Bob Webb.

Although her adventures ran in all 167 issues of the series [canceled in 1953—two years before the striking six-foot-tall Irish McCalla portrayed her in a 26-episode T.V. series]—she also became the first heroine to be granted her own title. Published irregularly, *Sheena, Queen of the Jungle* lasted 18 issues from 1942 to 1953.

Sheena's last appearance in a Fiction House title was in 1953's *3-D Sheena Jungle Queen*, reprinted in 1985 by both Eclipse Comics and Blackthorne Publishing with a cover by top good girl artist Dave Stevens.

She next turned up in *Marvel Super Special* #34. Reprinted as the two-issue *Sheena*, it was an adaptation of the dire 1984 movie that featured former *Charlie's Angels* star Tanya Roberts in the title role. This was followed in 1998 by *Sheena—Queen of the Jungle*.

A black-and-white four-parter published by little-known London Night Studios, it transplanted her to South America where, as the sole survivor of a 1970s plane crash, she grows up and takes to wearing a skin-tight black leather catsuit with a leopard-skin vest.

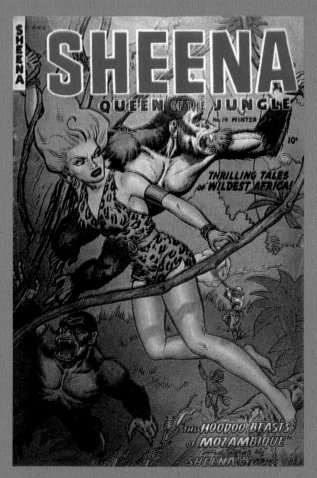

Sheena, Queen of the Jungle [Fiction House Magazines, 1952].

Wonder Woman: The First Female Superhero

There is something synchronous about a character who wields a lasso of truth having sprung from the mind of the psychologist who developed the lie detector.

Sent from Paradise Island, the hidden home of the Amazons, on a mission to help combat Ares' effect on "Man's World," Wonder Woman was created by William Moulton Marston. His discovery of the systolic blood pressure test—in 1915 at the age of 22—had resulted in the invention of the lie detector.

Marston's experiments had led him to conclude that women were more honest, more reliable, and could work faster and more accurately than men. An early champion of women's rights, he conceived the Amazon Princess as a counter to what he considered to be an overly masculine-dominated culture.

Introduced in 1941 in *All-Star Comics* #8, Wonder Woman was the first female superhero. Now far from her peak, she remains at the forefront of her gender today. While her origin has been tweaked several times since, particularly to reestablish her in the post-*Crisis on Infinite Earths'* [1985] DC Universe, its basis remains steeped in Greek mythology.

Crafted from clay by Queen Hippolyta and given life by the soul of the queen's unborn daughter, Diana, as she was named, has god-given abilities. She was granted strength and power by Demeter, beauty and a loving heart by Aphrodite, wisdom by Athena, hunting ability and unity with the beasts by Artemis, sisterhood with fire by Hestia, and speed and the power of flight by Hermes. In addition, as she grew to adulthood, the Amazons trained her in all ancient Greek methods of hand-to-hand combat.

Immediately following her debut, Wonder Woman gained her own series, beginning as the cover feature in the first issue of *Sensation Comics* [1942]. Although she starred there until #106 [1951], she was also promoted to her own title, which launched just a few months later. *Wonder Woman* was to continue until 1986, a total of 329 issues, and was only canceled for a relaunch—under the guidance of writer/ artist George Perez—which continues today.

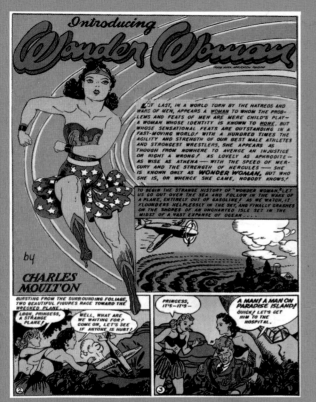

Sensation Comics #1 [National Periodical Publications, 1942]. The second appearance of Wonder Woman.

Paralleling her 1940s appearances in *Sensation Comics* and her own title, Wonder Woman also had a series running in *Comic Cavalcade* #1–29 [1942–48] and featured in *Big All-American Comic* #1. She was also a part of the Justice Society of America, joining in *All-Star Comics* #11 and remaining until #57 [1951]. The team's only distaff member, initially she served as the team's secretary, a sign of the times despite Marston's beliefs. She was finally inducted into full membership in #38 [1947].

With changing times and attitudes, when DC revived the superteam concept in *The Brave & the Bold* #28 [1960], Wonder Woman was made a charter member of the Justice League of America, now being on an equal footing with DC's other archetypal superheroes, Superman and Batman.

In 1968, Denny O'Neill teamed up with artists Mike Sekowsky and Dick Giordano to make the Amazon Princess more relevant to the changing times.

They removed her superpowers, remodeled her along the lines of Emma Peel from *The Avengers* T.V. show, and gave her a blind Oriental mentor, I-Ching, who taught her martial arts. They also dispatched Paradise Island and her sister Amazons to another dimension, ostensibly so they could renew their magical energies.

The makeover lasted 25 issues—*Wonder Woman* #179–203 [1972]. Diana reverted to her original costumed persona and mythological trappings when ABC optioned Wonder Woman for a T.V. movie.

Set during World War II, it finally premiered in 1975 with Cathy Lee Crosby—who was subsequently replaced by Linda Carter for the further two movies and *The New, Original Wonder Woman* series that followed—in the title role. Retitled *The New Adventures of Wonder Woman*, the series moved to CBS and modern times in 1977.

Chapter 3
Teams

It didn't take comic book publishers long to appreciate that a group of heroes would be more popular than one on his own or even a dynamic duo. The archetypal superteam, the Justice Society of America convened for the first time in 1940, and from then on such groups would become a mainstay of the comics industry. The Fantastic Four, X-Men, All-Star Squadron, T.H.U.N.D.E.R. Agents, these and other such power posses continue to thrive throughout the world of comic books.

All-Star Squadron [1981]

First appearing in a 16-page prelude to its own title given away with *Justice League of America* #193, the team was created by Roy Thomas and artist Rich Buckler to enable the writer to tell new stories of DC Comics' Golden Age [1940s] heroes during World War II.

Following 1985's *Crisis on Infinite Earths*, Superman, Batman, Wonder Woman, and other early members of the Justice Society of America had been eradicated. All-Star Squadron was retroactively designated to fill the continuity gap.

Initially the All-Star Squadron consisted of the Justice Society of America's Hawkman, Atom, and Dr. Mid-Nite together with Robotman, Liberty Belle, and Johnny Quick. Plastic Man acted as the Squadron's F.B.I. liaison. Mobilized by President Franklin D. Roosevelt on December 7, 1941, the team went on to include every DC, Quality Comics, and Fawcett Comics superhero and costumed crime fighter active during World War II.

DC's All-Star Squadron ran for 67 issues until 1987. A spin-off—*Young All-Stars*—ran from 1987 to 1989.

All-Winners Squad [1941]

Introduced in a text story written by Stan Lee for the first issue of *All-Winners Comics*, Captain America, the Human Torch, Namor the Sub-Mariner, Bucky, Toro, the Whizzer, and Miss America didn't make their first comics appearance as the *All-Winners Squad* until #19 [1946].

Formed by President Harry S. Truman as a peacetime replacement for the Invaders, the first *Timely [Marvel] Comics* superhero team also featured in #21; there was no #20. In 1948, a revised and truncated lineup featuring just Cap, the Sub-Mariner, the Torch, and the Blonde Phantom appeared in the one and only issue of the relaunched *All-Winners Comics*.

Alpha Flight [1979]

Created by Chris Claremont and artist John Byrne, this Canadian superteam was introduced in *X-Men* #120.

A government unit sanctioned by Department H, they came to retrieve one of their former comrades, Wolverine, who had gone AWOL to join the mutant band. Initially the lineup consisted of:

- Vindicator (also named Guardian)— First seen in *X-Men* #109 [1978], James MacDonald Hudson is the leader of Alpha Flight. He had developed Alpha Flight assisted by Wolverine, who he'd decided should head up the team.
- Sasquatch—The team's strongman, Walter Lankoswki is a scientist who can change into a being resembling the legendary Yeti.
- Northstar—A French-Canadian, Jean-Paul Beaubier was Marvel's first gay superhero. A mutant with the power to move at superspeed, he is the twin brother of

- Aurora—Jeanne Marie Beaubier is capable of superhuman speed and of generating an intense white light.
- Shaman—One of Canada's greatest surgeons, Michael Twoyoungmen is a member of the Sacree tribe. A powerful magic wielder, Shaman uses mystical potions and spells to subdue his foes.
- Snowbird—Narya, a.k.a. Anne McKenzie, was born a demigoddess. The daughter of Canadian archaeologist Richard Easton and Nelvanna, the Inuit (Eskimo) goddess of the Northern Lights, she can morph into any animal native to Canada's Arctic.

The team gained its own title in 1983. *Alpha Flight* #1 introduced the first two of several new members:

- Puck—Eugene Milton Judd was born in 1914. A former mercenary, soldier of fortune and adventurer, he is highly acrobatic; his gymnastic skills and reflexes border on superhuman.
- Marrina—A member of the extraterrestrial race known as the Plodex, her alien nature enables her to mimic human and aquatic life.

Alpha Flight ran a total of 130 issues—the first 28 written and drawn by Byrne—until 1994. With the team and its various members, new and old, often sighted in and around the Marvel Universe, the title was relaunched in 1997, to be canceled in 1999 after 20 issues.

Asskickers of The Fantastic [1978]

In action at a time when monsters have become so numerous that their own pressure groups had lobbied for them to be called Fantastics (considering the M-word to be derogatory) and for the passing of the Fantastic Rights Amendment, this group's slogan is, "We haul ours to kick theirs."

Introduced in #4 of Warren Magazine's 1984, the *Asskickers of the Fantastic*, they are led by the strong but not very bright Rex Havoc. His teammates are monster expert and scientific genius Major Lars Wurlitzer, mechanic Springer, and busty Bruno Zagwides.

Created by Jim Stenstrum and drawn by Abel Laxamana, they appeared in issues #4–6 and 8–9 of the black-and-white magazine.

The Authority [1999]

Created by Warren Ellis and artist Bryan Hitch out of the ashes of WildStorm's StormWatch, this team of superheroes took comic book violence to new levels, confronting villains capable of leveling cities with world-wide destruction and the deaths of millions.

Introduced in the first issue of its own *WildStorm*—a DC Comics imprint—title,

Continued on page 238

Fantastic 4: First Family

Never one to hide his light under a basket, writer/editor Stan Lee proudly proclaimed Fantastic Four to be "The Greatest Comics Magazine in the World" from its third issue.

Not a bad boast for a comic that owes its existence to a chance conversation between two rival publishers.

During a round of golf, Marvel publisher Martin Goodman was told by Jack Liebowitz, his opposite number at DC, that the teaming up of Superman, Batman, Wonder Woman, and other heroes in the recently launched *Justice League of America* was proving to be a success. Ever one to jump on a bandwagon, Goodman returned to Marvel where he instructed Lee to create the company's own super group.

That Marvel did not have a single extant superhero did not deter Goodman in his determination.

Setting about the task, Lee got together with Jack Kirby. The artist had been working in comics since 1938 and with his previous partner, Joe Simon, had been responsible for many industry milestones, including the creation of Captain America, romance, and kid gang comics.

The Fantastic Four were not a band of disparate heroes but rather a family. Its members were "the world's greatest scientist" Reed Richards, his fiancée Sue Storm, her hot-headed brother Johnny, and Reed's best friend, the avuncular but gruff Ben Grimm. While Reed was something of a bore, none of the others were depicted as a cliché.

They made their debut in *Fantastic Four* #1 [1961] in a story in which the four made a desperate bid to beat the Communists into space in a rocket Reed had constructed. That origin has now been updated to a threat of loss of funding and a starship, but the outcome was still the same.

Cosmic changes

The four are bombarded by cosmic rays which trigger mutagenic changes in their bodies when they return to Earth. Reed gained a flexible, stretchable body à la Jack Cole's Plastic Man or Marvel's own 1940s Timely hero, Flex the Rubber Man, while Sue learned she could make herself disappear. Resurrecting another of Timely's Golden Age heroes, Johnny

became the Human Torch, a more accurate label for him than it was for the android that Carlos Burgos introduced in *Marvel Comics* #1 [1939].

Ben was the unlucky one. Where the others could turn their powers on and off, he was transformed into an orange humanoid seemingly composed of rocks. While his teammates adopted Mr. Fantastic, Invisible Girl (later woman), and the Human Torch as their operating names, Ben selected the Thing.

Such was Lee's faith in Kirby's talent and creativity that he instituted a new method of writing comics that would eventually come to be known as "the Marvel way." Instead of providing the artist with a full script, broken down frame by frame, he just gave him a short plot synopsis, leaving it to Kirby to structure the rhythm and pace of the story.

It began as a timesaving device for the writer—who added dialogue and captions once the art was complete—but it enabled both collaborators to display their strengths. Lee and Kirby became to comics what Lennon and McCartney are to pop music or Laurel and Hardy to comedy.

While they continued to work together until 1970 and cocreated many of Marvel's major heroes, Fantastic Four was their magnum opus. A mix of soap opera, strong characterization, and adventure, the series opened the door to the Marvel Age of Comics.

The 102 issues they collaborated on are littered with the first appearances of many memorable characters who have since become an integral part of the Marvel

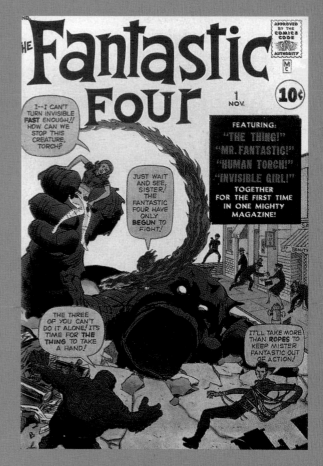

Fantastic Four #1 [Marvel Comics, 1961].

Universe. Among them are the Skrulls [#2], Doctor Doom [#5], the Watcher [#13], the Inhumans [#45], the Silver Surfer and Galactus [#48], Black Panther [#52], the Kree [#64] and Him (now known as Warlock) [#66], and, importantly, the Sub-Mariner [#4].

the team consisted of:

- Jenny Sparks—The spirit of the 20th century, she first appeared in *StormWatch* #37 [1996]. She has the ability to control electricity, even moving through power lines by converting her body to pure energy.
- Apollo—An augmented human who gains his powers from the Sun, he first appeared in *StormWatch* volume 2 #4 [1998].
- Jack Hawksmoore—The God of the Cities was introduced in the same 1996 *StormWatch* issue as Jenny Sparks. Unable to live outside a city for more than 15 minutes, he gains his strength from the city and he sees what its windows "see."
- The Midnighter—Artificially enhanced, he is tough and very fast. Night's Bringer of War, he made his debut in *StormWatch* volume 2 #4 alongside Apollo, his gay lover.
- Swift—The enigmatic Shen-Li Min, a.k.a. The Winged Huntress, first appeared in *StormWatch* #29 [1995]. She is able to grow wings out of her back and have them fall off at will.
- Engineer—Angela Spica is The Maker, able to create anything her mind can conceive.
- The Doctor—Ex-junkie Jeroen is the Shaman, able to change things around by moving them with his powers.

The Authority was canceled in 2002 after 30 issues. Described as widescreen comics, it stirred up a great deal of controversy because of the level of violence but also because of the homosexual relationship between Apollo and the Midnighter, its Superman and Batman analogues. DC does have plans to revive the title in 2003 and is keeping the concept alive with miniseries and specials.

The Avengers [1963]

Dubbed Earth's mightiest superheroes by Marvel Comics, its second superteam banded together for the first time as a result of the machinations of Loki.

As depicted in a story by Stan Lee and artists Jack Kirby and Dick Ayers, the initial lineup was Iron Man, the Hulk, Thor, Ant-Man, and the Wasp. The Hulk left with #2 while Captain America—making his first appearance since the 1950s—joined the team in #4. A new character, Wonder Man, joined and died in #9, but it was with #16 that Lee, Kirby, and Ayers established the group as no ordinary comic book team.

Over the years, the Avengers has become a mainstay of the Marvel Universe with virtually every major Marvel hero joining its ranks at one time or another. But whoever is on the roster, Captain America, Iron Man, and Thor remain the heart of the team.

Bratpack [1990]

Rick Veitch explored the seamier side of the kid sidekick issue in *Bratpack*, a Tundra five-parter that explained just why some adult costumed crime fighters felt the need to put the lives of youngsters at risk.

Challengers of The Unknown [1957]

Often considered a prototype for Marvel Comics' Fantastic Four, Jack Kirby introduced his four daredevil adventurers—each of whom considered he was living on borrowed time after surviving a terrible accident—in issue #6 of *Showcase*, DC Comics' try-out title.

After three more tryouts, pilot and astronaut Kyle "Ace" Morgan, playboy scientist Professor Walter Haley, adventurer and acrobat Matthew "Red" Ryan, and ex-Olympic wrestler Leslie "Rocky" Davis moved into their own title. Kirby left after number #8, but *Challengers of the Unknown* ran 77 issues until 1971.

The series was relaunched in 1973, resurrected for a second time in 1977, and came to an end in 1988.

In 1991, Jeph Loeb and artist Time Sale revived the team for an eight-issue series that depicted the Challengers as a merchandising phenomena with a whole town, Challengerville, built as a tourist attraction.

This mini was followed by another *Challengers of the Unknown* revival in 1997. Written initially by Steven Grant and Len Kaminski and drawn by John Paul Leon and Shawn Martinbrough, it featured a new team— Clay Brody, Marlon Corbet, Brenda Ruskin, and Kenn Kawa—involved in assignments reminiscent of *The X-Files*. Challengers of The Unknown was finally canceled in 1998 after 18 issues.

Champions [1975]

Not to be confused with the stars of Hero Games' *Champions* role-playing game, Marvel's Los Angeles-based group of oddballs were funded by Warren Worthington III a.k.a. Angel of the X-Men to help the "man in the street."

Debuting in the first issue of its own title in a story by Tony Isabella and artists Don Heck and Mike Esposito, the team initially consisted of the wealthy mutant plus the Black Widow, Hercules, Iceman, and Ghost Rider.

The Champions lasted 17 issues until 1978. Introduced in #7 was Darkstar. A former agent for the U.S.S.R., Laynia Petrovna is a mutant who can manipulate the Darkforce to create objects or to be used as a force beam.

Although the group disbanded after its title was canceled, it was subsequently featured in 1998's *X-Force/Champions* one-shot.

Checkmate [1988]

Created by Paul Kupperberg and artist Steve Erwin, this DC covert action group was formed by former N.Y.P.D. Lieutenant Harry Stein. Its hierarchy is modeled on the game of chess. At the top is the Queen—initially Amanda Waller [see Suicide Squad]—who reports to the president and determines agency policy. Below her is the King (Stein), who controls Checkmate's day-to-day operations assisted

Continued on page 242

Vertigo: Dizzy Heights and Worrying Lows

Since the 1950s, DC Comics has flirted with many horror/ supernatural anthologies with varying degrees of success.

Most notable of these were *House of Mystery* [1951] and *House of Secrets* [1956] series, both of which survived their scarier EC Comics predecessors to 1983 and 1978, respectively.

House of Secrets #92 is pivotal in the development of DC's line of mature readers' titles in the 1990s. That 1971 issue features the first appearance of Swamp Thing—created by Len Wein and artist Berni Wrightson—whose own 1982 series would later not only become an integral part of the initial wave of Vertigo titles but also introduce the protagonist of the only one of the line's comics that has continued from the imprint's debut. Cain and Abel, the sibling hosts of *House of Mystery* and *House of Secrets*, have also become semiregular supporting characters in *The Sandman* and its spin-off, *The Dreaming* [1996].

Complementing *House of Secrets* and *House of Mystery* were other such titles as *Weird War Tales* [1971], *Weird Western Tales,* and *Weird Mystery Tales* [1972].

In the late 1980s/early 1990s, a British invasion of writers led by Alan Moore began

to take over various stilted DC characters and breathe new life into them. Moore began with *Swamp Thing* in 1984. He was followed by Grant Morrison on *Animal Man* [1988] and *Doom Patrol* [1989] and Jamie Delano's 1988 launch of *Hellblazer*—a spin-off from Moore's *Swamp Thing*.

With the DC's superhero universe (a.k.a. DCU) firmly established, it became obvious that supernatural and offbeat characters such as the Phantom Stranger, Deadman, and Mr E., were in danger of being marginalized.

Karen Berger had edited many of the British-written series. In 1993 she was given the task of establishing a separate imprint within DC to consolidate these disparate titles and to cash in on the rising interest in "adult" comics. Many comics already in existence—including those already mentioned, along with Peter Milligan's *Shade: The Changing Man* [1990] and Neil Gaiman's *The Sandman* [1989]—were all rebranded under the Vertigo imprint.

Nearly all the titles had a self-imposed "Suggested For Mature Readers" warning on

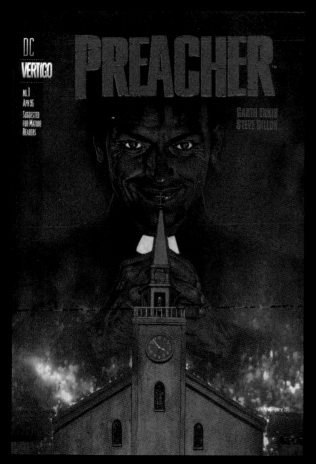

Preacher #1 [DC Comics/Vertigo, 1995].

the cover and dealt with sensitive subjects such as sexuality, drugs, violence, and politics. Swearing was finally allowed with the first issue of Morrison's *The Invisibles* [1994].

Berger brought ex-DC editor, Art Young, back from Touchmark—the ill-fated Disney comics line—along with his planned projects for that imprint. Among them were Milligan's *Enigma*, Morrison's *Sebastian O,* and *Mercy*, all of which became Vertigo titles in 1993.

Gradually Vertigo turned away from updating old DC properties such as *The Sandman and Black Orchid* [1993] as creators demanded more rights. Thus a string of creator-owned series sprung up, including Morrison's *The Invisibles*.

The imprint suffered an identity crisis while publishing cute fairy stories with *The Books of Magic* [1994] alongside bloodletting in *Vamps* [1994] and historical fiction with *Chiaroscuro: The Private Lives of Leonardo Da Vinci* [1995]. The only supposed unifying factor was that all stories should have a "Vertigo twist."

Despite this, Vertigo has outlived other DC imprints. Ironically, the only title to survive, *Helix, Transmetropolitan* [1997] by Warren Ellis and artist Darrick Robertson, has flourished.

Vertigo has now reconciled its schizophrenic personality, realizing that it is a strength rather than a weakness and quite happily publishes supernatural westerns like *Jonah Hex* [1993 & 1995], which featured a cowboy originally from *Weird Western Tales* revamped by horror novelist Joe R Lansdale and artist Timothy Truman. Also from that 1970s series was *El Diablo*, given a 2001 Vertigo makeover in a four-parter by American Brian Azzarello who also writes the creator-owned, hard-boiled *100 Bullets* for the DC imprint.

Most Vertigo titles don't break sales records, but the imprint remains an important experimental outlet for creators.

by Bishops—admin. assistants. The next level down is the Rooks—field directors responsible for the agency's missions—who control the 30 costumed field agents known as Knights. They are aided when necessary by Pawns, noncostumed backups.

Introduced in *Action Comics* #598 in a story cowritten by Kupperberg and penciler John Byrne and inked by Ty Templeton, the law enforcement agency gained its own title in 1988. Although *Checkmate* was canceled in 1991 after 33 issues, the team still operates in the DC Universe.

Clandestine [1994]

Where the Fantastic Four are often referred to as Marvel's first family, the members of the Clan Destine really are all blood relatives.

Introduced in *ClanDestine* #1, the family are the long-lived children of immortal Englishman Adam Destine – born in the 13th century – and his wife, a genie, who have been living covertly among humans for all those years.

Created by Alan Davis, the first eight issues of the series were written and drawn by him assisted by inker Mark Farmer. *ClanDestine* was cancelled with #12 [1995] although the family reappeared in 1996's *X-Men: Clandestine* two-parter which was also by Davis and Farmer.

Cloak And Dagger [1982]

Blonde Tandy Bowen met African-American Tyrone Johnson, another runaway, on the streets of New York. Kidnapped by the mob, they were used as guinea pigs to test a cheap, synthetic form of heroin, an experiment which triggered the mutant powers latent within each of the youngsters.

Introduced in *Peter Parker, Spectacular Spider-Man* #64 in a story by Bill Mantlo and artists Ed Hannigan and Jim Mooney, the child of darkness and the child of light decided to team up as Cloak and Dagger to protect other young runaways.

Spotlighted in an eponymous 1983 four-issue series, they were granted their own title in 1985 after several further appearances in *Spectacular Spider-Man* and in other Marvel Universe comics. *Cloak and Dagger* was canceled in 1987 after just 11 issues.

Frequent Marvel Universe guest stars, they regained their own series as part of 1987's *Strange Tales* relaunch. When that title was canceled in 1998 after 19 issues, the storyline was continued in *The Mutant Misadventures of Cloak and Dagger*, a series that also lasted 19 issues—until 1991. The pair were also featured in a 1988 Marvel Graphic Novel [#34: *Predator and Prey*] and shared top billing with Power Pack in another— 1989's *Shelter from the Storm*. Most recently, they have appeared in the Marvel Knights, the aptly titled *Marvel Knights Team* title.

Crusaders I [1977]

Appearing in *Invaders* #14–15, this World War II squad featured Captain Wings, Dyna-Mite, Ghost Girl, Thunder Fist, Tommy Lightning, and the Spirit of '76. A Marvel Comics continuity implant, it was the work of Roy Thomas and artist Frank Robbins.

Crusaders II

—See Mighty Crusaders

Cyberforce [1992]

Conceived by Top Cow Productions' Marc Silvestri, this team of cybernetically enhanced superheroes was created by Cyberdata.

Having escaped from the evil multinational corporation's clutches, the team battled Cyberdata and its army of robotic S.H.O.C. (Special Hazardous Operations Cyborg) soldiers to prevent it achieving world domination. The original members were:

- Ripclaw—After Native-American Robert Bearclaw lost his hands, Cyberdata provided him with cybernetic replacements.
- Stryker—Morgan Stryker is a mutant whose four arms were replaced by Cyberdata as was his left eye, which now offers him vision in infrared and ultraviolet.
- Velocity—A former S.H.O.C., Carin Taylor has the potential to run at speeds in excess of 3,300 miles per hour.
- Cyblade—A powerful mutant, Dominique Thibaut has the ability to psionically trigger "blades" of electromagnetic energy, which she can aim and fire.
- Heatwave—Now deceased, Dylan Cruise was the leader of Cyberforce. Able to absorb and release solar energy, he wore a suit specially designed to contain and control the energy.
- Impact—Known only as Boomer, he's big, strong, and covered with metal.
- Ballistic—Cassandra Lane, Velocity's older sister with incredible athletic ability, is a member of Cyberforce when it suits her.

Introduced in an eponymous Image Comics four-parter, the team gained its own ongoing title later in 1992. *Cyberforce*—which gave rise to several spin-offs, miniseries, and one-shots—was canceled with 1997's #35.

Damage Control [1988]

This massive repairs and renovations operation cleans up after the battles between Marvel's superheroes and villains.

Created by Dwayne McDuffie and artist Ernie Colon, the commercial enterprise charges superheroes for its services. They then make claims on their Extraordinary Activity Assurance policies or request federal aid. Marvel published three *Damage Control* four-parters between 1988 and 1991.

Continued on page 248

Secret Society of Super-Villains

To make an incorrigible villain the focus of an ongoing series must be a difficult task.

There have been attempts to make villains the stars of their own books, but in the 1940s Timely/Marvel's *Sub-Mariner*, for example, was always characterized as a paradox—on the side of right and justice but with a loathing of mankind.

In 1956, *Atlas* (Marvel) did premiere a new villain in his own title, but **Yellow Claw** lasted only four issues. The series—written by Stan Lee and initially drawn by Joe Maneely—featured a brilliant Chinese scientist, a Communist who also dabbled in the occult and had created a miraculous elixir that extended his life span.

Unabashedly based on Fu Manchu, the oriental villain created by Sax Rohmer in 1913, the *Yellow Claw* was resurrected in 1973—after a robot version had appeared in 1967—as a would-be world conqueror.

Toward the end of the Silver Age, Marvel launched the Fantastic Four's nemesis, Doctor Doom, into his own series in *Astonishing Tales* #1–8 [1970–71] and later brought him and the Sub-Mariner back together—they had first joined forces in *Fantastic Four* #6 [1962]—in

Giant-Size Super-Villain Team-Up #1 [1974]. A second giant-sized issue the following year led into a regular monthly comic. Namor only costarred in the ongoing series until #10, replaced by others such as the Red Skull and Magneto. To retain copyright on the title, instead of being canceled *Super-Villain Team-Up* became an annual with #16 [1979] following a year after #15. But the 1980 issue was still the last.

Hurled out of the Marvel Universe and on to Counter-Earth during 1996's Onslaught event, the despotic Latverian dictator has also starred in *Doom* [2000] and *Doom: The Emperor Returns* [2001], two three-parters set on that world on the far side of the sun.

Far more successful, at least in terms of maintaining the integrity of the bad guys, was *Secret Society of Super-Villains,* which DC launched in 1976 shortly before it pulled the plug on *The Joker*, which ran for 9 issues between 1975 and 1976.

Written by Gerry Conway, the first issue featured nine supervillains called together by

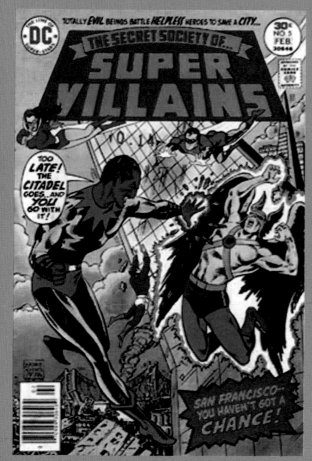

Secret Society of Super-Villains [National Periodical Publications, 1977].

a clone of Manhunter/Paul Kirk acting as the representative of a mysterious benefactor. From Flash's *Rogues Gallery* came **Captain Boomerang**, **Captain Cold**, **Gorilla Grodd**, and **Mirror Master**—four characters created

by John Broome and artist Carmine Infantino— while **Sinestro** and a new **Star Sapphire** represented Green Lantern's foes, **Copperhead** Batman's, and **Shadow Thief** Hawkman's, with the Justice Society of America's old foe, the **Wizard**, completing the lineup.

- Captain Boomerang—Perhaps not too surprisingly, he is an Australian. Making his first appearance in *The Flash* #117 [1960], he is George "Digger" Harkness, the illegitimate son of American toy maker W. W. Wiggins. A wayward teenager always getting into scrapes with the law, he was sent to America to work for his father. He adopted the Captain Boomerang persona to pursue a criminal career in which he used both regular and gimmicked boomerangs for ever more spectacular crimes.
- Captain Cold—Introduced in *Showcase* #8 [1957], he is Leonard Snart, a small-time crook who learned that a cyclotron might interfere with the Flash's speed. He designed a weapon and exposed it to radiation in a cyclotron laboratory. However, rather than the desired effect, the gun could instantly freeze anything. As the costumed villain, Snart learned to create ice slicks, to freeze people in suspended animation, and to make walls (and safe doors) so brittle with cold that he could simply knock his way through.
- Gorilla Grodd—He is a scientific genius and dangerous renegade from Gorilla City, a hidden civilization of highly evolved talking apes. Debuting in *The Flash* #106 [1959], in addition to his natural physical strength,

Grodd's powerful mind force can move solid objects and control weaker minds.

- Mirror Master—Sam Scudder accidentally stumbled upon a mirror that could project holograms while working in a prison workshop. He used it to escape, developed more mirror gadgets, and embarked upon a career of crime. The most respected member of the *Rogues' Gallery*, he premiered in *The Flash* #105.

- Sinestro—Originally the Green Lantern of space sector 1417, Sinestro of Korugar kept order by fear and intimidation. For abusing his powers he was stripped of his power ring and banished to the antimatter universe of Qward by the Guardians of the Universe. Returning armed with a yellow power ring provided by the Qwardian Weaponers, he has sworn vengeance on the Guardians, the Green Lantern Corps, and Earth's Green Lantern (Hal Jordan), in particular. Created by Broome and artist Gil Kane, he first appeared in *Green Lantern* #7 [1961].

- Star Sapphire—The Star Sapphire is the chosen queen of the Zamarons, an immortal race of females descended from the planet Maltus. By tradition, the Queen of the Zamarons was always a mortal, and each successive queen would be an exact duplicate in appearance. Jordan's girlfriend, Carol Ferris was selected—in Broome and Kane's *Green Lantern* #16 [1962]—But the Zamarons needed to have her prove that Green Lantern was weak and telepathically induced her to attack him. Armed with the gemstone, she had the power of flight and a repelling ray. Introduced in *Secret Society of Super-Villains* #1, the new Star Sapphire is Remoni-Notra, a.k.a. Debbie Camille Darnell. Ferris's rival for queenship of Zamaron and her virtual duplicate, she feels she must defeat Ferris to claim the crown even though Ferris has relinquished her claim on it.

- Copperhead—Created by Bob Haney and artist Bob Brown, little is known of the small-time thief before his debut in *The Brave and the Bold* #78 [1968]. Incarcerated after a run-in with Batman, Wonder Woman, and Batgirl, he spent his time in prison concentrating on various odd yogalike exercises that helped him gain total control of his body and then used his abilities to escape. Resurfacing years later, he had mastered his skills and become a master assassin who does whatever he's paid to do by anyone.

- Shadow Thief—After acquiring a Thanagarian Dimensionometer, Carl Sands became an untouchable criminal—his body is in one dimension and his shadow image committing crimes in another—and a major adversary of Hawkman. Created by Gardner Fox and artist Joe Kubert, he was introduced in *The Brave and the Bold* #36 [1961].

- Wizard—William I. Zard was a small-time criminal who learned the art of magic in Tibet. Introduced in *All-Star Comics* #34 (1947), he adopted the the identity of the Wizard and, in the following years, battled the Justice Society of America, both on his own and as a member of the first Injustice Society of the World. Magically retaining his youth, he resurfaced in 1963 as part of the

Crime Champions of two eras [*Justice League of America* #21–22].

What made the series so different was that these were unmitigated bad guys who suddenly learned they were at the beck and call of an even greater villain when their benefactor was revealed to be Darkseid. Possibly the most malevolent of all the inhabitants of the DC Universe, the ruler of Apokolips was establishing the Society to represent him on Earth, a more efficient replacement for Inter-Gang. Led by Manhunter, their mission came to be to thwart their master's ambitions, which took no account of their own.

It was to be bad guys against bad guys with nary a hero in sight. At least not until #2 when Conway and cowriter David Anthony Kraft revived a DC character last seen in 1954.

Another Broome/Infantino creation, **Captain Comet** first appeared in *Strange Adventures* #9 [1951]. Comicdom's first mutant, he was Adam Blake, who had mutated when an especially bright, previously unknown comet had shone upon him minutes after birth. Described as a man born 100,000 years ahead of his time, his abilities—which developed as he matured— included extraordinary intelligence and athletic prowess, clairvoyance, psychokinesis, and prodigy-level talent in many fields. He appeared with decreasing regularity until *Strange Adventures* #49, then vanished for the next 22 years.

Returning to Earth and duped into believing the SSoV were the good guys, Comet joined the group only to have Manhunter put him

straight. From then on, the returning hero did his best to upset all the villains' plans.

Like many such alliances, the SSoV did not have a stable membership, especially once Darkseid's dominance had been removed. Not only did it lose members like Copperhead to jail, but others, such as Sinestro, quit because their aims and the Society's were now at odds.

Among those that joined the Society or tried to mold it to their own ends over the course of its 17 issue run—which includes 1977's *DC Special* #27 and a story in *Super-Team Family* #14 [1978]—were Hi-Jack, Lex Luthor, Captain Stingaree, Felix Faust, Matter Master, The Trickster, Bizzaro No. 1, Poison Ivy, Angle Man, Floronic Man, Blockbuster, Professor Zoom, Silver Ghost, and The Creeper, another hero mistakenly inducted into the group.

Until its cancellation in 1978, the *Secret Society of Super-Villains* continued to play different villainous coalitions off against each other with Captain Comet helping to keep all the sides at loggerheads. But there can be only so many variations on that theme before the concept starts getting stale.

"It was to be bad guys against bad guys with nary a hero in sight."

Daughters of The Dragon [1975]

Also operating as the Daughters of the Dragon, Nightwing Restorations is made up of two female private investigators who have appeared regularly across several Marvel titles for almost 30 years: the Chinese-American Colleen Wing and African American Misty Night.

Colleen Wing first appeared as a supporting character to the then-new Iron Fist strip in *Marvel Premiere* #19 (1974). This connection led to her fight various criminals, one of whom captured her and for a time turned her into a heroin addict. She has also had a close relationship with Cyclops of the X-Men and worked with Iron Fist and Power Man, the Heroes for Hire team.

Misty Knight, who first appeared in *Marvel Team-Up* #1 (1972), is a former N.Y.P.D. detective and the ex-roommate of the X-Men's Jean (Phoenix) Grey, making her no stranger to the superhero world.

The two women had so much in common that they pooled their talents to become the New York-based partnership of Nightwing Restorations, although because of their martial arts skills, they are often referred to as the Daughters of the Dragon.

Defenders [1971]

In direct contrast to the Avengers, this loosely knit band of Marvel heroes has no formal membership. Often described as a nonteam, the unstructured group most often featured Dr. Strange, Namor the Sub-Mariner, and the Hulk.

Following a Namor, Hulk, Silver Surfer tryout in *The Sub-Mariner* #34–35, the Defenders first appeared under that name in *Marvel Feature* #1. Launched in 1972, *The Defenders* ran 151 issues until 1986. Revived in 2001, the title—initially written by Kurt Busiek and penciler Erik Larsen—is still extant.

Apart from those already mentioned, during its first incarnation the nonteam's principal participants were Valkyrie, Nighthawk, Hellcat, Son of Satan, Gargoyle, and the X-Men's Beast (also an Avenger). The roster for the revival consists of Dr. Strange, the Hulk, the Sub-Mariner, the Silver Surfer, Nighthawk, Hellcat, and—introduced in #4—a new version of the Valkyrie, about whom nothing is known.

DNAgents [1983]

Grown and programmed by the Matrix Corporation, five genetically engineered youngsters refused to become subservient.

Created by Mark Evanier and artist Will Meugniot and introduced in the first issue of Eclipse Comics' *DNAgents*, they are the super-strong Tank, Sham—a metamorph, Rainbow—who can create illusions in the minds of others,

the flying Amber, and Surge—who generates energy bolts.

The series lasted 24 issues until 1985 when it was replaced by *The New DNAgent*—canceled in 1987 after a further 17 issues. Surge featured in his own four-parter in 1984, while a supporting character, Crossfire, was spun off into his own comic in 1984. He also costarred in *Crossfire and Rainbow*, a 1986 four-parter.

Doom Patrol [1963]

An example of comic book synchronicity, DC's team of three misfits led by the wheelchair-bound Chief, a.k.a. scientific genius Niles Caulder, debuted just three months prior to Marvel's X-Men, a team of five mutants led by the wheelchair-bound Professor X.

Created by Bob Haney and Arnold Drake and initially drawn by Bruno Premiani, the team of embittered freaks first appeared in *My Greatest Adventure* #83 until its 1968 cancellation with #121. A further three issues [#122–124] were published in 1973, but these were reprints.

Initially the team consisted of Elasti-Girl, Robotman—racing driver Cliff Steele unable to come to terms with his brain being placed in a metal body after a near-fatal crash—and pilot Larry Trainor, who was otherwise known as Negative Man.

Wrapped in lead bandages to contain the radioactivity that contaminated him during a spaceflight, he was cut off from humanity but could release a being of pure energy from his body, although only for a minute at a time.

In an unusual move for the era, with sales falling, the last issue of *Doom Patrol* saw the World's Strangest Heroes, as they were dubbed, killed off during a mission.

A short-lived Doom Patrol revival began in *Showcase* #94 [1977]. Continuing in #95-96, it featured a new team except for Robotman, who had survived the 1968 explosion only because of his near-indestructible body. Written by Paul Kupperberg, the three issues introduced Celsius—who claimed to be the Chief's widow, Tempest, and Negative Woman.

Together with Robotman, all three returned when Kupperberg revived *Doom Patrol* 10 years later. The 1987 series also saw the resurrection of both the Chief and Larry Trainor, his energy now being inhabited by Negative Woman. After 18 issues, British writer Grant Morrison and artist Richard Case took over the series, plunging the World's Strangest Heroes into some seriously weird and bizarre adventures involving such characters as Danny the Street—a sentient transvestite street, Crazy Jane, who has 64 different personalities—each with its own superpower, and Rebis, a radioactive hermaphrodite composed of Trainor and Eleanor Poole, a.k.a. Negative Woman.

DC relaunched Doom Patrol in 2002. Written by John Arcudi and drawn by Tang Eng Huat, it features Robotman and introduced Fever (Shyleen Lao), Fast Forward (Ted Bruder), Kid Slick (Vic Darge), and Freak (Ava).

Continued on page 252

J.S.A: The Spark That Became a Revolution

In 1940, DC's Batman and Superman comics resoundingly outsold everything in the All-American line.

In 1940, DC's Batman and Superman comics resoundingly outsold everything in the All-American line. Looking for a concept that could compete with his rival's best-sellers, publisher M.C. Gaines turned to his editor Sheldon Mayer and top writer Gardner Fox.

Their notion was very simple: group All-American's most popular heroes together in a single title. Thus was born the Justice Society of America. The first superteam, its initial line-up consisted of the Flash, Green Lantern, Hawkman, the Atom, and, an indication of the close relationship between Gaines' company and the Batman publisher, DC's the Spectre, Dr. Fate, Hourman, and Sandman.

Debuting in issue #3 [1940] of the *All-Star Comics* anthology, the J.S.A.'s earliest adventures were really nothing more than the individual member's solo adventures book-ended by a team meeting and a grand finale in which they got together to defeat that issue's menace. It was only in the last years of their existence—from 1947 to 1951—that they began to act as a team readily recognizable by modern fans.

Over the years, the J.S.A. saw many changes to its roster. Superman and Batman made their first appearance together there. Wonder Woman—introduced in *All-Star Comics* #8—joined the team with #12 although, a sign of the times, she was nominated as its secretary and spent most of her time on the sidelines. The Black Canary, Dr. Mid-Nite, Johnny Thunder, Mr. Terrific, the Sandman, Harlequin, and Wildcat also participated along the way.

Another was the Red Tornado, whose sole appearance was at the team's inaugural meeting. A supporting character from Scribbly, —an All-Star Comics humor strip—"he" was really Ma Hunkel, a woman who donned a pair of red long johns, a cape, and a saucepan to fight crime as a mystery "man!"

In 1960, with its superhero revival going from strength to strength, DC decided to resurrect the superhero team concept. The Justice League of America made its first appearance in *The Brave and the Bold* #28. Editor Julius Schwartz then made the group a league, with its sporting implications of fair play.

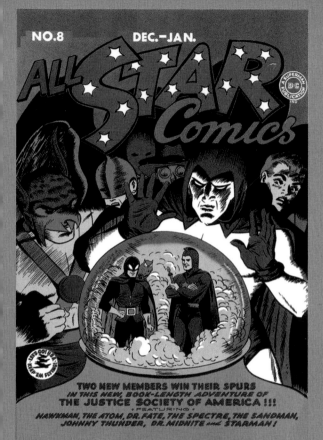

All-Star Comics #8 [National Periodical Publications, 1941].

That, however, didn't prevent him and the by-then J.L.A. writer Gardner Fox from resurrecting the J.S.A. which they did—via DC's Earth-2 parallel world concept—in *Justice League of America* #21 [1963]. A two-issue story, it was the first in a series of annual meetings between the teams that was to last until 1985.

It was also to lead—15 years later—to the Golden Age team's return in its original title. In 1976, DC relaunched *All-Star Comics* with #58, picking up the numbering with the first issue following the Justice Society's final 1951 appearance. Set on Earth-2, the home of DC's Golden Age heroes, the revival introduced Robin, the Star-Spangled Kid, and Power Girl as the Super Squad was absorbed into the J.S.A.

In 1978, the title was canceled. The following year, the team's adventures were continued in the Adventure Comics anthology, but this was a short-lived exercise, and the J.S.A. were reduced to guest-star status throughout the 1980s.

By 1992, following *Crisis on Infinite Earths*, DC's 1985 "house-cleaning" integration of its various alternate Earths, the team was considered part of regular continuity and—after an eight-issue series set in the early 1950s—was granted its own title. Unfortunately, this lasted just 10 issues, canceled allegedly because it was felt readers couldn't relate to aged heroes.

Whatever the rationale, in 1999 DC pulled out all the stops to relaunch the series, now retitled J.S.A. Following a major month-long S.A. Returns event, founder members Green Lantern—now Sentinel—and the Flash were joined by Wildcat, Wonder Woman (or rather her mother, Hippolyta), the new Black Canary and Starman—daughter and son of the originals, Atom Smasher, and the new Hourman as well as Sand, the original Sandman's sidekick Sandy now grown-up, for the team's most popular outing.

Eternals [1976]

Created by Jack Kirby for Marvel Comics, this is one of two races that have lived among humanity since the dawn of time.

Offshoots of humankind, they were created by the enigmatic 100-foot-tall Celestials who conducted genetic experiments on human's primate ancestors. The results evolved not only into humans but also the mountaintop dwelling Eternals—superpowered godlike being who inspired the Greek myths—and the Deviants, a genetically unstable race that lives beneath the Earth's surface.

Written and drawn by Kirby with inker John Verpoorten, *The Eternals* #1 introduced the concept of the Celestials, the Eternals, and the Deviants. The series was canceled in 1978 after 19 issues, only to be revived in 1985—sans Kirby—as a 12-parter.

A one-shot—*Eternals: The Herod Factor,* followed in 1991.

Excalibur [1988]

A British-based version of the X-Men, the team made its debut in a one-shot subtitled *The Sword is Drawn*.

Led by Captain Britain, the mutant team's initial lineup consisted of three former X-Men —Nightcrawler, Kitty Pryde, a.k.a. Shadowcat, and Rachel Summers, the second Phoenix—as well as the metamorph Meggan.

Introduced by Alan Moore and artist Alan Davis in the Captain Britain strip in *Mighty World of Marvel* #7, Meggan made her U.S. debut in *New Mutants Annual* #2 [1986] in a Davis-drawn story written by Chris Claremont. Captain Britain's girlfriend, later his wife, she has the power to change shape.

Created by Claremont and Davis, the team moved into its own title almost immediately after Marvel published *Excalibur: The Sword is Drawn*. It lasted 125 issues until 1988 and was followed in 2001 by an Excalibur four-parter that features Captain Britain, Meggan, Psylocke—another former member of the team—and the Black Knight.

Exiles [1995]

Created by Steve Gerber, Tom Mason, Dave Olbrich, Chris Ulm, and artist Paul Pelletier, this team consisted of youths whose superpowers had been triggered by the Theta Virus. Normally this would be deadly, but Dr. Rachel Deming developed a process to suppress the terminal side effects.

Recruiting Catapult, Deadeye, Ghoul, Mustang, Tinsel, and Trax, she set up herself and her Exiles in opposition to Malcolm Kost, who intended to use the virus to create an unstoppable army for his own benefit. Introduced in an eponymous Malibu Comics Ultraverse four-parter, all of the Exiles except Ghoul—who went on to join Ultraforce—were dead by the end of the miniseries.

A new team, lead by Marvel Comics' Juggernaut, debuted in the *All-New Exiles*

following the Spider-Man publisher's acquisition of Malibu earlier that year. The series—which featured Reaper, Siren, Blaze, Shuriken, Amber Hunt, and Warstrike—was canceled in 1996 after 11 issues. Marvel has since allowed the characters to be forgotten.

Fightin' Five [1964]

Created by editor Dick Giordano and writer Joe Gill, this band of superpatriots were introduced in the first issue [#28] of their own comic, the previously titled *Space Wars*.

Funded and led by former U.S. Special Forces operative Hank Hennesey (FF4), the team consisted of Frenchy the Fox (FF1), Irv "The Nerve" Haganah (FF2), Granite Gallero (FF3) and Tom-Tom (FF5). When Hennesey lost his left eye on a mission, he led from behind a desk, his place in the field taken by Sonya.

Wearing military-style uniforms like the Blackhawks, they took on would-be world conquerors and criminal gangs in Fightin' Five until the Charlton comic was canceled with #41 [1967]. The Peacemaker was introduced as a backup in #40 and the Five became his supporting feature—in all five issues—when he gained his own title later in 1967.

Freedom Fighters [1973]

Introduced in *Justice League of America* #107 in a story by Len Wein and artists Dick Dillin and Dick Giordano, DC Comics' Freedom Fighters consists of Uncle Sam, Doll Man, Human Bomb, Phantom Lady, the Ray, and Black Condor.

But they are Earth-2 duplicates of the Quality Comics heroes from the 1940s who had emigrated to Earth-X, a world where the Nazis had won World War II.

Transporting themselves to Earth-1, they began a crime-fighting career in the 1976 first issue of their own title. This continued until *Freedom Fighters* was canceled with #15 [1978]. The team appears to have been wiped from existence by 1985's *Crisis on Infinite Earths*.

GEN13 [1993]

Bobby Lane, Caitlin Fairchild, Roxanne "Roxy" Spaulding, Percival Edmund Chang, and Sarah Rainmaker were five ordinary teenagers. Then they were put through the Gen-Active process by Project Genesis in an attempt to unleash the powers inherited from their fathers—the government-created supersoldiers of Team 7. Following their processing, the five youngsters —who now have John Lynch, the superhuman Gen-Active former I.O. director of operations as their mentor—became:
• Burnout (Lane)—Impervious to heat and able

to fly by creating thermal currents, he can unleash high-energy plasma, which bursts into flame.
- Fairchild—Despite her mass being considerably denser than a normal human's she is quick and agile.
- Freefall (Spaulding)—Able to void the pull of gravity, she can levitate herself or any object she wishes.
- Grunge (Chang)—He can mimic the molecular structure of any material he touches.
- Rainmaker—Apache-born, she has control of the elements.

Created by Jim Lee, Brandon Choi, and artist J. Scott Campbell, the team first appeared in *Black*, an issue of *Deathmate*, the Image Comics/Valiant crossover. In 1994 it gained its own Image/WildStorm Productions' five-parter. An ongoing *Gen13* title followed in 1995.

Canceled early in 2002 after 77 issues, the core *Gen13* title was relaunched later the same year with Chris Claremont and artists Alé Garza and Sandra Hope.

Generation X [1994]

After Marvel's New Mutants had evolved into X-Force, Scott Lobdell and artist Chris Bachalo were next to develop a team based around the concept of a school for mutants.

For Generation X, Professor X [see X-Men] chose Banshee and the reformed White Queen to teach a class that included:
- M—Monet St. Croix is a nearly invulnerable Algerian with superhuman strength.
- Jubilee—The orphaned Jubilation Lee has the power to generate energy plasma explosions.
- Husk—The sister of X-Force's Cannonball, Paige Guthrie changes form by shedding her outer skin.
- Skin—A Latino from Los Angeles' inner city, he has six feet of extended epidermis that he can use as, for instance, a rope.
- Mondo—A Samoan omnimorph who can take on the properties of any type of matter.
- Chamber—Jonathan Evan Starsmore's body is composed of psionic energy. Telepathic, he can fire psionic blasts.
- Penance—Originally the form that Monet St. Croix [see M] was transformed into by her brother Marius—a.k.a. the villainous Empath—this mutant has become her younger twin sisters. Every edge of their shared body is sharp enough to cut through stone.
- Synch—Everett Thomas can tap other mutants' energies.

Introduced in the first issue of its own title, the team's adventures continued until *Generation X* was canceled in 2001 with #75.

Harbinger [1992]

The Valiant equivalent of Marvel Comics' mutants, harbingers are paranormals, possibly the next step in human evolution.

Written by Jim Shooter and drawn by David Lapham and John Dixon, *Harbinger* #1 featured

Toyo Harada. Introduced in *Solar, Man of the Atom* #3 [1991], this powerful psionic heads the Harbinger Foundation, which recruits others with similar abilities to aid him in his quest for world domination. One such recruit—Peter Stanchek a.k.a. Sting—learns of the schemes and flees with his girlfriend Kris and three other renegades: Zepplin, Flamingo, and Torque.

Waging war on Harada's forces leads to the death of Torque at the hands of the Eggbreakers, Harada's elite Harbingers, but not before Torque has fathered a child by Kris, a boy who will grow to become Magnus, Robot Fighter—champion of the 41st century.

Harbinger lasted 41 issues to be finally canceled in 1995.

H.A.R.D. Corps [1992]

Introduced in *Harbinger* #10 in a story written by Jim Shooter and David Lapham and drawn by the latter and inker Gonzalo Mayo, the Harbinger Active Resistance Division was created by the Omen Corporation as a response to the Harbinger Foundation.

The team members are psi-borg soldiers who have been brought out of comas by means of cybernetic brain implants.

The initial lineup consisted of Maniac, Gunslinger, Hammerhead, and Shakespeare. Following the murder of Maniac—beaten to death by the Harbinger Foundations' Big Boy—others such as Hotshot, Wipeout, and Perp

joined the Corps. Almost simultaneously with its second appearance—in *Rai* #0—the team gained its own title. *H.A.R.D. Corps* ran 30 issues from 1992 to 1995.

Hawk and Dove I/II

[1968/1988]

Created by Steve Ditko and writer Steve Skeates, teenaged brothers Hank and Don Hall symbolized divided American opinion over the then extant war in Vietnam.

Introduced in *Showcase* #75, they were granted their birdlike costumes and enhanced athletic prowess—superhuman reflections of their opposing philosophies—by a mysterious mystic voice after being captured by their father's would-be killers. By saying "Hawk," the belligerent, physical Hank becomes super-strong but violent, while the word "Dove" transforms the more cerebral, peace-loving Don, making him agile and superintelligent.

After saving their father's life in the DC Comics' tryout, the brothers began a crime-fighting career in the first issue of their own short-lived title. Launched in 1968, *The Hawk and the Dove* was canceled in 1969 after just six issues.

A new series ran 28 issues between 1988 and 1991. It was wound up as a result of events that transpired at the conclusion of the company-wide Armageddon 2001 event [*Armageddon 2001* #2]. Dove was killed by Monarch, who was in turned killed by an

enraged Hawk who then discovered the time-traveling villain was in fact his older self. That Monarch was Hawk was a last-minute decision, taken by DC after the comics fan press had revealed he was to have been Captain Atom. Monarch subsequently became Extant, the villain responsible for yet another company-wide event, 1994's *Zero Hour: Crisis in Time*.

Hawk and Dove III [1997]

With the death of the original Dove and transformation of the first Hawk into a mad villain, the way was open for new heroes to bear the names.

Introduced in the four-issue *Genesis*—another event à la *Crisis on Infinite Earths*, *Armageddon 2001,* and *Zero Hour: Crisis in Time*—the new Hawk and Dove were an example of gender reversal, being Sasha Martens, a female Air Force cadet intent on a military career, and Wiley Wolverman, a member of a rock band called. The Doves.

Both have the ability to sprout and retract wings that enable them to fly and a "shriek of death" that temporarily incapacitates an opponent. In addition and somewhat paradoxically, Dove—who can also fly faster than Hawk—has talonlike claws on his hands.

Created by Mike Baron and artist Dean Zachary, the new duo also starred in *The Hawk and the Dove*, a 1997 five-parter.

Infinity Inc. [1983]

Refused permission to join the Justice Society of America, the sons, daughters, and protégés of the original superteam's members united to form Infinity Inc.

Founded by the Star Spangled Kid, a former J.S.A. member who now possessed a cosmic belt that gave him the power to fly and emit energy blasts, the team's initial lineup was:

- The Silver Scarab—The son of Carter and Sheira Sanders Hall, a.k.a. Hawkman and Hawkgirl, Hector Sanders Hall wore a suit made of ninth metal. In *Infinity Inc.* #49 [1988], he became Sandman—living in the Dream Stream but only able to enter the real world for one hour in every 24—and subsequently took on the mantle of Doctor Fate.
- Fury—The daughter of General Steve Trevor and Diana Prince Trevor—the Golden Age Wonder Woman—she inherited her super strength and stamina from her mother.
- Nuklon—Albert Julian Rothstein inherited his extraordinary strength, speed, and agility from his grandfather, Terrence "Terry Curtis" Kurtzberger, a.k.a. Cyclotron. Currently a member of the new J.S.A. where he is now known as Atom Smasher, his godfather is Al Pratt, a.k.a. WildCat.
- Northwind—Norda Cantrell's godparents are the Halls, a.k.a. Hawkman and Hawkgirl. A native of Feithera, he can also fly.
- Obsidian—Todd James Rice was separated at birth from his twin sister, Jennie-Lynn Hayden [see Jade]. The son of Alan Scott—the Golden

Age Green Lantern—and Rose Forest, a.k.a. the Thorn, he has the ability to merge with his shadow either in a three-dimensional form, when he has enhanced strength and vitality, or in a two-dimensional mode, when he can float weightlessly.

• Jade—Jennie-Lynn Hayden had a green, star-shaped birthmark on her left palm through which emanated a mystical green energy, which she could mentally command to do almost anything.

• Power Girl—Originally Kara, a native of Krypton and the cousin of the Golden Age Superman, post-*Crisis on Infinite Earths* continuity dictates that she is the granddaughter of Arion of Atlantis.

• Huntress—Eradicated from DC continuity by *Crisis on Infinite Earths* [1985], Helena Wayne was the daughter of Bruce Wayne and Selina Kyle—the Golden Age Batman and Catwoman.

• Brainwave Jr. [later Brainwave]—Born a mutant like his father—the J.S.A.'s Golden Age foe also known as Brainwave—Henry "Hank" King Jr. became one of the most powerful telepaths on Earth after his father transferred all his powers to him on his death.

Created by Roy Thomas and artists Jerry Ordway and Mike Machlan, the team first appeared in *All-Star Squadron* #25–26 before moving into its own title in 1984. In *Infinity Inc.* #51, the Star-Spangled Kid, now calling himself Skyman, was killed. As a result, the team disbanded and the series was canceled with #53 [1988].

Inhumans [1965]

The result of experimentation carried out on our ancestors by the alien Kree more than two-and-a-half millennia ago, this race of mutated beings continued the genetic tinkering, creating the Terrigen Mist which causes extreme physical change that is unique to each individual.

With similarities to Jack Kirby's later Eternals, the Inhumans were created by the artist with writer Stan Lee. The first of what is often called Marvel Comics' Royal Family to appear was Medusalith Amaquelin. Introduced in *Fantastic Four* #3 and better known as Medusa, the red-headed wife of Black Bolt has the psychokinetic ability to animate her lengthy 6-foot tresses.

Her husband, the superhumanly strong Blackagar Boltagon, a.k.a. Black Bolt, and the rest of his court first appeared in *Fantastic Four* #45, going on to become an integral part of the Marvel Universe.

The other immediate members of Black Bolt's bizarre court are the hoof-footed Gorgon, who is superstrong beyond the average Inhuman; Karnak, known as the Shatter, a creature which is capable of smashing even mild steel; and the amphibious, green-scaled Triton.

Perennial guest stars, the Inhumans had their own series in *Amazing Adventures* #1–10 [1970–72]. Marvel also launched an Inhumans title in 1975. It ran 12 issues until 1977 and was followed by a Marvel Graphic Novel

[*The Inhumans*, 1988], a 1990 one-shot—*Inhumans: The Untold Saga*—and 1995's *Inhumans: The Great Refuge* special. In 1998, Paul Jenkins and artist Jae Lee launched a highly acclaimed *Marvel Knights* 12-parter. A further *Inhumans* four-parter was published by Marvel in 2000.

Invaders [1975]

Another of writer Roy Thomas's continuity implants, this band of Marvel superheroes fought against the Axis in World War II although Captain America, the Human Torch, and Namor the Sub-Mariner did not actually get together until 1969 [in *Avengers* #71, drawn by Sal Buscema and Sam Grainger]. Even then they didn't adopt the team title until the Frank Robbins and Vince Colletta-drawn *Giant-Size Invaders* #1, which also featured Cap and the Torch's kid sidekicks Bucky and Toro and led into the team's own series.

Mainly penciled by Robbins, *The Invaders* ran 40 issues until 1979. During the course of the series, other members included Miss America and the Whizzer as well as three from the same English family:

• Union Jack I—A hero of World War I who came out of retirement to join the team in *Invaders* #7 [1976]. Now deceased, after retiring for a second time, he handed the mantle over to his son Brian.

• Union Jack II—Brian Falsworth had been imprisoned in Germany at the outbreak of World War II. There he had shared a cell with

the German scientist given the task of recreating the supersoldier formula that had produced Captain America. Given the scientist's only sample, he gained superhuman athletic ability and began fighting the Nazis as the Destroyer. On his return to England, he took over from his father as Union Jack, gaining electrical powers from Thor, the Norse god of thunder. First appearing in *Invaders* #8 [1976], he died in a car crash in 1953.

• Spitfire—Introduced in *Invaders* #11 [1977], Lady Jacqueline Falsworth-Crichton gained the ability to run at lightning speed, with reflexes and agility to match, after receiving a blood transfusion from the Human Torch.

With artists Dave Hoover and Brian Garvey, Thomas revived *The Invaders* as a four-issue series in 1993.

Justice League of America [1960]

DC Comics' premiere superteam, the J.L.A., has had virtually every major hero in the DC Universe as a member at one time or another.

Conceived as a Silver Age version of the archetypal Justice Society of America, editor Julie Schwartz chose to modify the team's name because he felt the Golden Age sobriquet was "uppity" while the modern one—which suggested sports—implied democracy and fair play.

Introduced in *The Brave and the Bold* #28 in a story by Gardner Fox and penciler Mike

Sekowsky, the team initially consisted of the Flash, Green Lantern, Wonder Woman, Aquaman, and J'Onn J'onzz the Martian Manhunter. Superman and Batman were also members although they initially played a lesser role. The League moved into its own title, which, across the years, has featured several major overhauls of the team lineup. Launched in 1960, *Justice League of America* was canceled in 1987 after 261 issues.

To shift the focus on to the world stage, *Justice League*—with an International suffix added with #7—was launched in 1987 as the replacement for *Justice League of America*. Retitled *Justice League America*, it initially featured Batman, Green Lantern/Guy Gardner, Blue Beetle, Mr. Miracle, Captain Marvel, and the Martian Manhunter. It lasted 113 issues until 1996. A spin-off, *Justice League Europe*—retitled *Justice League International*—was launched in 1989 for a 68-issue run ending in 1994. Premiering in 1993, a second offshoot, *Justice League Task Force*, was canceled in 1996.

In 1997, British writer Grant Morrison was handed the task of relaunching the team in a new title. The still extant JLA initially featured a back-to-basics line-up consisting of Superman, Batman, Wonder Woman, the Flash, Green Lantern, Aquaman, and J'Onn J'onzz the Martian Manhunter.

Labor Force [1986]

Created by Greg Swan and artist David Ammerman, this group of superheroes

operated as a business venture, complete with a marketing consultant and an accountant to watch the budget. It appeared in its own Blackthorne title, which lasted eight issues.

Liberty Legion [1976]

In 1976, Roy Thomas and artists Don Heck and Vince Colletta retroactively created the Liberty Legion as a home front version of Marvel Comics' World War II superteam, the Invaders —itself a continuity implant. First appearing in *Marvel Premiere* #29, its membership consisted of the Patriot, Whizzer, Miss America, Red Raven, the Thin Man, Blue Diamond, and Jack Frost.

They were initially brought together by Bucky, Captain America's kid sidekick, to fight the Invaders who had been brainwashed by the Red Skull and then remained together, making the occasional guest appearances in the Marvel Universe.

Liberty Project [1987]

Slick, Crackshot, Johnny Savage, Burnout, and Cinnamon are teenaged superpowered delinquents given a chance for parole by the U.S. government.

Created by Kurt Busiek and artist James Fry, they appeared in all eight issues of Eclipse Comics' *The Liberty Project*, which was canceled in 1988.

M.A.R.S. Patrol [1965]

Initially drawn by Wally Wood, this paramilitary group dedicated to repelling an alien invasion of Earth debuted in the first issue of Gold Key's *Total War*, retitled *M.A.R.S. Patrol Total War* with #3. The series was canceled in 1969 after 10 issues.

Maze Agency [1988]

Private detective Jennifer Mays and her partner, true crime writer and amateur sleuth Gabriel Webb, are the stars of a series that creator/writer Mike Barr calls a "love story about detectives; a detective story about love."

The mystery-solving couple debuted in the first issue of their own Comico's *The Maze Agency*. Initially drawn by Adam Hughes, the series—which ran 20 issues until 1991—was taken over by Innovation Publishing with #8. A 1997 Caliber Comics relaunch in black and white lasted three issues.

Men In Black [1990]

Agents Jay and Kay are two operatives at a covert government agency responsible for policing alien activity on Earth as well as dealing with such supernatural creatures as werewolves and demons.

Created, written, and drawn by Lowell Cunningham, Jay and Kay starred in two black- and-white *Men in Black* three-parters published by Malibu Graphics' Aircel Comics imprint in 1990 and 1991 before Will Smith and Tommy Lee Jones portrayed them on the screen in 1997's movie of the same name.

That S.F. blockbuster encouraged Marvel Comics—which had, by then, acquired Malibu —to release three one-shot tie-ins. Published in 1997 were *Men in Black: Far Cry*, *Men in Black: The Movie*, and *Men in Black: Retribution*.

META-4 [1991]

Created by Stefan Petrucha and drawn in First Comics' *Meta-4* three-parter by Ian Gibson, they are four youths, zapped into a three-year-long coma by a bolt of sentient cosmic energy, each of them developing paranormal abilities linked to one of the four elements. They have been chosen to guide others who are wakening to their cosmic divinity. Aided by Doctor Fortean of the New Age Institute, they are opposed by forces both political and cosmic.

Metal Men [1962]

Take six robots, each fitted with responso- meters to give them human characteristics and endowed with the properties of different metal, and you have the team that writer Robert Kanigher created virtually overnight to fill DC's *Showcase* #37, an issue left without a feature due to scheduling problems.

Drawn at first by Ross Andru and Mike Esposito, the sextet—led by their comic book creator Dr. Will Magnus—were:

- Gold—Aristocratic but dependable, the leader of the robots could stretch himself into superfine wire nearly 50 miles long or into a sheet four millionths of an inch thick.
- Lead—Stolid, he makes an excellent barrier, especially against radiation.
- Mercury—Intellectual but quick-tempered, he can make himself liquid at room temperature and endure extremes of heat.
- Iron—Reliable, he is the team's strongman.
- Tin—Flexible but ineffectual, brave but weak, the stuttering robot is the team's Achilles heel.
- Tina—Platinum is the only female on the team. Tough and strong but highly strung, she has a faulty responsometer.

After featuring in three more issues of the tryout, the team gained its own title in 1963. Initially *Metal Men* ran 44 issues until 1973. A not uncommon sight around the DC Universe, Magnus and his robots also starred in 1993's *Metal Men* four-parter.

Mighty Crusaders [1965]

Superman cocreator/writer Jerry Siegel was responsible for bringing Archie Comics' superheroes together for the first time.

In collaboration with artist Paul Reinman, he launched a team consisting of Fly Man, Fly Girl, the Shield, the Black Hood, and the Comet in the first issue of *The Mighty Crusaders*, a Mighty Comics Group title that was canceled in 1966 after seven issues. A 1983 relaunch under Archie's Red Circle Productions imprint dropped the Comet from the lineup and added the Web, the Jaguar, Lancelot Strong and the Wizard—a superhero who had been a foe of the 1965 team.

Almost a decade later, DC Comics licensed the Archie heroes for a line of Impact Comics aimed at a younger readership. Its team title—simply called The Crusaders—featured new versions of the Shield, the Fly, and the Jaguar plus Fireball and a rotating position to be filled by W.E.B. agents [see The Web].

Launched in 1992, *The Crusaders* was canceled the same year after eight issues.

Miracle Squad [1986]

Created by John Wooley and artist Terry Tidwell, this loose-knit band of actors, detectives, stuntmen and the like worked for a tiny B-movie studio—Miracle Studios—in the 1930s. They appeared in just two black-and-white four-parters.

In the introductory *Miracle Squad,* they tackled gangsters trying to take over the studio, while in Apple Comics' *The Miracle Squad: Blood and Dust* [1989] they encountered the Ku Klux Klan while shooting a film in dustbowl America.

Continued on page 264

The Coming of the Code

Near the top of the cover on nearly any post-1955 American comic book, you will find a strange little postage stamp containing the words "Approved by the Comics Code Authority."

For nearly 50 years, the "C.C.A." has controlled what you are permitted to read in almost all comics distributed to America's newsstands. So what is the origin of the C.C.A., still in force today, and how did it acquire this superpower?

Back in the late 1940s, before television, 10¢ comic books were the biggest selling entertainment around, consumed by nearly all children and many adults. In this expanding market, publishers jumped onto whatever was the next bandwagon: "true" crime launched by Lev Gleason's *Crime Does Not Pay*; romantic confessions introduced by Joe Simon and Jack Kirby's *Young Love*; and the twist-ending horror story perfected in *Tales from the Crypt* and William Gaines' other EC titles.

But the more popular these racy genres grew, the more concerned certain Americans

The controversial cover of Horrific #3.

became about their possible harmful effects on younger readers' morals. Since they first emerged in the mid-1930s, comic books had been criticized for promoting illiteracy and even eyestrain. But after World War II, America's moral guardians became alarmed by the rise in juvenile delinquency. Rather than confront issues within society or the family, they picked on comic books, misunderstood as solely for children, as the easy scapegoat.

The case studies of leading psychiatrist Fredric Wertham provided their campaign with the vital voice of scientific authority. Treating troubled youngsters in his clinic in New York's Harlem ghetto, Dr. Wertham

became convinced that reading comic books had a negative influence on every patient. As the media seized on his findings, moral panic swept the nation. Religious and civic groups blacklisted offending titles and told their members to boycott retailers who stocked them. Schoolteachers organized mass comic book burnings. Nearly 50 cities adopted local laws banning the sale of certain titles.

Damning testimony

The anticomics crusade climaxed in 1954, when Wertham published his unrelenting exposé of the industry, *Seduction of the Innocent*, and his calls for government intervention prompted three days of televised Senate Committee hearings into the links between comic books and juvenile delinquency. It was the comic's darkest hour.

Ranged against the damning testimony of Wertham and other experts, the defenses of EC Comics' William Gaines and only three other publishers failed to persuade. Although federal legislation was ruled out as contrary to freedom of the press, the pressure was on the comics industry to clean up its act.

Gaines attempted to rally his fellow publishers into opposing regulation and funding independent research and a public relations counteroffensive. But nearly all either closed down or caved in and conformed to the C.C.A., the industry's new self-regulating authority with the strictest code applied to any medium. Publishers could not get their product onto the newsstands unless they paid to submit their material for approval and removed any objectionable content. Only Dell's range and *Classics Illustrateds* were wholesome or educational enough not to need the C.C.A.'s stamp. Of EC's once proud line, only the satirical *Mad* survived by converting to a magazine.

Thanks to the Code, comics survived this attack but at a price. The market was decimated, artists exiled, content infantilized. The medium had to wait until the unregulated underground comix outrage of the late 1960s to address adult subjects again.

In 1971 and 1989, the Code was gingerly revised. It still polices the minority of comics sold from the newsstand, though most publishers now supply their comics just to specialist shops. The future of the C.C.A. looks less secure after Marvel Comics' withdrawal in 2001 of its entire line, replaced by in-house, movie-style ratings.

Still, the critics have not completely disappeared, so the industry has set up the Comic Book Legal Defense Fund, just in case

**Crime SuspenStories #22
[EC Comics, 1954].**

New Mutants [1982]

With the members of the X-Men now older, the concept of Professor Xavier's School for Gifted Youngsters as an academy for training young mutants was in need of new students.

These came from Chris Claremont and artist Bob McLeod, who introduced the New Mutants in the eponymous *Marvel Graphic Novel* #4 at a time when the X-Men were thought dead. Introduced were:

- Cannonball—Kentuckian Samuel Zachary Guthrie can generate a thermoelectrical reaction, which propels him through the air like a rocket. Since leaving Generation X, he has been a member of the X-Men and X-Force.
- Sunspot—Robert Da Costa is the Brazilian heir to a fortune. He can absorb solar radiation, which he converts into super-strength. He, too, went on to join X-Force.
- Wolfsbane—Orphaned while still very young, Rahne Sinclair can transform herself into a wolf or a wolflike humanoid. She went on to join X-Factor and later Excalibur.
- Mirage—Gifted with the power to create solid images of a person's greatest fear or desire, the Native American Danielle "Dani" Moonstar was originally code-named Psyche. Later a member of X-Force, where she is known by her surname.

The team also included the Vietnamese Karma. Introduced in *Marvel Team-Up* #100 [1980], X'ian Coy Manh has the psionic ability to posses the mind of a person or animal and thus control their actions.

The team was launched into its own title in 1983. *New Mutants* ran until 1991 [#100], but the arrival of Cable in #87 [1990] radically changed the nature of the series, which had been growing steadily darker under the direction of writer Louise Simonson and penciler Rob Liefeld.

The warrior from the future set about transforming the youngsters into a paramilitary unit trained to battle mutant terrorists. The cancellation of *New Mutants* was to make way for X-Force, which would take that concept further still.

New Warriors [1989]

Nova, Namorita, Firestar, Speedball, Night Thrasher, and Vance Astro, a.k.a. Marvel Boy, were first seen in action together when they joined forces with Thor to tackle the Juggernaut in *Thor* #411. But, as was recounted in the first issue of *New Warriors* [1990], this group of young minor-league Marvel heroes had formed the team prior to that.

Created by Fabian Nicieza and artist Mark Bagley, the New Warriors were brought together by Night Thrasher to "fight the kind of crime they [the Avengers, Fantastic Four, X-Men] never touch, to help people, to make a difference." The team's title was canceled in 1996 after 75 issues. The team then disbanded only to be revived by Aegis, Bolt, Dagger [see Cloak and. . . .], Darkhawk, Firestar, Justice,

Namorita, Night Thrasher, Nova, Rage, Speedball, Turbo, and Zero-G when *New Warriors* was relaunched in 1999. This time it lasted only 10 issues, until 2000.

Next Men [1991]

Created, written, and drawn by John Byrne, this group of five youngsters with special abilities who escaped from a government research facility first appeared in *Dark Horse Presents* #57, although their story began in issue #54 of the *Dark Horse Comics* anthology.

The research lab was testing for the gene that would trigger the next step in human evolution. The gene enhanced an aspect of their body, giving each a different ability:
• Nathan, a.k.a. Scanner, is their leader. He has enhanced eyesight, which allows him to see right across the electromagnetic spectrum.
• Bethany is invulnerable. Known as Hardbody, she is losing her sense of touch and taste.
• Jack, a.k.a. Brawn, possesses superhuman strength but has to wear restraining armor because he lacks control over his power.
• Jasmine Desoto has enhanced speed, endurance, and agility.
• Danny Hilltyop, a.k.a. Sprint, has superhuman speed.
• Gillian Hilltop is Squatter. She can get into a person's mind and take control of their body.

Project Next Men was set up by Senator Aldus Hilltop—father of Danny and Gillian—who was receiving information from Sathanas, a 235-year-old mystery being from the future who had been found in the 1950s by a scientific research team in Antarctica.

Next Men was launched in 1992 after the series had appeared in *Dark Horse Presents*.

Night Force [1982]

Master occultist Baron Winters periodically forms a taskforce of men and women to confront evil supernatural forces on his behalf.

Among the members of Night Force are Vanessa van Helsing—granddaughter of Dracula's nemesis; Jack Gold, an alcoholic former journalist; and Donovan Caine, a professor of parapsychology.

Thought a charlatan by the police and not above lying, cheating, and sending his team to their deaths, Winters and his crew were created by Marv Wolfman and artist Gene Colan. They first appeared in DC Comics' *New Teen Titans* #21 in a 16-page prelude to the *Night Force* series that ran 14 issues until 1983. A 1996 relaunch was canceled in 1997 after 12 issues.

Nocturnals [1995]

Introduced by creator/writer/painter Dan Brereton in an eponymous six-parter, Doc Horror, The Gunwitch, Halloween Girl, Komodo, Starfish, The Raccoon, Firelion, and Polychrome are "monsters," outcast from human society.

Halloween Girl's father, Doctor Nicodemus

Horror is a scientist from the other-dimensional Black Planet. Horror created the Gunwitch—a former outlaw who is equal parts scarecrow and zombie—to be his enforcer and to watch over his daughter, Evening "Eve" Horror. A.k.a. Halloween Girl, she has supernatural powers as well as animated toys that can come to life.

The remaining two Nocturnals members are both female. Starfish is an alien aquatic gunslinger while Polychrome—otherwise Pollyanna Shale—is an ectomorph, her spirit brought to Earth by Doc Horror.

After *Bravura* folded, Dark Horse Comics published *Nocturnals: The Witching Hour* in 1998. In 2000, Brereton moved the team to Oni Press, which has since published a variety of *Nocturnals* miniseries and one-shots.

The Outsiders [1983]

The last issue of *The Brave and the Bold* [#200]—DC's Batman team-up title—introduced a team founded by the Dark Knight and made up of second-stringers and new heroes.

The veterans were Metamorpho and Black Lightning, joined by Katana—martial arts expert Tatsu Yamashiro—and Geo-Force, otherwise known as Prince Brion Markov of Markovia, who can nullify gravity.

The replacement for the canceled *Brave & Bold*, the first issue of *Batman and the Outsiders* introduced Halo. Geo-Force's half-sister, Gabrielle Doe, née Violet Harper, can fly and make herself invisible as well as shoot fiery blasts from her hands. Created by Mike Barr and artist Jim Aparo, the team appeared in its own comic—retitled *Adventures of the Outsiders* with #33 [1986], following Batman's departure. It ran 46 issues until 1987. A 1993 relaunch featured Geo-Force, Halo, Katana, and introduced three new members:

- Faust—Like his father, the Justice League of America foe, Felix Faust—Sebastian Faust is a sorcerer specializing in soul magic.
- Technocrat is the specially adapted battle suit-wearing Geoffrey Baron.
- Wylde—Charlie Wylde is gifted with metahuman strength.

Completing the lineup was Looker, who had originally joined the team in *The Outsiders* #1 [1985] although she first appeared as Emily "Lia" Briggs in *Batman and the Outsiders* #25 [1985]. With an enhanced metabolism, she is telepathic, and as a vampire, at night she has metahuman strength although she does not share other vampires' weakness to sunlight.

The second *Outsiders* series was canceled in 1994 after 24 issues.

Power Pack [1984]

Probably the youngest superheroes in comics, Alex, Julie, Jack, and Katie Power are the pre-adolescent children of scientist Dr. James Power and his wife Margaret.

Created by Louise Simonson and artist June Brigman, they debuted in *Power Pack* #1. The siblings each had one of Aelfyre Whitemane's superhuman abilities transferred into them by

the dying Kymellian. Alex gained power over gravity, Jack could become gaseous or condense his mass to become tiny, Julie gained the ability to fly fast, and Katie was able to store energy, transform into an energy being, and fire destructive bolts.

As Gee, Mass Master, Lightspeed, and Energizer, the brothers and sisters appeared in their own title until it was canceled in 1991 after 62 issues.

Later, Alex, now a teenager, stole his sibling's powers for himself and, as Powerhouse, became a member of the New Warriors. Subsequently leaving that team he reconciled himself with his brother and sisters and restored their abilities. *Power Pack* was revived as a four-parter in 2000.

Sea Devils [1960]

Offering obvious comparisons with the make-up of Marvel Comics' later Fantastic Four, this DC Comics skin diving team consists of Dane Dorrance—the cerebral pipe-smoking leader, beautiful actress Judy Walton and her kid brother Nicky, and lovable hunk Biff Bailey.

Created by Robert Kanigher and artist Russ Heath, they traveled the world's oceans, taking on undersea monsters and the occasional human menace. After appearing in three consecutive issues of *Showcase*, DC's try-out series, they graduated into their own title. Canceled in 1967, *Sea Devils* lasted for 35 issues.

Secret Defenders [1993]

The only common link between this Marvel team and the Defenders is Dr. Strange who selects the team members on a mission-by-mission basis after consulting the Tarot.

Among those who pitted themselves against mystical menaces at the Sorcerer Supreme's side across the 25 issues of the Secret Defenders were Nomad, Wolverine, Spider-Woman, Darkhawk, Silver Surfer, Thunderstrike, War Machine, Dr. Druid, Giant-Man, and Iron Fist. Thanos replaced Strange as team leader as of #13.

The series was canceled in 1995.

Secret Six [1968]

Mockingbird brought together six people from different backgrounds and with different abilities to form an espionage outfit that operates outside of the law.

Each of the team—Mike Tempest, a Vietnam veteran who testified against the mob; Crimson Dawn—a.k.a. Kim Dawn—a model turned actress who ended up a prostitute who killed her pimp; Dr. August Durant, a government scientist who has been poisoned by Soviet agents; King Savage, another Vietnam vet who, as a POW was tortured until he compromised U.S. forces; Carlo di Rienzi, a magician who crossed the Mafia; and Lili de Neuve, a French actress accused of a murder she didn't commit—owe their continued safety

and existence to Mockingbird. Created by E. Nelson Bridwell and artist Frank Springer, the team debuted in their own title. *Secret Six* was canceled in 1969 before the identity of Mockingbird—who was one of the Six—could be revealed. The series was revived in 1988 for the *Action Comics Weekly* anthology.

Stormwatch [1993]

Operating from an orbiting Skywatch space station, this United Nations crisis response team is under the command of Henry Bendix. Also known as Weatherman One, he keeps the entire world under surveillance.

Created by Jim Lee and Brandon Choi, this second of WildStorm Productions' superhero teams after WildC.A.T.s was led by Jackson King. Otherwise known as Battalion, he wore a battlesuit that gave him increased psionic powers. Introduced in the first issue of their own Image Comics title, the other heroes in the initial lineup were:

• Diva—An Italian who used her voice to create sonic vibrations that could lift an object or cause it to explode.
• Winter—A Russian citizen, Nikolas Kamarov can absorb energy, which he projects as a weapon.
• Fuji—Toshiro Misawa's unstable molecular state is managed only by a specially made costume.
• Hellstrike—Nigel Keane, formerly a British detective working out of Scotland Yard, is now a being of pure energy.

The team underwent dramatic changes via Warren Ellis. Taking over with #37 [1996], the British writer reorganized the heroes as a more proactive international police force.

Following the restructuring, the title continued to #50 [1997], when it was canceled to make way for an Ellis-driven relaunch. Running 11 issues until 1998, that ended with the United Nations shutting down the team—which had been decimated by a clash with 20th Century Fox's movie *Aliens* in the *WildC.A.T.s/Aliens* one-shot after #10—ostensibly due to lack of funding. In reality, the team was being scrapped to make way for The Authority, a new team concept that the writer and British penciler Bryan Hitch—who joined Ellis with *StormWatch* #4—had been moving toward.

The Strangers [1993]

When a San Franciscan cable car is struck by a strange lightning bolt which bestows all the passengers with ultra powers, six of them gather together to discover the secret behind their newfound abilities.

Created by Steve Englehart with artist Rick Hoberg, this Malibu Comics Ultraverse team debuted in the first issue of its own title. Its members were:

• Atom Bob—Bob Hardin has the ability to convert any matter or energy into anything else.
• Electrocute—An android, Candy is telepathic and can discharge electrical bolts from her hands.

- Grenade—By using his body, Hugh Fox can create explosive blasts.
- Lady Killer—Gifted with incredible aim, Elana La Brava can hit whatever she wishes.
- Spectral—David Castigliona has the ability to cover his body in seven different colors of flame.
- Zip-Zap—A minor, Leon Balford can move at unimaginable speed.

The team was joined by Yrial, a member of an ancient hidden civilization whose leader claims to know the reason the six were gifted their abilities.

The Strangers was canceled in 1995 with #26.

Suicide Squad [1959]

Originally the nickname for a group of unruly and disrespectful soldiers—led by U.S.A.F. captain Rick Flag—who fought America's dirty battles during World War II.

Reactivated during the Korean War as a division of Task Force X, the squad was divided into two sections, with Argent handling domestic crimes usually tackled by superheroes. The Suicide Squad itself took on the overseas missions.

Following his father's death, Rick Flag Jr. was selected to lead yet another new Suicide Squad, one that dealt with alien and paranormal threats to America. Active during the 1960s and 1970s, the team consisted of astronomer Hugh Jones, physicist Jess Bright and Karin Grace, a nurse who's speciality was space medicine.

It broke up following a final mission in Tibet, which left Jones and Bright, presumed dead and Grace suffering a nervous breakdown.

Created by Robert Kanigher and artist Ross Andru, the Suicide Squad appeared in DC Comics' *The Brave and the Bold* in 1961 as well as in *Star Spangled War Stories* in 1966. The origins of the various incarnations were explained in *Secret Origins* #14 [1987].

Introduced in *Legends* #2 [1986], another new version of the team was again led by Flag Jr. under the command of mission leader Amanda Waller, a congressional aide. This time the membership would consist of metahumans, or supervillains who would be offered parole in return for laying their lives on the line. Among those who took up the offer were Oracle, Bronze Tiger, Count Vertigo, Deadshot, Captain Boomerang, the Atom, the New Thinker, Poison Ivy, Shade the Changing Man, and Nightshade.

The new team, created by John Ostrander, Len Wein, and artist John Byrne, appeared in its own title from 1987 to 1992. *Suicide Squad* was canceled with #66. Revived in 2001 with the team now led by Sgt. Rock, the title was canceled in 2002.

Continued on page 272

True Brit Adventure— But No Superheroes

With soccer and soldiers, British comic heroes had a different ancestry from their colorful American cousins.

Many of the adventure weeklies had evolved in the 1930s and 1940s from the "Boy's Own" type story papers. In fact, some characters like Rockfist Rogan had already been popular text heroes.

In the early days, all you needed was a square jaw, a good right hook, and an alliterative name. Identikit heroes like Knuckles Nixon (and his boxing bear), Captain Condor, and Battler Britton fought for truth and justice in an assortment of uniforms and locales from the Yukon to outer space.

Comics then were anthologies of different types of strips. It wasn't until the 1970s that the single genre comic arrived with the likes of *Warlord* and *Battle* and, most famously, *2000 AD*. They reflected the changing tastes of British schoolboys. While *Sea Hunt* was popular on TV in the 1950s, Spike and Dusty the Fighting Frogmen swam through *Tiger*. In the 1970s, when *Jaws* was the event film, Hookjaw was terrorizing the beaches in *Action*. But it wasn't just imitation, anthology comics boasted memorable characters in all genres.

The two staples of British comics were sport and war stories. Most famous of all the sports heroes has to be Roy of the Rovers who kicked off in *Tiger* in 1954 and dribbled his way across the front page for 22 years before scoring his own comic. He shepherded Melchester Rovers through countless travails while finding time—unusual for a comic character—to age (slowly), marry, and have a family. Football strips were always popular.

Toughing it out

In *Lion,* the underage Carson's Cubs took on the cream of the first division, while in *Jag* Football Family Robinson drafted in some remarkably unfit looking relatives to Thatchem United. There were other stars from other sports too, from wrestler Johnny Cougar and swimmer Splash Gorton. British comics were full of plucky lads from the back streets who showed the snobs and bullies a thing or two. Like Alf Tupper the Tough of the Track, easily

outdistancing the rich kids at his local club or Billy Dean, living a lonely existence with his granny until he finds the magic boots of the legendary Dead Shot Keene in *Billy's Boots*.

War stories were the backbone of D. C. Thompson titles like *Victor*, *Hornet*, and *Hotspur*. One of their stars was Union Jack Jackson, the only survivor of an air attack who was found floating on a raft by American marines and became the only Brit in the U.S. marines, proceeding to give the Japanese hell in the Pacific. More humorous was the irascible Captain Hercules Hurricane in *Valiant*, a bulbous muscle-bound giant of a man always accompanied by his diminutive batman Maggot and given to "raging furies" that would make whole Panzer divisions quake in terror.

Featured in *Buster* and drawn by Eric Bradbury, Maxwell Hawke was unusual in a number of ways. Not only did he have no alliteration and a pretty girl assistant, but he also spent his time investigating mysterious menaces in fog-shrouded castles in the early 1960s in moody, gothic strips.

Robots were popular too; one of the most loved was the metallic giant Robot Archie who lurched across the pages of *Lion*. Endearingly, he had Archie stenciled across his chest plate, just in case anyone got him mixed up with any other eight-foot-tall red mechanical men.

Among the most fondly remembered characters is The Steel Claw, a reformed villain who could become invisible when electricity surged through him, all apart from his savage looking metal hand which floated eerily through the pages of *Valiant*. He later swapped

Battle Action [1PC, 1979].

his natty white suit for a superhero costume, not an essential accessory for an invisible hero.

Valiant also featured Kelly's Eye, whose hero discovered a talisman in the temple of Zoltec that rendered him indestructible.

For a while it seemed that British adventure comics, like Kelly, were indestructible, but gradually the illustrious names fell to the grim reaper of dwindling circulations.

All but one . . . but that is another story.

Team 7 [1994]

Although little was seen of America's premiere covert operations unit in action, it played a pivotal role in the WildStorm Universe.

A continuity implant that had operated several decades previously, its members—such as Backlash, Deathblow, and Grifter—were either a contemporary WildStorm Productions hero or the father of at least one of the Image Comics imprint's major characters. Exposed to the Gen-Factor by the then head of International Operations in an attempt to create government-controlled superhumans, they gained psionic powers. However, questioning their superiors' motives, they eventually disbanded.

Three of the team's missions were chronicled in *Team 7* [1994], *Team 7: Objective Hell* [1995], and *Team 7: Dead Reckoning* [1996]. While the latter was a three-parter, the other two mini-series ran to four issues. A 1996 one-shot, *Team X/Team 7* featured the team in a Marvel Comics/Image–WildStorm crossover with some of the Spider-Man publisher's mutant heroes.

Team Titans [1991]

A spin-off from New Titans, these six youngsters came from a false future 10 years hence where they struggled to overthrow the tyrannical Lord Chaos. They journeyed into their past to stop the despot ever being born.

Joined by their "drill sergeant from hell," Battalion, who has enhanced speed, strength and durability, the six were:
- Redwing—Carrie Levine can fly using the wings that give her her name.
- Mirage—The shape-shifting Miriam Delgado.
- Kilowatt—An electrical being otherwise known as Charlie Watkins, he can fly and shoot electric blasts.
- Nightrider, later Dagon—The lad known only as David is now a vampire with the ability to change his shape at will.
- Prestor Jon—The twin brother of Carrie Levine, Jonathan has the ability to interface with any computerized technology.
- Terra—The illegitimate half-sister of Prince Brion of Markovia [see Geo-Force], Tara Markov controls the consistency of rock to create earthquakes and manipulate lava flow.

Created by Marv Wolfman and artist Tom Grindberg, the Team Titans were introduced in *New Titans* #79 (a cameo) and *New Titans Annual* #7. A *Team Titans* title was launched 1992. It was canceled in 1994 after 24 issues.

Other than Terra and Mirage—who had learned she was from this era—all the Team Titans were wiped from existence when their alternate future collapsed during 1994's *Zero Hero: Crisis in Time*.

Terrific Three

The Jaguar, Mr. Justice, and Steel Sterling teamed up for the one and only time in *Mighty Crusaders* #5. The comic—published by

Archie Comics' Mighty Comics Group imprint —also featured the only appearance of the Ultra-Men: Captain Flag, the Web, and the Fox.

T.H.U.N.D.E.R. Agents [1965]

Created by Wally Wood, Dynamo, NoMan, Menthor, Lightning, Raven, and Vulcan are a team of United Nations agents who battle international crime.

Introduced in *T.H.U.N.D.E.R. Agents* #1, The Higher United Nations Defense Enforcement Reserves featured in their own Tower Comics title until 1969.

Highly regarded despite its short life, the team was acquired by John Carbonaro who—between 1981 and 1983—revived the title at Archie Comics for two issues as well as featuring T.H.U.N.D.E.R. Agents in *Blue Ribbon Comics* #12, and in the only issue of *JCP Features*. In 1984, Deluxe Comics launched the first of two unauthorized titles. Wally Wood's *T.H.U.N.D.E.R. Agents* lasted five issues, while 1985's *Tales of Thunder* was aborted after one.

Triple Terror [1946]

Introduced in *Tip Top Comics* #54, the Brandon Brothers fight crime as Lectra, an electronics genius, Chemix, a chemical genius, and Menta, "the mental master

of men." Their adventures as Triple Terror ran in the Dell Publishing title until #119 [1946].

Ultraforce [1994]

This superhuman strike force from Malibu Comics' Ultraverse Universe was conceived to take advantage of an offer of an animated television series.

Introduced by Gerard Jones and artists George Perez and Al Vey in the first issue of its own title, *Ultraforce*'s initial lineup consisted of Prime, Protype, Hardcase, Contrary, Topaz, Ghoul, and Pixx. The series ran until #10 [1995], by which point Marvel Comics had acquired Malibu.

The Spider-Man publisher relaunched the title later in 1995 with its own Black Knight—who crossed over from the Marvel Universe—as team leader. As a Marvel title, *Ultraforce* lasted 15 issues until 1996. As with all the Ultraverse characters, this band of superheroes has since faded from view.

Warpsmith [1983]

Created by Alan Moore and artist Garry Leach for Quality comics, this alien intergalactic peacekeeping race is ruled by a triumvirate of godlike beings. They appeared in *Warrior* #8-9 with the black-and-white story continued in the first issue of Atomeka Press's *A-1* [1989].

Warriors Three [1965]

Hogun the Grim, Fandral the Dashing, and the immensely corpulent Volstagg the Enormous, Lion of Asgard, are three of the most celebrated heroes in the Marvel Universe version of the home of the Norse gods.

Comrades-in-arms to Thor, they first appeared in *Journey into Mystery* #119 in a story by Stan Lee and artists Jack Kirby and Vince Colletta and have been part of the Thunder God's supporting cast ever since. They were the stars of *Marvel Spotlight* #30 [1976] and also featured in the anthological *Marvel Fanfare*.

The Web [1991]

A relaunch of an Archie Comics/MLJ concept licensed by DC Comics for its Impact Comics imprint, these agents of a supersecret government organization should not be confused with the solo superhero also known as the Web. Created by Len Strazewski and artist Tom Artis, the agency was charged with monitoring such crime fighters as the Shield, the Fly, the Comet, and the Jaguar. With a quasi-military network, some of its operatives wear armor and carry weapons which, to all intents and purposes, provide them with superpowers.

The agency, which featured in all 14 issues of *The Web*, was canceled in 1992.

Wetworks [1992]

Created by Whlce Portacio and writer Brandon Choi, this WildStorm Productions group is headed by Jackson Dane, one of the original members of Team 7. Introduced in a four-page preview of a planned WetWorks series in *WildC.A.T.s* #2, the other inaugural members were Dozer, Pilgrim, Mother One, Claymore, Jester, Grail, Crossbones, and Flattop.

The virtually invulnerable team broke away from the covert government agency that employed them to wage their own war on the Night Tribes, legions of monsters that posed a supernatural threat to humanity.

Delayed by Portacio, the team's Image Comics title did not premiere until 1994. *WetWorks* lasted for 43 issues until 1998. A 1999 *Night Tribes* one-shot, it featured Dane and Pilgrim as they fought to stave off a demonic invasion. It was published by DC Comics, which had acquired WildStorm Productions earlier that year.

WildC.A.T.s [1992]

Formed by billionaire Jacob Marlowe—actually centuries-old Lord Emp of the Kherubim—this unsanctioned covert action team [C.A.T.] consists of Kherubim and half-Kherubim men and women. Its mission was to protect the Earth from the Daemonites . . . until they learned the war between the two alien races had been over for 300 years.

Created by Jim Lee and Brandon Choi, the premiere WildStorm Productions superteam debuted with a membership consisting of:

- Maul—A human/Kherubim crossbreed, Jeremy Stone can increase his mass and strength as required.
- Grifter—A former member of Team 7, Cole Cash has enhanced reflexes and an ability to withstand pain.
- Spartan—A biosynthetic humanoid, Hadrian 7 is able to fly, project biomolecular blasts, and create a protective plasma field.
- Voodoo—Priscilla Kitaen is human/Kherubim and possesses the ability to see through a Daemonite's human disguise.
- Void—A former Russian cosmonaut, Adianna Tereshkova has the power to teleport herself and others.
- Zealot—A full-blooded Kherubim, the superhumanly strong Zannah of Khera is highly skilled in all forms of combat.
- Warblade—Highly proficient at martial arts, Reno Bryce is part-human, part-Kherubim.

The team debuted in the first issue of Image Comics' *WildC.A.T.s: Covert Action Teams*, a four-parter resurrected as an ongoing series late in 1993. Canceled in 1998 after 50 issues, the comic had proved enormously popular, giving rise to numerous miniseries, specials, spin-off titles, and even *WildC.A.T.s Adventures*. A tie-in with the *WildC.A.T.s* animated TV show, it lasted 10 issues from 1994–95.

WildC.A.T.s was relaunched by DC Comics in 1999. This second version was canceled with #28 [2001] to make way for an *Eye of the Storm* —mature readers'—incarnation in 2002.

X-Factor [1986]

With the popularity of its mutants at a then all-time high, the original X-Men dispersed. Marvel Comics decided the time was right to resurrect Jean Grey, presumed dead, the former Marvel Girl, alongside her one-time teammates in a new team title.

Created by Bob Layton and artist Jackson "Butch" Guice, *X-Factor* featured Cyclops, the Beast, Iceman, and the Angel together with Grey. In their secret identities posing as normal humans, they could be hired to hunt down "mutant menaces" while, in fact, rescuing their prey from their persecutors.

Realizing this perpetuated the idea that being a mutant was wrong, Marvel called for a change of direction. With *X-Factor* #6, new writer Louise Simonson—joined by her artist husband Walter as of #10—had X-Factor reveal themselves to be mutants while renouncing their previous policy. The new direction was only minor compared with the upheaval that took place in 1991's #71.

A completely new creative team—writer Peter David and penciler Larry Stroman—had the team's original members return to the X-Men. Their replacements were Havok, Polaris, Strong Guy, Wolfsbane, and Madrox the Multiple Man.

With the team now effectively controlled by the U.S. government, they undertook assignments involving superhuman menaces until the team's charter was revoked. Forced underground, they subsequently disbanded.

Wolverine was then brought in to head an X-Factor made up of mercenaries, X-Men, and inexperienced mutants. Following the departure of Marvel's most popular mutant, the team came to be made up increasingly of "reformed" criminals.

X-Factor was canceled in 1998 after 149 issues, although the title had a four-issue revival in 2002.

X-Force [1991]

Boomer, Cannonball, Feral, Shatterstar, Warpath, Domino, and Sunspot are the warriors who followed Cable from the New Mutants to form a paramilitary unit that tackles terrorist outfits like the Mutant Liberation Front.

Initially written by Fabian Nicieza and penciled by Rob Liefeld, the team's title underwent a radical revamp with issue #116 [2001] and the arrival of British writer Pete Milligan and artist Michael Allred. They introduced a totally new, media-friendly line-up of eight superstar mutants who are adored by their fans. The newcomers are:

- The Anarchist—African-American Tike Alicar has sweat that is acidic.
- Doop—A protoplasmic sex symbol, he has infinite space inside him.
- U-Go Girl—Now deceased, Edie Sawyer can transport herself and others instantaneously.
- Zeitgeist—A real pinup, the team stud, Axel Cluney can project energy blasts.
- Plazm—Almost nothing is known about this

mutant who died in X-Force #116.
- Gin Genie—Otherwise known as Beckah Parker, she died along with U-Go Girl, Zeitgeist, and Plazm.
- Battering Ram—The team strongman also bought it in X-Force #116.
- La Nuit—Frenchman Pierre Truffaut was another casualty of the new lineup's first issue.

X-Force was canceled in 2002 [#129] with the team moving immediately into X-Statix.

Youngblood [1987]

The team that launched Image Comics on the road to superstardom had a rather inauspicious start, especially when compared with sales in excess of a million copies generated by its 1992 reappearance.

A then-unknown, Rob Liefeld's Youngblood had debuted as a two-page spread in Megaton Publishing's Megaton Explosion, a 16-page Who's Who-style giveaway. Five years later the writer/artist was at the peak of his popularity. His main characters in the Image incarnation of Youngblood were:

- Badrock—Adolescent Thomas John McCall swallowed genetic material created by his scientist father.
- Shaft—A former F.B.I. agent, Jeff Terrell is Youngblood's leader. Skilled in most weapons, he favors the bow. He uses trick arrows and can fire up to three simultaneously.
- Chapel—A ruthless killer, Bruce Stinson is

the assassin who killed Al Simmons—the man
who became Spawn.
• Vogue—A world-class gymnast, Nikola
Yaganova is a Russian defector who now runs
a cosmetics empire. Armored, she is fitted
with retractable claws.
• Diehard—Chosen in the 1940s to be
the first of the U.S. government's genetic
experiments, this enigmatic supersoldier is
a fusion of man and machine.
 Presented as media celebrities, the team
debuted in its own Image title. A three-parter
converted to four and then extended to an
ongoing series, it was canceled in 1994 after
10 issues. A huge hit upon release, *Youngblood*
gave rise to numerous spin-offs despite
constant delays between issues. Relaunched
in 1995, Liefeld moved the title to his own
Maximum Press when he parted company with
Image. This second volume lasted until 1996
and #14.

Watching the Watchmen

Alan Moore and Dave Gibbons' Watchmen has become a benchmark against which all other comics aimed at a more mature audience are measured.

When the British writer and artist began developing their 1986 12-parter, their intention was only to use the Charlton heroes recently acquired by DC, but the powers that be nixed the idea once it became apparent that those characters would be unusable once the story reached its conclusion.

Moore and Gibbons therefore chose to set their apocalyptic tale on an alternate Earth, one that only began to differ from our own in 1938 with the appearance of Hooded Justice, the world's first costumed crime fighter. Other masked adventurers followed him, but the most substantial divergence came in 1959 with the transformation of Jon Osterman into Doctor Manhattan, the world's only superhero with true superpowers.

When an experiment with an "intrinsic field separator" went wrong, the physicist's body was altered on a molecular level. He gained full control of his atomic structure and could teleport and disassemble an object without touching it. Almost godlike, he exists in serial time—past, present, and future are open to him.

After Manhattan, several other new superheroes appeared. So successful were they at fighting crime that, in 1977, the Keene Act was passed. This outlawed costumed vigilantes, forcing some to retire, while some received government sanction to continue operating, and others went underground.

Staying close to their original intent, Moore and Gibbons still chose to base their Watchmen on the Charlton heroes, making Nightowl, Ozymandias, the Comedian, Silk Spectre, Dr. Manhattan, and Rorschach their own versions of Blue Beetle, Thunderbolt, the Peacemaker, Nightshade, Captain Atom, and the Question, respectively.

Ozymandias is a scientific genius and master of martial arts who uses techniques taught him by Tibetan monks to utilize 100% of his brain capacity. In 1966, having concluded Earth was doomed to destruction, he set in motion a plan to save it. He built a massive economic empire to fund his scheme, which involved the deaths of Comedian, Moloch, and over three million New York citizens.

The Comedian was the longest active costumed adventurer until he died in 1985.

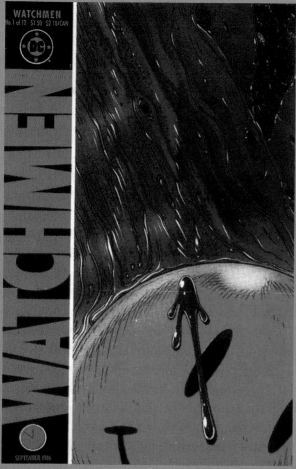

Watchmen #1 [DC Comics, 1986]. Alan Moore and Dave Gibbons' groundbreaking 12-parter.

He started out with the Minutemen, eventually becoming a government operative in 1942. He remained active through the 1960s and 1970s, fighting in Vietnam, suppressing riots, and freeing the hostages held in Iran. Linked to a number of deaths—including Hooded Justice, John F. Kennedy, and Woodward and Bernstein, the reporters who uncovered the Watergate scandal—it's his death that sets off the chain of events chronicled in the *Watchmen*.

A former stage magician, by the 1960s, Moloch—who first appeared in the 1940s—was a powerful crime lord. After his empire collapsed later in that decade, he spent the 1970s in jail. He was living alone and poor when he too was murdered in 1985.

Rorschach is the other former member of the Watchmen intimately involved in Moore and Gibbons' saga. A former garment worker, his crime-fighting career began in 1963. The last unsanctioned vigilante, he was killed by Dr. Manhattan in 1985.

Dan Dreiberg inherited the Night Owl mantle from Hollis Mason, a New York police officer and one of the first superheroes. A member of the Minutemen, he fought crime until 1962. He was killed in 1985 by a street gang who mistook him for his successor.

As Night Owl II, Dreiberg used an impressive array of gadgets to fight crime from 1962 to 1977. He retired with the passing of the Keene Act but came out of retirement in 1985.

Laurel Jane Juspeczyk, the second Silk Spectre, began her superhero career in 1966 at the age of 16. She is the daughter of Sally Jupiter, the first Silk Spectre, and Edward Blake, also known as the Comedian. Having been forced into becoming a costumed crime fighter by her mother, she was more than happy to retire in 1977.

X-Men: Like a Phoenix from the Ashes

Created by Stan Lee and his artistic collaborator Jack Kirby as an allegory of racial intolerance, for almost two decades Marvel's X-Men and its spin-offs ruled the comics industry's sales charts. Not a bad achievement for a comic that struggled —and failed—to stave off cancellation in its early years.

Introduced in the 1963 first issue of their own title, the mutant misfits were brought together by the crippled Professor Charles Xavier—the world's most powerful psychic—at his School for Gifted Youngsters. This private academy is a cover so that the telepathic Professor X can not only train his students in the use of their powers but also mold them into a team that can defend humanity from other mutants.

The team's founding members were Scott (Slim) Summers, Robert (Bobby) Drake, Warren Worthington III, Henry (Hank) McCoy, and Jean Grey or rather:

- Cyclops—The leader of the X-Men, his eyes fire a ruby-colored beam of enormous force. As a result, he must wear a visor or glasses fitted with ruby quartz lenses at all times.
- Iceman—The youngest of the team, he has the ability to lower his body temperature, turning himself or nearby objects to ice. He can also throw balls of ice and create slides and walls out of the moisture in the air.
- The Angel—He flies by means of the feathered wings that grow naturally from his back, although the ability is enhanced by his skeleton, which is hollow like a bird's. With a wingspan of 16 feet, he is capable of lifting at least twice his own weight but the wings are highly flexible, allowing him to hide them under his normal street clothing.
- Beast—Born with unusually large hands and feet, the highly intelligent McCoy is a superb athlete with superhuman ability.

Giant-Size X-Men #1 [Marvel Comics, 1975]. Marvel's next generation of mutants debut.

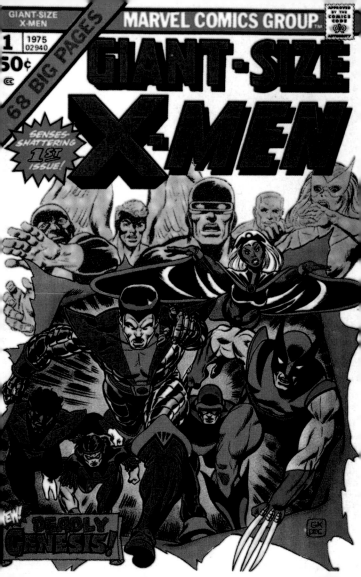

• Marvel Girl—When she joined the team, she had telepathic powers that enabled her to read minds, project her thoughts, and stun opponents with "thought punches." She is also telekinetic.

Over the next few years, the team expanded to include the now deceased Calvin Rankin—otherwise the aptly named Mimic—who joined in #27 and resigned two issues later and Scott Summer's younger brother Alexander (Alex) and his girlfriend Lorna Dane.

Introduced in #56 and 49 as Havok and Polaris respectively, they joined the team as reservists in #65. Where Summers' power enables him to generate waves of super-heated energy, the green-haired Dane's allows her to manipulate magnetic, electrical, and gravitic fields.

Despite later issues being drawn by then fan favorite artists like Jim Steranko [#51] and Neal Adams [#56–63 and 65], sales of the title continued to flag. It was canceled in 1977 with #70. Revived later that same year as a reprint series, it struggled on until #93 [1975].

A new lineup

The second cancellation was to make way for the team's relaunch with a more international and expanded roster. The new lineup made its entrance in *Giant-Size X-Men* #1 [1975]. Appearing alongside their wheelchair-bound mentor and Cyclops were four new characters: Storm, Colossus, Nightcrawler, and Thunderbird as well as three that had been seen before: Banshee, Sunfire, and Wolverine.

From Africa, Storm is Ororo Monroe, who had the power to control the weather and who had been worshipped as a goddess by her people; Colossus is Poitr "Peter" Nikolievitch Rasputin, a hefty Russian peasant who could turn his skin to armor; Nightcrawler is Kurt Wagner, a teleporting German who looked like an evil furry black demon; and Thunderbird is John Proudstar, a Native American with superhuman strength and endurance.

Banshee is Sean Cassidey. An Irishman who had been associated with the team since his first appearance in 1967's *X-Men* #28, he has the ability to generate a sonic scream that can propel him through air, shatter objects, and induce mental blackouts in other people. Shiro Yoshida is Sunfire. A Japanese mutant who first appeared in *X-Men* #64, he can convert matter to superheated plasma.

Sunfire quit the team after *Giant-Size X-Men* #1, while Thunderbird died [in *X-Men* #95] during the new X-Men's second adventure.

The team established in *Giant-Size X-Men* had been conceived by Roy Thomas, Len Wein, and artist Dave Cockrum, and the story—inked by Peter Iro—was written by Wein and his assistant Chris Claremont, who took over the relaunched *X-Men* with its third issue [#96].

The title really began to take off when John Byrne and inker Terry Austin came on board with #108 [1977]. With Claremont they created a foundation that was to take the comic—renamed *Uncanny X-Men* with #142 [1981]—to the top of the sales charts. A new adjectiveless

Uncanny X-Men #362 [Marvel Comics, 1998].

X-Men title—written by Claremont and drawn by Jim Lee and Scott Williams—was launched in 1991. It was the biggest selling single issue of an American comic book ever, at 7½ million copies across five alternate cover editions.

The franchise has spun off several other successful ongoing series including *New Mutants* [1983], *X-Factor* [1986], *Excalibur* and *Wolverine* [1988], *X-Force* [1991], *Cable* [1993] and *Generation X* [1994] as well as numerous miniseries, one-shots, and graphic novels.

Of the founding members, Beast became physically more like his nom de guerre when an experiment went awry. As depicted in *Amazing Adventures #11* [1972]—in a story by Gerry Conway and artists Tom Sutton and Syd Shores—he became blue and furry while the Angel lost his original wings [*X-Factor #24,* 1988] in a story by Louise Simonson, her artist husband Walter, and inker Bob Wiacek. He was subsequently given razor-sharp techno-organic wings with metallic feathers, which could be "fired," temporarily paralyzing.

Later he gained wings made of light. These could shoot energy darts, which would force the target to see the painful truth about themselves. He also gained empathic psionic abilities and could grow energy talons from his fingers. Subsequently returned to his original form, he now calls himself Dark Angel.

As for Marvel Girl, she is now known as Jean Grey. Transformed into the psionic Phoenix [*X-Men #101,* 1976], she was seen to die in the groundbreaking *X-Men #137* [1980]. However, Grey had simply been rescued and replaced by an almost infinitely powerful cosmic entity and was resurrected in *X-Factor #1* [1986] by Bob Layton and penciler Jackson Guice.

As a result of her ordeal, she has lost her telepathic ability, but this has been offset by an increase in her telekinetic powers.

Chapter 4
Newspaper and Pulp Heroes

Comic books owe as much to the newspaper strips that introduced the likes of the Phantom and Dick Tracy as they do to the pulp novels that begat Tarzan and Conan—as well as that first wave of mystery men, which included Doc Savage, the Shadow, the Spirit, and others. Syndicated worldwide, many went on to transcend their beginnings, but all influenced the heroes that came after.

The Avenger [1939]

Richard Henry Benson made his debut in the first issue of Street and Smith Publications' *The Avenger*. A wealthy former soldier of fortune, his mind snapped when he returned from an airplane toilet to find his wife and daughter gone and all the passengers insisting he boarded alone. After hospitalization, he discovered he could manipulate his flesh like putty, so he could impersonate others.

He travels the world in an aircraft he designed, like Doc Savage, accompanied by a team of loyal aides, known as Justice Inc.

Although created by Walter Gibson and Lester Dent—see The Shadow and Doc Savage, respectively—the Avenger's adventures were written by Paul Ernst as Kenneth Robeson, a Street and Smith house name.

The Avenger was canceled in 1942 after 24 issues and only reappeared in 1975 in a comic book. DC Comics' *Justice Inc.* was canceled the same year after four issues, the last three of them drawn by Jack Kirby and Mike Royer. It was followed 14 years later by a *Justice Inc.* two-parter. Written by Andy Helfer and drawn by Kyle Baker, the 1989 miniseries spanned 20 years from 1948.

Buck Rogers [1928]

The star of America's first science fiction newspaper strip debuted in the world's first S.F. magazine, *Amazing Stories*, and led to a request from the John F. Dille Co.—a leading newspaper strip syndicate—that the writer (Philip Francis Nowlan) adapt it and his planned series to a comic format.

Rogers was popularized in the U.S. through a CBS radio serial [1932–39] and worldwide by the 1939 movie serial starring Larry "Buster" Crabbe (see also Flash Gordon) in the title role, the 1950–51 ABC TV series, the 1979 *Buck Rogers in the 25th Century* movie, and the TV series that followed it.

The newspaper strip was revived by Jim Lawrence and artist Gray Morrow as a tie-in with that TV show. Although both premiered in 1979, the strip was canceled in 1983, outlasting its TV progenitor by two years.

The Buck Rogers strip established many of the conventions of what has come to be called space opera. The archetypal S.F. hero, Rogers made his comic book debut in a 1933 Kellogg's Cornflakes Giveaway [#370-A] by Nolan and Calkin, but it wasn't until 1964—after numerous reprints of the newspaper strip—that any further original material was published in that format.

Gold Key's *Buck Rogers*—with *In the 25th Century* added from #5 on—ran until 1982 [#16], but the second issue didn't appear until 1979 when the title was revived as a TV tie-in. Whitman took over publication with #7 and skipped #10. A second *Buck Rogers* comic book was launched by TSR Inc. in 1990. It lasted 10 issues until 1991.

Dick Tracy [1931]

The now famous newspaper strip syndicated by the *Chicago Tribune* that introduced the lantern-jawed detective created by Chester Gould was originally to have been titled *Plainclothes Tracy*.

Joining the police after the father of his fiancé was shot in a holdup, Tracy went on to face a rogues gallery that included Prune-face, the Mole, Mumbles, Breathless Mahoney, and the midget Jerome Trohs, among others. Tracy's only non-newspaper strip reprint comic book appearance was in WD Publications' three-issue tie-in with the 1990 *Dick Tracy* movie that starred Warren Beatty in the title role. Published the same year, *Dick Tracy* was drawn by Kyle Baker.

Doc Savage [1933]

An obvious influence on Superman creators Jerry Siegel and Joe Shuster, Clark Savage Jr. was one of the major stars in Street & Smith Publications' pantheon. The pulp novel publisher introduced the Man of Bronze in the first issue of *Doc Savage* magazine, an issue that also featured the debut of his Famous Five —an engineer, a geologist, and electrical genius, an attorney, and a chemist—each a master in his chosen field, with only Savage their better, and all martial arts experts.

Created by Lester Dent, he appeared in 181 issues of *Doc Savage* between 1933 and 1949.

His adventures were published as written by Kenneth Robeson—a Street & Smith house name—although 165 of them were actually authored by Dent.

In 1940, Doc Savage was featured in the first issue of *Shadow Comics*, graduating to his own series two months later. Nowhere near as successful as its pulp counterpart, *Doc Savage Comics* lasted only 20 issues until 1943. However Kent Jr. continued in *Shadow* until the title was canceled in 1949.

The series was followed in 1966 by *Doc Savage*, a Gold Key one-shot that adapted the Doc Savage novel, *The Thousand-Headed Man*. Further adaptations followed in Marvel's *Doc Savage*. Launched in 1972, the series ran eight issues until 1974.

Following the release of 1975's *Doc Savage: The Man of Bronze* movie, which featured Ron Ely in the title role, Marvel premiered a black-and-white *Doc Savage* magazine. Canceled in 1977, it, too, lasted only eight issues. Another black-and-white title, the digest-sized *Doc Savage: The Man of Bronze,* was published by Bantam Books' Skylark Publications imprint in 1979. Drawn by Maurice Whitman, the 68-page graphic novel was another adaptation of *The Man of Bronze*.

DC next took a turn with the pulp hero, debuting a four-issue *Doc Savage* mini in 1987. This brought the Man of Bronze into the present day and launched an ongoing series that ran 24 issues from 1988 to 1990. With *Doc Savage* #19, the stories reverted to the more

Continued on page 292

1940s Horror: Comics To Make The Flesh Crawl

While the horror boom was associated with the early 1950s, its origins lie in the years prior to the end of the World War II.

Initially there were superficial attempts to introduce a flesh-creeping element to the contents of certain anthology titles. Charlton included Edgar Allan Poe adaptations in its *Famous Tales of Terror*, later retitled *Tales of Terror*, in the pages of *Yellow Jacket Comics* [1944] while Continental's *Suspense Comics* [1943] had occasion to unleash its unsettling penchant for the macabre. These tales were certainly pioneering, but in reality they were nothing more than fillers, none of which wholly managed to capture the imagination of their intended readership.

With the cessation of hostilities across the globe, publishers looked to experiment with a variety of new genres to revive a once booming comic book market. It was Avon that at the very end of 1946 released the comic now acknowledged to be the first of this ghastly reign of terror, fittingly entitled *Eerie*. Behind a creepy cover came a collection of stories to be savored at the darkest hour. Unfortunately, their abject content was unable to convince Avon's editorial team of their

potential. Seemingly a one-shot, *Eerie* would only manage to unleash its terror with its relaunch when the horror phenomena gripped North America in 1951.

The first ongoing horror series was accredited to a company not readily associated with the infamy of this dark era, the American Comics Group (ACG). They introduced the first of their four dread tomes with *Adventures into the Unknown* in 1948. Its tales chose to follow precepts found in the mystery stories of the day and succeeded in attracting a significant readership. The interest was such that others began to look in the unlikely direction of ACG.

Prior to this ghoulish activity among the creators at ACG, Sheldon Moldoff had attempted to sell Bill Gaines, the proprietor of EC Comics, the idea of producing a regular horror comic. The name *Tales of the*

Right: Fight against Crime #20 [Story Comics, 1942]. A decapitation cover leads to a hanging, ax murder, and more inside.

FIGHT AGAINST

CRIME

JULY
NO. 20

HORROR AND TERROR

10¢

CRIME · TERROR

SCARFACE TOLD ME THIS ROAD WAS BLOCKED.. BUT HERE COME THE COPS!

Mister Mystery #12 [Aragon Magazines, 1953].

Supernatural was bandied about the EC offices as the project began to take shape. Initially Gaines was not entirely receptive to the idea, but using ideas now understood to have been sold to EC by Moldoff, Gaines released several try-out stories in the pages of some of his existing titles. EC's first venture into the then

virtually unexplored realm of horror came in *Moon Girl* #4 [1948] with *Vampire of the Bayous* and the next issue's *Zombie Terror*. In 1949 *War Against Crime* #10 [1949], and *Crime Patrol* #15, issues of a couple of titles which had never been particularly successful, also found themselves plagued by these new tales. This assay proved quite successful, so much so that *Crime Patrol* underwent a metamorphosis to become *The Crypt of Terror* with issue #17 [1950]—re-titled *Tales from the Crypt* with issue #20 [1950]—and *War Against Crime* summarily became *The Vault of Horror* with #12 [1950]. A third title to complement this diabolical duo was released a month later in the loathsome guise of *The Haunt of Fear*— the previously titled *Gunfighter*.

These festering newcomers were to have an unparalleled influence. With Gaines supplying endless springboards, Al Feldstein provided the scripts for a series of nasty little tales many would try to emulate but none would surpass.

If this wasn't enough, they had some of the finest artists of the day at their behest. Johnny Craig, Jack Davis, Bernie Krigstein, Jack Kamen, Reed Crandall, Joe Orlando, and the master of these years of menace "Ghastly" Graham Ingels each contributed.

Having observed the almost immediate success ACG had enjoyed with the introduction of *Adventures into the Unknown*, Atlas Comics typically followed suit with *Amazing Mysteries* [1949]. It crept its way onto the newsstands with its 32nd issue, nine months prior to the debut of EC's *Crypt of Terror*. *Amazing Mysteries* had been *Sub-*

Mariner Comics until the previous month. *Marvel Mystery Comics* went through a similar transformation to become *Marvel Tales* with #93 [1949]. And so horror comics began to terrorize every town and city across America. Atlas would continue to release new titles, such as *Adventures into Terror* [1950], *Strange Tales* [1951], and *Menace* [1953]. Harvey Comics unveiled its line with *Black Cat Mystery*, [1951]—yet another revamp of the superheroine title *Black Cat Comics*, which had already had a title change to *Black Cat Western*, to reflect another popular trend—as well as *Witches' Tales* [1951], *Chamber of Chills* [1951], and *Tomb of Terror* [1952]. Moldoff finally introduced his style of horror at Fawcett with *This Magazine is Haunted* [1951] and *Worlds of Fear* [1952]. New companies would appear such as Comic Media and Stanley P. Morse, each of which added to this abominable yet highly creative era in comics publishing.

At first these tales were little more than ghost stories, with the appearance of the odd ghoul or vampire for good measure, but by 1952 with competition on the newsstands at it most fierce, publishers became obsessed with the gruesome in the narration of these ever darkening stories.

From its fifth issue, Charlton's *The Thing!* [1952] satiated itself in an excess of violence and brutality; cannibalism, severed heads and dismemberment were now the order of the day. Stanley P. Morse's *Mister Mystery* #12 appalled casual bystanders with its graphic injury to the eye cover, an image matched only by the scenes of decapitation terrorizing the

covers of *Fight Against Crime* #20 and *Crime Suspenstories* #22.

As if that wasn't enough, these comics were now the bastions for entire armies of zombies, indeed *Ajax's Voodoo* #14 witnessed America vanquished in the wake of their putrescent onslaught. The content of these titles degenerated into a deranged catalog of unrepentant atrocity. Harvey's *Chamber of Chills* #6 detailed how an innocent woman was melted alive, Comic Media's *Horrific* #3 used an alarming bullet through the head cover to ensnare its readers, while its companion title *Weird Terror* slid the tale *Den of Horror* into its third issue. Its scandalous portrayal of whipping and torture could have only appealed to the most ardent fetishist. But it wasn't to end here.

The most notorious story of the period, *Foul Play*, was published by EC in the pages of *Haunt of Fear* #19; its shocking content epitomized the horrors now rife in these comics. A vendetta on the baseball field led to the victim's remains being used in the game itself. The sardonic wit accompanying this heinous spectacle only added to the abhorrence at hand. If EC's rivals were to survive, it seemed they would have to match this new level of depravity.

It seemed nothing could stem this pernicious tide until Dr. Frederic Wertham released his alarmist text *Seduction of the Innocent* prior to the Senate Subcommittee Hearings of April 1954. These responses to the growing public concern led directly to the formation of the Comics Code.

familiar 1930s milieu although the series ended with a serial that tied both eras' adventures together.

Since then Millennium Publications, Innovation Publishing, and Dark Horse Comics have all published *Doc Savage* miniseries, the last in 1995.

Flash Gordon [1934]

Created by Alex Raymond and ghost writer Don Moore, King Features Syndicate's Flash Gordon was America's third S.F. newspaper strip after Buck Rogers and Brick Bradford [1933].

Flash, along with his companion Dale Arden and the scientist Dr. Zarkov, is transported to the planet Mongo where he saves Earth from attack by Ming the Merciless. Popularized by the 1930s Universal movie serials featuring Larry "Buster" Crabbe in the title role, the strip was also adapted to radio (1935–36) and TV (1953–54). It came to an end in 1993.

After numerous newspaper reprints, Gordon was first featured in an original comic book story in *Eat Right to Work and Win*, a 1942 giveaway from Swift & Company.

Dell Publishing launched the first original *Flash Gordon* comicbook title under its *Four Color Comics* umbrella title, publishing six issues between 1947 and 1953. King Features premiered its own *Flash Gordon* in 1966 with Archie Goodwin and artist Al Williamson.

Canceled after #11 in 1967, the title was relaunched by Charlton comics. The revival—which featured art by Reed Crandall and

Jeffrey Jones among others—ran until 1970. Gold Key then took over, publishing #19 in 1978 and continuing *Flash Gordon* until 1982. Whitman took over publication in 1980, including an adaptation of the 1980 *Flash Gordon* movie for which Queen provided the soundtrack.

DC picked up the franchise in 1988. Its *Flash Gordon* nine-parter was followed in 1995 by a two-issue Marvel mini drawn by Williamson.

Garth [1943]

Created by Steve Dowling for Britain's *Daily Mirror*, the eponymous star of Garth was a time-traveling giant of a man. Highly intelligent, he also had abnormal strength.

Initially the science-fantasy newspaper strip crossed the boundaries of time and space as it featured constant battles against demonic forces. It was discontinued in the late 1990s. Over the years its contributors included Peter O'Donnell—creator/writer of *Modesty Blaise*—and artists Frank Bellamy and Martin Asbury. Bellamy's 1971–1976 run on the series is considered a high point of British strips.

James Bond [1953]

Although it was the feature films that popularized Ian Fleming's *James Bond*, he gained his newspaper strip in 1958, four years before Connery made his debut in the first Bond movie, *Dr. No* [1962]. The strip, which

launched with an adaptation of *Casino Royale* by Anthony Hearne and artist John McLusky, premiered in Britain's *Daily Express*.

McLusky continued working on adaptations of the novels and short stories until 1962 when the strip was dropped in the middle of *Thunderball* following a contractual dispute. It was reinstated in 1964 with an adaptation of *On Her Majesty's Secret Service*.

In 1966 writer Jim Lawrence and artist Yaroslav Horak took over the strip, which continued in the *Express* until 1980. It was then picked up by the *Daily Star* [1981–83]. After the first serial—drawn by Harry North—Lawrence and McLusky reunited for the *Star* run.

007's first comic book appearance was in *British Classics Illustrated* #158A. An adaptation of *Dr. No*, a censored version was released in the U.S. in 1963 [as *Showcase* #43] by DC Comics as a tie-in with the Connery movie. Two further movie adaptations—of *For Your Eyes Only* and *Octopussy*—were published as *Marvel Super Special* in 1981 and 1983, while Eclipse Comics adapted *Licence to Kill* in a 1989 one-shot.

Eclipse, in collaboration with British-based Acme Press, began originating James Bond comic book stories in 1989 with *Permission to Die*, a three-parter written and drawn by Mike Grell. Dark Horse then hooked up with Acme to continue the line through four further mini-series between 1992 and 1995.

In Britain, World Distributors published a *James Bond Annual* [1966] as a tie-in with the *Thunderball* movie.

Jeff Hawke [1954]

Created by Sidney Jordan and writer Eric Souster, Jeff Hawke, *Space Rider* was Britain's leading S.F. newspaper strip.

Debuting in the Daily Express in 1954, the series depicted the Earth as a backward planet on the periphery of a highly developed intergalactic civilization. With serials written by Willie Patterson and S.F. author Harry Harrison, the strip ran until 1974. Squadron Leader Hawke also appeared in Beaverbrook's *Junior Express Weekly*. Drawn by Ferdinando Tacconi, the strip lasted from 1954 until 1956.

Mandrake The Magician [1934]

Created by Lee Falk, the first costumed hero created exclusively for comics, the formally attired (top hat, tails, and a cape) Mandrake was a stage magician who had acquired the ability to make anyone see and hear anything he wished, aided by his bodyguard Lothar and the princess Narda.

Despite almost 70 years in a newspaper strip, Falk's creation has not been able to duplicate its success in comic books. He was the star of a 1951 issue of Harvey Publications' *Harvey Comic Hits* and of Dell Publishing's *Four Color Comics* in 1956 before King Features

Continued on page 296

The Phantom: The Ghost Who Walks

When he first appeared, Leon (Lee) Falk's Phantom may have been the 21st of that crime-fighting dynasty, but his debut in a February 17, 1936 King Features newspaper strip gave him the honor of being the first costumed hero created exclusively for comics.

Conceived by the *Mandrake the Magician* writer and drawn by him for the first few weeks until Ray Moore took over, the Phantom was a British subject named Christopher Standish. Initially based in India, the setting was changed to Africa and the alter ego confirmed as the American Kit Walker at about the same time as Moore handed over art on the strip to his assistant Wilson McCoy in 1949.

Whatever the identity of the man behind the mask, the origin of the hero remains the same —he is the direct descendant of a 16th-century seafarer, the sole survivor of a pirate raid. Rescued by pygmies, the sailor swore an oath on the skull of the pirate who killed his father. "I swear to devote my life to the destruction of piracy, greed, cruelty and injustice, and my sons and their sons shall follow me."

Such is the secrecy surrounding the lineage that few beyond the pygmy tribesmen realize that the Phantom is anyone other than the hero who first emerged from the jungle in the 1500s. Building on this "immortality" and rumors of supernatural powers, he is often referred to as the Ghost Who Walks.

Armed with two revolvers, the Phantom now pursues crime on a worldwide basis although his earlier adventures were confined to the jungles around his home with occasional expeditions to New York, London, Paris, or other such big cities. He is often accompanied by a mountain wolf he has named Devil.

On his right hand the Phantom wears a ring, which leaves the Mark of the Skull, a death's head, when he strikes a foe. This warning sign indicates the victim has battled The Phantom

The Phantom: A wrongly colored reprint of the black-and-white syndicated newspaper strip.

and lost. On his left hand—the one closer to the heart—is a ring embossed with four overlapping P-shapes which form a cross in a circle. Anyone thus marked is designated as being under the Phantom's protection.

Falk wrote *Phantom* daily and Sunday strips up until his death in 1999 with a variety of artists following in McCoy's footsteps. Among them were Bill Lignante—who went on to draw *The Phantom* comic book for Gold Key and King—and Sy Barry assisted by Don Heck, Frank Springer, and Joe Giella.

His first comic book appearance was in 1938 when David McKay Publishing began reprinting the newspaper strips in *Ace Comics* where the

series ran from #11 until the title's cancellation with #151 [1949]. Beginning in 1939 McKay also issued the strips in a series of *Phantom* feature books (numbered 20, 22, 39, 53, 56, and 57), continued the reprints in the four issues of *Future Comics* [1940], and then into *King Comics* where they appeared from 1941 to the end of that comic in 1952 [#61–159].

In 1951 the newspaper strip rights moved to Harvey Publications which reprinted it in *Harvey Comics Hits* #51 and 56 and *Harvey Hits* #1, 6, 12, 15, 26, 36, 44 and in 1961 [#48].

Gold Key then acquired the rights and in 1962 published the first original comic book stories to star Falk's hero in *The Phantom* #1. Initially drawn by Lignante, the series moved to King Features comic book division with 1966's #18, to Charlton with #29 [1969]—only published overseas—where it was canceled with #74 [1977]. Most of the Charlton issues were drawn by either Jim Aparo or Pat Boyette, but of particular note is the arrival of artist Don Newton on the series with #67.

In 1988, after an 11-year gap, DC published a *Phantom* four-parter. The next year this was followed by an ongoing series that was canceled in 1990 after only 13 issues and by the four-issue Lee Falk's *The Phantom* released by Marvel in 1995.

More recently, the little-known Moonstone Publications has acquired the comic book rights and in 2001 began a semiregular series of *Phantom* one-shots.

Meanwhile, a constant flow of new material continues to appear on newsstands in Scandinavia and Australia.

launched a *Mandrake the Magician* title in 1966. It was canceled the following year after 10 issues.

Almost 30 years later, Marvel followed with a two-issue *Mandrake the Magician* mini in 1995.

Modesty Blaise [1963]

Introduced in London's *Evening Standard*, Princess, as her Cockney partner Willie Garvin calls her, tackled would-be world conquerors and major terrorists over the years. Initially drawn by Jim Holdaway and later by John M. Burns and Enrique Badia-Romero among others, the *Modesty Blaise* newspaper strip ran until 2001.

The star of several novels written by creator/writer Peter O'Donnell, Blaise— sometimes referred to as the female James Bond—also featured in a 1993 DC three-parter. An adaptation of O'Donnell's 1966 *Modesty Blaise* novel—itself initially based on Joseph Losey's *Modesty Blaise* movie from the same year—it was drawn by Dick Giordano.

Prince Valiant [1937]

Created by Hal Foster for King Features, Prince Valiant is one of the premiere newspaper adventure strips. More accurately an illustrated epic novel—no word balloons are used—it is the story of a Norse prince who becomes a knight of King Arthur's Round Table in an idealized, almost pre-Raphaelite, 5th century.

Mainly set in and around fabled Camelot in England, the Prince's adventures have taken him to Africa, Europe, the Far East, and even to the New World . . . hundreds of years before Columbus. Valiant wields the Singing Sword which makes its owner all-but invincible. In 1946 Valiant married Aleta, Queen of the Misty Isles.

As for original comic book material, the knight's comic book exposure has been limited to seven issues of Dell Publishing's *Four Color Comics* between 1954 and 1958 and *Prince Valiant*, a Marvel four-parter published in 1994.

Secret Agent X-9 [1934]

Maltese Falcon author Dashiell Hammett was commissioned by King Features Syndicate to create a police strip to rival *Dick Tracy*.

The result was *Secret Agent X-9*, which featured a covert operative for an unspecified U.S. government agency who, as war clouds gathered over Europe, became increasingly involved with Nazi spies and such.

When Hammett left the strip in 1935, his place was taken by Leslie (The Saint) Charteris who was joined by artist Charles Flanders later that same year. Since World War II, among those who have worked on *Secret Agent X-9*—renamed *Secret Agent Corrigan* in 1967—are the writer/artist team of Archie Goodwin and Al Williamson [1967–80] and writer/artist George Evans who took over and remained with the strip until it was canceled in 1996.

The Shadow [1931]

"Who knows what evil lurks within the hearts of men? The Shadow knows." Followed by a peal of mirthless laughter, that is the slogan of the mysterious crime fighter who was first heard as the narrator of Street & Smith's *Detective Story Hour* radio series [1930–31].

The Shadow then became the narrator of *Blue Coal Radio Revue* and of *Love Story Drama* —later *Love Story Hour*—from 1931 until 1932 when he took up residence on his own show. After years narrating the tales on *The Shadow*, in 1937 he became involved in the adventures. Portrayed in 1937 and 1938 by the 22-year-old Orson Welles, he continued on U.S. radio until 1954.

Although his radio exploits did not begin until 1937, The Shadow's popularity was such that—even while still a narrator—he was given his own Street & Smith pulp series in 1931. *The Shadow* magazine was to run 325 issues until 1949 with 282 written by Walter Brown Gibson under the house pseudonym Maxwell Grant. It was Gibson who developed the Master of Darkness and his elite corps of agents as he battled mobsters, evil scientists, and oriental villains.

In 1939 the Ledger Syndicate launched *The Shadow* newspaper strip. Written by Gibson in collaboration with artist Vernon Greene, it lasted until 1942. The year after the strip started, Street & Smith launched its own comic book with *Shadow Comics*. Written until 1946 by Gibson, the series would prove more popular than the newspaper strip, running until 1949.

In 1964 Archie Comics decided to return to the superhero field and licensed the Street & Smith hero for its line. Dressed inappropriately in a blue and green costume, *The Master of Darkness* starred in his own title. *The Shadow* was canceled in 1965 after just eight issues, the final five written by *Superman* cocreator Jerry Siegel and drawn by Paul Reinman.

Eight years later in 1973, DC launched its own *Shadow* comic. Written by Denny O'Neil and initially illustrated by Mike Kaluta, the series was highly praised for its evocation of the 1930s era.

Howard Chaykin was next to revive the character for DC, reworking the *Master of Darkness* and bringing him into the contemporary world for his 1986 *Shadow* four-parter. The mini was followed by an ongoing *Shadow* series that lasted 19 issues from 1987. Written by Andy Helfer with Bill Sienkiewicz and Kyle Baker among the contributing artists, it was abruptly canceled in 1989 following objections from the licensors relating to its modern-day setting.

Premiering later in 1989, *The Shadow*'s replacement was *The Shadow Strikes!* Written by Gerard Jones and drawn by Eduardo Barreto, the DC title reverted to the more familiar 1930s milieu. It lasted 31 issues until 1992, including two crossovers with Doc Savage.

Dark Horse also brought Street & Smith's two major pulp heroes together in *The Shadow* and

Continued on page 300

A Spirited Influence

Not as well known to the public as other newspaper heroes such as Flash Gordon and Dick Tracy, the Spirit has been far more influential in the development of comics as an art form.

Until creator Will Eisner introduced his hero as the lead feature in a 16-page comic book-sized Sunday supplement for the *Register* and *Tribune* Syndicate, comics were basically pictures in sequence. The writer/artist changed that by experimenting with lighting and angles and innovations like incorporating The Spirit logo into his landscapes rather than having it added almost as an afterthought.

Described as the *Citizen Kane* of comics, *The Spirit* is thought to have been an influence on Orson Welles when shooting his 1941 movie masterpiece, and the converse is certainly true that Welles' work has been influential on comics artists.

Creative freedom

Importantly, the cartoonist also retained copyright—allowing him creative and intellectual freedom—on his character. Written and drawn by Eisner, the first seven-page *Spirit* story debuted in 1940. It introduced Detective Denny Colt, who seemingly died during a fight with evil scientist Dr. Cobra. Two days after Colt's apparent death, Police Commissioner Dolan—the father of the detective's girlfriend, Ellen—is visited by a man wearing a domino mask. Revealing himself to be Colt, he tells the commissioner of his decision to remain "dead" and operate as *The Spirit* from a local cemetery.

Aiming the strip at a more mature reader than what he described as "the 10-year-old cretin in Kansas City," Eisner incorporated character studies, flights of fancy, and cautionary fables into tales of justice, retribution, love, and hate. He wrote and drew the mystery/humor series until 1942 when he was drafted into the armed forces. While away, other artists such as Lou Fine and Bob Powell drew *The Spirit* with S.F. author Manly Wade Wellman among the contributing writers.

Eisner returned to the strip in 1946 and kept it going until 1952. During its last years, others including Jules Feiffer, Tex Blaisdell, and Wally Wood assisted him.

At its peak, *The Spirit* was carried by 20 Sunday newspapers and had a readership in

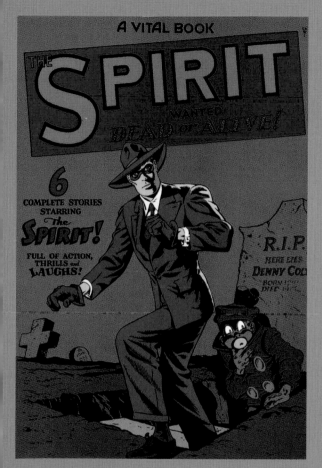

The Spirit #1 [Quality Comics, 1944].

second title was also canceled in 1950, after 22 issues. Fiction House was next to reprint the strip, launching its own *Spirit* comic book in 1952, which was canceled in 1954 with #5.

It was to be another 12 years before the masked crimefighter surfaced again, when Harvey Publications launched *The Spirit* in 1966. Although the series lasted only two issues, it is notable for containing Eisner's first new work on the character since the strip had folded in 1952. The first of these stories featured a revised version of the Spirit's origin, retroactively including The Octopus, a more prominent villain.

Krupp Comics—a division of Kitchen Sink Press—wasn't quite as lucky as Harvey with its two 1973 issues of its *Spirit*. A black-and-white underground comic, each issue featured four new pages by Eisner.

In 1976 Warren Publishing began black-and-white reprints of Eisner's strip in *The Spirit*. Kitchen Sink then relaunched the magazine in 1983 for an 87-issue run that ended in 1987.

In 1992 Kitchen Sink began reprinting the strip comic book-size, *The Spirit: The Origins Years* lasting only 10 issues. Canceled in 1993, the black-and-white title was followed in 1997 by the first major new Spirit material in 45 years. Kitchen Sink's *The Spirit: The New Adventures* featured stories by such writers as Alan Moore, Neil Gaiman, and Kurt Busiek with art by Dave Gibbons and Brian Bolland. Others wrote and drew for the anthology, which ceased in 1998 when Kitchen Sink folded.

DC Comics is now making the ground-breaking strip available in *The Spirit Archives*.

excess of five million. A daily strip was launched in 1941 only to be wound up in 1944 after less than 18 months.

In 1942 Quality Comics began reprinting the series in *Police Comics* where it ran until 1950 and also in *The Spirit*. Launched in 1942, the

Doc Savage. A two-parter, it was the last of four *Shadow* minis they produced between 1993 and 1995. Of these Kaluta wrote two—one adapted the 1994 *Shadow* movie which featured Alex Baldwin in the title role.

In 1988 Kaluta—the artist most readily associated with the pulp hero—had also reunited with O'Neil for *The Shadow: Hitler's Astrologer*. Published as a Marvel graphic novel, it was followed a year later by *The Private Files of The Shadow*. This DC collection —which reprinted the first five issues of the 1973 *Shadow* title—featured a new adventure drawn by Kaluta.

The Spider [1933]

The Master of Men, as he was known, was a vigilante serial killer hunted by both the underworld and the police. Playboy Richard Wentworth was aided by his Sikh servant Ram Singh, a makeup expert who created disguises for his master. As the Spider, Wentworth began his war on crime in *The Spider* magazine #1. Created by R. T. M. Scott—who wrote his first two adventures— he appeared in all 118 issues of the Popular Publications pulp. The remainder of the stories were authored by Norvell Page, writing under the house name Grant Stockbridge.

It wasn't until 1991 that the Master of Men made his first comic book appearance—in an eponymous Eclipse Comics three-parter written by Tim Truman and drawn by him and Quique Alcatena, who were also responsible

for *The Spider: Reign of the Vampire King*, a 1992 three-parter based on the 1935 story of the same title.

In 2002 Vanguard Productions published *The Spider: Scavengers of the Slaughtered Sacrifices*. A graphic novel with a contemporary setting, it was written by Don McGregor and illustrated by Gene Colan.

Starhawks [1977]

Originally to have been titled *Star Cops*, the S.F. newspaper strip created by Ron Goulart and artist Gil Kane debuted in an innovative two-tier format.

One of the few strips created in the last two decades of the 20th century, its stars are Rex Jaxan and ladies' man Chavez. Agents of the Interplan Law Service, their mission is to keep peace throughout the universe. Their boss is Chief Agent Alice K. Benyon, Jaxan's lover, and aiding them on their assignments is Canine Robot Agent Sniffer, which fires debilitating beams from its eyes. A Newspaper Enterprise Association Syndicate strip, *Star Hawks* was canceled in 1981.

Steve Canyon [1947]

Created by Milton Caniff after he left Terry and the Pirates, Canyon was head of Horizons Unlimited, an air transport company that the former captain in the U.S. Air Force had started up after World War II.

His new business brought him into contact with Communists, ex-Nazis, drug dealers, and smugglers until he reenlisted at the outbreak of the Korean War. He undertook covert operations on behalf of the government, something he continued to do in civilian life before re-enlisting in the air force again during the Vietnam War. *Steve Canyon*, a Field Newspaper Syndicate strip, was ended in 1988 with Caniff's death.

The aviator hero made his comic book debut in 1951's *Harvey Comics Hits* #52. Subtitled *Steve Canyon's Air Power*, the Air Force-sponsored issue of the Harvey Publications title was devoted to Falk's creation. It was followed by seven *Steve Canyon* issues of Dell Publishing's *Four Color Comics*. Published between 1953 and 1959, all but the first and the last two featured Caniff art. In 1986, Kitchen Sink Press released *Steve Canyon in 3-D*. A one-shot, it contained an unpublished Caniff story from 1954.

Tarzan [1912]

Introduced by Edgar Rice Burroughs in *Tarzan of the Apes*, a short story in the October 1912 issue of *All Story* magazine, the Lord of the Jungle is one of the iconic characters of the 20th century.

A leading movie and TV hero, his first comics appearance was in a newspaper strip launched in 1929 by Metropolitan Newspaper Services. An adaptation of *Tarzan of the Apes* by Hal Foster, it was followed by *The Return of Tarzan* by Rex Maxon, who relaunched the strip in 1931. He was swiftly replaced on the newly launched Sunday strip by Foster, whose work on the Sunday *Tarzan* became a milestone in the history of comics.

When Foster moved on to *Prince Valiant*, his place was taken by Burne Hogarth, whose own Tarzan work would establish him as one of comicdoms most celebrated artists. The daily strip has been drawn by Dan Barry, Paul Reinman, and Russ Manning. Mainly original stories from 1931 to 1972, it has been entirely reprints since.

Other artists who have contributed to the Sunday strip include Manning, Gil Kane, Mike Grell, and Gray Morrow.

The apeman made his debut in an original comic book story in 1947. Written by Gaylord Dubois and drawn by Jesse Marsh, *Tarzan and the Devil Ogre* appeared in Dell Publishing's *Four Color Comics* #134. The same creative team followed up with another new story before Dell launched the Jungle Lord into his own title early in 1948.

Initially written by Dubois and illustrated by Marsh, *Tarzan of the Apes* ran until 1972 under Dell. It was then taken over by DC Comics, which brought Joe Kubert in to draw the apeman's adventures. Canceled in 1977, it was immediately replaced by Marvel's *Tarzan* [Lord of the Jungle] with adaptations of Burroughs' stories drawn by John Buscema. The Marvel title was canceled in 1979. Between 1952 and 1972, Tarzan also appeared in 21 issues of K K Publishing's *March of Comics* giveaway.

In 1964, Charlton Comics had premiered *Jungle Tales of Tarzan*. Drawn by Sam Glanzman and adapted by Joe Gill, it featured strips based on Burroughs' stories in the public domain. However, pressure from Dell and the E.R.B. estate caused it to fold after just four issues. After Marvel, the Tarzan licence was next picked up by Malibu Comics, with three miniseries between 1992 and 1993. Dark Horse took over in 1995, publishing a further nine by 2000.

In Britain, the apeman's first original comic book stories appeared in Westworld's *Tarzan: The Grand Adventure Comic*, which mixed U.K.-originated strips in with the U.S. reprints. Retitled simply *Tarzan Adventures* in 1953, the series ran a total of 401 issues until 1959.

The Lord of the Jungle next turned up in City's *TV Tornado* in a Tarzan strip initially drawn by Harry Bishop. It ran through 1967 and 1968 and continued in *TV Century 21* [1968–69] when *Tornado* merged with that title. Drawn by Don Lawrence, the Tarzan strip then continued in *TV 21* and *Joe 90* when City launched that comic in 1969, until 1971.

Terry [1934]

Created by Lee Falk, in the *Terry and the Pirates* newspaper strip adolescent Terry Lee (accompanied by two-fisted adventurer Pat Ryan) has various exploits in the Far East before tackling the Japanese in World War II and Communists in Korea and after.

Following a contractual dispute with Tribune-News Syndicate, Falk left the strip at the end of 1946 to begin work on *Steve Canyon*. His replacement on *Terry and the Pirates* was George Wunder, who continued until its cancellation in 1973.

Revived by Michael Uslan and sibling artists The Brothers Hildebrandt, a contemporary version was launched in 1995 only to be canceled the following year.

The first original *Terry and the Pirates* comic book appearance was in a 1939 giveaway, *Merry Christmas from Sears Toyland*. Dedicated *Terry and the Pirates* promotional comic books followed in Western Publishing's *Super Book of Comics* between 1942 and 1947. While there was never an original *Terry and the Pirates* title per se, Dell Publishing starred Falk's young hero in three issues of its *Four Color Comics* umbrella title between 1940 and 1945.

"Described as the Citizen Kane of comics, The Spirit is thought to have been an influence on Orson Welles when shooting his 1941 movie masterpiece."

Chapter 5
War Heroes

Like every war before it, World War II created heroes out of ordinary men and women. The difference was that this time the media was there to embellish the legend, whether of legless flying ace Douglas Bader or of Medal of Honor winner and movie star Audie Murphy. Comic book publishers were quick to pick up on the public's fascination with the courage of the regular man in the street, and World War II continued to be fought for another 50 years through the exploits of Sgt. Rock, Battler Britton, and the rest.

Balloon Buster [1965]

As a DC hero, Lieutenant Steven Henry Savage continues a family tradition. His grandfather was trail boss Matt Savage while his father was Brian Savage a.k.a. Scalphunter.

One of the few comic book heroes whose exploits take place during World War I, Savage was raised by a poor farmer named Jennings who encouraged him to hone his marksman skills. Joining the Army Air Corps, he became something of a maverick hero, constantly taking out German observation balloons.

Introduced in *All-American Men of War* #112, Savage was created by Robert Kanigher and artist Russ Heath who based him on real-life World War I flying ace Frank Luke Jr., a.k.a. *The Arizona Balloon Buster*. He appeared in *All-American Men of War* #112–114 and 121 [1965–66] as well as in *Star Spangled War Stories* #160 [1971] and 181–183 [1974] and *Unknown Soldier* #262-264 [1982].

In 1997's *Batman: Legends of the Dark Knight Annual* #7, writer James Robinson, Heath, and inker Steve Yeowell purportedly adapted fictional author Harold Jennings' *I Am a Gun: The Biography of Steve Savage*, which revealed how the aviator had died in the late 1930s.

Battler Britton [1956]

Known as the Fighting Ace of Land, Sea, and Air, Wing Commander Robert Britton flew into Amalgamated Press's *Sun* in #361. The series,

initially drawn by Geoff Campion but later by Eric Bradbury and Ian Kennedy among others, ran there until the comic was canceled with the unnumbered October 17, 1959 issue.

AP then moved its *Battler Britton* strip into *Knockout* where it featured in the issues dated from May 21, 1960 to February 16, 1963 when the title merged with Fleetway's *Valiant*. Britton was also the star of 65 issues of AP's *Thriller Comics*—later *Picture*—*Library* between #160 and the digest-sized series cancellation in 1963 with #450. Fleetway published *Battler Britton* hardcovers in 1960 and 1961, also featuring the British World War II Spitfire pilot in a number of its *Air Ace Picture Library*.

Blackhawk [1941]

Although they didn't appear until almost eight months after National Periodical Publications' *Justice Society of America*, as the Blackhawks the unnamed Polish aviator and his international band of pilots were the original comic book team in the truest sense of the word. Where the superheroes worked independently of each other until an adventure's climax, the Blackhawks lived and fought together. They had no secret identities to distract them. Their sole purpose was to fight the Germans.

Introduced in Quality Comics' *Military Comics* #1, the team was named by Will Eisner but actually created by Charles "Chuck" Cuidera and Bob Powell. Inspired by Jack Cole's tongue-in-cheek *Death Patrol* series

which they premiered alongside, the Blackhawks—all clad in black leather uniforms—flew Grumman F5Fs. The team, recruited by the Pole after he was shot down by Nazis, consisted of Olaf, a Swede; André, a Frenchman; Chop-Chop, a "humorous" Chinese complete with pigtail; the Dutchman Hendrickson; and Stanislaus, another Pole. Operating from Blackhawk Island, the freelancers flew missions against the Nazis in *Military Comics* until #43 [1945] when it changed its name to *Modern Comics*. From then on, they fought all manner of menaces until the title folded in 1952 with #102. By that time, Quality had already launched a Blackhawk title. Formerly *Uncle Sam Quarterly*, it ran from #9 to #251 [1944–77] with National Periodical Publications taking over publication as of 1957's #108.

Given a number of makeovers to try to modernize the team, they began an association with a secret agency which outfitted them in garish red and green uniforms. With #228 [1967], the agency—now named G.E.O.R.G.E.—had the Blackhawks adopt silly costumes that gave them second-rate superpowers. The new lineup was the Listener (Chuck), the Leaper (Olaf), the Weapons Master (Hendrickson), the Golden Centurion (Stanislaus), M'sieu Machine (André), and Dr. Hands (Chop-Chop). Only Blackhawk himself was exempt.

With #242 the team reverted to its old self, but *Blackhawk* #243 [1968] was to be the last. DC—formerly National Periodicals—relaunched the title in 1976. Picking up the numbering from its previous incarnation, it was canceled again with #250 [1977] in which Chuck died. A second [1982] revival lasted until 1984 [#251–73].

In 1988 writer/artist Howard Chaykin gave Blackhawk a makeover in a three-issue story that named him Janos Prohaska and left him and his teammates virtually unrecognizable from their former selves. It was followed by a new *Blackhawk* title that ran 16 issues from 1989 to 1990.

Boy Commandos [1942]

Created by Joe Simon and Jack Kirby, this multinational team of orphaned fighting kids first appeared in *Detective Comics* #64. Traveling the world, the gang was ostensibly led by Captain Rip Carter. Its members were Alfred "Alfy" Twidgett, André Chavard, Daniel "Brooklyn" Turpin, and Jan Haasan. Their exploits were featured in *Detective Comics* until #150 [1949] and in *World's Finest Comics* #8–41 [1943–49]. They also gained their own title. One of National Periodical Publications' top-selling titles of the war years, *Boy Commandos* ran 36 issues from 1942 until 1949. In the postwar years, the group gradually became all-American. Jan returned to Holland while Alfy and André went with Brooklyn and Rip to the U.S.A. [1945]. Then, in 1947, Alfy returned to England and was replaced by Tex. André went home to France, his place being taken by Percy Clearweather.

Continued on page 312

Crime Comics: Hard Boiled, Sin City, and Beyond

Superheroes always had their roots in crime fiction, as far back as the 1930s classic pulp and radio series The Shadow, but it wasn't until the 1990s that a real revival in the genre, sans superpowers, began.

Writer/artist Frank Miller was the doyen of comics until 1990 when he wrote the hugely disappointing three-issue *Hard Boiled* for artist Geoff Darrow. Using a mixture of crime clichés and oversimplistic sci-fi, it is a triumph of style over content.

Miller drew his other noir homage, *Sin City*, using solid black and whites to create a stark tale of Marv, a less than intelligent goon sucked into a mystery of babes, bodies, and bloody retribution. The series went on to spawn a continuing variety of miniseries, one-shots, and graphic novels including A Dame to Kill For; The Big Fat Kill; and Hell & Back among others.

In 1994 DC Comics launched Paradox Press. The imprint's initial Graphic Mystery line consisted of numerous crime graphic novels and miniseries. Despite the use of such published crime novelists as by Jerome (Blue Eyes) Charyn on *Family Man* [1995] and Kill the Poor's Joel Rose and filmmaker Amos Poe on *La Pacifica* [1995], the titles ultimately failed to engage. However, *A History of Violence* [1998] by comics stalwarts John Wagner and artist Vince Locke tells a successful tale about Tom McKenna, an unremarkable man with a secret, who—unknown to his friends and family—may have a history of violence.

The Bogie Man by Alan Grant, Wagner and artist Robin Smith—originally published in 1989 by Fat Man Press—was collected and reprinted by Paradox Press in 1998. It tells the story of an escaped mental patient roaming

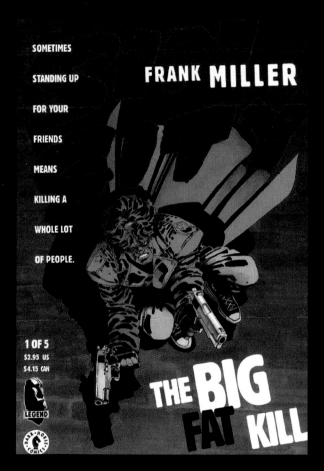

SOMETIMES

STANDING UP

FOR YOUR

FRIENDS

MEANS

KILLING A

WHOLE LOT

OF PEOPLE.

FRANK **MILLER**

1 OF 5
$2.95 US
$4.15 CAN

THE **BIG FAT KILL**

**Sin City: The Big Fat Kill #1
[Dark Horse Comics/Legend, 1994].**

Glasgow believing he is every single
Humphrey Bogart role.

The most successful of the Paradox Press
titles is *Road To Perdition* by Ms. Tree writer
Max Allan Collins and artist Richard Piers
Rayner. Set in Depression-era Chicago, it tells
of hitman Michael O'Sullivan as he embarks
after revenge for the deaths of his youngest
son and wife with his surviving son, Michael Jr.

Acclaim also jumped on the crime revival
bandwagon with *Gravediggers* by Mark Moretti
and artist Rodney Ramos, and Bob Hall's *A&D:
Armed & Dangerous*.

Drawn by Eduardo Risso, Vertigo's *100 Bullets*
by Brian Azzarello is possibly the finest
example of an ongoing crime fiction comic
running today. It deals with the enigmatic
Agent Graves, a man who offers those with no
hope the chance for revenge via an attaché
case, a gun, and 100 untraceable bullets.

Vertigo's *The Sandman Mystery Theatre* by
writers Matt Wagner and Steven T. Seagle is a
hit-and-miss homage to the pulp origins of the
genre, set in the 1930s. Another pulp hero, The
Shadow, has made many comic appearances
over the decades, and Mike Kaluta's *In The
Coils of the Leviathan* [Dark Horse, 1993] is a
good place to start. DC Comics published an
excellent *Gangland Anthology* [1998] by
various creators.

Of the independent crime comics, David
Lapham's critically acclaimed *Stray Bullets*
[El Capitan, 1995] is a must. Also, his nine-
issue *Murder Me Dead* [2000] conjures up the
best of the Cohen Bros. dealing with a family's
investigation into their daughter's suicide/
murder and the chief suspect, her husband.

The '90s saw the crime comic mature and
diversify, embracing all aspects of the genre
besides the traditional down-at-the-heels
gumshoe path previously trodden.

Sergeant Rock

World War II may have lasted only six years, but somehow the adventures of Sergeant Rock and "the combat-happy Joes of Easy Company" ran for a staggering 29 years.

With the outbreak of the Korean War, the American comics scene became awash with war comics, DC alone weighing in with four—later five—titles of its own. However, *G.I. Joe* apart, few of these comics featured recurring characters until writer Robert Kanigher and artist Joe Kubert collaborated on the Sgt. Rock story, The Rock, and the Wall Sgt. Rock in *Our Army at War* #83 [1959].

Rock lived up to his name; he was a granite-faced Titan, an indomitable and seemingly invincible G.I. who, through sheer force of will, always won the day. As a rookie private, Frank Rock's first taste of war came on the bloody French beaches of D-Day, but he soon rose to the rank of sergeant, overseeing the colorful men of Easy Company. Among his motley battalion were the colossal Gatling gun-wielding Bulldozer, the Indian brave Little Sure Shot, the hillbilly Wild Man, Zack, Icecream Soldier, and (literally) hundreds more.

Through the 1960s, Rock's adventures were well crafted but often fanciful, with Easy Company as likely to duke it out with their fists as to fire their guns at the enemy. Rock acquired a nemesis—an apparently indestructible metal-handed Nazi called the Iron Major—and the strip saw him take on dinosaurs, Vikings, and knights in armor!

Fighting on

But as America's attitude to war and society changed, so too did the strip as, for instance, Kanigher introduced Easy's first African-American recruit, the ex-boxer Jackie Johnson. At the end of the decade, Kubert became the comic's editor and immediately introduced a strong antiwar theme, which featured scenes such as a feverish Rock shouting, "Stop the war, I want to get off!"

This mood reached its apotheosis with the 1971 *Head Count* strip—which echoed the notorious Vietnam Mai-Lai massacre—and Kubert's decision to end each episode with the phrase "make war no more."

But fight on Rock did, across every theater of war from the devastated Europe of 1940s France, Italy, and Germany to the Pacific Basin,

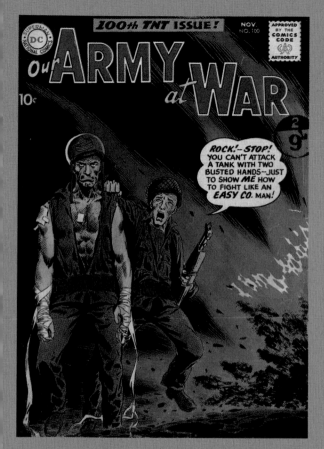

Our Army at War #100 [National Periodical Publications, 1960].

elsewhere, and a new wave of war characters appeared in his wake.

DC added The Haunted Tank, Gunner and Sarge, Enemy Ace, The Unknown Soldier, Johnny Cloud, and The Losers to their roster. Marvel weighed in with the rather more gung-ho Sergeant Fury and his howling commandos while, in Britain, the outrageous and outlandish Captain Hurricane became the lead feature in the weekly *Valiant*.

Throughout its long existence, *Sgt. Rock* was graced with inventive scripts from Kanigher and terrific art. After a decade's service, Kubert was replaced by the talented Russ Heath, followed by John Severin, Frank Redondo, and many others. Rock himself became a mainstay of DC's comics line, with *Our Army at War* being retitled *Sgt. Rock* with 1977's #302 and even teaming up—somewhat improbably—with Superman and Batman. As victory followed victory, Rock's war heroics merited countless promotions but he always refused, claiming his place was with his men.

In interviews and letter columns, Kanigher stated that Rock could have no life beyond the war and that he was to die on the last day of the war. In the event, even after the comic's cancellation in 1988, Rock lives on in specials and collections to this day, and he has even had his own action figure. Rumors of a film have persisted to this day.

(Robert Kanigher died in 2002 without writing that final Rock story. The Easy Company sergeant lives on in the DC Universe and was last seen heading up the 2001 revival of *Suicide Squad*.)

Burma, and Africa. Easy Company suffered terrible losses—though never the regular cast members—and Rock himself was shot, drowned, blown up, or crushed countless times but somehow was always there again next month. Rock's success did not go unnoticed

Braddock [1952]

The exploits of Britain's greatest pilot of World War II were chronicled by his navigator, Sergeant George Bourne, in a series entitled *I Flew with Braddock*. Initially appearing in a text serial that began in D. C. Thomson's *Rover* #1414, the story of Sergeant Matt Braddock V.C., D.F.M., transferred to comics with the first issue of *Victor* [1961]. A new series—*Bomber Braddock*—was launched in 1974 with the premiere of *Warlord*.

Captain Hurricane [1962]

Described as the toughest fighting man of World War II, the Mighty Marine was introduced in—and cover featured on—the first issue of Fleetway's *Valiant*. Accompanied by his pint-sized batman-cum-mate Maggot Malone, Royal Marine Commando Captain Hercules Hurricane was subject to raging furies which provided him with prodigious—almost super—strength enabling him to wield telephone poles and the like at the enemy. The *Captain Hurricane* strip ended in 1976 when *Valiant* merged with *Battle*.

Captain Savage [1968]

The leader of the Leatherneck Raiders was a married man with a child whose wife divorced him while he was overseas.

His unit—created by Gary Friedrich and artists Dick Ayers, Syd Shores and Simon Savage—consisted of tough guy Sergeant Sam "Yakkety" Yates, Corporal Jacques "Frenchy" Larocque, Privates Jay Little Bear, and Lee Baker—a white teacher from the ghetto—and Seaman Roy "Blarney" Stone. Savage led them through all 19 issues of *Captain Savage and the Leatherneck Raiders*—amended to the *Battlefield Raiders* with #9—between 1968 and 1970. Referred to as the Skipper, he was introduced in the 1964 tenth issue of *Sgt. Fury* in a story by Stan Lee, Ayers, and inker George Roussos. With his team he also featured in #64 [1969] of that Marvel title.

Baker was killed in *Captain Savage* #10, and Little Bear went on to become a member of the Deadly Dozen serving under Combat Kelly. He lost his life in the final issue of *Combat Kelly* [#9, 1973].

Captain Storm [1964]

P.T. boat commander Captain William Storm was probably inspired by President John F. Kennedy who had served in a similar position during World War II.

Introduced in the first issue of his own title, Storm was created by Robert Kanigher and artist Irv Novick. Despite having only one eye and a wooden leg, he sailed through 18 issues of *Captain Storm*, canceled by DC in 1967. He also appeared in *Unknown Soldier* #257–259 in a three-part story that also featured Kennedy. A member of the Losers, he gave his life by

throwing himself on a grenade to shield his teammates as depicted in *The Losers Special* # 1 [1985].

Charley Bourne [1979]

Charley's War was a groundbreaking series created by Pat Mills and artist Joe Colquhoun for IPC's *Battle Picture Weekly*. Chronicling the horrors of World War I through the eyes of an ordinary infantryman, the strip first appeared in #200.

Introduced as a 16 year old from the lower working classes, Bourne survives the war, going on to serve his country again in World War II, as depicted from the [unnumbered] February 2, 1985 issue on. His trials and tribulations during the 1939–45 conflict were left incomplete when the strip was canceled with the October 4, 1986 issue.

Codename: Gravedigger [1977]

One of comicdom's few African-American war heroes, Ulysses Hazard served during World War II.

Prevented from using his exceptional physical skills in a combat role and assigned to the graveyard detail—as all African-American soldiers were given menial tasks—because of racism, Hazard went AWOL and made an appeal to the high-ranking officials at the Pentagon.

Established as the Pentagon's special agent, he operates as a one-man commando unit. Introduced in *Men of War* #1 in a story by David Michelinie and artist Ed Davis, *Gravedigger* appeared in all 26 issues of the title, which was canceled in 1980.

Combat Kelly I [1951]

Described as a "gold-bricking, girl-crazy, chow-gulping, battle-batty G.I." by his superior, Major Thorn, Kelly is a veteran of World War II—where Thorn was his captain. Making his debut in the first issue of his own title, Kelly appeared in all 44 issues of *Combat Kelly,* which was canceled by Atlas [Marvel] in 1957. He also featured in *Battle* #60 and 62 [1958–59].

Combat Kelly II [1972]

Gary Friedrich and artists Dick Ayers and Jim Mooney introduced Corporal Michael Lee "Combat" Kelly, a red-haired Irishman from Boston, as a member of a group of convicts who had volunteered for combat duty in return for pardons. Undoubtedly inspired by Robert Aldrich's 1967 movie, *The Dirty Dozen*, the Deadly Dozen—as the team was brazenly dubbed—was initially led by Dum-Dum Dugan of the Howling Commandos. Kelly—a former heavyweight boxer inside for killing a man with his bare hands—was subsequently chosen by Captain "Happy" Sam Sawyer,

commanding officer to Sgt. Fury, to lead the squad introduced in *Sgt. Fury* #98.

Over the nine issues of *Combat Kelly*, the team featured Doc Watson; Jay Little Bear; "Mad Dog" Martin; Larry "Hillbilly" Wagner, a Southerner and country singer who carries his guitar into battle and serenades the enemy with it; Jake Jensen, a middle-aged African-American pickpocket; Howard Shigeta, a Japanese American; Emory "Snake-Eye" Simpson; Donald Sample, a French lock picker and spy who served time for theft of valuable government papers; Bullseye Miller, an African-American mechanic and sharpshooter; Roland "Ace" Hamilton, a "pretty-boy" who is also a psychotic, bloodthirsty knife fighter from a wealthy, upper-class family; and Laurie Livingston, a British woman.

Kelly took over as leader of the team with *Combat Kelly* #1, the same issue in which Little Bear and Watson were introduced into the Dozen. Both Miller and Wagner were killed in action in #4 while Martin debuted in #6. The final [1973] issue saw the deaths of Hamilton, Little Bear, Watson, Jensen, Shigeta, Simpson, Sample, and Martin. With unit disbanded, Kelly resigned from the Army.

Creature Commandos [1980]

Introduced in *Weird War Tales* #93 and led by Lieutenant Matthew Shreive, the Creature Commandos were Wolfpack, Patchwork, and Velcoro. Originally Warren Griffith, Private Elliot "Lucky" Taylor, and Sergeant Vincent Velcoro, they had been altered by Project M, a World War II secret government organization specializing in experimental biotechnology. As a result, Griffith gained the ability to transform into a werewolf, Taylor—blown to pieces in an explosion—was stitched back together and revived à la Frankenstein's Monster, and Velcoro became positively vampiric—able to change into a bat but requiring human blood to survive. In *Weird War Tales* #110, their ranks were swelled by the addition of Medusa. She was the former Doctor Myrra Rhodes who had inhaled fumes and grown snakes for hair.

Created by J. M. DeMatteis and artists Pat Broderick and John Celardo, the Creature Commandos featured in *Weird War Tales* until the DC title was canceled in 1983 with #124.

Darkie's Mob [1976]

Created by writer John Wagner and drawn by Mike Western, the story of a ragtag bunch of British soldiers operating behind Japanese lines premiered in IPC's *Battle Picture Weekly* in the unnumbered August 14, 1976 issue. It continued—except for a one-week break—until June 18, 1977. The series is narrated by Private Richard "Shorty" Shortland, the only one who knows that the mysterious and crazed Captain Joe Darkie is not a British army officer. During the course of Darkie's Mob, the supposed captain transforms his motley crew into a brutal and feared

commando-style fighting unit only to die with several of his mob in the final episode.

Enemy Ace [1965]

Created by Robert Kanigher and drawn by Joe Kubert, Baron Hans von Hammer flew for the first time in *Our Army at War* #151. Based on Germany's World War I fighter pilot aviator Manfred von Richthofen, a.k.a. The Red Baron, Enemy Ace also appeared in *Our Army at War* #153 and 155 before moving into *Showcase* for a two-issue run beginning with #57 [1965]. In 1970 he became a feature of *Star-Spangled War Stories* where—initially drawn by Russ Heath – he appeared in #138–150, 152, and 181–183, in which he first encountered Balloon Buster, and in 200 [1976] before moving into *Men of War* from 1977 to 1979 [#1–3, 8–10, 12–14, and 19–20] and from there into *Unknown Soldier* #251–253 and 260–267 [1981–82].

In 1990, the German fighter ace, now an elderly resident of a nursing home, recounted his World War I exploits to a reporter—as depicted by George Pratt in his *Enemy Ace: War Idyll* graphic novel. This was followed by Tim Truman's *The Last Dragon,* which featured von Hammer—along with Bat Lash among others—in a 1927 adventure set on Dinosaur Island. Von Hammer took to the skies again in *Enemy Ace: War in Heaven.* A 2001 two-parter written by Garth Ennis and illustrated by Christian Alamy, Chris Weston, and Heath, it featured the fighter pilot as he reluctantly flew for Hitler and the Nazis in the World War II.

After crash landing at the Dachau concentration camp, he surrendered to Sgt. Rock in the spring of 1944.

G.I. Robot [1962]

As later revealed in *Young All-Stars* #12 and 28 [1987 and 1988], this line of mechanical men was another of Project M's creations after Mac and Joe—two earlier models—were destroyed in missions to Dinosaur Island, as depicted in *Star-Spangled War Stories* # 101–103 and 125 [1966]. Jungle Automatic Killer—Experimental 1 or JAKE-1 was introduced in *Weird War Tales* #101 [1981]. He also appeared in #108 and in 111 in which he too was destroyed.

JAKE-2 debuted in *Weird War Tales* #113 [1982]. Following adventures in #115–118, 120, and 122, he and the Creature Commandos avoided a government-mandated death sentence by manning a rocket aimed at Berlin. As depicted in 1983's #124, the final issue of the title, the rocket went radically off course and headed deep into outer space. G.I. Robot was created by Robert Kanigher and artists Ross Andru and Mike Esposito.

Gunner & Sarge [1958]

Introduced in *All-American Men of War* #67, Gunner MacKay and Sarge Clay were part of a Marine unit assigned to take a Japanese-held island during World War II. After also featuring in *All-American* #68, the duo moved into

Our Fighting Forces where—occasionally accompanied by a dog named Pooch (introduced in #49)—they appeared from #45 to #94 [1959–65].

They later joined the U.S.-sanctioned special forces unit designated the Losers. Although depicted as having been killed in the spring of 1944 in 1985's *Crisis On Infinite Earths* # 3, the same year's *Losers Special* #1 showed them dying within minutes of each other, killed by enemy fire almost a year later.

The Howling Commandos [1963]

Stereotypes every one of them, the Howlers made their first appearance along with Sergeant Fury in the first issue of *Sgt. Fury,* which had him and his *Howling Commandos* aptly added on the cover. As introduced by Stan Lee and artists Jack Kirby and Dick Ayers, the initial Howlers were the hot-tempered, red-haired Irish-American Corporal Timothy "Dum Dum" Dugan and five privates: Izzy Cohen (possibly the first hero in comics that was definitely Jewish), easygoing Robert "Reb" Ralston from Kentucky, Italian-American Dino Manelli, Ivy League college man Jonathan "Junior" Juniper, and, somewhat anachronistically included in a white unit, Gabriel "Gabe" Jones, Marvel's first African-American hero.

Juniper was killed off in #4. His replacement, Percival "Pinky" Pinkerton, an umbrella-wielding Englishman, arrived in 1964's #8.

Another arrival was Eric Koenig who joined the unit in #35. A German who despised what the Nazi party had done to his homeland, he first appeared in #27 [1966]. Their World War II exploits were featured in *Sgt. Fury* until the series was canceled in 1981 with #167. Following a flood of reprints between #80 [1970] and #120, the title went all-reprint with #121 [1974] at which point it officially became *Sgt. Fury and His Howling Commandos.*

Johnny Cloud [1960]

The son of a Navajo chief, Flying Cloud—as he was named by his father—flew P-47s during World War II.

Introduced in *All-American Men of War* #8, Lieutenant—later Captain—Cloud led a squadron he named the Happy Braves in recognition of his Native-American heritage. His exploits featured in *All-American* until 1966 and the title's cancellation with #117.

Created by Robert Kanigher and artist Irv Novick, he became a member of the Losers. Despite apparently having been killed with the rest of that team in the spring of 1944 as depicted in 1985's *Crisis On Infinite Earths* #3, Cloud is known to have survived to fight in December 1944's Battle of the Bulge [*Sgt. Rock Special* #2, 1994].

He was shot and killed by enemy troops, dying moments after his comrades in the Losers in the spring of 1945 as recounted in *The Losers Special* #1 [1985].

The Losers [1969]

Introduced in a Haunted Tank story in *G.I. Combat* #138, this U.S.-initiated team of "combat troubleshooters" consisted of Captain William Storm, Gunner & Sarge, and Johnny Cloud. In a story by Robert Kanigher and artist Russ Heath (aided by Joe Kubert), the four come together after they each suffer a major setback: Storm losing his P.T. boat, his crew, and part of his left leg in an encounter with a Japanese submarine; Gunner & Sarge seeing the first team of recruits they are training killed by Germans; and Cloud crashing his plane after a pilot new to his wing is killed in a crash. As a team they fought in *Our Fighting Forces* #123 [1970] until the DC title's cancellation with #181 [1978] with Jack Kirby writing and drawing #151–162. The Losers also appeared in *Unknown Soldier* #250 and 265 [1981 and 1982] and in 1985's *The Losers Special* #1.

Paddy Payne [1957]

Initially written by Mark Ross, the Warrior of the Skies took his maiden flight in Fleetway's *Lion* #248. Leaping straight onto the cover of the British comic, the fighter pilot was as at home flying Mosquitoes and Hurricanes as he was Spitfires. He flew through *Lion* accompanied by his pal Flying Officer Dick Smith until the [unnumbered] February 26, 1972 issue, although his strip had been reprinted since April 26, 1969. Considered the Royal Air Force's top troubleshooter, he also starred in 11 issues of *Lion Picture Library* between 1963 and 1964, although some of these were also reprints.

Phantom Eagle I [1942]

An ace pilot, teenager Mickey Malone is stationed on an English airfield. Forbidden to fly against the Germans by his superior, Sergeant Flagg, he builds his own plane, dons a costume—a makeshift aviator's suit—and flies off to fight.

Introduced in Fawcett Publications' *Wow Comics* #6, he eventually hooked up with the Phoenix Squadron in #27 [1944] to continue his successful raids on the Germans. Postwar he formed a charter airline and went in search of the Golden Chalice which has the Formula for Peace inscribed upon it.

The Phantom Eagle flew in *Wow* until the title was canceled in 1948 with #69. From #32 [1945] on, the strip was written and drawn by Mark Swayze. In 1943, the pilot starred in the only comic entirely devoted to his exploits—*Phantom Eagle* #12, an issue of Samuel E. Lowe and Co.'s Mighty Midget Comics.

Phantom Eagle II [1968]

Karl Kaufman, an American citizen of German heritage was an experienced fighter pilot who flew for the Allies during World War I. He

assumed the Phantom Eagle identity for fear of reprisals against his parents who had returned to their homeland.

The sole American member of the Freedom Five—a team of costumed heroes that also included Union Jack, the Crimson Cavalier, Sir Steel, and the Silver Squire—he debuted in *Marvel Super-Heroes* #16 in a story by Gary Friedrich and artist Herb Trimpe.

As depicted in *Ghost Rider* #12 [1975], he was shot and killed on the ground in Germany—along with his parents—shortly before the war's end. They were slaughtered by Hermann von Reitberger, a German pilot who was pursued by Kaufman's ghost until it gained revenge in that same issue.

Phoenix Squadron [1944]

Introduced in *Wow Comics* #27, this international sextet of teenagers flew with the Phantom Eagle (I). Sven (Norway), Josef (Poland), Hans (Denmark), Nickolas (Greece), Pierre (France), and Hendrik Voorhees (Holland) were assisted by their plane designer and companion Jenny.

Sgt. Fury [1963]

For a World War II hero, Marvel's Nicholas Joseph Fury had more in common with Fleetway's Captain Hurricane than he did with DC's Sgt. Rock. He was the comic book equivalent of an Arnold Schwarzenegger

movie soldier, years before the *Terminator* star made his screen debut.

Gruff, often unshaven, and with his shirt frequently torn to reveal lots of muscles, the cigar-chomping sergeant had an open contempt for authority but inspired loyalty from his men. Created by Stan Lee and artist Jack Kirby and introduced in the first issue of *Sgt. Fury*, the uncultivated, earthy New Yorker raised on Manhattan's Lower East Side led his Howling Commandoes through 167 issues of the title, which ran until 1981, becoming *Sgt. Fury and his Howling Commandos* with #121 [1974]. Most of the issues between #80 [1970] and 120 were reprints; and from #121 they were all reprints.

Unknown Soldier [1970]

To some he is a fanatically patriotic American agent who would do absolutely anything for his country, no matter what. To others he is a James Bond-like superspy with a conscience who despises the secret and sometimes less-than-holy missions he undertakes for the U.S. government. Still others see him as an old-fashioned American hero.

Introduced in *Star-Spangled War Stories* #151, the unnamed man who became the *Unknown Soldier* joined the army in the early days of World War II. Assigned to a Pacific island, his face is hideously disfigured by the Japanese grenade that killed his brother.

Determined to make a difference to the war effort, he became a one-man undercover

agent. Training himself to the peak of physical perfection, he also became skilled in makeup and disguise, learning how to impersonate almost anyone. Based at the Pentagon in Washington, D.C., he operated in the European, North African, and Pacific theaters of World War II. Created by Joe Kubert, the "Immortal G.I." with the bandaged head remained in *Star-Spangled*—renamed *Unknown Soldier* in 1977 with #205—until the DC series was canceled with #268 [1982]. More of his background was revealed when it was revived in 1988.

The later series—which ran 12 issues until 1989—followed his exploits through Cambodia in the 1970s to the U.S. Embassy in Iran in 1977 and to Afghanistan in the 1980s. Written by Jim Owsley and drawn by Phil Gascoine, it also established that he was the second *Unknown Soldier* but never explicitly explained which of the earlier missions were carried out by which of the heroes nor anything about the first *Unknown Soldier*.

In 1997 Garth Ennis and artist Kilian Plunkett gave the character a Vertigo makeover in an *Unknown Soldier* four-parter that follows William Clyde, a C.I.A. agent as he investigates the assassination of people who have seen him at work. Asked by the disillusioned hero to be his replacement, Clyde kills himself.

Viking Commando [1979]

Wounded on a mission to rescue a kidnapped princess from Huns and taken by the Valkyrie before his time, Valoric—a 5th-century Viking—was sent back to Earth at Odin's command. But his return transported him to Europe in 1944 where he joined forces with the Allies against the Germans—the contemporary equivalent of his old foe, the Huns.

With Fey, the Valkyrie that mistakenly took him to Valhalla, constantly watching, waiting for him to die, the *Viking Commando* was created by Robert Kanigher and artist George Evans. Complementing his military hardware with his trusty battle-ax, Iron Fang, Valoric appeared in all six issues of DC's *All-Out War* [1979–80] and also in *Unknown Soldier* #266–67 [1982].

"With the outbreak of the Korean War, the American comics scene became awash with war comics, DC alone weighing in with four—later five—titles of its own."

Chapter 6
Western Heroes

The Wild West lasted less than two decades, but the legends that have grown up around the era have mythologized far beyond the reality. Beginning with the dime novels and continuing through the movies, the cowboy, the gunslinger, and the outlaw have become part of modern folklore. Comic books have continued the tradition, creating its own Western heroes in Blueberry, Ghost Rider, and Tex while also expanding on the exploits of such real-life cowboys as Buffalo Bill, Kit Carson, and Billy the Kid.

Annie Oakley [1860–1926]

Annie Oakley as transferred to comics is far different from the real star of Buffalo Bill's Wild West Show, transforming her into a female adventurer who mixed it with claim jumpers, cattle rustlers, and bank robbers.

Atlas launched an *Annie Oakley* series in 1948 only to cancel it later that same year with #4, relaunching in 1955 to cash in on the popularity of a Dell series based on the Gene Autry-produced TV series—itself launched off the back of the 1950 movie musical *Annie Get Your Gun* with Betty Hutton. Premiering in late 1952, the TV show—geared toward children—starred Gail Davis and ran four seasons until 1956. Dell premiered its comic book in 1952 as issue #438 of *Four Color*, launching the series at #4 after two more issues [#481 and 575] of the umbrella title. *Annie Oakley and Tagg* (her young brother) ran until 1959 [#18]. Atlas [Marvel] pulled the plug on its *Annie Oakley* series—which had picked up the numbering from its earlier incarnation—with #11 [1956].

Bat Lash [1968]

Created and written by Sergio Aragones with script by Denny O'Neil and art by Nick Cardy, Bartholmew Aloysius Lash was more lover than fighter but was still fast with a gun. Although the *Bat Lash* series that followed lasted only seven issues [1968–69], this atypical western hero is still fondly remembered by fans.

Billy The Kid [died 1884]

Billy the Kid first appeared in comics in the 1950 first issue of Toby Press's *Billy the Kid Adventure Magazine*, which ran 29 issues until 1955. It was followed by Charlton Comics' *Billy the Kid*—the former *Masked Raider*—which ran 145 issues [#9–153] between 1957 and 1983.

As well as having his own British annual—*Billy the Kid Western Annual* published by World Distributors from 1953 to 1961—the Kid also appeared in his own strip in *The Sun*. Running from #184 [1952] to the [unnumbered] October 17, 1959 issue, it was mainly drawn by Geoff Campion, although Eric Bradbury, Ian Kennedy, Jesus Blasco, and Don Lawrence were later contributors. Its focus was a rancher who donned a mask and rode in the name of justice as the Lone Avenger, Billy the Kid. The Kid was also the star of 10 of Amalgamated Press's digest-sized *Cowboy Picture Library* between 1960 and 1961.

Blackbow The Cheyenne

See Strongbow the Mohawk.

Blueberry [1963]

Created by Jean-Michel Charlier and Jean Giraud, cavalry officer Lieutenant Mike

Blueberry was introduced in *Editions Dargaud's Pilote* #210 (1963) in the first episode of the 46-page *Fort Navaho*. A later series, entitled *Young Blueberry*, filled in some of the character's pre-Fort Navaho background. Begun in *Super-Pocket Pilote* #2 [1968] and initially by Charlier and Giraud, the first of the 11 albums to date revealed that Blueberry was actually Mike Steve Donovan, the son of a plantation owner.

The Bravados [1971]

Created by editor Sol Brodsky and writer Len Wein, this band of heroes first appeared in the third and final issue of Skywald's *Wild Western Action* [1971] before being launched into their own title, which lasted just one issue.

Buffalo Bill [1846–1917]

Like Billy the Kid's, William F. Cody's comic book adventures have more in common with 19th-century dime novels than they do with the real-life exploits of the famed Pony Express Rider, prairie scout, and showman.

Bill's first U.S. comic book appearance was in the only issue of Dell's *Western Action Thrillers* [1937], which was followed 12 years later by Street & Smith Publications' *Buffalo Bill Picture Stories* #1–2 [1949]. The following year Fox Features Syndicates published *Cody of the Pony Express*, a one-shot tie-in with the Jock Mahoney-starring 1950 Columbia movie serial of the same name. The story continued in *Colossal Features Magazine* #33–34. It was succeeded by Charlton Comics' similarly titled [Buffalo Bill] *Cody of the Pony Express*, which ran three issues [#8–10] between 1955 and 1956. In 1950, Youthful Magazines launched *Super Western Fighters*, which became Buffalo Bill with #2. Canceled in 1951, Cody was featured in all nine issues. The one-time buffalo hunter was also one of the subjects of Parents' Magazine *Press's True Comics* #7 [1941] and featured in all eight issues of National Periodicals' *Frontier Fighters*, sharing with Davy Crockett and Kit Carson. Britain's Butterfly beat Dell's Western *Action Thrillers* #1 by featuring the first comic strip of Cody—drawn by G. W. Backhouse—on the back page of the Amalgamated Press title in 1936. AP followed up with Buffalo Bill stories in *Knockout* between 1940 and 1951.

In 1950 they also began appearing in AP's *The Comet*. Initially reprints of European strips [#96–115] and then of U.S. material [#274–288, 1952–54], the U.K.—originated series launched in #289 [1954]. Running until [the unnumbered] October 17, 1959 issue, it was drawn by Derek Eyles, Geoff Campion, and Jesus Blasco among others. AP also devoted #107 and 347 [1954 and 1960] of its *Cowboy Comics Library/ Cowboy Picture Library* to the one-time Pony Express rider as well as two issues [#100 and 119] of its *Thriller Comics Library*.

In the mid-1950s, L. Miller launched its own title, Buffalo Bill Cody, with art by Harry Cunningham and ran for 19 issues. Boardman/ Popular published 18 haphazardly numbered

issues of *Buffalo Bill/Buffalo Bill Comic* between 1948 and 1955—of which nine featured original U.K. material, mainly drawn by Denis McLoughlin. It also published the *Buffalo Bill Wild West Annual* between 1949 and 1961.

Caleb Hammer [1980]

Introduced by Peter Gillis and artists Gene Day and Tony DeZuniga, the former priest turned Pinkerton Agent's only appearance was in *Marvel Premiere* #54 until John Ostrander and artist Leonardo Manco revived him, along with many of Marvel's better-known Western heroes, for 2000's highly acclaimed *Blaze of Glory: The Last Ride of the Western Heroes* four-parter. As recounted in X-Force #37 [1994], Hammer died in 1886, murdered by a young outlaw anxious to make his reputation by killing the former gunslinger.

Champion
The Wonder Horse

See Gene Autry.

Cisco Kid [1907]

Created by novelist O. Henry, the Mexican outlaw known as the Robin Hood of the Old West was depicted as a dangerous desperado when he made his entrance in the short story *The Caballero's Way*. It was in the movies that he became a flamboyantly dressed righter of wrongs in turn-of-the-century New Mexico accompanied by Pancho, his crafty, potbellied sidekick. Following a 1914 silent adaptation of the O. Henry story—in which the Kid died—he became the focus of a series of 24 films. Beginning with 1929's *In Old Arizona*, these led to *The Cisco Kid* TV series from 1950–56.

Following six movies [1938–41] with Cesar Romero in the starring role, Bernard Bailey/Swappers Quarterly published *Cisco Kid Comics*, a 1944 one-shot that not only marked the Kid's sequential art debut but also included two unlikely companion strips— *Illustrated Stories of the Operas: Faust* and *Superbaby*. The premiere of the TV show prompted Dell to launch a tie-in in 1950. With its first issue published as #292 of Dell's *Four Color* umbrella title, *The Cisco Kid* ran from 1951 until 1958 [#2–41]. Also premiered in 1951 was a King Features Syndicate newspaper strip. Written by Rod Reed and drawn by Argentinian artist José-Luis Salinas, *The Cisco Kid* was discontinued in 1968.

Dale Evans [1913–2001]

See Roy Rogers.

Davy Crocket [1786–1836]

The famed Indian fighter, frontiersman, and backwoods statesman made his first foray into

comics in Avon Periodical's *Davy Crockett*, a 1951 one-shot.

But it was in 1955 he really hit the U.S. comic book scene. It was that year that Disney's movie *Davy Crockett, King of the Wild Frontier* with Fess Parker kicked off a worldwide craze that inspired Dell to devote four issues of its *Four Color* comic to the coonskin cap-wearing hero as well as a *Dell Giant Comics* titled *Davy Crockett, King of the Wild Frontier*. Charlton launched a *Davy Crockett* title—that became *Kid Montana* with #9 [1957]—that same year and followed by starring the frontiersman in the first six issues of *Wild Frontier* [1955–57].

Despite the flurry of American titles, Crockett fared much better in British comics. L. Miller launched its own *Davy Crockett* in 1956. Initially drawn by Don Lawrence, it ran 50 issues until 1960. In 1956, the frontiersman also made the first of more than 50 appearances as the star of Amalgamated Press's *Cowboy Picture Library*, spanning issues 165 to 363 [1960]. A *Davy Crockett* strip—with many episodes drawn by Ian Kennedy—appeared in AP's *Knockout* between 1955 and 1959. Another Crockett series, this time drawn by Jim Holdaway, ran in Odhams Press's *Mickey Mouse Weekly* from 1955 to 1956.

Desperadoes [1997]

Created by writer Jeff Mariotte, this mismatched quartet were introduced in an Image Comics/Homage five-parter drawn by John Cassaday. A mix of Western elements, supernatural villains, and occult mysteries, *Desperadoes: A Moment's Sunlight* featured detective Gideon Brood, reformed prostitute Abby DeGrazia, ex-slave Jerome Alexander Betts, and Pinkerton man Race Kennedy. On the run from the law, they are also tracking down a serial killer. The four appeared in two more *Desperadoes* titles: the *Epidemic* one-shot [1999] and *Quiet of the Grave*, a 2001 five-parter drawn by John Severin.

El Diablo [1970]

Lazarus Lane is a banker, paralyzed by a bolt of lightning who as El Diablo wields a bullwhip and six-gun, riding a coal-black stallion named Lucifer. Created by Robert Kanigher and artist Gray Morrow, he first appeared in *All-Star Western*—retitled *Weird Western Tales* with #12—where his stories were featured [in 1976] as well as in Jonah Hex between 1981 and 1983. Brian Azzarello and artist Danijel Zezelj revived the character for 2001's El Diablo, a Vertigo four-parter.

Firehair I [1945]

The White Queen of the Redskin Range was introduced in Fiction House's *Rangers Comics* #21 as Princess Smith. Inexplicably renamed Lynn Cabot in #24, she had been adopted by the Sioux as a young girl and was equally

Continued on page 330

Manga: The World's Largest Comics Industry

Why have manga, as comics are called by the Japanese, played such a significant part throughout that people's postwar lives, more so than in any other country, equivalent in the West only to movies and television?

One answer might be that, in Japan's highly ordered, competitive society, the massive fictional world of manga has become an uninhibited outlet for cartoonists to deal with the society's shared fantasies and neuroses.

As a result, there are manga for every age group and on every subject, as many as two billion of them sold each year in cheap periodicals and compact book collections. Manga sales have accounted for nearly 40% of total publishing, or more than 15 for every man, woman, and child. The biggest comics industry in the world permeates everywhere, from commuter trains to restaurants, from classrooms to the stock market, and inspires films and television shows, both live action and animated or "anime," as well as plays, games, fashion, design, literature, and fine art.

Where did manga come from? The name means "irresponsible pictures" and was invented by the woodblock-print artist Hokusai in 1814 to describe his personal sketchbooks. Isolated for centuries, Japan had developed its own rich traditions of visual storytelling. To these were added the cartoon styles from British humor magazines like *Punch* and from American newspaper strips, once Japan opened up to Western influences. But modern manga began to evolve only after the nation's defeat at the end of World War II, when the occupying American forces brought with them their comic books and animation.

From these sources, one man above all else harnessed their energy and clarity into a totally new form of manga. Starting in 1947, Osamu Tezuka (1926–89) pioneered highly cinematic, long-form graphic novels, innovating layouts and pacing to "decompress" comics into

Right: Akira [Marvel Comics/Epic].

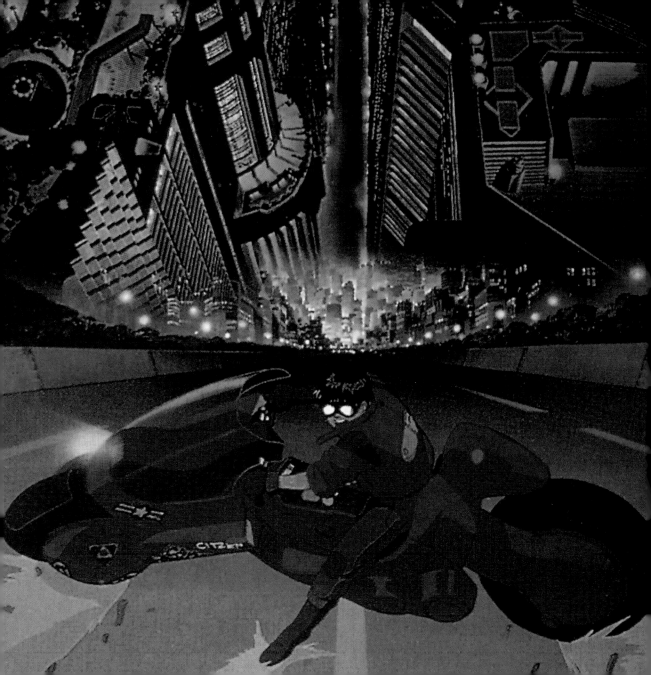

almost real-time movies on paper. In the record-setting 150,000 pages which he created in his lifetime, Tezuka, revered as the "god of manga," continually advanced the medium, tackling fresh themes and galvanizing generations of manga creators to follow his lead. Today's most successful cartoonists, such as Rumiko Takahashi, are among Japan's highest earners. Many hire armies of assistants to maintain their huge output.

Tezuka's science fiction tales such as *Metropolis* (1949), and *Astro Boy* (1952–68) often included warnings about the dangers of scientific progress. Only the Japanese have suffered the unprecedented destruction and aftereffects of the first atomic bombings in 1945, and in a sense they are already living in the future. So it is no surprise that their science fiction manga have fixated ever since on humankind's relationships to technology, from the robots of *Go Nagai* to the devastating powers of Katsuhiro Otomo's mutant *Akira*.

A dizzying variety

Science fiction may be the genre most widely translated into English, but almost every subject imaginable can be found in the dizzying variety of manga publications. The most popular serials can be hundreds, if not thousands, of pages long, compiled into series of smaller volumes, mostly paperbacks, racked floor to ceiling along bookshop shelves.

Manga are constantly diversifying to win over new audiences. In the 1960s, the student movement adopted such darker, more realistic manga or "gekiga" as Sanpci Shirato's 16th-century ninja and Yoshihiro Tatsumi's bittersweet slices of urban life. When romantic "shojo" manga for girls caught on, women cartoonists invented a whole visual vocabulary to convey emotions, using huge, sparkling eyes, or flurries of stars and flowers. Sex comics for men have been joined by so-called ladies' comics, erotica by and for women. Fans of every conceivable sport, young mothers, businessmen, senior citizens, chefs, pachinko players, all have manga of their own.

For years, manga were little known outside Japan, but gradually exported television cartoons, starting with Tezuka's *Astro Boy* in 1963, and breakthrough animated movies led by Akira, paved the way for manga to emerge as a global youth culture export. Increasingly, manga are one part of a cross-media promotion linked to gaming and merchandise, as seen with the success of *Pokèmon*.

Left: Nausicaa in the Valley of Wind part III [Viz Communications, 1993].

"Manga sales have accounted for nearly 40% of total publishing, or more than 15 for every man, woman, and child."

adept with bow, six-gun, knife, or tomahawk. Also known as the Warrior-Maid of the Wild Dakotas, she appeared in *Rangers Comics* until #65 [1952]. She gained her own title in 1948, retitled *Pioneer West Romances* in 1950, *Firehair Comics* was relaunched from #7 in 1951 only to be canceled in 1952 with #11.

Firehair II [1969]

The story of a man lost between two cultures, the redheaded white boy who was raised by the Blackfoot tribe, Firehair was created, written, and drawn by Joe Kubert. He first appeared in *Showcase* #85. After two further appearances in the try-out title, he moved into the back of *Tomahawk* through 1970–71.

Gene Autry [1907–1998]

A movie and radio star, the singing cowboy made his comic debut in 1940 when Autry himself launched *Gene Autry Rides!*, a newspaper strip written by Gerald Geraghty and drawn by Till Goodan. It premiered with an adaptation of *The Phantom Empire* movie and was canceled in 1952.

In 1941, Fawcett Publications debuted *Gene Autry Comics*. The series ran for 10 issues to 1943 when it was picked up by Dell who continued it until #12 [#1944] and then, after featuring Autry in seven issues of its *Four Color* series, relaunched the title from #1 in 1946. The new comic—which was later tied into *The Gene Autry Show* which ran on U.S. TV from 1950–56—lasted until 1959 [#121]. Autry was also featured in 10 issues of *March of Comics*, a KKK Publications giveaway between 1947 and 1956 and in issues #1–18 of *Western Roundup*, a Dell Giant Comic, between 1952 and 1957. A second newspaper strip, *Gene Autry*, was also launched off the back of the TV series. Purportedly written by Autry himself, it was canceled in 1955. Even Champion, Autry's horse, got its own Dell comic. Launched with #3 after two *Four Color* issues in 1950 and '51 [#287 and 319], *Gene Autry's Champion* lasted 19 issues until 1955.

Autry—the star of 90 features and serials between 1935 and 1953—didn't do so well in print in the U.K. where, apart from several titles reprinting the U.S. Dell material, his appearances were limited to illustrated stories in the four issues of Adprint's *Gene Autry Stories* [1954–58] and in Birn Brothers' *Gene Autry Adventures* one-shot [1958].

Ghost Rider I [1949]

Inspired by Vaughan Monroe's song "Ghost Riders in the Sky" and the Walt Disney movie *The Headless Horseman*, this spooky gunfighter was created by Magazine Enterprises editor/publisher Vincent Sullivan and writer Ray Krank. Drawn by Dick Ayers, he first appeared as a backup in Tim Holt #6 as the Calico Kid, a gunslinger who masqueraded as a wimp to hide his true abilities. With #11, he revealed himself to be U.S. Marshall Rex

Fury and abruptly dropped the Calico Kid persona in favor of Ghost Rider. Clad in white, he covered himself and his white horse, Spectre, in phosphorus so he seemed to be a glowing wraith that could appear and disappear at will.

Tim Holt was retitled Red Mask with #42 [1954], but Ghost Rider remained in the comic until #50 [1955], his stay outlasting his own title, which was launched in 1950 and canceled in 1954. Ghost Rider's 14 issues were actually published under the A-1 Comics banner with several featuring Frank Frazetta covers. Other A-1 numbers became Best of the West #1–12, an anthology that also featured Ghost Rider. Highly popular, at his peak the spectral cowboy also appeared in The Black Phantom, a 1954 one-shot starring a female outlaw; in Bobby Benson's B-Bar-B Riders #13–15 [1952]; and Great Western #9 and 11 [A-1 #105 and 127, 1954].

Ghost Rider II [1967]

Replace U.S. Marshall Rex Fury with schoolteacher Carter Slade and you have Marvel's first Ghost Rider; a complete knock-off of the ME hero—Ayers even drew all seven issues of the Ghost Rider title published in 1967. Left for dead after a shoot-out, Slade was healed by a Comanche medicine man who covered him with a luminescent substance that glowed in the dark. Now known as the Phantom Rider—but initially renamed Night Rider in the 1970s, to avoid confusion with

Marvel's demonic motorbike-riding superhero —he died in Western Gunfighters #7.

Ghost Rider III [1980]

This incarnation was Carter Slade's brother, U.S. Marshall Lincoln Slade who learned his sibling's secret identity and took his place in Western Gunfighters #7. He died in West Coast Avengers #41 [1989].

Ghost Rider IV [2000]

See Gunhawks.

Gunhawks [1972]

Kid Cassidy and Reno Jones were the sons of a plantation owner and a former slave. They first appeared in the their own title when Cassidy first meets Jones, saving the ex-slave from being whipped to death. John Ostrander and Leonardo Manco revised the story slightly in 2000 when they revived Jones for their Blaze of Glory: The Last Ride of the Western Heroes four-parter.

Cassidy and Jones had played together as children and, although the former had grown to treat Jones as just another slave, it was this friendship that caused them to ride together when the Civil War left both of them with nothing. But Cassidy grew increasingly bitter about the way his life had gone until—as

depicted in Gunhawks #6—he drew on Jones, who shot him dead. *Gunhawks* became *Gunhawk* for its seventh and last issue [1973]. As depicted in *Blaze of Glory* #3, Jones had adopted a new identity. He had become the fourth Ghost Rider.

Hawk [1970]

The son of Tomahawk first appeared in *Tomahawk* #131 with the title changed to *Hawk, Son of Tomahawk* to reflect the comic's new star. The half-Native American appeared in the title alongside his now elderly father until it was canceled in 1972. Robert Kanigher wrote the series, which was drawn by Frank Thorne who had actually begun illustrating *Tomahawk* with #119.

Hopalong Cassidy [1907]

Forever associated with William Boyd who starred as the [originally limping] cowboy in 66 movies between 1935 and 1948 as well as on TV [1949–52] and radio [1950–52], Hoppy was created by Clarence E. Mulford, who introduced the straight shooting Man in Black in his 1907 novel, *Bar-20*.

Fawcett Publications featured Cassidy in *Master Comics* #33–49 [1942–44], publishing the first *Hopalong Cassidy* comic book in 1943. With #86 [1954]—drawn by Gene Colan—the title moved to National Periodicals which kept the comic going to 1959, canceling it with

#135. Fawcett also published a companion title, *Bill Boyd Western*, which ran 23 issues from 1950 to 1952. From 1948 to 1950, the straight-laced cowboy also starred in 25 issues of *Real Western Hero*, which became simply *Western Hero* in 1949. Boyd was featured in #87–95 although Cassidy was also the mainstay of another Fawcett title, *Six-Gun Heroes*. Launched in 1950, it was taken over by Charlton in 1954. Hoppy was dropped from the lineup soon after. In 1949 Boyd—who had acquired the rights to the character—licenced a *Hopalong Cassidy* newspaper strip. Drawn by Dan Spiegle, it lasted until 1955.

In Britain, Boyd's interpretation of Mulford's hero—which didn't sit too well with the author—was not much of a success under the cowboy's name. Apart from the ubiquitous U.S. reprints, the only title in which he starred was Adprint's *Hopalong Cassidy Stories*, which featured illustrated text and ran six issues between 1953 and 1958. However, he fared much better as a feature in *Knockout Comic* where the *Hopalong Cassidy* series—which kicked off in 1954 by reprinting the Spiegle newspaper strip—turned to original material in 1957 and ran continuously until 1960.

Jeff Arnold [1949]

Created by Charles Chilton for the B.B.C. radio series *Riders of the Range*, this one-time Texas Ranger made his comic book debut in the *Riders of the Range* strip that premiered in Hulton Press's *Eagle* volume 1 #37 [1950].

Written by Chilton and illustrated initially by Jack Daniel, the strip was later drawn by Frank Humphris, who took over with volume 3 #7 [1952] and continued until it was dropped with volume 13 #9 [1962]. Juvenile Productions published *Charles Chilton's Western Annual—Riders of the Range* from 1951 to 55 and a *Riders of the Range Strip Book*—with art by Pat Williams—in 1954 while Hulton's own *Riders of the Range Annual* appeared from 1956 to 1961.

Jesse James [1847–1882]

Launched by Avon Periodicals in 1950, *Jesse James* ran 9 issues—several featuring art by Joe Kubert and Carmine Infantino—until 1952 and then, after a brief hiatus, a further 15 issues [#15–29] from 1953 to 1956, which were mainly reprints. James also featured in Avon's *Blazing Six-Guns* one-shot [1952]. In 1956, Dell published a movie tie-in, *The True Story of Jesse James*, as *Four Color* #757 while Gold Key released *The Legend of Jesse James* as a TV tie-in in 1966.

Jim Bowie [1796–1836]

The frontiersman and creator of the Bowie knife was another legend who died at the Battle of the Alamo.

In 1955 *Danger* was retitled *Jim Bowie* by Charlton Comics but the new title lasted only three issues [#16–19] before it was again changed in 1957 to Black Jack with #20. From 1956 to 1958 *The Adventures of Jim Bowie* aired on U.S. TV. The year the show premiered, Joe Simon and Jack Kirby wrote and drew a Bowie issue of *Harvey's Western Tales* [#33] while Dell released two Jim Bowie issues of *Four Color* [#893 and 993] as tie-ins to the show in 1958 and '59. In Britain, L. Miller launched its own *Jim Bowie* title in 1957. Initially reprinting American material, it began featuring original stories with #5. The series was canceled in 1959 with #24.

Jonah Hex [1972]

The antithesis of the traditional Western hero, this badly scarred former Confederate officer was a bounty hunter. He was created by John Albano and artist Tony DeZuniga and first appeared in *All-Star Western* #10. He stayed with the series—which became *Weird Western Tales* with #12—until #38 [1977] when he moved into his own title.

Jonah Hex lasted 92 issues until 1985 when it was dropped in favor of *Hex*, a futuristic series in which the grizzled bounty hunter is transported to 2050 where he had to fight to stay alive while trying to find his way back to his own time. Hex lasted 18 issues until 1987.

When writer Michael Fleisher took over writing Jonah Hex's adventures with *Weird Western Tales* #22, he gave the series a new and even more realistic edge, making it one of DC's most popular Westerns. Fleisher and artist

Continued on page 338

Tex: A Comic Book Spaghetti Western

The story of Tex is in many ways the story of postwar comics in Italy, and its rise and rise over more than 50 years makes it that country's most successful title. While the cowboy was a staple of U.S. comics for many years, peaking in the 1950s, it is in Europe that the genre has enjoyed its most enduring appeal, particularly in France and Italy.

Tex first saw the light of day in 1948 as one of many small-format Western comics emerging after the war. It was published by Tea Bonelli and written by her husband Gian Luigi, already a comics veteran of many years' standing. As the postwar paper shortage finally ended in the late 1950s, Bonelli decided to change the comic's format to a thick, square-bound black-and-white book which could be treasured and reread as a paperback would.

With this format change, *Tex* really took off, and sales increased throughout the 1960s and 1970s. By the late 1970s, however, the rise of television decimated the Italian comics market, with the exception of *Tex*. What that title gave the reader was a depth and intensity they simply could not get on TV, and over the next two decades Bonelli Comics—now managed by Tea and Gian Luigi's son Sergio— expanded exponentially to the point where they now dominate the country's comics scene.

Social conscience

Tex Willer himself is a square-jawed Texas Ranger who patrols the West with his partner Kit Carson and Kit, Tex's son by Lilith, the daughter of Chief Red Arrow of the Navajo. Tex's West is the West of John Wayne and the American cinema, albeit with perhaps more of a social conscience.

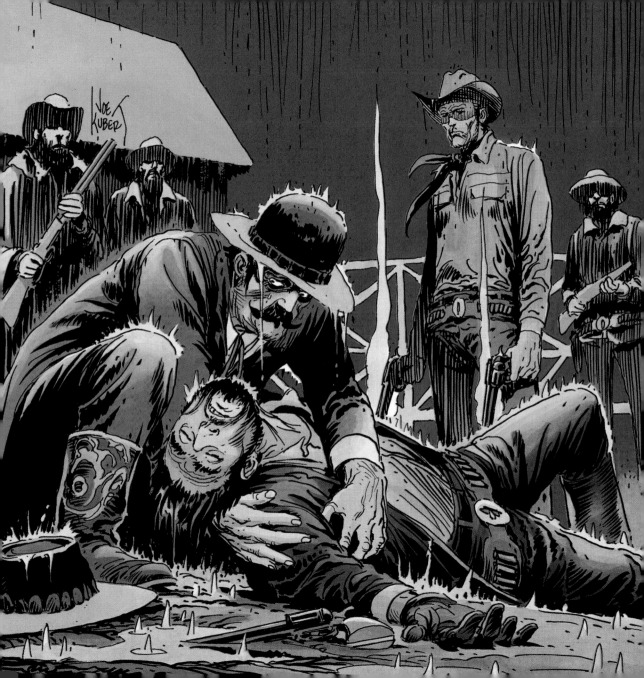

This page and previous—Joe Kubert art from Tex: The Four Killers volume 1—The Barrett Brothers [Dark Horse Comics, 2002].

Tex is a friend of the Navajo Indians—by whom he is known as Night Eagle—and mostly spends his time pursuing bandits, rustlers, and corrupt politicians. Gian Luigi Bonelli's scripts mixed an epic scale with historical accuracy, which made for comics that were both intelligent and gripping.

From the beginning, Bonelli was joined by artist Aurelio Galleppini, who shared the writer's appreciation for classic American adventure strips. Galleppini—or Galep as he was better known—had a realistic, straightforward style with a sure grasp of storytelling and a keen eye for the dramatic.

As *Tex* became more popular, other artists also contributed to the series, including Ferdinando Fusco, Guglielmo Letteri, and Jesus Blasco. Similarly, while Bonelli was the title's principal writer for decades, more recently creators such as Claudio Nizzi and Mauro Boselli have become its regular scripters.

Under Sergio Bonelli, the success of *Tex* has

"Tex's West is the West of John Wayne and the American cinema, albeit with perhaps more of a social conscience."

spawned a whole line of highly successful comics in the same format, including the Western's *Zagor and Ken Parker*, the ecologically themed *Mister No,* the crime series *Nick Raider and Julia*, and the horror-themed *Dylan Dog and Martin Mystere*.

A phenomenon

The latter's phenomenal success—over 300,000 copies sold each month—led to a short-lived U.S. version but, astonishingly, while *Tex* has been a big hit in translations across Europe, its only English translation was a barely noticeable British version in the mid-1970s.

At around 600,000 copies sold each month, *Tex* is a genuine publishing phenomenon, with all manner of companion titles, fanzines, and web sites devoted to the character. Foremost among its spin-offs are the large-format *Almanacs*, which mix comics with articles, and the colossal *Specials*—240-page stories which resemble small telephone directories. The *Specials* are real epics, which have allowed writer Claudio Nizzi to create some truly cinematic stories with a different star artist in each issue.

These have ranged from Spain's Victor De La Fuente and José Ortiz to Colin Wilson from New Zealand and even the legendary American artist Joe Kubert.

While the Western may have fallen into neglect in its own country, for Italy's *Tex* the future is bright.

Russ Heath chronicled the bounty hunter's last days in the *Jonah Hex Spectacular* [*DC Special Series* #16], a 1978 one-shot that dealt with Hex's death in 1904. In 1993, author Joe R. Lansdale and artists Tim Truman and Sam Glanzman got together for *Jonah Hex: Two Gun Mojo*, a Vertigo five-parter that involved Hex in a supernatural version of the Old West. It was followed in 1995 by another five-issue mini, *Jonah Hex: Riders of the Worm and Such* and in 1999 by a three-issue *Jonah Hex: Shadows West*.

Johnny Thunder [1948]

Created by Robert Kanigher and artist Alex Toth, another cowboy hero with a secret identity. In reality he is schoolteacher John Tane, who promised his dying mother that he would never use a gun though his sheriff father wants him to follow in his footsteps; John blackens his hair with coal dust and effects a whole different way of talking so he can serve covertly as a deputy.

Introduced in *All-American Comics* #100, Johnny Thunder remained a feature in the title —which became *All-American Western* with #102—until #126 [1952]. From there he moved into *All-Star Western,* where he appeared from #67 to 119 [1961] with many of his stories drawn by Gil Kane.

He ended up married to Jeanne Walker, a.k.a. Madame .44, as was revealed in writer Mike Tiefenbacher and Kane's *Whatever Happened to Johnny Thunder?*, a backup in *DC Comics Presents* #28 [1980].

John Wayne [1907–1979]

In a movie career that spanned six decades, the man born Marion Michael Morrison was the quintessential Western hero. The Duke made his comic book debut in Toby Press's *John Wayne Adventure Comics*, a series that ran 31 issues from 1949 to 1951 and featured stories drawn by Frank Frazetta and Al Williamson. He also appeared in the first issue [1953] of *Toby's With the Marines on the Battlefields of the World*.

Tie-ins with his Western movies were also features of comics, including Charlton Comics' *Tim McCoy* #16 [*Red River*, 1948]; Dell's *Movie Classics* #12 [*El Dorado*, 1967], [*Hatari*, 1963], [*The Sons of Katie Elder*, 1965], [*The War Wagon*, 1967]; National Periodicals Publication's *Movie Comics* #2 [*Stagecoach*, 1939]; Gold Key's *Movie Comics* [McLintock, 1964] and [*The Searchers*, 1956], drawn by Alex Toth [*Rio Bravo*] and with art by Mike Sekowsky [*The Horse Soldiers*, 1959], [North to Alaska, 1960], and [*The Commancheros*, 1961].

Wayne's only original British comics appearances were in World Distributors' *John Wayne Adventure Annual*, published between 1953 and 1959.

Kid Colt [1948]

Introduced in the first of *Kid Colt*—lengthened to *Kid Colt, Outlaw* by Atlas [Marvel] with #5— the Kid became one of Marvel's most popular

and longest-lived cowboy stars. His own comic ran 229 issues, with short breaks, until 1979. Most of the issues from #140 on were reprints, but artistic contributors to the title included Dick Ayers, Gene Colan, Russ Heath, Jack Kirby, and Joe Maneely.

He also featured in *All-Western Winners*— shortened to *Western Winners* with #5—[1948–49], in both issues [#58–59] of *Best Western* [1949], in *Black Rider* #26–27 [1955], *Gunsmoke Western* #32–77 [1955–63], *Two-Gun Kid* #13–21 [1954–55], and *Two-Gun Western* #8-9 [1951].

A member of the Sunset Riders, Kid Colt was revived in 2000 by John Ostrander and artist Leonardo Manco for their acclaimed *Blaze of Glory: The Last Ride of the Western Heroes* four-parter in which he was slain.

Kit Carson [1809–1868]

Trapper, scout, and soldier, this authentic legend fared better in British comic books than he did in his homeland.

Avon Periodicals published his only U.S. title, which began life as 1950's *Kit Carson, Indian Scout*. It became simply *Kit Carson* in 1951 when it was relaunched with #2. The third issue followed that same year with #5-8—there was no #4—appearing in 1954–55. Carson also featured in the one and only issue of Avon's *Blazing Sixguns* and in all eight issues [1955–56] of National Periodicals' *Frontier Fighters* alongside Buffalo Bill and Davy Crockett.

In Britain, he was not only a mainstay of Amalgamated Press's *Cowboy Comics Library*—later *Cowboy Picture Library*—with almost a third of the title's 468 digest-sized issues published between 1950 and 1962 devoted to his exploits, but he also had his own strip which ran in AP's *Knockout* from 1949–50 and then continued in *The Comet* until 1953. AP also published *Kit Carson Annual* from 1954–60.

Lash Larue [died 1996]

The first U.S. comic book appearance of this character was in Fawcett's *Lash Larue Western* which ran 84 issues from 1949 to 1961 with Charlton Comics taking over publication as of #47 [1954]. Tie-ins with his *King of the Bullwhip*, *The Thundering Trail*, and *The Vanishing Outpost* featured in Fawcett *Movie Comic* #8 [1950] and #11 [1951] and *Motion Picture Comics* #111 [1952], respectively. LaRue also starred in another Fawcett title, *Six-Gun Heroes*, from its launch in 1950 until shortly after it too was taken over by Charlton, with #24 [1954].

Lone Ranger [1933]

Originally a play for a Detroit radio station by Fran Striker, the story of John Reid—the only survivor of a Texas Ranger patrol ambushed by a gang of desperadoes—and his mission to bring law and order to the West aided by his faithful companion Tonto must be one of the best known in Western fiction.

The masked avenger made his comics debut

in a King Features Syndicate newspaper strip. Initially drawn by Ed Kressy and later by Charles Flanders, *The Lone Ranger* ran from 1938 to 1971. It was revived from 1981–84—by Cary Bates and artist Russ Heath—off the back of 1981's *Legend of the Lone Ranger* movie.

After devoting #3, 7, 21, and 24 of its *Large Feature Comics*—illustrated text books—to the former Texas Ranger between 1939 and 1941, Dell next featured the silver bullet-shooting cowboy in nine issues of *Four Color Comics* between 1945 and 1947, launching *The Lone Ranger* as a series in 1948. This became a tie-in with *The Lone Ranger* TV show which premiered in 1949 and continued until 1957.

Although the first 37 issues of the Dell comic were reprints of the newspaper strips, the series lasted until 1962 [#145].

Another Lone Ranger series was launched by Dell in 1964. It ran 16 issues until 1969, with #17 following in 1972 and #18 to 28 from 1974 to 1977. The masked cowboy also appeared in four issues of Dell Giant Comics—*Lone Ranger Western Treasury* #1 and [1953–54], *Lone Ranger Golden West* [1955], and *Lone Ranger Movie Story* [1956] as well as in seven issues of KKK Publications' *March of Comics* giveaway between 1957 and 1969. In addition in 1974, the Lone Ranger and Tonto each appeared in a comic book drawn by Gil Kane and given away with their respective model kits. Following their Jonah Hex collaborations, horror author Joe R. Lansdale and artist Tim Truman reunited for *The Lone Ranger and Tonto*, a Topps Comics four-parter which surrounded the duo with S.F./supernatural trappings.

In Britain, World Distributors published four volumes of its *Lone Ranger Comic Album* between 1950 and 1954 and a *Lone Ranger Album* in 1957, while Adprint released its *Lone Ranger Adventure Stories*—featuring illustrated text stories—annually from 1957 to 1960. PBS followed these with *The Lone Ranger Television Story Book* [1963] and *The Lone Ranger Television Picture Story Book* [1967], which competed against World's *The Lone Ranger*, an annual published from 1964 to 1969. Brown and Watson wrapped it all up with another Lone Ranger annual in 1975. Britains's first original *Lone Ranger* comic strip appeared in Beaverbrook's *Express Weekly* in 1959. Drawn by Mike Noble, it ran until 1960. *News of the World's TV Comic* was next, running its own *Lone Ranger* strip in 1961.

Madame .44 [1961]

Introduced in *All-Star Western* #117 in *Six-Gun Showdown with Madame .44*, a Johnny Thunder story by Gardner Fox and artists Gil Kane and Joe Giella, Jeanne Walker was a photographer who traveled the Old West.

Depicted as a masked female Robin Hood, as Madame .44 she crossed swords with and romanced Thunder until the comic's cancellation with #119 [1961]. The story was resolved in writer Mike Tiefenbacher and Kane's *Whatever Happened to Johnny Thunder?*, a backup in *DC Comics Presents* #28 [1980] in which it was revealed that she married Thunder and became Jeanne Walker Tane.

Matt Mariott [1955]

Created by Tony Weare—who also produced biographies of Billy the Kid and Jesse James for Tornado—this gunslinger was the eponymous star of a newspaper strip that ran in the *London Evening News* until 1977.

Matt Savage [1959]

Introduced in *Western Comics* #77 by Gardner Fox and artists Gil Kane and Joe Giella, this former rancher became an army scout after he lost his son in a Kiowa raid [see Scalphunter]. Eventually he became a trail boss, herding cattle through *Western Comics* until it was canceled with #85 [1961].

Matt Slade [1956]

Initially drawn by Werner Roth and probably written by Stan Lee or his brother Larry Lieber, this undercover lawman galloped into comic books in the first issue of his own Atlas title. Originally titled *Matt Slade Gunfighter,* the series—which dropped the Matt in favor of Kid with #5—lasted only until #8 [1957].

Nighthawk [1948]

Another Western hero with a secret identity, very little is known about what made traveling "Fix-It-Man" Hannibal Hawkes adopt the guise of a masked champion of law and order.

Created by Robert Kanigher and artist Charles Paris, Nighthawk debuted in National Periodicals' *Western Comics* #5 [1948] with his adventures continuing from #7 to #76 [1959].

Seen to have died during 1985's *Crisis on Infinite Earths*, a 1996 continuity implant described him as having been slain by the immortal Vandal Savage [see Hawkman #29].

Night Rider

See Ghost Rider (II).

Phantom Rider

See Ghost Rider (II).

Pow-Wow Smith [1949]

One of only a handful of Native-American comic book heroes, Ohiyesa is a Sioux and Sheriff of the town of Elkhorn. Created by Don Cameron and artist Carmine Infantino, it was his descendant who first appeared in contemporary Western stories in *Detective Comics* #151, remaining in the Batman-starring title until 1953 [#202]. From there the series moved to Western Comics and back in time to when Ohiyesa—the Winner—left his tribe to learn more about the white man's world. His skills at tracking (and with a gun) won him a

job as deputy sheriff in Elkhorn where townsfolk dubbed him Pow-Wow Smith. He featured in *Western Comics* from #43 until the title's cancellation in 1961 with #85.

Rawhide Kid I [1955]

Created by Stan Lee and initially drawn by Bob Brown, he had been a gunfighter before settling down to life as a rancher but still used his skills to uphold justice. Never given a real name, he appeared in the first 16 issues of *Rawhide Kid*, an Atlas [Marvel] title that lasted from 1955 until 1957. He also featured in *Wyatt Earp* #20 [1958].

Rawhide Kid II [1960]

Lee together with artists Jack Kirby and Dick Ayers introduced the new *Rawhide Kid* when the hero's Marvel title was relaunched with #17. In the revised version, he was John Bart, formerly Clay. Orphaned when his parents were killed by Cheyenne, he was adopted and raised by Texas Ranger Ben Bart near the town of Rawhide, Texas. After he gunned down the two owlhoots who killed Ben, the diminutive Johnny took to drifting—his reputation as a killer always preceding him.

The relaunched *Rawhide Kid* featured new material until #115 [1973], continuing with reprints until #151 [1979]. The Kid also appeared in the single issue of Marvel's *Western Team-Up* in a story by Larry Lieber

and inker Vince Colletta that introduced the Dakota Kid. He also teamed up with *Two-Gun Kid* in #89 [1967] of that hero's own comic and with the star of *Kid Colt, Outlaw* in #59 and 121 [1965] of that title.

Bill Mantlo and artists Herb Trimpe and John Severin relaunched *Rawhide Kid* as a four-issue miniseries in 1985, while John Ostrander and artist Leonardo Manco revived the character for their four-issue Blaze of *Glory: The Last Ride of the Western Heroes* [2000].

Red Wolf [1970]

Another of Marvel's Western heroes revived by John Ostrander and artist Leonardo Manco for their four-issue *Blaze of Glory: The Last Ride of the Western Heroes* [2000], Red Wolf was first seen as a contemporary hero when Will Talltrees, son of a Cheyenne tribal leader, donned the ceremonial garb of Red Wolf to avenge the massacre of his family, He first appeared in *Avengers* #80 in a story by Roy Thomas and artists John Buscema and Tom Palmer. The "original" Red Wolf was introduced over a year later in *Marvel Spotlight* #1 [1971] in a story written by Gardner Fox and drawn by Syd Shores and Wally Wood.

Brought up as Johnny Wakely after his Cheyenne family were slaughtered by white men, he was shunned by both communities after his adoptive parents, Martin and Emma Wakeley, were slain by Native Americans. As an army scout, he was shot by Cheyenne and fell off a cliff, falling near the tomb of the first

Red Wolf, regaining consciousness to learn he was completely healed. Aided by his wolf, Lobo, he sought to bring bring peace and justice to the plains. After his single appearance in *Marvel Spotlight*, Red Wolf moved into his own title, which ran 9 issues from 1972 to '73 with #7–9 devoted to his modern-day successor. Will Talltrees/Red Wolf also appeared in *Marvel Chillers* #3 and 5–7 [1976] alongside Tigra the Were-Woman.

Roy Rogers [1911–1998]

The King of the Cowboys was born Leonard Frank Slye. A singing cowpoke who starred in more than 100 movies, he would shoot the gun out of the baddie's hand rather than wounding him. Killing his foe was a definite no-no.

He made his comic book debut in the first of 13 issues of *Roy Rogers Comics* published under Dell's *Four Color Comics* umbrella title between 1944 and 1947. Dell followed up with his own comic. Still titled *Roy Rogers Comics*, this ran 145 issues from 1948 to 1961 with John Buscema and Russ Manning among contributing artists. Between 1948 and 1961, he also appeared in 25 issues of KKK Publications' March of Comics giveaway and was featured in Standard's *It Really Happened* #8 [1947].

A *Roy Rogers* newspaper strip was launched by King Features Syndicate in 1949. It was initially drawn by brothers Chuck and Tom (Al) McKimson and then later by Mike Arens. It lasted until 1961. Even Rogers' wife, Dale Evans, got in on the act. The cowgirl—

composer of the duo's "Happy Trails" theme song was his co-star in most of her 38 movies and in two TV series—*The Roy Rogers Show* [1952–1957] and *The Roy Rogers and Dale Evans Show* [1962] and on the *Roy Rogers radio show* [1944–55]. She also shared top billing with her husband in the last three *March of Comics* issues and got her own comic book series—twice.

Published by National Periodical Publications between 1948 and 1952, *Dale Evans Comics* ran for 24 issues with Alex Toth among its artists. *Queen of the West, Dale Evans* followed in 1953 from Dell. Launched with two *Four Color* issues [#479 and 528], it ran until #22 [1959] with Toth, Manning, and Jesse Marsh working on the comic.

Both Rogers and Evans were also featured in *Western Roundup*, a *Dell Giant Comics* title. The King of the West's strip began in #1 [1952], while his queen's didn't get started until #11 [1955]. Both remained until the title was canceled with #24.

And there's no forgetting Roy's four-legged friend, Trigger. Dell gave the horse his own series from 1951 to 1955. Kicking off with a *Four Color* issue [#329], the series ran to #17 when it merged with *Roy Roger Comics* which became, unsurprisingly, *Roy Roger and Trigger* with #92 [1955].

In the midst of all that American activity, the Rogers-Evans-Trigger triumvirate's U.K. exposure was somewhat muted being limited to World Distributors' *Roy Rogers Annual*. Published between 1952 and 1966, the first contained U.S. reprints.

Scalphunter [1977]

Created by Michael Fleisher and artist Dick Ayers, Brian Savage was the son of Matt Savage. Taken from his family by the Kiowa who raised him as their own, he first appeared in *Weird Western Tales* #39.

Later dubbed Scalphunter, he sometimes worked as a lawman, sometimes as a gun for hire. Eventually he became the sheriff of Opal City though never losing touch with his roots. After retiring, Savage donned the badge again, only to be shot in the back and killed.

His series featured in *Weird Western* until #70 [1980] and then transferred to *Jonah Hex* where it ran as a backup in #40–41 and 45–47 [1980–81]. He also appeared in *Crisis on Infinite Earths,* and his death was depicted in *Starman* #74 [2001].

Strongbow The Mohawk [1953]

Making his debut in *Comet* #264, he was a white boy raised by Grey Cloud, chief of the Mohawks, to be his own son. Known as Blue Bos by his adoptive father, after Grey Cloud's death he carried the tribe's sacred war bow.

Initially drawn by Geoff Campion, the strip ran in *Comet* from #264–288 [1954] and featured Strongbow with a dual identity. A doctor in a frontier town, he would don tribal garb and become a Native-American avenger.

With #289, the premise was discarded in favor of a storyline in which the adopted Mohawk—accompanied by Hawkeye the Trapper—fought his tribe's traditional foe, the Huron, led by their chief Rattlesnake. The series lasted until #463 [1957].

The dual identity theme was later duplicated for Swift's *Blackbow the Cheyenne* which merged with *Eagle* with volume 14 #10 [1963]. A clone of the *Comet* series in all but name, it continued until the latter title was canceled in 1969 [volume 20 #17].

Strongbow the Mohawk was also the star of two issue [#111 and 201] of Amalgamated Press's *Thriller Comics*—later *Picture—Library*.

Sunset Riders [1995]

In some ways similar to John Ostrander and Leonardo Manco's later *Blaze of Glory: The Last Ride of the Western Heroes*, 1995's *Two-Gun Kid: The Sunset Riders* featured a motley crew brought together to confront a major menace, in this case the governments of the United States, Canada, Russia, and Japan!!! The group's only appearance was in the Marvel two-parter by Fabian Nicieza and artist Christian Gorney.

Tex Ritter [1905–1974]

Another Hollywood singing cowboy, Woodard Maurice Ritter appeared in 85 movies—78 of them Westerns—between 1936 and 1967. He also starred in *Ranch Party*, a TV series that

aired from 1959 to 1962. His first comic book appearance was in his own Fawcett title. *Tex Ritter Western* ran 46 issues from 1950 to 1959. Charlton Comics took over as publisher with #21 [1954]. Ritter was also featured in *Western Hero* from #96 until it was canceled in 1952 with #112 and in *Six-Gun Heroes* beginning when Charlton took over that Fawcett title with #24 [1954], although the singing cowboy was dropped soon after.

Tomahawk [1947]

The longest-lasting of all National Periodicals' Western heroes, Thomas Hawk's adventures took place during and just after the American War of Independence.

First appearing in *Star-Spangled Comics* #69, he had been kidnapped by Native Americans who raised him to be "woods-wise." Created by Joe Samachson and artist Edmond Good but later drawn by Fred Ray, the frontiersman's adventures—either accompanied by his ward, the orphaned Dan Hunter [later revealed to be a time traveler from the 20th century] or leading Tomahawk's Rangers—were featured in Star-Spangled until #121 [1955]. They also appeared in World's Finest Comics #33–35 [1948] and then for a 37-issue run [#65–101] between 1953 and 1959.

The coonskin cap-wearing hero gained his own title in 1950. Tomahawk—retitled Hawk, Son of Tomahawk on the cover from #131—was canceled with 1972's #140. In 1998, Rachel Pollack revived Tomahawk as the eponymous

star of a Vertigo Visions one-shot. Drawn by Tom Yeates, the special gave his origin a supernatural slant as it revealed how a stuffy Englishman, Hawke, was captured by the Wampanoag.

Tomahawk's Rangers [1962]

Formed in *Tomahawk* #83 [1962], the Ranger squad initially consisted of Tomahawk and Dan Hunter with blacksmith Big Anvil, strongman Horace "Cannonball" Calhoun, Frenchie Duvall, pacifist Kaintuck Jones, and Long Rifle Morgan. Among the later recruits were Jed "Brass Buttons" Fuller [*Tomahawk* #85], the religious *Wildcat* [#92], general's son Leroy "Stovepipe" Johnson [#97], and African-American Healer Randolph [#97]. The squad disbanded at the end of the war.

Trigger

See Roy Rogers.

Trigger Twins [1951]

Walter Trigger is Sheriff of Rocky City where his identical sibling Wayne runs the general store. Ironically, Wayne is braver and a better shot than his brother and often ends up secretly having to cover for his bungling twin

who was given the badge based on his exaggeration of his exploits during the Civil War. The red-haired brothers were introduced in *All-Star Western* #58 in a story by Robert Kanigher and artists Carmine Infantino and Joe Giella, featuring the title until #116 [1961].

Two-Gun Kid I [1948]

Introduced in a Syd Shores-drawn story, the Atlas [Marvel] hero was singing cowboy Clay Harder who dispensed justice with his six-guns. Sharing equal billing as Marvel's first cowboy comic, *Two-Gun Kid* premiered simultaneously with *Wild West* in the first issue of which the Kid also appeared in another story drawn by Shores.

After #10 [1949], *Two-Gun Kid* was put on hiatus until 1953. Relaunched with #11, it was again shelved with #59 [1961]. When it was revived in 1962, it was to be with a new Kid, but the original had also appeared in *All-Western Winners*—which became *Western Winners* with #5—#2-6 [1948–49], *Best Western* #58-59 [1949], *Black Rider* #19–23 [1953–54], *Blaze Carson* #4 [1949], and *Gunsmoke Western* #57-63 [1960-61] as well as in *Wild West*—retitled *Wild Western* [1955].

Two-Gun Kid II [1962]

When Two-Gun Kid returned in 1962, he was now recreated as a masked adventurer who came in contact with the kind of menaces more closely associated with Marvel's superheroes.

As explained by Stan Lee and artists Jack Kirby and Dick Ayers, the old kid had been eradicated from continuity by the revelation that all the earlier stories were dime novel tales published within the Marvel Universe. These were the inspiration for lawyer Matthew Liebowicz to adopt the Two-Gun Kid identity.

After settling in Texas, he was befriended by the legendary gunfighter Ben Dancer, who taught him how to defend himself. Heeding Dancer's advice, he kept his newfound skills secret. Posing as lawyer Matthew J. Hawke, he also fights injustice as the Two-Gun Kid.

Marvel's *Two-Gun Kid* relaunch ran from #60 to #92 [1968] when it was again put on hiatus. Revived again in 1970, its final run lasted until 1977 [#93–136] although it featured only reprints from #102 on. The Kid also appeared in *Kid Colt, Outlaw* #125, and *Rawhide Kid* #40 and 66. Revived and apparently killed off by Fabian Nicieza and artist Christian Gorney in their *Two-Gun Kid: Sunset Riders* [1995] two-parter, the Kid rode again in John Ostrander and artist Leonardo Manco's *Blaze of Glory: The Last Ride of the Western Heroes* [2000] four-parter in which he finally died.

Zorro [1919]

Created by writer Johnston McCulley, his novel serialized in five installments in *All-Story Weekly*. The romantic hero who fought injustice in southern California was first portrayed on the screen in 1920 by Douglas Fairbanks. Since

then, the masked, sword-wielding "Spanish Fox" has been the focus of numerous movies— the latest being 1998's *The Mask of Zorro* with Antonio Banderas and Catherine Zeta Jones— as well as a musical and five TV shows, two animated, including Disney's *Zorro* [1957–59] which starred Guy Williams.

It was Dell that brought Zorro to comics, initially with 14 issues of *Four Color Comics* between 1949 and 1959. These were followed by a *Zorro* series that launched in 1960 with #8 and ran until 1961 [#15]. Gold Key launched its own Zorro comic—tied in with the Disney TV show—in 1966. With the first issue drawn by Alex Toth—who had also contributed to the Dell series—nine issues were published before it folded in 1968.

Marvel was next up. In 1990 it premiered another *Zorro* off the back of the New World TV series with Duncan Regehr in the title role. The comic was canceled in 1991 after 12 issues, although the new TV Zorro ran from 1989 to 1994. Topps Comics then picked up the gauntlet, premiering its own *Zorro* title in 1993 and following up with eleven issues that took it through to 1994.

Drawn by Ron Wagner and Rick Magyar, a four-issue adaptation of the Banderas movie was published by Image in 1998. In 1999, Don McGregor—writer of the Topps comics and the Image film tie-in—launched a *Zorro* newspaper strip. Drawn by artist Tom Yeates— with whom McGregor had collaborated on Topps' 1993 *Dracula vs. Zorro* two-parter, inked by Magyar—it lasted less than two years, being canceled early in 2001.

Chapter 7
Sci-Fi Heroes and Heroines

It was hardly surprising comic book writers and artists saw the possibilities inherent in science fiction. Unrestricted by budgetary considerations and constrained by only their imaginations, they could realize alien worlds and creatures, and advanced technology, beyond the scope of movie makers. They could explore new worlds, time, and even alternate dimensions following the adventures of such heroes as Barbarella, Jet Ace Logan, and Ultra the Multi-Alien.

ABC Warriors [1979]

Programmed to kill, this futuristic squad of seven robots first appeared in Prog 119 of the U.K.'s *2000 AD* comic and a number of times since.

The Atomic, Bacterial, and Chemical Warriors are expendable robot soldiers designed to wage war across any kind of terrain in any type of warfare. Led by Hammerstein [see Ro-Busters], the unit consisted of Joe Pineapples formerly with the X-Terminators—a squad of robot assassins; the now-deceased Happy Shrapnel; ex-robo-paratrooper Mongrol; Deadlock, the former Grand Wizard of the Knights Martial; Blackblood, one-time leader of the Straw Dogs jungle unit; and the indestructible Steelhorn.

Known as the Mek-nificent Seven, the unit was created by Pat Mills and artist Kev O'Neill.

Absalom Daak [1980]

Introduced by Steve Moore and artist Steve Dillon in Marvel U.K.'s *Doctor Who Weekly*, the Dalek Killer was an ultraviolent criminal. Sentenced to die, he was armed to the teeth and dropped on a planet overrun by the mechanized exterminators—the TV *Time Lord*'s most implacable foe—in a four-part story concluded in #20. A further adventure followed in 1983's *Doctor Who Monthly Summer Special*.

Atari Force [1983]

Based on the Atari video game of the same name, these DC Comics space adventurers first appeared in a 16-page prelude to their own title. A free insert in *New Teen Titans* #27, it introduced this mixed band of humans and aliens.

Under the command of Martin Champion, the crew of *Scanner One*—the first spaceship to be fitted with the multiverse drive—came to include Chris (Tempest) Champion, Erin Bia O'Rourke-Singh, a.k.a. Dart, Hukka, Morphea, Babe, Pakrat, Blackjak, Taz, and Kargg. Champion had led a previous version of the Advanced Technology and Research Institute Force, as depicted in the five-issue minicomic given away in 1982 with the Atari Force game.

Atari Force ran to 20 issues. It was canceled in 1985 although a special followed in 1986.

Atomic Knights [1960]

Retroactively stated to be part of a computer-assisted fantasy, this group wore radiation-proof suits of medieval armor to protect themselves in the aftermath of a nuclear war.

Led by Gardner Grayle, whose latent telepathic abilities conjured up the scenario, the Atomic Knights helped restore order in a post-World War III America.

Created by John Broome and artist Murphy Anderson, the team first appeared in DC

Comics' *Strange Adventures* #117 in a series that featured sporadically in the title until #160 [1964].

Barbarella [1962]

Made famous by the Roger Vadim-directed eponymous 1968 movie that featured Jane Fonda in the title role, the sex-loving blonde astronaut from the 40th century was created by Jean-Claude Forest.

With her first adventures originally serialized in the French *V-Magazine*, she went on to star in two graphic albums: *Les Colères du Mange-Minutes* (*The Wrath Of The Minute Eater*) [1974] and *Le Semble-Lune* (*The False Moon*) [1977], which was featured in America's *Heavy Metal* magazine as *Barbarella & The Moon Child* from February to July 1978. In 1981, Forest revived the character in *Le Miroir aux Tempêtes* (*The Storm Mirror*). Serialized in *L'Écho des Savanes*, it was drawn by Daniel Billon.

Barbarella was France's first comics heroine since World War II and the country's first science fiction character. Dubbed the first comic strip for grown-ups by the French Press, the first serial featured creatures as diverse as pirates living inside a giant jellyfish; a gang of vicious children who employ carnivorous dolls as instruments of torture; air-sharks who devour people as they climb up the labyrinth in which they're forced to live; an exquisitely handsome blind angel; and an amorous robot named Diktor.

Captain Condor [1952]

Introduced in the first issue of Britain's *Lion*, the Inter-Planet Space Lines pilot was created to be the Amalgamated Press equivalent of the *Eagle*'s *Dan Dare*.

Created by Frank S. Pepper and drawn initially by Ronald Forbes, Condor operated in the 31st century when the planets are ruled by a ruthless dictator. After escaping from Titan's uranium mines where he had been sent for refusing to ship slaves to Venus, he helped overthrow the evil despot. Rewarded by being made the commander of the freshly established New Special Space Patrol, he turned to ridding the solar system of space pirates, criminals, and other scum.

His stories featured in *Lion* almost without interruption until the [unnumbered] April 26, 1969 issue, the title's last before it merged, ironically, with *Eagle*.

Cave Carson [1960]

Introduced in *The Brave and the Bold* #31, this DC Comics hero was an expert on the subteranean world.

Accompanied by ex-convict, strongman, and tunnel expert Bulldozer Smith; renowned geologist Christie Madison; and devil-may-care adventurer and Johnny Blake, Calvin "Cave" Carson explored beneath the Earth in

Continued on page 356

50s Sci-Fi: Ray Guns, Rocketships, and Aliens

Science fiction in comic form had been around prior to the halcyon years of the Golden Age, principally with the appearance of Buck Rogers [1929] and then Flash Gordon [1934] in the funny pages of the newspapers of the day.

Between 1939 and 1941 there came an explosion of science fiction-based stories blasting their way into the ever-expanding comic book medium.

Amid the panoply of ray guns, rocket ships, and monsters, Fiction House's legendary *Planet Comics* was first seen in the latter months of 1939, which dominated the newsstands selection of S.F. comics. It was the only one to dedicate the entirety of its content to this alien-infested realm, and to this day it remains the epitome of this wonder-filled epoch.

Planet Comics

While *Planet Comics* sent its rocket ships to the stars, the world as we know it changed forever with the detonation of the atomic bomb in August 1945. This would manifest itself in the pages of *Planet Comics,* but it was EC Comics which confronted this threat of impending annihilation to produce the most celebrated collection of comic book science fiction stories.

Harry Harrison, later to become a best-selling S.F. author, and Wallace Wood approached publisher Bill Gaines with their thoughts on an alternative approach to this prodigy in the pages of a comic book, one which was a far cry from the adventures found in *Planet Comics.*

Gaines' reading had introduced him to some of the concepts Harrison and Wood proposed. His interest was such he gave the go-ahead for a new Earth-shattering era in science fiction comics. And so, in 1950, came to our humble world two of the giants of comic book science

**Right: Planet Comics #21
[Fiction House Magazines, 1942].**

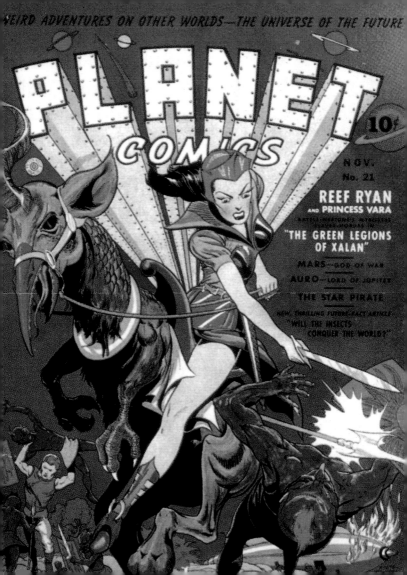

fiction—*Weird Science* and *Weird Fantasy*. As he did for EC's horror line, Al Feldstein once again did much of the scripting, using Gaines' intricate plots and the twist endings, synonymous with the EC formula. These stories expressed a concern with the technological implications of this age and the moral complexities that came with it.

Gaines and Feldstein were never afraid to show humans' failings in this uncharted atomic age. Their journey would take them into realms other comic book creators steered clear of: sex, religion, bigotry, and prejudice were theirs to play with. Feldstein also adapted some of Ray Bradbury's thought-provoking stories in a way no other creator in comic book history has ever managed to.

Weird Science and *Weird Fantasy* merged to become *Weird Science Fantasy* following a protracted period of adverse sales in 1954. After the introduction the Comics Code, it was forced to change its name one last time to *Incredible Science Fiction* in 1955.

The silver screen

These revered titles no doubt inspired many other publishers, but just as they were beginning to explore these alien worlds, the first major science fiction cinema release in well over a decade hit the silver screen. *Destination Moon* [1950] immediately captured the imagination of the cinema-going public; in its wake there came a host of other films from across the universe, *Rocketship X-M* [1955] and *When Worlds Collide, The Day the Earth Stood Still,* and *The Thing* [1951].

This interest provided a further stimulus for a new era in comic books. DC launched *Strange Adventures* [1950] with an adaptation of *Destination Moon,* and the following year it brought out *Mystery in Space.*

During the 1951–52 boom period in the genre, a plethora of science fiction titles hit the newsstand. After the implementation of the Comics Code, DC introduced a third science fiction title in the shape of *Tales of the Unexpected* [1956].

In 1952 Charlton released *Space Adventures* and *Space Western,* Ziff Davis produced *Amazing Adventures* [1950], and the following year, *Crusader from Mars, Lars of Mars,* and the Jerry Seigel-edited *Space Busters*—each with beautifully painted covers. Avon took us to *Strange Worlds* and warned of *Flying Saucers* in 1950, while Youthful sent *Captain Science* to the rescue. Dell adapted the successful TV series to bring us *Tom Corbett Space Cadet* [1952] and, against Martin Goodman's better judgment, Atlas released *Journey into Unknown Worlds* [1950], *Space Squadron* [1951], *Adventures into Weird Worlds* [1952], and *[Speed Carter] Spaceman* [1953].

But despite this abundance of new titles, the science fiction phenomena imploded in upon itself during 1952, leaving but a handful of comic books to traverse the universe in search of the infinite.

Right: Weird Science #17 [EC Comics, 1953].

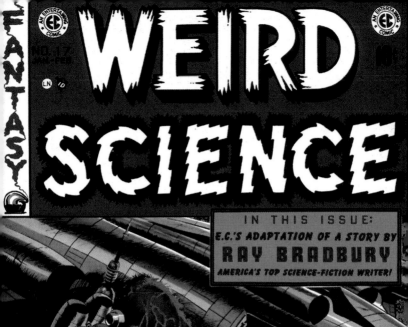

WEIRD SCIENCE

FANTASY

NO. 17
JAN-FEB

AN ENTERTAINING COMIC

LN 10

10¢

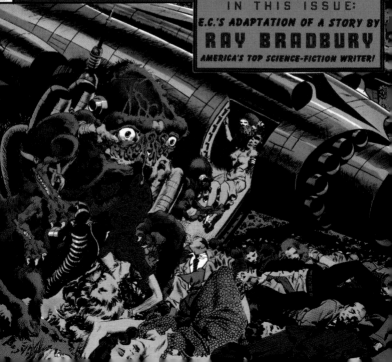

IN THIS ISSUE:
E.C.'S ADAPTATION OF A STORY BY
RAY BRADBURY
AMERICA'S TOP SCIENCE-FICTION WRITER!

the Mighty Mole, a powerful tunneling machine he had invented.

Created by Ed Herron and artist Bruno Premiani, Carson and his crew also appeared in *The Brave and the Bold* in 1962 as well as in *Showcase* in 1964.

Deathlok I [1974]

Predating *Robocop* by 13 years, Colonel Luther Manning is a soldier in the then-future 1990, who died only to be resurrected as a cyborg by the government's Project Alpha-Mech, a covert program designed to create an army of invincible troops.

Code-named Deathlok, over 75% of his body parts have been replaced with cybernetics, which give him enhanced physical attributes. His body is now armored, and he has a mini-computer—which his human consciousness has conversations with—implanted in his brain.

Created by Rich Buckler, the half-human, half-machine first appeared in *Astonishing Tales* #25 in a story that continued until 1976 [#26–28 and 30–36] when the title was canceled. The saga, considered to have taken place in an alternate timeline—was concluded in *Captain America* #288 [1983].

Dragon Chaing [1991]

Trucking goods destined for a future America gripped by a Great Recession, one of the world's last mavericks travels the Iron Road from Russia heading for the Great Bridge that crosses the Bering Strait. On the way, the Chinese-Communist trucker picks up a beautiful hitchhiker and is attacked by bandits in an eponymous Eclipse Comics one-shot written and drawn by Tim Truman.

Dragon's Claws [1988]

Originally to have been called Dragon's Teeth, this group of unwilling government operatives was created by Simon Furman and artist Geoff Senior.

Introduced in the first issue of their own Marvel U.K. title, they were Mercy, Scavenger, Digit, Steel, and their leader Dragon. Former champions of The Game, the murderous free-for-all, now outlawed by the World Development Council, they reluctantly undertook missions in Greater Britain in 8162 A.D. *Dragon's Claws* was canceled in 1989 after 10 issues.

Dreadstar [1981]

The hero of creator Jim Starlin's *Metamorphosis Odyssey* first appeared in the premiere issue of *Epic Illustrated* in a story that continued in Marvel Comics' magazine-sized anthology until #9 and then in *The Price* [1981], a black-and-white Eclipse Comics' graphic novel and in Marvel Graphic Novel #3: *Dreadstar* [1982].

Late in 1982, Dreadstar moved into his own title. Initially published by Epic Comics—

Marvel's creator-owned imprint—*Dreadstar* was taken over by First Comics with 1986's #27 and canceled in 1991 with #64.

The head of a small band of rebels, Dreadstar is out to end a 200-year-old intergalactic war between The Church of the Instrumentality and The Monarchy. Aiding him in his struggle are Odei the cat-man, ex-smuggler Skeevo, Willow, and Darklon, a deformed mystic.

The space-faring hero returned in 1994 in Jim Starlin's *Dreadstar*. A six-parter published by Bravura, Malibu Comics' creator-owned imprint, it was drawn by Ernie Colon and written by Peter David who—along with artist Angel Medina—had replaced Starlin when he left the first series after #40.

Grimjack [1983]

John Gaunt is a sword for hire in Cynosure, a city where realities fade in and out and literally anything can happen.

Created by John Ostrander and artist Tim Truman, Gaunt had been a gladiator, a demon-fighting soldier, an agent for the transdimensional police, and has rode with the Lawkillers. Now he is Grimjack, a freelancer, one of the deadliest men in a city where magic may work in one part and science in another but swords are deadly all over.

Introduced in a back-up story in *Starslayer* #10, his adventures continued in that title until 1983 when First Comics launched *Grimjack*. The series—canceled with 1991's #81—began a new direction with a jump 200 years into its future after #54. The following issue introduced Jim Twilley, Grimjack reincarnated. Ostrander and Truman's sword-wielding hero also featured in *Demon Knight: A Grimjack Graphic Novel* [1990].

Guardians of The Galaxy [1969]

In the 31st century of an alternate Marvel Comics future, the Badoon—a warlike race of sentient reptiles—has conquered Earth and its interstellar empire.

To liberate the Earth, Vance Astro gathered together others—each the last of their kind—from around the galaxy. Introduced in *Marvel Super-Heroes* #18 in a story by Arnold Drake and penciler Gene Colan they were:

- Charlie 27—Biologically engineered, he has been given additional strength, which enables him to live comfortably under Jupiter's incredible gravity.
- Yondu—A native of Centauri-IV in the Beta Centauri system, he uses a bow and yaka arrows. Made of a sound-sensitive metal, he controls them with high-pitched whistles.
- Martinex—A genetically altered human, his body tissue has been restructured out of silicon to enable him to withstand Pluto's extreme environment.
- Astro, an astronaut from the 20th century, had made the first interstellar flight, traveling to the Centauri system in cryogenic stasis.

The team next featured in *Marvel Presents*, between 1976 and 1977. Its ranks were swelled by "the one who knows"—the enigmatic Starhawk, a being encountered in *Defenders* #26–29 [1975] in a story that led into the Guardians revival.

After numerous guest appearances, the team was given its own title in 1990. Initially written and drawn by Jim Valentino, *Guardians of the Galaxy* introduced several additions to the team as well as 31st-century versions of many of Marvel's 20th-century heroes. It was canceled in 1995 after 62 issues.

Halo Jones [1984]

This young *2000 A.D.* heroine resides on The Hoop, an enormous artificial island anchored just off Manhattan where the Allied Municipalities of America dumps its unemployed.

Jones is just an ordinary girl, anxious to escape from Earth, from the endemic violence of society and from the boredom of her everyday life in 4949 AD when 70% of the population is female. She gets away by working her passage on the space liner *Clara Pandy* but eventually ends up enlisting in the Earth army where she is sent to the heart of a war in the Tarantula Nebula.

It is rumored that creators Alan Moore and artist Ian Gibson intended *The Ballad of Halo Jones* to run to seven books. Whatever the truth of the matter, only four were published, in *2000 AD* in 1986.

Jet Ace Logan

In the year 2056, Jim Logan is a Royal Air Force space cadet. A trainee jet-ship pilot, he first appeared in the [unnumbered] September 15, 1956 issue of *The Comet*. Initially featured in stories written by David R. Moton and drawn by Geoff Campion, he continued in the Allied Press comic until October 17, 1959 when the title merged with *Tiger*. His stay in the latter comic lasted until March 9, 1968, although the issues from August 22, 1964 on were reprint.

Logan also starred in 15 issues of *Thriller Picture Library* between 1961 and 1963.

Kamandi [1972]

Created by Jack Kirby, the Last Boy on Earth lives in a post-Great Disaster future where Earth is a barren wasteland.

Seemingly inspired by the 1968 *Planet of the Apes* movie and its sequels, the writer/artist peopled this world with sentient apes, lions, tigers, dogs, gophers, and dolphins, which have evolved into humanoid form. Other animals have mutated into bizarre monstrosities, and the few humans have regressed.

It was a theme Kirby had already used in a story for the 1957 first issue of Harvey Publications' *Alarming Tales* anthology.

Kirby introduced his teenager in the first issue of the aptly titled *Kamandi: the Last Boy on Earth*. The DC Comics title lasted until #59

[1978] although its creator departed after 1976's #40. In 1993, Tom Veitch and artists Frank Gomez and Mike Barriero revived the concept in the six-issue *Kamandi: At Earth's End*. An Elseworlds—i.e., noncontinuity—series, it elaborated on Kirby's themes.

Killraven [1973]

Amazing Adventures #18 began a new series. Based on the H. G. Wells' novel of the same name, Marvel Comics' *War of the Worlds*—which became Killraven with #29—was conceived by Roy Thomas, Neal Adams, and Howard Chaykin, who hypothesized that the Martians returned 100 years after their defeat in the 1898 Wells novel to successfully invade Earth.

Thus the scene was set for the introduction of Jonathan Raven, the freedom fighter who became known as Killraven. Taken by the Martians to be a gladiator while still a child, Raven is surgically augmented. But his human surgeon is not as brainwashed as the invaders believe and gives the youth the ability to transfer his mind into a Martian's body as well as enhancing his physical abilities and implanting the sum total of human knowledge in his brain.

Escaping from captivity, Killraven becomes the leader of a band of freedom fighters known as the Freemen. Among them are former gladiators Old Skull and M'Shulla Scott and scientist Carmilla Frost.

War of the Worlds/Killraven continued in *Amazing Adventures* until the title was canceled with #39 [1976]. The story of Earth's freedom fighter was continued by Don McGregor and artist P. Craig Russell—who had begun collaborating on the series with #27—in Marvel Graphic Novel #7: *Killraven—Warrior of the Worlds*. The milieu was also visited in the standalone *Killraven: 2020*, a 2001 Marvel Knights one-shot by Joseph Michael Linsner.

In 2002, Marvel launched a *Killraven* six-part series by Alan Davis in which he went back to the basic concept of *War of the Worlds* to begin the story anew.

Knights of The Galaxy [1951]

This 30th-century band of space-faring crime busters was created by Robert Kanigher and artist Carmine Infantino. Based on the planetoid Gala and equipped with individual spaceships, the Knights appeared in *Strange Adventures* #1–8 [1951].

Lance Barnes [1993]

Not only is this private investigator living in a postnuclear world where crazed survivors and degenerate mutants struggle to survive, but the situation that he finds himself in is largely his own fault. Landed with the task of

Continued on page 364

Dan Dare: A Very British Space Hero

In early 1950s, a comic like no other previously seen in Britain suddenly burst into the drab postwar newsagents. Produced by the high-quality photogravure process, the full-color Eagle was an explosion of brightness among its dowdy competitors.

Created by the Reverend Marcus Morris and artist Frank Hampson and published by Hulton Press, the tabloid's characters ranged from police constable PC49, Tommy Walls: Wonder Boy, and the Great Adventurer (Saint Paul).

But the hero most associated with the comic —which ran weekly for 987 issues until 1969 when it was amalgamated with IPC's *Lion*—was the cover-featured Dan Dare. As with their other heroes, children of the 1950s needed to believe in the space-going Pilot of the Future, so Colonel Daniel McGregor Dare was presented as not too dissimilar to the movie depictions of World War II Battle of Britain fighter pilots of the Royal Air Force.

Square jawed and clean-cut and originally created as a dog-collared Chaplain of the Future, Dare is a space pilot in the United Nations Space Fleet. He zips about the solar system, and occasionally beyond, having adventures with a variety of humanoid aliens; distinguished mainly by their different color skins—green, blue, gold—and battling the evil Mekon and other dangers with a combination of courage, integrity, and two strong fists.

The strip was conceived by Hampson who wrote much of the story, with science fiction author Arthur C. Clarke initially acting as science and plot adviser. The artist also drew or oversaw the drawing of Dan Dare for 10 years, laying out each two-page installment, then making reference photos for each panel, using a building full of props, miniatures, models, and costumes.

Right: Dan Dare, space pilot of the future.

The first Dan Dare story began with a starving Earth and failed attempts to reach Venus, where it is hoped food may be found. Setting off for the planet, Dare discovers Venus is divided: the north inhabited by Treens, emotionless, ruthless, and capable of any barbarity; the south by Therons, peace loving, living lives of gentle contemplation in floating homes in the sky; the two civilizations existing in an uneasy truce that has lasted centuries.

Dare also discovers the Treens are using Atlantines—Earth people they abducted many thousands of years ago—as slaves. Enlisting these and the Therons, he manages to overthrow the Treens—making an eternal enemy out of their leader, the dome-headed, frail, hoverchair-bound Mekon in the process— and assure food supplies for Earth.

As befits a member of the U.N. Space Fleet, Dare didn't go solo. That first adventure introduced several important members of the regular supporting cast. Foremost among them was Albert Fitzwilliam Digby, Dare's rotund Lancastrian batman (a personal servant of an officer, responsible for making sure his kit, etc. was prepared and complete) and sidekick. Dig provided the comic relief—he was not only "other ranks" but also working class.

Among the others were Sir Hubert Guest, Spacefleet Controller—based physically entirely on Hampson's father—the man with the responsibilities, and Professor Peabody, the glamorous and competent female—initially modeled on Greta Tomlinson, one of the Hampson studio artists—and one of only two women in the whole saga.

Except for a four-parter in volume 18 #52 to volume 19 #3, the last original Dan Dare story was concluded in *Eagle* volume 18 #1 [1967], replaced by reprints which continued with its merger with *Lion* in 1969.

In 1977 IPC premiered a new Dan Dare in *2000 AD* Prog 1. Drawn by Massimo Bellardinelli, this featured a very radical version, one whose transformation was explained in 1979's *Dan Dare Annual*.

This depicted a near-fatal space explosion that put Dare into suspended animation until such time as medical science had advanced sufficiently to be able to save his life. The Dare that emerged over a 100 years after was much changed, both in appearance and character. Teamed up with a bunch of gun-toting heavies, he became a far rougher, tougher type of hero in a strip that ran until Prog 126 [1979].

IPC relaunched *Eagle* in 1982, but the Pilot of the Future was no longer the cover feature. Initially written by Pat Mills and John Wagner and drawn by Gerry Embleton—quickly succeeded by Ian Kennedy—this new Dare was the great-great-grandson of the original. Although set 200 years after the original adventures, care was taken to echo the classic 1950s strip, with the uniforms and structure of the space fleet replicated.

In a 1987 story, Dan Dare met his death in a fight with the alien Dargath. After being promptly resurrected by the mysterious Mytherons, he now became Dan Dare, Space Marshall, with an ongoing mission to cruise the galaxy, disintegrating nefarious aliens with his Peacemaker.

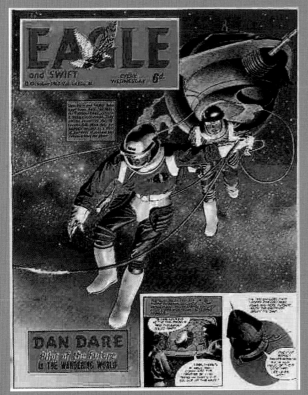

Eagle volume 14 #41 [Longacre, 1963].

By mid-1991, after 574 weekly issues, the relaunched *Eagle* became a monthly and Dan Dare, along with most of the other strips, once again became a reprint.

In 1990, Fleetway, which by then had acquired *Eagle*, launched a more politically aware, hip comics magazine aimed at older readers. The first issue of *Revolver* began a nine-chapter serial in which writer Grant Morrison brought a crippled Pilot of the Future out of retirement to be used as a propaganda tool by an unpopular right-wing government. Drawn By Rian Hughes, Dan Dare ran in *Revolver* #1–7 and *Crisis* #55–56.

August 1989 saw the return of the original Dare to the *Eagle* in a new six-part story, illustrated by one of the artists from the 1960s, Keith Watson. Although true to the original, it was followed by several more short serials in which radical changes were made. Dare gained a "ram gun," his uniform began to be heavily punk influenced, and after a short time, the strip had degenerated into simplistic "blast the aliens" stories.

"In a 1987 story, Dan Dare met his death in a fight with the alien Dargath. After being promptly resurrected by the mysterious Mytherons, he now became Dan Dare, Space Marshall, with an ongoing mission to cruise the galaxy, disintegrating nefarious aliens with his Peacemaker."

363

disarming a nuclear missile, he cut the wrong wire and accidentally triggered the oubreak of World War III.

Now he scrapes a living assisted by Peg, his one-legged girl Friday.

Created by Stefan Petrucha and artist Barry Crain, the hapless detective appeared in the four-issue *Lance Barnes, Post Nuke Dick*, published by Epic Comics, Marvel Comics' creator-owned imprint.

Laser Eraser And Pressbutton [1982]

The hard-hearted professional assassin and her kill-crazy cyborg sidekick lay waste to anything that gets in their way as they roam the galaxy.

Created by writer Pedro Henry—who's pseudonym was Steve Moore—and first drawn by Steve Dillon, the beautiful Eraser and the mentally unstable Pressbutton were introduced in the first issue of Quality Communications' *Warrior*. They featured in issues #1–12 and 15–16 [1983] of the independently run black-and-white British magazine.

These adventures were reprinted in the United States in the six-issue *Axel Pressbutton* by Eclipse Comics, the company going on to commission new material for *Laser Eraser* and *Pressbutton*. This latter title was published between 1985 and 1986, however, it was only to last for six issues.

Last American

Revived from suspended animation 20 years after nuclear war had ravaged the planet in 1999, Ulysses S. Pilgrim begins to search for anyone who survived the holocaust.

Accompanied by three robots, Able, Baker, and Charlie, he appeared in all four issues of *The Last American* miniseries. Published by Epic Comics, Marvel Comics' creator-owned imprint, it was written by John Wagner and Alan Grant and drawn by Mike McMahon.

L. E.G.I.O.N. [1989]

Formed by the green-skinned Vril Dox, the son of Superman's enemy Brainiac, the Licensed Extra Governmental Operatives Network is set up to function as an interplanetary police force. Its officers come from a variety of planets in the DC Universe. Each has his, her, or its own superpower.

Created by Keith Giffen and Alan Grant and artist Barry Kitson, the 20th-century organization—which has only indirect links with the 30th-century Legion of Super-Heroes—debuted in the first issue of its own title, which was suffixed '89. *L.E.G.I.O.N.* ran 70 issues until 1994 when it made way for *R.E.B.E.L.S.* The latter comic, which launched with an issue #0 and was canceled with 1996's #17, focused on a group of rebel superheroes who took on L.E.G.I.O.N., which had become a sinister interplanetary security agency.

Legion of Substitute Heroes [1963]

These are the rejects, the superheroes who couldn't get into the Legion of Super-Heroes because their powers were crap.

First featured in *Adventure Comics* #306, the team was formed by Polar Boy—who can create supercold conditions—in conjunction with Night Girl who has superstrength only when it's dark, Stone Boy who can become a statue, Chlorophyll Kid who can make plants grow quickly, and Fire Lad who has the ability to breathe fire but not control it.

Created by S.F. author Edmund Hamilton and artist John Forte, the Substitutes have become a part of Legion of Super-Heroes lore. DC Comics published a *Legion of Substitute Heroes* one-shot in 1985.

Legion of Super-Heroes [1958]

When three teenage superheroes from the 30th century made their debut in *Adventure Comics* #247, they were intended as one-shots. Writer Otto Binder and artist Al Plastino had no idea that they were introducing a concept that would quickly become an integral part of the DC Universe.

The telepathic Saturn Girl from Titan, the aptly named Lightning Lad from Winath, and,

from Braal, Cosmic Boy who wields a magnetic power had come to the past to invite Superboy to join their club. They had formed the Legion of Super-Heroes after preventing the assassination of R. J. Brande, a billionaire who offered to fund the organization.

The three heroes returned in *Adventures Comics* #267 [1959] and then in *Action Comics* #267 [1960] when they were accompanied by three new members—Earth's Colossal Boy, the Durlan shape shifter Chameleon Boy, and, also from Earth, Invisible Kid. These and various other guest appearances led to a regular series, *Tales of the Legion*, in *Adventure Comics* where it featured between 1962 and 1969 [#300-80].

With new members from throughout the galaxy having been added seemingly every issue, the Legion moved into *Action Comics* where it featured as a backup from 1969 to 1970. After a brief hiatus, it began appearing sporadically in *Superboy* until it became a permanent fixture. In 1977 the series was retitled *Superboy & the Legion of Super-Heroes*, and three years later—over 20 years after the team was introduced, it gained its own title. With 1980's #259, Superboy departed and the series became simply *The Legion of Super-Heroes*.

Since then the *Legion of Super-Heroes* has been relaunched several times and much of Legion history has been changed in the wake of such events as *Crisis on Infinite Earths* [1985] and 1994's *Zero Hour: Crisis in Time*. But the team continues to flourish, remaining an integral part of the DC mythos. Since the Legion first gained its own title in 1980,

the team, its members, villains, and supporting cast have appeared in numerous miniseries, specials, and as guests in other titles throughout the DC Universe.

Legionnaires [1991]

Initially thought to be clones, which were manufactured by the Time Trapper, these teenagers are now revealed to be time-displaced versions of their older counterparts in the Legion of Super-Heroes.

After a shadowy cameo in #20, the SW6 Batch as they were known were revealed in 1991's *Legion of Super-Heroes* #24 in a story written by Keith Giffen with Tom and Mary Bierbaum and penciled by Jason Person and Dusty Abel. Having been discovered by Earth's invaders, the Dominators, and placed in suspended animation, they were released by freedom fighters led by members of the Legion of Substitute Heroes.

Following Earth's destruction, they became protectors of New Earth, created by the surviving domed cities. They formed their own team which debuted in *Legionnaires* #1 [1993], written by the Bierbaums and drawn by Chris Sprouse and Karl Story. The DC Comics series ran until 2000, a total of 81 issues.

As a result of *Zero Hour: A Crisis in Time* [1994], the *Legionnaires'* continuity was retroactively altered. In 1994's issue #0—published between #18 and 19—it merged with the *Legion of Super-Heroes* as that team was itself relaunched with a fresh beginning.

Magnus [1963]

A robot fighter in 4000 A.D., he has been specially trained from birth by Robot 1A to have the speed and power to karate chop and destroy automatons that have gone rogue.

Created by editor Chaise Craig and writer/artist Russ Manning, the 41st-century hero was conceived to provide the sort of S.F. adventures that TV couldn't produce because of budget. Introduced in Gold Key's *Magnus, Robot Fighter* #1, he continued to battle renegade robots until 1977's #46 although most issues from #29 on were reprints.

Never a major Silver Age hero, Magnus was revived in 1991 by *Valiant*, which licensed the character from Western Publishing, Gold Key's successor. Initially written by Jim Shooter and drawn by Art Nichols and Bob Layton, the relaunched *Magnus, Robot Fighter* was a cornerstone of the *Valiant* Universe, which proved to be ultrasuccessful during the early 1990s. Issue #16 of the series—canceled in 1996 with #64—revealed that Magnus was the child of two 20th-century Harbingers.

Magnus, Robot Fighter was revived by Acclaim Comics in 1997. It lasted 18 issues until 1998.

Martha Washington [1990]

An angry young African American living in a near-future America, she resides in The Green, an area of Chicago where the poor are

effectively imprisoned. In 2014, the U.S.A. is governed by fascists, on the brink of war with 40 different nations, and an ecological cesspool.

With the country also on the brink of civil war, she enlists in the PAX Corp. The supermilitary force is battling to save the Amazon rain forest and asks no questions of its recruits.

Created by Frank Miller and British artist Dave Gibbons, Washington debuted in 1990's *Give Me Liberty* four-parter, subsequently appearing in *Dark Horse Presents' Fifth Anniversary Special* [1991]. She next starred in the five-issue *Martha Washington Goes to War* [1994]—in which she ends up fighting against PAX. This was followed by two one-shots: *Happy Birthday Martha Washington* [1995] and 1996's *Martha Washington Stranded in Space* and a story in *Dark Horse Presents* in 1996.

Her last appearance to date was in 1997's *Martha Washington Saves the World*. A three-parter, it features Washington leading a mission to observe the destruction of a giant asteroid while a global computer intelligence plots to enslave every mind on Earth.

Metacops [1991]

Created by Link Yaco and artist John Heebink, the Metaphysical Police patrols time, attempting to protect history from meddlers, creeps, and opportunists.

Metacops officers include such renowned historical figures as the Queen of Sheba, Albert Einstein, and Jimi Hendrix as well as Nicolas Tesla, the inventor of the history machine upon which their mission depends.

A *Metacops* three-parter was released by Monster Comics, a Fantagraphics Books imprint in 1991. It was published in black and white as was the *Metacops* one-shot issued by Caliber Comics' Gauntlet imprint in 1993.

Morlock 2001 [1975]

Set in a then near-future America ruled by a repressive government, this weird plant-man may or may not be a reclusive scientist murdered by the secret police as a freethinker.

Able to kill at a touch, Morlock is hired to be a government assassin, but he has a conscience. The plant-man appeared in all three issues of Atlas/Seaboard Publications' *Morlock 2001*.

The first two were written by Michael Fleisher and drawn by Allen Milgrom and Jack Abel, while #3 was by Gary Friedrich and artist Steve Ditko who introduced Whitlock, an intellectual revolutionary whose entire body was horribly scarred. At the end of that third and final issue, he shot Morlock in the face and then seemingly blew himself and everybody else up.

Microbots [1971]

The indestructible miniature robots created by his scientist father were there to protect and assist Jeff Micron and his pal when they

emerged from cryogenic stasis into a primitive future. Their adventures were limited to the one and only issue of Gold Key's *Microbots*.

Mighty Samson [1964]

Together with his companions Mindor and Mindor's daughter Sharmaine, the one-eyed strongman wandered a postholocaust America where nearly all the plants and animals had mutated and civilization has reverted to the stone age.

Samson was one of the humans whose mutation was positive. It made him a giant and also provided him with incredible strength.

Created by Otto Binder and artist Frank Thorne, the mighty one appeared in 32 issues of his own Gold Key title, the last a reprint released by Western Publishing. Although Mighty Samson finally bit the dust in 1982, publication slowed down after #20 [1969] with #21 appearing in 1972 and #22–31 between 1973 and 1976.

OMAC [1974]

A Jack Kirby creation, Buddy Blank is a puny caretaker who is transformed into a One Man Army Corp. Introduced in the first issue of his own futuristic DC Comics title, *Blank* gets his power via a link with Brother Eye, an orbiting satellite.

After appearing in eight issues of his own Kirby-written and drawn title—canceled in 1975—the agent of the Global Peace Agency went on to feature as a backup in *Kamandi* in 1978 and Warlord through 1980–81 before writer/artist John Byrne revived *OMAC* as a black-and-white comic. A four-parter, it remained true to Kirby's concept.

Omega Men [1981]

Introduced in *Green Lantern* #141 in a story by Marv Wolfman and artist Joe Staton, the motley band of aliens are rebels, fighting to free the Vegan system from the rule of the Citadel.

They are the survivors of a Prison Planet revolt initiated by Primus and Tigorr. Although the two leaders led over 1,200 in the bid to escape from Citadel captivity, more than 70 died in the attempt and only 200 made it to freedom and to Earth where they set up a base in Newfoundland and began planning the overthrow of their former captors.

Returning to the Vegan system after a number of guest appearances in various DC Universe titles, the Omega Men launched their rebellion in earnest in the first issue of their own title in a story by Roger Slifer and artist Keith Giffen. *Omega Men*, canceled in 1986, lasted 38 issues. The war was over by #6 [1983], but there was much for the Omega Men to do in its aftermath.

The Omega Men constituted a large team— more an army. Many of them have appeared in other DC comics since they ceased to have their own series.

Rip Hunter [1959]

Created by Jack Miller and artist Ruben Moreira, the Time Master, as he was known, first appeared in *Showcase* #20. Following further appearances in 1960 in the DC Comics try-out title, the inventor of the Time Sphere graduated to his own comic in 1961.

Traveling almost exclusively into the past, Hunter and his companions—his girlfriend Bonnie Baxter, her young brother Corky, and Jeff Smith, his assistant—encountered dinosaurs, aliens, supernatural entities and more dinosaurs until 1965 when *Rip Hunter: Time Master* was canceled with #29.

In 1990, Hunter resurfaced in *Time Masters,* an eight-issue series, which began with the premise that Hunter had developed two methods of time travel only to discover that every person can use each only once. To prevent the Illuminati, the ultimate covert conspiracy group, from starting a nuclear war, he needed to discover two more methods so that each of his comrades can go back in time and return.

Ro-Busters [1978]

The robot squad that dealt with the mega-disasters of the future was created by Pat Mills and artist Carlos Pino, who introduced the team in *Starlord* #1.

Appearing in all 22 issues of the British comic, *Ro-Busters*—a sort of robotic version of International Rescue from Gerry Anderson's 1966 puppet-starring TV series *Thunderbirds* —went with it when it merged with *2000 AD* in 1978. Run by the semihuman Howard Quartz from his base on Devil's Island, the most featured automatons were the demented demolition robot, Mekquake and the team of Ro-Jaws and Hammerstein—one an ex-sewer droid programmed to enjoy eating waste, the other the perfect soldier.

Following the *Starlord/2000 AD* merger, Ro-Busters Disasters Ltd appeared in several more editions of the self-styled *Galaxy's Greatest Comic* with MekQuake and Ro-Jaws and Hammerstein ultimately going on to feature in *ABC Warriors*.

Rogue Trooper [1981]

The last of the G.I.s—Genetically Engineered Infantry—was fighting a one-man war against the Norts when Gerry Finlay-Day and artist Dave Gibbons introduced him in Prog 228 of *2000 AD*. Battling the evil aliens on Nu-Earth, a war-ravaged planet on the edge of the galaxy, he was also seeking the traitorous general who betrayed his battalion, resulting in all their deaths at the Quartz Zone Massacre. The blue-skinned Trooper is aided by the biochips of three of his fallen comrades: Bagman his backpack, Helm his helmet and Gunnar his gun.

One of the British comics' most popular heroes after *Judge Dredd*, *Rogue Trooper* has been featured regularly in *2000 AD* since his first appearance.

Shatter [1985]

A 21st-century private eye, Jack Scratch was the tough guy star of the first commercially produced computerized comic. Published by First Comics, the *Shatter* one-shot was illustrated, lettered, and colored by artist Michael Saenz using an Apple Mac and working from a story written by Peter Gillis.

The special—heavily influenced by Ridley Scott's 1982 movie *Bladerunner*—segued into a back-up series that ran in *Jon Sable, Freelance* in 1985. A *Shatter* series followed.
It lasted 14 issues from 1985 to 1988.

Space Ranger [1958]

Dubbed the Guardian of the Solar System, Rick Starr operated out of a secret base within an asteroid out beyond Mars' orbit. In his secret identity of Space Ranger, the son of the wealthy owner of the vast business empire known as Allied Solar Enterprises tangled with such interplanetary menaces as The Alien Brat from Planet Byra and The Jungle Beasts of Jupiter as well as preventing the Invasion of the Jewel Men.

Created by writers Edmond Hamilton and Gardner Fox and artist Bob Brown, *Space Ranger* made his debut in *Showcase* #115. After also appearing in #16 of the try-out title, he moved into *Tales of the Unexpected* where he cover featured between 1959 and 1964. Transferred to *Mystery in Space,* he appeared

there through 1964–65. After two more 1965 appearances, he virtually disappeared.

The Ranger was assisted by his secretary, Myra Mason, and his cute extraterrestrial friend Cryll who could transform himself into any kind of alien fauna with exotic abilities.

Star Hawkins [1960]

The 21st-century detective was always being bailed out by Ilda, his robot secretary—except when she was in the pawnshop because he was short of funds . . . again.

Initially written by John Broome and drawn by Mike Sekowsky, he appeared semi-regularly in DC Comics' *Strange Adventures in 1965.* In 1981, *DC Comics Presents* #33 featured a *Whatever Happened to Star Hawkins?* story.

Starjammers [1977]

Introduced in *Uncanny X-Men* #104 by writer Chris Claremont and artists Dave Cockrum and Sam Grainger, this small band of alien space pirates roam the Shi'ar Galaxy plundering Shi'ar starships in a guerilla war against the Shi'ar Empire.

Fugitives from the empire's slave pits, they are led by former U.S. Air Force test pilot Major Christopher Summers, who now calls himself Corsair and is the father of the mutants Cyclops and Havok.

Occasional guest stars, most notably in Marvel Comics' mutants titles, the pirate band

—who call themselves after their starship, the Starjammer—were the stars of *X-Men Spotlight on . . . Starjammers*, a 1990 two-parter.

Star Slammers [1983]

Created by Walter Simonson, this race of elite intergalactic mercenaries are the end result of concepts the writer/artist used in the comic book he created for his senior thesis while at The Rhode Island School of Design in the early 1970s. That project became his portfolio and landed him his first professional work, at DC Comics.

Able to out-shoot, out-fight, and out-kill anybody, they are paid such fabulous sums for their services they went into business and have become the most successful business-people in history.

Introduced in the eponymous *Marvel Graphic Novel* #6, they went on to appear in a *Star Slammers* series. Four issues of the latter were published by Bravura, Malibu Comics creator-owned imprint in 1995. The stories' conclusion came from Dark Horse/Legends, which released it as *Star Slammers Special* [1996].

Star Rovers [1961]

Author and sportsman Homer Gint, the sharp-shooting former Miss Solar System Karel Sorensen, and playboy athlete Rick Purvis are dilettante adventurers. Each rich enough to own their own personal spacecraft, they compete against each other to solve interplanetary mysteries.

Introduced in *Mystery in Space* #66 in a story by Gardner Fox and artist Sid Greene, they continued with appearances through 1963 and in *Strange Adventures* in 1963 and 1964.

Strontium Dog [1978]

Johnny Alpha is a mutant who eyes emit alpha rays, which enable him to see through solid eyes and manipulate objects by telekinesis.

A member of the victimized underclass, like all of those on Earth affected by strontium 90 fallout, he is unable to get a normal job. So he took one of the jobs norms consider beneath them: bounty hunting. Out on the expanding frontier of space, he is a Strontium Dog, hunting down the criminals the Galactic Crime Commission considers too dangerous.

Created by John Wagner and artist Carlos Ezquerra and introduced in *2000 AD* Prog 86, he is second only to *Judge Dredd* in popularity among readers of the self-styled *Galaxy's Greatest Comic*. He has starred in 32 different multipart stories since he debuted.

Tommy Tomorrow [1947]

Starting out in *Real Facts Comics* #6—where he was chosen to pilot the first manned mission to Mars—as part of an attempt to present predictions of scientific advances, the future Ace of the Planeteers also appeared in issues

#8, 13, and 16 of the National Periodicals title. He was then transformed into a member of the Planeteers, an elite 21st-century law enforcement corps.

Created by editors Jack Schiff and Mort Weisinger, he began his new career as an interplanetary policeman in *Action Comics* #127, appearing there until #251 [1959]. He then moved into the back of *World's Finest* where he remained from #102 to 124 [1959–62].

He got several tryouts in *Showcase* during 1962–63 but never graduated to his own title.

In DC's post-*Crisis on Infinite Earths* continuity, *Tomorrow* was a child named Kamandi Blank, grandson of Buddy Blank a.k.a. OMAC. Discovered in Bunker D of the Space Planeteer H.Q. by General Horatio Tomorrow of the Planeteers and renamed Thomas, he later joined the 22nd-century Planeteers.

Tyler Flynn [1987]

The star of *Lost Planet* is an Earthman, a soldier of fortune transported to a world populated by prehistoric animals. There he encounters Amelia Earhart, Judge Crater, Ambrose Bierce, and others. The Eclipse Comics six-parter was written and drawn by Bo Hampton.

Ultra [1966]

Spaceman Ace Arn became the freakish multi-alien when an accident transformed him into an amalgamation of four different alien races.

Above the waist, his right side was green and possessed an inordinately strong arm, while the blue left side had magnetic powers. Below the waist the right leg was birdlike with a tiny wing that allowed him to fly, and the left was a bolt of lightning. One can only wonder what writer Dave Wood and artist Lee Elias were on.

Using his powers for good and gaining a hyperconverter disk capable of restoring his human form along the way, Ultra the Multi-Alien appeared in *Mystery in Space* #103–110 [1966] when the title was canceled.

The Wanderers [1968]

In the 30th century, Quantum Queen, Elvo, Immorto, Dartalg, Psyche, Orintho, and Celebrand were interstellar legends, the galaxy's preeminent superhero team before the coming of the *Legion of Super-Heroes*.

Introduced in *Adventure Comics* #375 in a story by Jim Shooter and artist Win Mortimer, they next appeared in *Superboy* #200 [1974] and then in *Legion of Super-Heroes* #294 [1982] and in #300 [1983].

When they reappeared in their own title, they were not the same. Some had adopted new identities: Dartalg became Dartalon, Elvo became Elvar, Immorto became Re-Animage, and Ornitho became Aviax. They were clones.

Once they had solved their own murder, they became agents of the United Planets but vanished into a space warp—never to be seen again—in the last issue [#13] of *The Wanderers*, canceled in 1989.

"... chock full of laughter and thrills, comic characters of every hue, knights and Vikings of ancient days, adventuring heroes, detectives, aviator daredevils of today, and hero supermen of the days to come!"

Bibliography

100 Years of American Newspaper Strips:
An Illustrated Encyclopedia
(Maurice Horn, editor)
Gramercy Books, 1996

Adventure Heroes: Legendary Characters
from Odysseus to James Bond
(Jeff Rovin)
Facts on File, 1994

The Classic Era of American Comics
(Nicky Wright)
Prion Books, 2000

The Comicbook Heroes
(Gerard Jones & Will Jacobs)
Prima Publishing, 1997

The Comic Book in America:
An Illustrated History
(Mike Benton)
Taylor Publishing, 1989

Comics between the Panels
(Steve Duin & Mike Richardson)
Dark Horse Comics, 1998

Comics, Comix & Graphic Novels:
A History of Comic Art
(Roger Sabin)
Phaidon Press, 1996

Comix: A History of Comic Books
in America
(Les Daniels)
Wildwood House, 1973

DC Comics: Sixty Years of the World's
Favorite Comic Book Heroes
(Les Daniels)
Virgin Publishing, 1995

The Encyclopedia of American Comics
(Ron Goulart)
Facts On File, 1990

Encyclopedia of Comic Characters
(Denis Gifford)
Longman Group, 1987

The Encyclopedia of Superheroes
(Jeff Rovin)
Facts on File, 1985

Ghastly Terror!
The Horrible Story of the Horror Comics
(Stephen Sennitt)
Headpress/Critical Visions, 1999

The International Book of Comics
(Denis Gifford)
Hamlyn Publishing, 1984

Manga! Manga!
The World of Japanese Comics
(Frederik L. Schodt)
Kodansha International, 1983

Marvel: Five Fabulous Decades
of the World's Greatest Comics
(Les Daniels)
Virgin Books, 1991

Marvel Universe
(Peter Sanderson)
Virgin Publishing, 1996

Master of Imagination:
The Comic Book Artists Hall of Fame
(Mike Benton)
Taylor Publishing, 1994

Over 50 Years of American Comic Books
(Ron Goulart)
Publications International, 1991

Ron Goulart's Great History
of Comic Books
Contemporary Books, 1986

The Slings & Arrows Comic Guide
(Frank Plowright, editor)
Aurum Press, 1997

Tales of Terror: The EC Companion
(Fred von Bernewitz & Grant Geissman)
Fantagraphics Books
& Gemstone Publishing, 2000

The Taylor History of Comics
1: Horror Comics: The Illustrated History 1991.
2: Superhero Comics of the Silver Age: The
 Illustrated History 1991.
3: Science Fiction Comics: The Illustrated
 History 1992.
4: Superhero Comics of the Golden Age: The
 Illustrated History 1992.
5: Crime Comics: The Illustrated History 1993.
(Mike Benton)
Taylor Publishing

The World Encyclopedia of Comics
(Maurice Horn, editor)
Chelsea House Publishers, 1999

Mike Conroy is a veteran comics journalist and historian; the news editor with Europe's trade paper, *Comics International*, he also has his own monthly column discussing the interaction between movies and comics. He was also editorial consultant to the *Cool Beans World* website. The founder of the Eagle Awards, one of the comics industry's earliest established and most coveted international prizes, he has written on comics for *London Editions* and *Marvel UK* as well as for such magazines as *Comic World*, *Fangoria*, *SFX* and *Starburst*.

Will Eisner has been a pioneering force in comics for over 60 years. His career spans ground breaking work in early newspaper comics to the mature graphic novels that he continues to produce today. Best-known for creating *The Spirit* newspaper strip, he also created Hawks of the Seas, Blackhawk, Doll Man, Uncle Sam and Sheena, Queen of the Jungle. Co-owner of the Eisner-Iger studio with Jerry Iger from 1938-40, he is the founder of American Visuals Corporation, which produced educational comics from the 1950s to the 1970s. In 1978, comics' master storyteller wrote and drew *A Contract with God*, the first of his graphic novels.